D1351822

History of London Art and
Artist's Guide and the Art Guide series.

In 1979 Heather Waddell wrote the London Art and Artist's Guide, while administering the International Visual Artists Exchange Programme at ACME Gallery and Housing Association for artists (then based in Covent Garden, now in the east end). In 1980 she set up Art Guide Publications, with an office at 89 Notting Hill gate (now Faron Sutaria estate agents). In 1982-86 the office was in Colville Road, then 15 Needham Road 1986-7. The Art Guide series was sold to A&C Black in 1987, a week before the stock market crash. HW remained at A&C Black as publisher and editor of the series, until 1989, when she became Arts Events editor at The European newspaper on élan the arts magazine. In 1992 the rights to London Art and Artists Guide reverted to HW.

London Art and Artist's Guide (Heather Waddell):
1st edn 1979, 2nd edn 1981, 3rd edn 1983, 4th edn 1986, 5th edn 1989, 6th edn 1993, 7th edn 1997, 8th edn 2000, 9th edn 2003

The Artists Directory (Heather Waddell and Richard Layzell):
1st edn 1982, 2nd edn 1984, 3rd edn 1989

Paris Art Guide (Fiona Dunlop):
1st edn 1981, 2nd edn 1983, 3rd edn 1989.

Australian Arts Guide (Roslyn Kean):
1st edn 1981, 2nd edn 1983, 3rd edn 1989

New York Art Guide (Deborah Gardner):
1st edn 1982, 2nd edn 1984

Amsterdam Arts Guide (Christian Reinewald):
1st edn 1985

Berlin Arts Guide (Irene Blumenfeld, photos Christiane Hartman):
1st edn 1986

Madrid Arts Guide (Claudia Oliveira Cesar, photos Candela Cort):
1st edn 1988

Glasgow Arts Guide (Alice Bain, photos Heather Waddell):
1st edn 1989

The London Art World 1979-1999
(Heather Waddell, introduction John Russell-Taylor):
1st edn 2000

LONDON ART AND ARTISTS GUIDE

Heather Waddell

LONDON ART & ARTISTS GUIDE

First edition published by ACME Housing Association 1979
Second edition published by Art Guide Publications 1981
Third edition published by Art Guide Publications Ltd 1983
Fourth edition published by Art Guide Publications Ltd 1986
Fifth edition published by Art Guide Publications/A&C Black 1989
Sixth edition published by London Art and Artists Guide 1993
Seventh edition published by London Art and Artists Guide 1997
Eighth edition published by London Art and Artists Guide 2000
Ninth edition published by London Art and Artists Guide 2003
Tenth edition published by London Art and Artists Guide 2006

BRITISH LIBRARY CATALOGUING IN PUBLICATION DATA
A CIP catalogue record for this book is available from the British Library
ISBN 978 0 9520004 6 6

Text copyright © 2006 Heather Waddell
Photographs copyright © 2006 Heather Waddell
Maps copyright © 2006 Heather Waddell

Published by London Art and Artist's Guide, London
Printed in Slovenia by Gorenjski Tisk
Designed by Waterman Design, Concord, Massachusetts, USA

CONTENTS

Introduction

In the last few years London's importance in the international art market has increased enormously. Overseas dealers have been moving to London from America and Europe, as well as artists, curators and art collectors. Larry Gagosian, the most powerful international art dealer, with galleries in New York and California, opened a second London space in 2004, in huge premises at Britannia Street, King's Cross, with a show of Cy Twombly's work. He has also bought Rachel Whiteread's work from Charles Saatchi and has taken over some of Anthony d'Offay's artists such as Howard Hodgkin and Michael Craig Martin. Iwan Wirth, an important European art dealer also opened Hauser&Wirth on Piccadilly in a renovated bank. Kenny Schachter, another American dealer, has moved to London in 2005 and Steven Cohen, the USA art collector, wants to collect more British art after his $8 million purchase of Damien Hirst's shark.

Other European dealers and gallerists have opened smaller galleries, capitalising on the boom in sales of Russian art and eastern European art. The community of eastern Europeans has money to buy paintings and prints and the work is now being shown to a public unacquainted with these artists, due to the previous political situation in eastern Europe. Artists are attracted to London, due to this vibrant atmosphere and the open system where artists can run their own art project spaces, as well as being able to use commercial galleries. The increase in artists' studios across the city has been enormous too. Leading curators are also attracted to London, where experimental work can be shown and new collectors have emerged, with all the publicity for art in newspapers, magazines and on radio and television. The choice of exhibitions on show at any one time in the city is amazing, ranging from at present as I write; African art, Turks 600-1600, Joseph Beuys, Strindberg, Frida Kahlo, Lee Miller photographs, Matisse, Hunting Group Prizes, Schweppes photo portrait prize, Dan Flavin the 1960s American artist, Turner, Whistler Monet, Matisse, Russian art, Norwegian art, American art and British contemporary art everywhere, as well as international names such as Tomoko Takahashi, Tatsuo Miyajima, Robert Mapplethorpe, Marine Hugonnier, Chinese photography, painting at the Saatchi gallery and the Kenneth Tyler print collection at Tate.

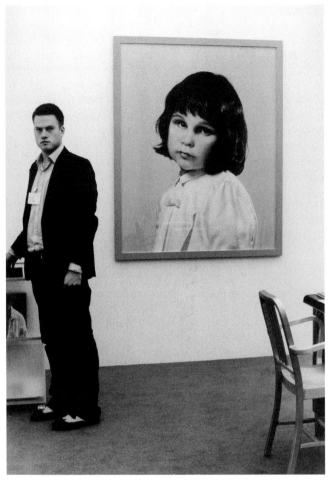

Don Gunn at Interim Fine Art/Maureen Paley stand at Frieze Art Fair, with Gillian Wearing photograph.

Frieze Art Fair opened in 2003 in Regent's Park, the first international art fair in London for some years, since the late 1980s. It has been a huge success and an annual event, with many galleries trying to be selected. In 2004 Zoo Art Fair, organised by David Risley and Soraya Rodriguez, who had both worked at east end galleries, showed off the art project space side of London to the public, at London Zoo, to coincide with Frieze Art Fair. In a nearby hotel Melia Art Fair tried to cash in on the visiting art collectors and dealers too. The London Art Fair

continues every January in Islington, selling more conventional work; paintings, prints, sculpture, photographs and drawings. Other art fairs in London are the 20th/21st Century Art Fair and the Art on Paper Fair at the Royal College of Art and the Affordable Art Fair in Battersea Park, as well as ArtLondon in Chelsea in the early summer. Photo London started in 2004 by Danny Newburg at the RA's Burlington Gardens space in May, was also a huge success, with the rise of interest in photography and increase in sales and prices recently.

The Droit de Suite Directive was finally agreed by the European Commission after great lobbying from the UK. In January 2006 it was implemented for living artists at a scale of 4% for low sales up to 0.25% for sales of £30,000. In January 2012 dead artists' work will be included on the same sliding scale. This means that it will be cheaper to sell American artists' work in London than in the rest of Europe, which should help London sales. It is said that the estates of artists such as Picasso, Matisse and Miro will benefit the most, but it is quite an achievement that it has been agreed at all for Britain, after being active in Europe for some years already.

Charles Saatchi decided to concentrate on painting in 2005 and has sold 12 Damien Hirst pieces back to the dealer Jay Jopling at White Cube, as well as Rachel Whiteread works to Larry Gagosian. Between 1989 and 1993 Saatchi sold his entire collection of minimal and conceptual art, which many art dealers believe to be a great mistake. Saatchi continues spats with Nicholas Serota, the director of all 4 Tates; he is supposed to have offered his collection to the Tate. Saatchi also lost 100 works in the fatal Momart blaze, when many major works were lost forever by Tracey Emin (The Tent and The Bed), the Chapman Brothers (Hell). Paula Rego lost many important paintings and Waddington galleries some 150 paintings, also Anthony d'Offay the major art dealer.

The government stated that museums should make their work more available to the public, to great uproar from museums across the country. The National Gallery shows all of its collection, which can also be seen on ArtStart its new multi media centre in the gallery. The British Museum has over 7 million works and shows some 75,000 at any one time but some are loaned for exhibitions and some are in conservation.

Lottery funding continues to enable renovations to take place at galleries and museums across Britain. The Museum in Docklands has benefited, the Whitechapel Gallery has £10 million to spend on moving into additional space next door in a library and to show its Archives to the public. Exhibition Road

which is used by visitors to the V&A, Natural History, Science and Geological museums is having £25 million spent on improving access for the disabled, underpasses, lighting, traffic locally. The Museum of London also had major renovations and new galleries for 20th and 21st century are to be completed by 2007. Camden Arts Centre had renovations and the V&A Museum has had work done on new galleries such as the Architecture Gallery, Miniatures Gallery and updating on its Eastern Galleries.

Nicholas Serota gave his report on all 4 Tate galleries (Modern, Britain, St. Ives, Liverpool) and has discovered a novel way to increase the contemporary art collection: 24 living artists are donating major works, to cover gaps when Tate has insufficient funds to purchase the work. Paula Rego, Caro, Gormley, Kapoor, Whiteread, Hirst, Emin, Taylor-Wood are some of the artists who have agreed so far. Serota commented in late 2004 that, "London is an important place in which their work should be shown. Artists regard themselves as part of the art community in Britain." He also pointed out that the Tate has a shortfall in Surrealism and works on paper. Ken Tyler's print collection will have helped on that front and 1200 sketches by Francis Bacon

Vicente Todoli, Director Tate Modern opening the Bruce Nauman Unilever Series at Tate Modern.

have also been donated recently. Maybe a major collector of Surrealism will oblige? All 4 Tates have good public attendance figures, but Tate Modern is a major world gallery, possibly only rivalled by the recently re-opened MOMA in New York. In 2004 the Edward Hopper exhibition at Tate Modern had one of the world's largest attendance figures at any exhibition.

Nasser David Khalili is setting up his own museum in London in the next five years, with a staggering 20,000 objects to display from his private collection of islamic art. There is also talk of a new Museum for Photography at Somerset House with work loaned by the National Museum of Photography and Film in Bradford and the V&A Museum. This is long overdue, as the V&A Photography Gallery lost sponsorship and Bradford is a long way from London. Photography galleries have increased in London in recent years. The Artists on Film Trust set up by Hannah Rothschild enables artists' films to be seen now by the public; an important archival history which was nearly lost forever. The Tate Hyman Kreitman Research Centre at Tate Britain stores artists' diaries, letters, smaller works, as well as archives from art critics, art dealers and other art groups.

The Royal Academy continues to have problems but Sir Nicholas Grimshaw, the famous architect, has taken over as RA president in 2005 and will hopefully lead to a more stable situation there. The RA continues to hold superb exhibitions despite cutbacks and walk outs by management. The John Madejski Rooms were completed thanks to a generous donation and now house the RA collection, which had not been fully on display before. The RA Schools continues to produce successful artist graduates and a Young RAs organisation has been set up. The Burlington Gardens space now shows contemporary work and houses the annual Photo London Fair in May, as well as a hugely-attended Armani show when it opened.

Artists in London are fortunate that there are so many art and photography prizes to enter, as well as scholarships to apply for and national and international residencies. The Beck's Futures attracts publicity every year and the Hunting Group prizes which have existed for 25 years pass to a new sponsor in 2006. The National Portrait Gallery holds the Schweppes photo portrait prize every year and the Photographers' Gallery the Deutsche Borse photography prize for leading photographers. The Singer Friedlander, Discerning Eye and printmaking prizes all add to the opportunities for artists in London and Britain. Some prize shows tour round the UK after London, to Glasgow, Manchester, Birmingham, Edinburgh and even Cornwall.

The greatest change on the London art scene is the rise of many art project spaces in the east end of London such as Art Lab, Bearspace, 1000,000mph, Cell, Dick Smith, David Risley, The Drawing Room, The Empire, EventNetwork, Flaca, Hotel, IBID Projects, Kate MacGarry, Keith Talent, Man in the Holocene, MOT, Numbers Gallery, One in the Other, Peer, Pilot, Platform, SevenSevenContemporary, Space-twotentwo, T1+2 Art Space, Temporary Contemporary, Trolley, Transition, Unrealised Projects, Vilma Gold, WAGDAS Gallery and many others. Some will survive, others will open, but these are spaces that are sought out by British and international artists and art collectors, who are interested in new work and ideas.

Recent new foundations and larger galleries include Asia House opened in autumn 2005 near Oxford Circus,Parasol Unit on Wharf Road designed by Claudio Silvestrin which has 800 square metres of space and an artist-in residence space. The Louise T Blouin Foundation, set up by the entrepreneur/collector who now owns Modern Painters and Art&Auction, opens in Notting Hill gate in a disused warehouse, also the White Cube additional new space opens in Mason's Yard, St James's.

Hoxton is still a gallery and artists' centre. Hoxton Square area has the celebrated White Cube gallery which has wonderful, light gallery space: works by Tracey Emin, Damien Hirst, Gavin Turk, the Chapman brothers, Sam Taylor-Wood and Sarah Lucas can all be seen here. Other galleries nearby include Flowers East, expanded to a new space on Kingsland Road, at the Shoreditch end, in September 2002. 30,000 artists are supposed to live and work in the east end and there are certainly many studio blocks in this area and the east end. The Contemporary Art Society usually organises visits to hundreds of these studios, often run by ACME, ACAVA and SPACE, but many are also independent. Look at the studiosection in this guide and you will see how many there are. The press continually covers the Hoxton area, especially celebrity visits to White Cube. White Cube is also renovating an electricity substation in Mason's yard in the West end which will open in a few years time.

Even estate agents are watching to see where artists move to. In the 1900s it was Camden, in the 1930s, Hampstead, 1950s, Soho, and 1960-90s, the East end. The east end is still populated by artists of all ages but Camberwell, Peckham and Deptford are now areas that are being chosen by artists. There are galleries there already such as Danielle Arnaud and the newly-independent South London Gallery. START (South Thames Art) is published to publicise galleries in this area between October-January annually. Danielle Arnaud, a dynamic gallerist, publishes this map. ACME

which provides studio space has worked with Barratt the builders to provide working space for 50 artists in Peckham and this co-operation between non-profit and commercial organisations bodes well for London's future.

The London section has an article about "The Changing Face of Multicultural London", as London now has well over 300 languages spoken here and communities from all over the world. Each community has its own restaurants, festivals and sometimes newspaper or magazine. I have covered details about some of the communities to give a taste of how cosmopolitan London has become. Although the West Indian and Asian communities have been here for some time it is the Eastern European and Middle Eastern communities that have mushroomed in the last ten years. I have added new communities and will continue to do so in the next edition. I regard myself to be very fortunate to live in this extraordinary, thriving city with such a huge interest in the arts. Yet again, I am staggered while updating, at the huge increase in outlets for the visual arts. The first edition in 1979 was a slim, stapled booklet but now in the 10th edition, the gallery listings are enormous, the largest increase ever so far.

Heather Waddell

White Cube2 opening in Hoxton Square.

Larry Gagosian at his gallery in Britannia Street, King's Cross.

London Art Galleries

Contemporary Art

Cork Street is still an important contemporary art area in London, but has seen changes in the last five years and its importance has declined, as the east end has risen as the place to see the latest contemporary art. Additions in recent years include **Robert Sandelson, Flowers Central, Alison Jacques, Adam, Petley Fine Art, Medici** and earlier **Art First** and **Alan Cristea** (who took over Waddington Graphics). Art First has some excellent colourful, figurative artists, such as Barbara Rae. **Waddington Galleries'** stable of artists has not changed dramatically, but has good painters such as Mimmo Paladino. Other Cork Street galleries include **Browse and Darby, Redfern, Mayor, Houldsworth, Bernard Jacobson's Gallery** and in Clifford Street, **Alison Jacques**.

Stephen Friedman, in Old Burlington Street shows work by lively contemporary conceptual and minimal artists, such as Vong Phaophanit, who was shortlisted for the Turner Prize, Yinka Shonibare and Kerry Stewart. The lavish **Sketch** restaurant has a gallery in Conduit Street which attracts major names to show video.

Old Bond Street and New Bond Street

At the Green Park end in Albemarle Street **Marlborough Galleries**, one of London's established and international galleries with branches in New York, Tokyo and Madrid has exhibitions of note, with artists such as Bill Jacklin, Christopher Le Brun, Stephen Conroy, Paula Rego, and work from the estate of Barbara Hepworth. **Agnew's** is another established family-run business with historical and contemporary art on show.

Sotheby's auction house is in Bond Street and dominates the galleries in the area. Auctions are held daily and pictures and objets d'art can be viewed daily, before the auction. Sales at Sotheby's are often a barometer for the fluctuating art market. When Saatchi sells part of his large, contemporary art collection the rest of the contemporary art world waits with bated breath. More recently he has been giving work to NHS hospitals. **Bonhams** is also in Bond Street.

Eva Rothschild sculpture at Frieze Art Fair.

Bruton Street, an offshoot from Bond Street, has **Osborne Samuel**. The **Gimpel Fils Gallery** is in Davies Street and the Gimpel family has been dealing in art for centuries. Recent exhibitions have included the colourful abstract paintings by Albert Irvin and Alan Davie. At the top end of Bond Street, nearer to Oxford Street, is Dering Street, where **Annely Juda** resides in a magnificent light, airy space and **Anthony Reynolds** gallery

for avant-garde conceptual work and installation has moved to Great Marlborough Street. **Anthony D'Offay** closed his gallery in 2001 and now deals privately. This was quite a shock for the London art world as D'Offay was the most important and successful London contemporary art dealer. Now the field is open to younger art dealers. **Gagosian Gallery** opened a huge new branch in Britannia Street King's Cross in 2004, as well as its branch already in Heddon Street next to **Sadie Coles HQ**. He has taken over some of d'Offay's artists such as Howard Hodgkin and Michael Craig-Martin and bought Rachel Whiteread's work from Saatchi. His new space in Kings Cross is the largest private gallery in London, also now one of the most important. **Hauser & Wirth** moved into a renovated bank at 126A Piccadilly and **Spruth Magers Lee** is in Berkeley Street near the **Fleming Collection**.

Chelsea

Chelsea used to be the artist area in London in the 17th -19th centuries and still houses the odd famous, more successful artist. The **Chelsea Arts Club** on Old Church Street continues to provide a meeting place for artists, actors, lawyers and media people interested in the arts. It makes a marked contrast to the Dover Street W.1. Arts club, where businessmen predominate and there is not a bohemian in sight! There was a scandal at the latter with paintings disappearing and reappearing at auction. Most of today's artists live in the east end rather than Chelsea, which is now one of London's wealthiest areas.

Green and Stone of Chelsea sell a good selection of artists' materials, art magazines and frames. Artists often work in the shop, giving it a friendly atmosphere.

East end and the City

In contrast with Chelsea, the East end is a changing area with the Docklands devlopments bringing newspapers, once based in Fleet Street, to Canary Wharf. Wapping was for a time an area full of artists' studios and still has some, but only for successful artists, also design and photography studios; designers can afford to pay the spiralling rents.

The East End has seen a huge rise in art project spaces near Bethnal Green and Hoxton. Vyner Street in particular has attracted many new experimental spaces. The Tea building houses **Hales Gallery** and Andrew Mummery. Peer, Pilot, Platform, Rachmaninoff, **MW Projects, MOT** are some of the names of the art project spaces in the area from Old Street to Bethnal Green. **www.capri-art.org** lists all the latest, as they change frequently.

13

The **Whitechapel Gallery** dominates the east end art scene with well-lit galleries and international shows. It has secured £10 million of Lottery fund money to double its size, taking in the library next door. Public access to its archive will also happen eventually. The Whitechapel allows the public to see work by east end professional artists, of whom there are many thousands, with occasional open-application events. Studios and galleries throughout the east end are open in a well-publicised opportunity to see what is going on in the east end art scene. **Flowers East** is the contemporary art venue of note in the commercial east end art scene and Matthew and Angela Flowers have brought interesting new artists to the fore, as well as providing shows

Anthony Wilkinson, Anthony Wilkinson Gallery at Frieze Art Fair.

such as the annual Abstract art exhibition every summer. They moved to Kingsland Road, the Shoreditch end, in 2002. Hoxton has now become a magnet for new galleries. **White Cube** is in Hoxton Square (specialising in Brit Art artists) and nearby are **Hales Gallery, Standpoint, Andrew Mummery** and **Victoria Miro**.The rise of Hoxton as a contemporary art area has been consolidated in the last three years and will continue to grow.

Interim Art is run by Maureen Paley, a dynamic American, who helps artists show work that is not perhaps so viable financially, though her profile is now very high internationally and she shows Wolfgang Tillmans' work, the Turner prizewinner. **Matt's Gallery, Chisenhale Art** and **The Showroom** are all East end galleries worth mentioning. Time Out weekly and The Independent and The Times on Tuesday list current shows there.

The biggest change has been the development of Hoxton. The **White Cube** gallery run by Jay Jopling has become greatly publicised as celebrities and film stars flock to its openings to see work by Damien Hirst, Tracey Emin, Sam Taylor-Wood and other famous YBAs (Young British artists). **Standpoint Galler**y is nearby in Coronet Street. White Cube is opening a new huge space in the west end in Mason's yard in the next few years.

The City

The **Barbican Arts Centre** in Silk Street in the City has a variety of art venues. The level 3 galleries have major photographic and painting shows and the Curve gallery is often used by artists' groups such as the London Group, Bloomberg contemporaries and Printmakers' groups, or by galleries and artists wishing to reach a wider public. The other areas at the Barbican have craft and art shows, often smaller or more intimate. The fountains and lake outside the centre are attractive and peaceful after the city pollution and noise and the cafés and restaurants at the centre provide a welcome breathing space for visitors. The Spitalfields area now has quite a number of galleries new and old: **Domo Baal Gallery, Stephen Lacey, Spitz** gallery and bar and **Five Princelet Street**, also **Network Gallery** for photography.

Portobello / Notting Hill Gate

At one point in the late 80s this area was throbbing with contemporary art galleries, but most have now closed, except **East West Gallery** which thrives and shows work by British and international artists from Argentina and Eastern Europe. The **Special Photographers Company**, now on Westbourne Park Road, has also survived, but they also act as photographers' agents. Chris Kewbank is aware of international photography

trends and exhibitions reflect this insight. Some smaller galleries and project spaces have opened up nearer Golborne Road in recent years.

Westbourne Grove, towards Queensway, has now become another small art area. **England & Co** has been there for some time and Jane England's Art Boxes show has become legendary every summer. She tends to show artists from the 50s and 60s as well as some contemporary art. **Flow Gallery**, on Needham Road shows avant-garde contemporary crafts.

Charlotte Street/Bloomsbury

On Windmill Street the **Rebecca Hossack Gallery** shows lively work by contemporary British and Australian and also Aboriginal artists. The Windmill street art party is a good opportunity to see work by many artists at all the local galleries. **Curwen Gallery, New Academy Gallery, Cass Sculpture Foundation** as well as **Contemporary Applied Arts** are also in this area.

Rest of London

It is impossible to cover all of London, but some areas that do fall into categories are **St James's**, where many galleries specialise in Old Master paintings and antiques. Christies auction house is in this area, in King Street. Fischer Fine art has gone but Mathiesen Fine Art, Bourne Fine Art and Whitford Fine Art remain. It makes an interesting comparison to look at works that in their day were seen as avant-garde,but are now established Old Masters. **The White Cube Gallery**/Jay Jopling is also opening a huge new space in the near future at an electricty substation in Mason's Yard near **James Hyman Fine Art** and **Art and Photographs**. The Hoxton branch is the current major space now in London's east end, but that may change with the new space when it opens. Danny Newburg at Art and Photographs runs **Photo London** the successful photography fair held in May annually in Burlington Gardens, as well as PLUK the photo listings magazine and New Exhibitions of Contemporary Art listings.

In Covent Garden the **Photographers Gallery** is in Great Newport Street, with several galleries for contemporary and historical photos and an excellent photography bookshop and print room with advice for buying photographs. Further out of the centre of London the Camden Arts Centre near Hampstead has regular exhibitions and travelling major contemporary shows. It has had a huge renovation project, completed in 2004. In Hampstead itself the **Catto Gallery** on Heath Street shows

sculpture, **Gallery K** work by Greek origin artists and **Duncan Miller Fine Art** paintings by established Scottish artists. Other small galleries come and go.

The **Ben Uri Art Gallery**, **The Jewish Museum of Art**, in Boundary Road, NW8, is a private collection with major shows of well known Jewish artists. Other galleries have moved in nearby, but the best known is the **Boundary Gallery** run by Agi Katz, which has a fine collection of works by Jewish artists such as Jacob Kramer, Josef Herman and many younger contemporary non-Jewish artists, especially recent Scottish colourists.

There are many other galleries, founded or opened in the last five or so years: **Hauser &Wirth, Spruth Magers Lee, Magnani, Platform, One in the Other, Vilma Gold, VTO, Herlad Street, Rove Gallery, Percy Miller, Milch, Essor Gallery, fa projects, Danielle Arnaud, Emily Tsingou, Hackelbury and Scout (both photography galleries), Domo Baal Gallery, Five Princelet Street, Spitz, One Plus One, APT Gallery, Peeps, Alchemy, Skylark, Naira Sakahian, Shirley Day, Rossi & Rossi, Paper Mint, Rachmaninoff, MW Projects, MOT, Museum 52, Rockwell, 1000.000 mph, Sevensevencontemporary, Temporary Contemporary, Hotel, IBID Projects, The Ship, Keith Talent, Kate MacGarry, T1+2 Art Space, Three Colts gallery, Trailer, Transition, WAGDAS Gallery, Sarah Myerscough, Osborne Samuel, Asian Art Gallery, farmilofiumano, Finelot, Plus 1 Plus 2, Sheridan Russell, Simmons, Mafuji, Mobile Home, Gagosian (new branch in Kings Cross opened in 2004), Sprovieri, Whitechapel Project Space, Flaca, Man in the Holocene, The Drawing Room, Drawing Centre, EventNtwork, Dick Smith, Cell Project Space, Artlab, The Empire, Indo, White Space, Red Star** and many others, growing daily! In fact there are some 200+ new contemporary galleries for this edition. Hoxton and Spitalfields have both attracted new galleries, alongside lively bars and restaurants. There is also a trend for important contemporary art dealers choosing to deal from home such as; Anthony D'Offay, the Lefevre gallery owners, Prue O'Day, Danielle Arnaud, Francis Graham-Dixon, Jibby Beane and others. By the time you read this many of the above may have moved on but this just shows you the expansion in London recently.

The full adresses of all the galleries mentioned above are listed alphabetically under the appropriate sections. Art maps are at the front and back of the guide. Enjoy the rich variety of art that London has to offer!

Ben Burdett at the Atlas Gallery, Dorset Street.

Interview with photography dealer, Ben Burdett, Atlas gallery

HW: Can you tell me about when Atlas gallery was founded and why you decided to deal in photography?

BB: Atlas was founded 10 years ago in 1994. At that time when the market for photography was growing we were antiquarian bookdealers. There were galleries such as Hamilton's that showed photographers such as Irving Penn and David Bailey. We had a more academic approach showing travel photography, such as the work of John Claude White, the official photographer on the Younghusband expedition to Tibet. I came to photography from antiquarian books to 19th century and early 20th century images. Most of the images we sold were historical or travel photography.

HW: Which were your earliest shows and what is the gallery's policy?

BB: We deal in 20th century photography almost exclusively. We do however sell 19th century and contemporary photography. Our exhibitions are also designed to educate. The images are accessible to view at first hand but in as many cases as possible classic images are present either as vintage prints or as later prints, but still collectable, signed, authorised and printed by the photographer.

HW: Which photographs are the most popular for collectors? Which have been your most successful shows?

BB: The first exhibition that we had, our first major show, was with the Royal Geographical Society with the Frank Hurley Collection. He accompanied Ernest Shackleton on his expedition to the Antarctic. It's still a very successful collection that we manage. This year Leni Riefenstahl was a huge success,

and also our Alvin Langdon Coburn and Edward Curtis shows. The clients who buy regularly chase the classic images such as 20th century classic photographers Edward Weston, Paul Strand and Imogen Cunningham. We also advise collectors on acquiring specific images.

HW: You also sell publications. Is this an important part of the business that you intend to expand?

BB: We do sell books. We produce catalogues every year. It started off as a showcase and each catalogue has two or three images by each photographer. The exhibitions that are the most successful are ones where we include both important vintage prints and also later prints or modern limited edition prints. Prices are more accessible for customers who are not collectors of vintage photography. We are not publishers as such, but we do print and publish catalogues for two out of six or seven shows a year.

HW: Did you show at Photo London or other fairs and if so how successful were they?

BB: Yes, we did show at Photo London which was extremely successful. We also show at Photo LA and in San Francisco, Canada and Switzerland. Photo London was a tremendous event for photography in London and long overdue. It tied together many different strands. There are so many distinct areas; contemporary artists working with photography; classic names such as Newton, Bailey and Penn and then historic works such as Fox Talbot and 19th century photography. These areas are very different but it is all the same medium.

HW: What is your own personal background and why did you choose photography? Is there any family connection with it or just a passionate interest?

BB: I have had a long-term interest in early travel photography, also an interest in travelling. When I left University I did the

London to Kathmandu trail. My family has always been involved in travel and I had a great uncle, Alexander Barnes, who travelled and photographed in Africa: from this I developed an interest in photographic records of the world. I then began to be interested more and more in classic twentieth century American photographers such as Stieglitz and Strand.

HW: Is the gallery position helpful: you were located elsewhere for many years?

BB: It's tremendous here and very accessible from all parts of London. That is very important for a gallery.

HW: What are your plans for the gallery over the next 5-10 years?

BB: We would like to work with more private and corporate collectors. British photography is the next thing we want to focus on.

Atlas Gallery
49 Dorset Street
London W1U 7NF
Open Monday-Friday 10-6, Saturdays 11-5.
Tube: Bond Street or Regents park
Tel: 020 7224 4192
Fax: 020 7224 3351
www.atlasgallery.com
info@atlasgallery.com

Michael Ajerman in his studio.

Interview
with artist, Michael Ajerman

HW: Where did you study painting?

MA: At Corcoran in Washington, DC, 1996-7; the New York Studio School, 1998-2000 and the Slade in London, 2001-3, where I completed my MFA in Fine Art.

HW: Why did you come to London?

MA: I lived here for 7 months in 1999 on a Slade exchange from New York Studio school. I returned to London in 2001 to study at the Slade. My work was stuck in New York. I found myself painting about London and I felt that I did not want to deal with the subject matter from a distance anymore.

HW: What have you achieved since you left the Slade in 2003?

MA: I was shortlisted for the DLA Art Award and I've been in group shows at Jill George gallery, Jeffrey Charles gallery, in the Contemporary Art Society Art Fair and in a group show in New York at the Edward Thorp gallery. I also won the British Institute award at the Royal Academy in 2003.

HW: What have been the most difficult aspects of the London art world for you?

MA: There is a tension in the air that I feel every so often which makes me uneasy, very uneasy.

HW: What have been the benefits of living and working in London?

MA: There has been interest in my work here. The London scene is much smaller than New York's and you can step back

and view the whole scene, whereas in New York it is so vast and changes so much. My peers are here, painters. In New York I know more musicians and photographers than painters.

HW: Which artists have influenced you?

MA: Chardin, El Greco, Pierre Klossowski, Kossoff, Alice Neel and Norman Mailer, the writer.

HW: How difficult did you find looking for an art dealer in London?

MA: I have people who are interested in my work, such as Jill George. The Slade degree here was very beneficial, in 2003. Jill has been really helpful.

HW: Have you entered any competitions or open exhibitions and how helpful have they been?

MA: I was asked to submit work for the DLA Art Award, through Sarah Myerscough Fine Arts. The show included 6 people. I sold a painting from the exhibition although I didn't win the award.

HW: Did the Slade give you any helpful advice about looking for a gallery and studio?

MA: No. A studio yes.

HW: What are your plans for the next 5-10 years?

MA: Just to keep going. I plan to stay in London for the near future at least.

HW: How would you describe your work and your concerns to someone?

MA: Women, radiators and rabbits; that's what my work is about at present. As time goes by, I really feel that I've got it all

backwards. I feel that my subject matter dictates the formal aspects. I'm catching myself finding the depiction through the subject matter. Norman Mailer has become very influential for me; there's a kind of intensity in his writing. You feel this drive, a focus, as you read his work. The writing seems to be bubbling with his focus and drive for the subject matter. It's very hard to not get excited about something when in fact an author is giving his all to the communication of the love and intensity for the novel itself. There's an intelligence and a regard for the past with a strong contemporary sense. This drive and wide range of skill and emotions I find really inspiring for my own work.

HW: Where did you grow up?

MA: I was born in the Bronx, but lived on Staten Island until about 10. We then moved to New Jersey in my teens. At 15, I started going to New York city every weekend. I knew Brooklyn well as my grandparents lived there. Coney Island I consider home; I moved there at 20. London is where I make my work and I find that I make it better here than at home.

HW: Who were your contemporaries at the Slade?

MA: Gideon Rubin, Silia Ka Ting, Emilia Izquierdo, Juan Arango, Jane Millican, Jacqueline Hallum, Aliquandro Ospina, Nathaniel Rackowe, Rana Begum, Cybille Baltzer, Laura Smith, Steve Green, Katherine Lannin, Ted Haddon, Sawako Ando, Jenny Lui, Charlie Danby and Nick Wriglesworth. They are all still making work.

Michael Ajerman
201 Union Street, London SE1 OLN, UK
0790 4 1422 77
m_ajerman@yahoo.com
3726 Laurel Avenue, Brooklyn, NY 112224, USA
001 718 266 0698

Celia Washington in her studio.

Interview
with artist, Celia Washington

HW: Can you give me some background details of where you went to art school?

CW: After I left school I went to Florence to study drawing with Nerina Simi 1976-77. I then went to the Byam Shaw and studied art 1977-81; a foundation course and then a three-year painting degree. During the second term of my degree I met Wynn Jones who was a huge influence on me. He was the first person who encouraged me to paint directly from my imagination. Other important influences were Ken Kiff, Tim Hyman and Peter Kennard.

HW: Immediately after art school did you find a studio or what did you do?

CW: My first studio was in Glebe Place in 1981. I found it through Stephen Bartley who has helped many other artists over the years. Two years later, searching for something more, I left London and moved to the country. Six years later I realized that the country was not what I was looking for and so, still searching, I returned to london in 1989 and found a studio in Lots Road, SW10.

HW: Where did you first exhibit and what did that lead to?

CW: Stephen Bartley gave me my first show at the Chenil galleries in 1983. Then I showed at the Charlotte Lampard gallery, followed by Long & Ryle from 1989-1998. I also did numerous mixed shows with other galleries. From 1990 I showed in New York with Nan Perrell at the Cricket Hill gallery. She discovered my work when she saw and bought a painting at the Royal Academy Summer Show: her gallery later closed in 2002 after September 9/11 had its disastrous effect on the New York art scene.

HW: Have you won any prizes, travel awards or have you worked abroad at all?

CW: I had a scholarship at Byam Shaw. Then in 1996-97 I did a part-time MA course at Kensington and Chelsea College run by Guillem Ramos-Poquí. This inspired me to move to Spain. I lived in Madrid where I painted and studied printmaking with the Andalucian printmaker José Rincón, 1998-2003. At first it was hard as I didn't speak Spanish and had no friends. Now I realize that it was one of the best decisions that I have made in my life. I learnt Spanish and made contact with the elusive group of European artists that I had been looking for. In 2004 the Spanish artist Manuel Sáenz Messía invited me to take part in an international art symposium in northern Spain near Santander. There were 14 artists from 9 countries, working together for 10 days, in an old palace by the sea: I was the only British artist. There I met the Slovenian artist Andrej Pavliè and through him I was invited to another art symposium in Medana, Slovenia (44 artists for 8 days and again I was the only British artist). Art Symposiums go on all over Central Europe; they are a movement of artists meeting together, working together and just being together. After all the years of searching, I feel I have finally found my tribe.

HW: Have you kept in touch with your contemporaries at at art school and where are they and what are they doing now?

CW: My closest friend, Louise de la Hey, paints, exhibits and teaches. Shanti Panchal exhibits in the UK and abroad. Francesca Boyd left the Byam Shaw to do theatre design and then went on to work for the BBC. I am still in touch with two tutors Wynn Jones and Tim Hyman.

HW: Which artists have influenced you and what is your work about now?

CW: At art school it was Chagall and Munch. Then Goya and Picasso were the reason I went to Spain. After that it is hard to

28

say as I have been influenced by so many artists over the years; Dubffet, Beckmann, Klee, Ernst, Basquait, Barceló. Every time I walk down the street or go to an exhibition I am influenced by something. Today there is constant sound and visual stimulation and speed is admired more than anything else. The subconscious is neglected and is only allowed out at night when people sleep. We all need this place in-between to allow us to process the images and ideas we are bombarded with. This is the area I explore in my art, to try to make sense of the whole, to articulate the subconscious visually.

HW: What plans do you have for the next 5-10 years?

CW: After working in Madrid with a central cheap studio, my main preoccupation when I returned to London was a studio. I found this current one in South Kensington on the council's commercial property list (often overlooked by artists in their quest for a studio). I want to use this as a base for the next 5-10 years and travel from here, doing art symposiums across Europe. In 2-3 years time I would also like to set up my own international art symposium in the Lake District or Scotland.

Celia Washington
www.celiawashington.com
1 Curran Studios
Lucan Place
London SW3 3PQ

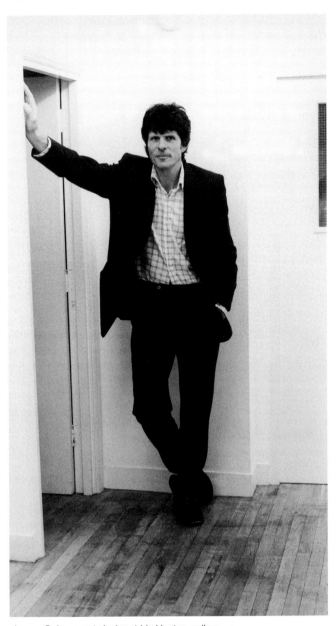

James Colman, art dealer at his Hoxton gallery.

Interview
with art dealer, James Colman

HW: Your current exhibition shows that you are interested in contemporary artists with a progressive vision. Which other artists do you show?

JC: This partuicular group of artists are largely untrained but have a very personal and immediate style of working. I have a regular stable of artists that I have been working with for a number of years and I show them intermittently in a programme of about 8-10 shows a year. I have started to bring in outside curators to give a different dimension to the programme. That has provided not only a way of meeting new artists, but also provides a general forum for the gallery from which artists, critics and collectors can become involved.

HW: How do you find Hoxton as an area? Is it important to be near other contemporary galleries? Which galleries are nearby?

JC: I It is important to be near other galleries. I like the Hoxton area. It is vibrant and busy which makes it an exciting place to work. For personal reasons I needed to be near Liverpool Street and looked for the highest density of galleries in this part of London and that decision made me move to Hoxton Square. There was an influx of galleries here 3 years ago such as White Cube, Jason Rhodes, Victoria Miro and in the last 18 months Flowers East, Hales, Andrew Mummery, and Standpoint have moved here.

HW: How did you start off as an art dealer? What were the most valuable lessons you learnt early on?

JC: I used to hawk prints about, working the auctions, selling privately and to other galleries. Gradually I found myself selling

paintings and then putting on exhibitions for artists in one-off spaces. Eventually I took the plunge into running a gallery. Most valuable lessons are that it is a tough business and you have to have a high degree of enthusiasm and a strong constitution to work all the strings that come attached to running a gallery. It takes a long time too. You also need to maintain your integrity at all costs. This is a small world. News of skulduggery travels fast. This applies to artists as well as dealers; remain focused and have a vision, the usual clichés.

HW: Which shows have been the most successful in the last five years?

JC: They have all had their own inimitable successes, though in terms of profile I guess the re-appearance of Colin Self this summer, the long lost Pop artist, was a particularly high moment for the gallery. I've done some great shows with Damian and Delaine le Bas, Joe Currie, Guy Harvey, David Holland and Denis Clarke.

HW: Do you show at art fairs and if so which do you find the most useful?

JC: I did a lot of fairs over a three-year period, perhaps five per year, both here and in Europe. Everyone who has done fairs will know how exhausting, both physically and mentally they are. Sometimes they are hugely productive, but quite often the reverse. I am now very selective and strive to attend the best ones, accoprding to the needs of particular artists. Some do far better in one country than another. I'm going to Bologna in January this year and would be happy to go to Cologne next autumn. I would also like to do a couple in the USA in the near future.

HW: What are your future plans?

JC: I want to continue showing contemporary work, promoting my artists internationally. Also I want to do many more site-specific shows outside the gallery environment. This is always interesting and new things develop out of such ventures.

James Colman has closed the Hoxton gallery and now shows his artists at different temporary spaces, also at the Frankfurt Art Fair, Prague Biennale and other art fairs.

Tel/Fax: 01508 491840
www.jamescolman.com
gallery@jamescolman.com

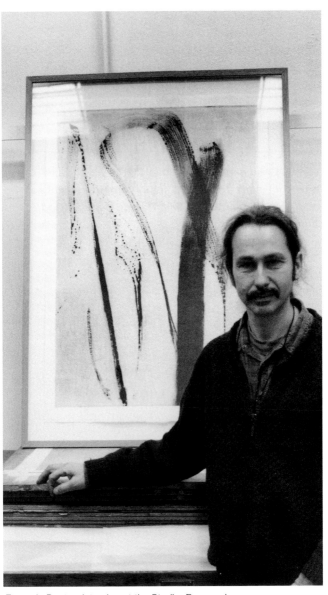

François Pont, printmaker at the Studio, Bermondsey.

Interview
with François Pont, printmaker &
Tam Giles, painter, at the Studio, SE1

HW: When did you set up this studio complex and what was the aim at first?

FP/TG: We bought the complex in 1997 and realised the potential at once: there was nearly 500 square feet of space. My two sons, Marcus, drummaker and gadget inventor, Arthur, a sculptor and I would have our own studios/workshops and there would be space to let out. Our present licensees (rents comparable with the lowest at Space, Acme and Acava) include an antique restorer, two local ladies making soft furnishings and theatrical costumes and Leslie who makes unique props for TV and museums as well as Jane, a sculptor and of course Francois. There are useful skill exchanges and links to the local community.

HW: Does François edition other artists' work as well as his own. If so which artists?

FP: I have five people; Victoria Achache, Mark Francis, Kate Boxer, Basia Laudman and Tam Giles.

HW: How did you come to live and work in London?

FP: I came over from Switzerland in 1979, as I needed to go away to pursue art. My family works a vineyard at Valais where the family still lives and I worked there before I set off for London. I was at the Byam Shaw 1980-83. I kept in touch with Tam Giles and I did a postgraduate in printmaking at Camberwell art school. I had ACME and SPACE Studios but they all had short leases. Tam decided to buy the Studios in 1997. I brought the Rochard etching press here and set up a print studio in Bermondsey. I do my own work which is predominantly black

and white. I find printmaking interesting and think differently about my work. The technical process means that you have to be decisive from the start.

HW: You had an exhibition recently in London.

FP: Yes, I had an exhibition at Studio Sienko in the summer. I showed 20 pieces of work, mainly etchings and drypoint, intaglio prints. They sell for £100-£600 in editons of about 10-15. I am about to go off to Berlin for 6 months on a scholarship, which will broaden my European background. I have had many exhibitions in Switzerland at the Fondation Louis Moret in Martigny, Galerie Arts et Lettres Vevey, Forum d'art contemporain at Sierre and Galerie Zimmerman Haus, Brugg and shown in group shows at the Paris Print triennial, the Jerwood Drawing Prize in London and the Krakow Print Triennial as well as the Printmakers' Council Biennial in London. I was also an artist in residence in Québec, Canada. Berlin will open up other possibilities, I hope.

The Studio
330 St James' Road
London SE1 5JX
Fax: 02072373354
tamgiles@tiscali.co.uk

François Pont
Telephone: 0207 375 0611

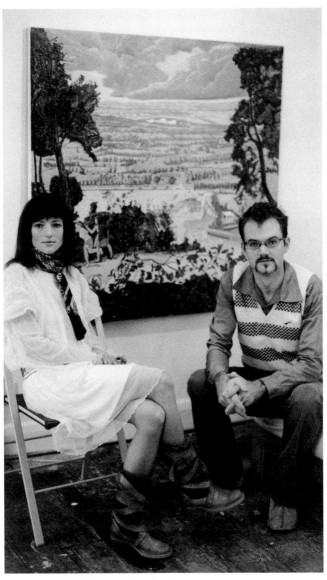

Peter Harrap and Natasha Kissell in their studio.

Interview
with painters, Peter Harrap &
Natasha Kissell

HW: You are having a show in Spring 2006 at Marlborough Fine Art. Where have you shown before 2005 and what art schools did you go to? Did you meet at art school?

PH/NK: We met at the Royal Academy schools in 2001. Peter was at Winchester and I was at Byam Shaw. We've both shown at Space in Eccleston Street's Stranger than Fiction show in 2004. In February 2005 we showed at the Jerwood Space with 6 ex RA Schools artists in RAdical Art.

HW: You seem to be very organised about publicity with reviews and photos in *The Times, Daily Telegraph* and other publications. Did you contact them about your Jerwood show before the Marlborough Fine Art show?

PH/NK: Yes. John Russell Taylor wrote about Peter as a "great British hope". Rachel Campbell-Johnston reviewed the Jerwood show in *The Times* and it was "Critic's Choice" and the *Daily Telegraph* magazine photographed all 6 artists for the RAdical Art show and interviewed all of us.

HW: Were you given advice about how to approach galleries when you were at art school?

PH/NK: No. There was an element of competition with the tutors; Vanessa Jackson, Sacha Craddock, John Wilkins, Brendan Neiland and Christopher Le Brun. Christopher was very encouraging.

HW: Are you looking ahead to 5-10 years from now? What do you hope for long-term with your paintings and life as artists?

PH/NK: We'd like to do a book. We'd also like to be in Marlborough's stable of artists. Eventually we'd also like to do a show in New York and Basel, maybe at the art fair: many Americans seem to be interested in our work. Axel Rohm, a plastics magnate bought work in 2005. Michel Roux has one of Peter's paintings in his Waterside Inn at restaurant at Bray. HSBC's CEO Stephen Green bought a painting too. Natasha has had Saatchi buy her work and the CEO of Gieves and Hawkes.

Peter Harrap and Natasha Kissell
www.peterharrap.com
www.natashakissell.com
peterharrap@hotmail.com
natashakissell@hotmail.com
Tel: 020 7034 0699

Collecting Photographs

Sotheby's and Christies, the top auction houses, are now holding major sales of 20th/21st century photographs, both in London and New York. Previously they concentrated mainly on 19th century photographs, but with prints by Edward Weston reaching $100,000 and the late Robert Mapplethorpe $33,000 ($70,000+ now) at a New York Sotheby's auction, 20th century photography is becoming more important than it was five years ago. In the May '98 sales at Sotheby's London, Eugene Atget photographs were sold for £10-31,000 (now far more). Man Ray's "Glass tears" sold for $1 million recently and Paul Stand's "Mullein maine", a vintage platinum print for $607,000. www.photoreview.org gives a comparative auction index for anyone interested in photography prices at auction.

In 1985 I had to sell six black and white photographs by Barbara Morgan the photographer, best known for her images of Martha Graham, the dancer, as in "Letter to the World". The photographs were in lieu of payment owed by the Morgan family in America, who distributed the international Art Guide series that I published in the1980s. Sotheby's London office at that time showed little interest in 20th century photography, so the prints were sold in New York for $1000 and the New York Art Guide author then received the sum for royalties due to her from USA sales. At that same sale a Man Ray photo was estimated at $1000-$2000, whereas in 1990 £4000 ($8000) would be the lowest price and far higher now. An Henri Cartier-Bresson at that sale was estimated at $1000 and would now fetch about 6 or 8 times more ('90) and in 2005 probably 10 times or more. Edward Weston nudes in 1985 were estimated at $1000-$2000, but in the1990 New York Sotheby's sale, an Edward Weston print reached a staggering $77,000! It does of course depend on the quality of each print. In '98 at Sotheby's London a David Bailey fetched £1092 but in general it is the famous names such as Weston, Adam, Mapplethorpe, Cartier-Bresson and Lartigue that attract the large sums.

When buying photographs, either for interest or investment, there are many important factors to be taken into consideration, such as whether the photographer printed the print himself, whether it has been signed and the condition of the print. It is also important to know if the print was done at the time the

photograph was taken or whether it was printed later. The National Portrait Gallery in London insists that photographers sell prints on fibre-based paper which lasts longer. For example, Imogen Cunningham early prints in platinum are more valuable than silver prints from the same negative, but printed later. The collector also needs to know the number of the edition, although unlike with etchings or graphics this does not necessarily affect the price. Ansel Adam's famous image "Moonrise, Hernandez, Mexico" has some 900 prints and all are still fetching large prices.

Collecting is an enjoyable pastime and can open a new world of contacts. The main factor when buying photographs is that "they are accessible to most income brackets", says Zelda Cheatle of the **Zelda Cheatle Photography Gallery** in Mount Street, London. She sells work by British photographers from £200 upwards, as well as photographs by international names. £500 would buy a Fay Godwin atmospheric landscape of say Cornwall or Devon, whereas a Mari Mahr surreal composition would cost £600 or more. As with most galleries, such as **The Photographers Gallery** where Zelda once worked, or **The Special Photographers Company** near Portobello Market, **Atlas Gallery**, or **Michael Hoppen** at Jubilee Place, Chelsea SW3, once you have been put on the mailing list, you will receive invitations to shows. Gradually you will be able to build on knowledge about what you might like and be able financially to buy.

The variety of photographs on display in most capital cities such as London, Paris, New York, Cologne, Frankfurt, Madrid or Rome, is enormous. There are always stock prints by the big international names such as Brassai who specialised in Parisian low-life and café scenes, whose prints sell for several thousand pounds now. Robert Doisneau's image of a Parisian couple kissing is well-known internationally, not least due to the court case about the couple who claimed to have modelled for it, (they lost), would cost about £700 now, whereas a Cartier-Bresson French scene would cost about £1500 or more. Sebastiao Salgado, a Magnum photographer took some breathtaking photographs of the Sierra Pelada mine in Brazil, photos almost mediaeval in composition and content, might be about £1000. Bravo or Imogen Cunningham prints of exquisite still-lives would be nearer £2000 now. Various exhibitions of her work in 1991 meant a rise in prices. In general much photography was underpriced for a long time and now that New York and London have both got many established photography dealers and buyers, the market is rising. Many of these galleries have exhibitions of work by contemporary photographers and prices are very accessible, especially compared to painting or sculpture.

Jacques Henri Lartigue: Bibi, Hendaye (Michael Hoppen Gallery).

In cities such as London, Paris and New York there are also key museums that exhibit photo collections. It is essential to visit several to see the kind of work that has been produced and merits attention. In New York **The International Photography Center** holds major shows and has an excellent bookshop, also the **Museum of Modern Art** collection where spectacular views of the city can be seen by the great American names such as Paul Strand, Berenice Abbott, Steichen, Stieglitz, as well as contemporary names. London has the **Photographers Gallery** and **The Photography Gallery at the V&A Museum** which opened in 1998 and has had many notable exhibitions of 19th and 20th century photographs from the collection. **The National Portrait Gallery** has photo-portraits of famous British people. In Paris the **Centre National de la Photographie** and the **Bibliotheque National**, also the **Centre Georges Pompidou** have photo displays and collections. **Agathe Gaillard, Zabriskie** and the **Comptoir de la Photographie** are known Paris photography galleries and in November each second year there is a **Mois de la photo**. In Spain the **Centro de Arte Reina Sofía** in Madrid, the **Kunsthalle** in Hamburg and the **Stedelijk** in Amsterdam all hold regular photography exhibitions.

Once you have bought photographs, it is important to know how to look after them. It is unwise to hang framed prints above central heating, but on the other hand they do need to be kept in a warm, moist atmosphere. Museums aim at 65 Fahrenheit and 40% humidity, but in general it is wise to avoid excesses of heat or cold. Most galleries will advise on mounting, framing and care of photographs if you are at all uncertain.

Whether you enjoy taking photographs or acquiring images by other photographers, a world of pleasure awaits. At galleries you will meet other collectors and the photographers themselves: eventually you will see your personal taste in photographs emerging. The important advice that the great American collector Lee D. Witkin gave was to, "follow your instincts when you collect; collect for pleasure and life-enrichment."

See the photography galleries section for addresses of all London photography galleries.

Museums

London is well-endowed with museums and there are some 150 in the area. I have only listed about half of these, many with particular reference to their art collections. The **Churchill Museum**, inside the War cabinet rooms, opened recently, after £13. million was spent on it. The **Petrie Museum**, a collection of Egyptian antiques received a £4.9 million grant and will be housed in a 5-storey building near the UCL Bloomsbury Theatre. Exhibition Road is having £25 million spent on it and will be completed by 2009. Access from South Kensington tube to the V&A, Science, Natural History and Geology museums will be greatly improved and changes in traffic flow.

Remember to ring first to check opening hours, especially on holidays. Most museums have stopped charging entrance fees, except smaller private ones. A number of new museums have opened in recent years such as **Eltham Palace** and **Zandra Rhodes' Textile and Fashion Museum.**

Apsley House, No 1 London, Hyde Park corner London W.1. Telephone: 020 7499 5676. Open Tuesday-Sunday 11-5. Admission now free.
Re-opened to the public in1995 this magnificent home of the Duke of Wellington houses Velázquez's "The Waterseller of Seville", works by Goya, Rubens, Caravaggio, Brueghel, Steen, De Hooch, Wilkie and Lawrence. Although the colours in some rooms question the word "taste", the opulent impression serves as a backdrop to memories of Waterloo and the Duke's great victory. The house was built by Robert Adam between 1771 and 1778 for Baron Apsley and has been home to the Dukes of Wellington since1817. Well worth a visit. Underground Hyde Park Corner.

Bethnal Green Museum of Childhood, Cambridge Heath Road, London E2 9PA. Telephone: 020 8983 5200. Recorded information 020 8980 2415. Open daily 10-5.50pm. Closed Fridays. The museum has just received a huge Lottery grant for renovation. Good collection of toys, children's games, dolls. Part of the V&A museum. 17th-century dolls' houses, children's clothing and artefacts. Special activities for children, often at holiday time. Birthday parties can be held here or the museum hired for private events. Underground Bethnal Green.

British Museum, Great Russell Street, London WC1. Telephone: 020 7323 8000. website www.thebritishmuseum.ac.uk. Open (BM including the Reading room and Hotung Great Court gallery) Saturday-Wednesday 10-5.30pm, Thursday-Friday 10-8.30pm. (Great Court excluding Reading Room and Hotung Great Court gallery) open Monday-Wednesday 9-9pm, Thursday-Saturday 9-11pm and Sunday 9-6pm.

The director is Neil MacGregor, previously National gallery director. In autumn 2000 the museum's inner courtyard became the Queen Elizabeth Great Court, a large area covered by a magnificent glass roof. Designed by Norman Foster and Partners, the Great Court houses a Centre for Education, galleries and temporary exhibition space, alongside improved facilities such as a terrace restaurant and easier access. The Reading Room, which is now a central part of the Great Court, houses a new public reference library. 6.1 million people visit the British Museum annually, making the new additions very welcome. The cost of the project—a mere £97 million, but money well spent, even if there are still arguments about the quality of the stone used.

One of the largest museums in the world, built in 1823-27. It is best to visit one section at a time, as you could easily spend a week in this museum alone. Wander through Greek pottery, Egyptian remains, past the famous Elgin Marbles brought from Greece in 1802, Bronze Age tombs, Indian paintings and exquisite manuscripts, Tibetan amulets, the Hotung gallery of

The Hotung Gallery of Oriental Antiquities, British Museum.

Antiquities and the recent Mexican gallery. The **Sainsbury African galleries** in the basement are magnificent with a more modern approach to displays and also include work by contemporary African artists. The **Korean Foundation Gallery** is now a permanent fixture with major loans from the National Museum of Korea. The **Wellcome Trust Gallery**: Living and Dying, opened in 2003 and the **Enlightenment Gallery**. The new **Small Gallery** by the entrance door is for temporary small exhibitions. Underground Tottenham Court Road.

Natural History Museum, Cromwell Road, South Kensington, London SW7. Telephone: 020 7942 5000. Website: www.nhm.ac.uk. Open Monday-Saturday 10-5.50, Sunday 11-5.50. Magnificent building next to the V&A museum and Geology museum. Best known for its lively displays and dinosaurs. Displays show the history of the world with mammals, fossils, plants and animals. Ideal museum to take children to. The Earth Galleries are fascinating. The Darwin Centre is a huge development which has had great public appeal in recent years. The Spirit Collection has 22 million zoological specimens dating back to Captain Cook's discoveries over 200 years ago. Phase 2 of this project houses the museums' Entomology and Botany collections with 28 millin insects and 6 million plants. www.nhm.ac.uk/darwincentre There are also temporary exhibitions relating to the exhibits, often of a very high standard. Underground South Kensington.

British Library, 96 Euston Road, St Pancras, London NW1 2DB. Telephone: 020 7412 7332. Website: www.bl.uk. The main building is open Monday, Wednesday, Thursday and Friday 9.30-6, Tuesday 9.30-8, Saturday 9.30-5, Sunday 11-5.
The new British Library buildings opened at St Pancras at a cost of many millions more than expected, but the building, designed by Professor Sir Colin St John Wilson, is more attractive than had been predicted. There are 11 reading rooms, 3 exhibition galleries, a bookshop, a fully equipped conference centre with 255-seat auditoium and restaurants. In the piazza and building there are sculptures by Eduardo Paolozzi, R.B.Kitaj and Antony Gormley. The British Library is the national library of the United Kingdom, the world's greatest libraries. There are some 12 million books here, including The King's Library (donated by George IV in 1823), rare books, music and manuscripts, books on display in exhibitions in the John Ritblat Gallery, (Magna Carta, The Gutenberg Bible, Shakespeare's first Folio (1623), works by many famous writers, composers and artists, and the

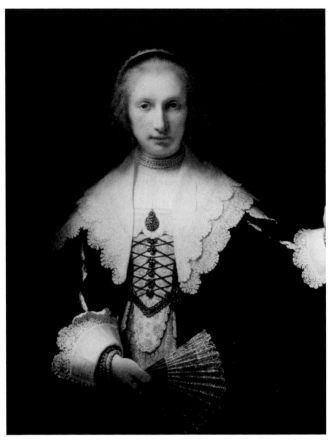

Portrait of Agatha Bas, Rembrandt, Buckingham Palace, Queen's Gallery

Lindisfarne Gospels), The Pearson Gallery of Living Words, The Workshop of Words, Sounds and Images tracing the story of communication through the ages and a permanent exhibition of philately. There are seats for 1200 readers and excellent Online Public access and automated book request system. The galleries are open to view manuscripts on the following days: Monday, Wednesday, Thursday and Friday 9.30-6, Tuesday 9.30-8, Saturday 9.30-5, Sunday 11-5. There are also talks by living contemporary writers, making this magnificent new building very welcome to London's buzzing contemporary life. A café, restaurant and coffee shop in the Piazza are also worth visiting for views of the King's Library. Underground Euston.

Buckingham Palace, State Rooms, Buckingham Palace London SW1. Telephone: 020 7321 2233. www.royalcollection.org.uk These magnificent State Rooms are open to the general public between August and October (check dates each year as they may change). Although some of the rooms are over-the-top in richly-coloured excessive taste,the paintings are worth visiting. On the one hand you have paintings by Winterhalter of Victoria and Albert and their children and grandchildren and on the other great masterpieces by Rembrandt, also Dutch, British and Flemish Masters. The White Drawing room is particularly attractive and the downstairs rooms have interesting collections of porcelain and china and views of the garden. There are plans to open the garden more to the public in future. The Royal Mews is also now open. Underground Victoria.

Carlyle's House, 24 Cheyne Row, Chelsea, London SW3. Telephone: 020 7352 7087. Open Wednesday-Sunday, 11-5pm. (April-October). Entrance fee.
Thomas Carlyle, the writer, lived in this 18th-century Chelsea house for many years. Maintained by the National Trust with many interesting items on display. Carlyle was friendly with Dickens, Thackeray, Browning and Tennyson and they all visited him here from time to time. Downstairs the dining room and parlour show what life was like for a successful writer in 18th century London. Upstairs is the library where John Stuart Mill burst in to tell Carlyle that his maid had burnt the manuscript for "The French Revolution", Carlyle's masterpiece. Underground Sloane Square and then buses 11, 19 or 22.

Churchill Museum and War Cabinet Rooms, Clive Steps, King Charles Street, London SW1A 2AQ. Telephone: 020 7930 6961 www.iwm.org.uk. E-mail: cwr@iwm.org.uk. Open daily 9.30-6pm (last admission 5pm).
Run by the Imperial War Museum this museum is dedicated to the life and achievements of Sir Winston Churchill. There are film and sound recordings, documentation, objects and photos covering his 90-year life. He is seen as Britain's greatest Prime Minister and it is accepted that he saved Britain from Nazi invasion by his dogged determination to battle to save the British Isles from 1940 until the end of World War II in 1945.
Underground Westminster.

Clarence House, St James's Palace, The Mall, London SW1. Telephone: 020 7766 7303. Open 9-7pm. Guided tours over the summer months of August-October. Booking essential. Entry fee.
Built in 1825-27 and first occupied by the Duke of Clarence, later

King William IV, it was also the home of Queen Victoria's sons, Alfred and then Arthur. It was home to the present Queen Elizabeth's parents and renovated then in 1947. Queen Elizabeth and her sister Princess Margaret spent their childhood there until her father beacme king. The Queen Mother lived there for 50 years, until her death. Her presence dominates the rooms even now, with many of her private clocks, Fabergé eggs, porcelain paintings and furniture. The paintings include a Fantin Latour, Lowry, two Sargent drawings of her as a bride, Sickert and an Augustus John. Since the Queen Mother's death the house has been restored and rewired and open to the public. The Prince of Wales uses it as his London home now. Underground St James's.

Courtauld Institute Galleries, Somerset House, The Strand, London WC2. Telephone: 020 7848 2526. Website: www.courtauld.ac.uk. Open daily 10-6. Fridays in late July-September until 9pm. This is one of London's most rewarding museums with a permanent collection of some 530 paintings, 7000 drawings and 27,000 prints. Samuel Courtauld's famous Impressionist and Post-Impressionist paintings have been added to by ten major bequests, greatly enriching the collection. Apart from the Italian Pre-Renaissance paintings, the Impressionist and Post-Impressionist paintings alone are magnificent; three Monets, four Degas, six Seurat, Manet's "Bar at the Folies-Bergere", nine Cézanne, Gauguin, two Van Gogh, Lautrec and three Manets. This is a unique and important art collection and very central to visit. There are also temporary exhibitions. As Somerset House now has the Hermitage Rooms and the Gilbert Collection the area has a real atmosphere and in summer there are fountains in the square and in winter a skating rink and Christmas tree. The Courtauld Institute for postgraduate studies in fine art is next door. The print and study room is open to the public. The café in the basement has an open-air seating area in summer. There is also an excellent bookshop across from the gallery. Underground Temple or 15, 23 buses.

Cricket Memorial Gallery, Lords Cricket Ground, St John's Wood, London NW8. Telephone: 020 7289 1611. Open match days only 10.30-5. Ground admission and entrance fees.
The history of cricket. Next to the famous Lords cricket ground. A must for cricket enthusiasts. Underground St John's Wood.

Cutty Sark, Greenwich Pier, London SE10. Telephone: 020 8853 3589. Open Monday-Saturday 10-5, Sunday 12-5. Admission £3 or more. The Cutty Sark has just received £11.25

million in 2005, as a grant from the Heritage Lottery Fund, saving it for the next 50 years. One of the most famous clipper ships. Exhibition on board of how the sailors lived on board ship in those days. A trip to the Cutty Sark and the National Maritime Museum can be done on the same day by taking the boat from Westminster Pier or Charing Cross to Greenwich, downriver. I'd also recommend a visit to the Royal Observatory and to Queen Anne's House, which is far more attractive than Buckingham Palace. On the way down the River Thames you will pass "Oliver Twist" warehouses, newly-converted loft properties and the Docklands development at Canary Wharf. Rail to Greenwich or take the boat from Westminster pier or Charing Cross Pier.

Dalí Universe, County Hall, London SE1. Telephone: 020 7620 2720. Website: www.daliuniverse.com. Open daily 10-5.30pm. Admission £7 adults, children under 16, £5.
This relatively recent museum is next to the London Aquarium and will also be next to the newly-planned Saatchi museum when it opens. Although the museum is the largest permanent display of the Surrealist artist Dalì, mostly from private collections, it only has one oil painting and the rest are drawings, watercolours, sketches and the famous Mae West red-lip sofa. There are early photographs and information about his life but for the paintings you will need to visit Tate Modern or elsewhere! Underground Waterloo.

De Morgan Centre, 38 West Hill, London SW18. Telephone: 020 8871 1144
A new home at last for the de Morgan art collection of work by William and Evelynde Morgan. Late 19th century art and society study centre also. Underground East Putney.

The Design Museum, Butler's Wharf, Shad Thames, London SE1 2YD. Telephone: 0870 833 9955/0870 909 9009. www.designmuseum.org. Entrance fee. Open daily 10-5.45 (last admission 5.15).
The Design museum examines the role of design in our lives and allows the visitor to look at mass-produced products and see why they have been designed in a particular way. Regular exhibitions of new and past designs. There are guided tours, a library, a well-stocked shop and a famous Riverside café/bar. Membership scheme often includes visits to designer workshops and special access to events and activities. Individuals £22, special £10, Dual £38, group £150-£500, corporate £1000-£4000. School and college visits are welcomed.

Technology and Design are important parts of the National Curriculum in British schools now. Underground Tower Hill and walk over Tower bridge. Boats by river.

Charles Dickens House Museum & Library, 48 Doughty Street, London WC1N 2 LX. Telephone: 020 7405 2127. Open Monday-Saturday 10-5pm. Sunday 11-5pm. Entry fee.
Charles Dickens rented this house between April 1837-December 1839. He wrote *Pickwick Papers*, *Oliver Twist* and *Nicholas Nickleby* while living here as well as some journalism. There are also portraits, letters, illustrations and household items from that era. In the dining room you can see the quill that he used to write *The Mysteries of Edwin Drood* with. The study has a painting called "Dickens Dream" by RW Buss and the table where Dickens wrote his last words. The Georgian terraced house was opened as a museum in 1925 by the Dickens Fellowship. There are also temporary exhibitions. Underground Holborn.

Dulwich College Art Gallery, College Road, London SE21. Telephone: 020 8693 5254. www.dulwichpicturegallery.org.uk Open Tuesday-Fridays 10-5pm, Saturdays, Sundays and Bank holidays 11-5. Entrance is £3, concessions £1.50. Free for disabled, unemployed and children.
Dulwich in South London is an attractive area with old historical houses. The gallery was designed by Sir John Soane (his museum at Lincoln's Inn Field may also be of interest) in 1811. Rick Mather has completely renovated the Gallery which reopened in 2000 with a new building complementing Soane's masterpiece. Works by Rembrandt, Van Dyck, Rubens, Reynolds and the Italian Masters. It was the first public gallery in London. There are many excellent temporary exhibitions during the year. The collection is very disappointing in many ways but the recent exhibitions have been good. There are also open-air public sculpture exhibitions by established British contemporary artists. Rail West Dulwich.

Chelsea Royal Hospital Museum, Royal Hospital Road, London SW3. Telephone: 020 7730 0161. Open Monday-Saturday. 10-12, 2-6pm, Sunday, 2-6pm.
Home of the famous Chelsea Pensioners, some whom you can occasionally see walking slowly in their heavy, red uniforms along the King's Road. Founded by Charles II. Christopher Wren building, with additions by Adam and John Soane. Wren's chapel is worth a visit. Underground Sloane Square.

Northampton Lodge, home of the Estorick Collection.

Eltham Palace and Gardens, Eltham, South London. Telephone: 020 8294 2548. Open Wednesdays, Thursday, Friday and Sunday 10-4 (10-6 April-September). Entrance to house and grounds £5.90.

Restored by English Heritage this magnificent house was a favoured residence for kings and queens ever since it was given to the Crown in the 14th century. It could accommodate the royal court of up to 800 people at the time. Stephen and Virginia Courtauld came across the Palace in the 1930s and decided to renovate it in a lavish Art Deco style of that period. All the latest 1930s gadgets were included and this has all been restored today, showing the luxurious lifestyle that the wealthy Courtaulds led. Rail from Victoria or Charing Cross to Eltham.

Estorick Collection of Modern Italian Art, 39A Canonbury Square, London N1 2AN. Telephone: 020 7704 9522. www.estorickcollection.com Open Wednesday-Saturday 11-6, Sunday 12-5. Closed Mondays & Tuesdays. Entrance fee.

Works from the collection of Modern Italian art created by Eric and Salomé Estorick. Magnificent opportunity to see paintings by the early 20th century Italian avant-garde Futurist painters including Balla, Boccioni, Carra, Severini and Russolo. Paintings by de Chirico, Modigliani, Sironi and Campigli are also on show. There is also a library of 2000 books, open by appointment. Café for weary visitors. Underground Highbury and Islington.

The Fan Museum, 12 Croom Hill, Greenwich, London SE10. Telephone: 0208305 1441. www.fan-museum.org. Ring for opening hours. A collection of fans through the ages, with occasional temporary exhibitions. Ideal to combine this with a visit to Greenwich's Cutty Sark or the National Maritime Museum. Rail Greenwich or boat by the River Thames from Westminster pier.

Faraday Museum, The Royal Institute, 21 Albemarle Street, London W.1. Telephone: 020 7409 2992. Open Tuesday and Thursday, 1-4pm. Entrance fee.
Michael Faraday the great discoverer of electromagnetism worked here and the great Electrical Machine built in 1803 is on display. Underground Green Park.

Fenton House, Hampstead Grove, London NW3. Telephone: 020 7435 3471. Open April-October, Saturday and Sunday 11-5.30, Monday-Wednesday 1-7. Closed, except weekends, in December, January and February. Entrance fee.
This is a wonderful house to visit, high up above Hampstead village, with views over London. It is maintained by the National Trust and houses the Binning collection of porcelain and furniture and the Benton Fletcher collection of keyboard instruments. Some musical instruments from the 16th and 18th centuries are still used by music students. The paintings in the house are by Dürer, Constable, Lawrence, Daubigny and William Nicholson. There are open-air theatre and concert performances in the summer in the garden. I'd recommend a visit if you want to escape central London pollution and noise. Underground Hampstead.

Florence Nightingale Museum, 2 Lambeth Palace Road (St Thomas's hospital), London SE1 7EW. Telephone: 020 7620 0374. Open Tuesday-Sunday, 10-4pm. Entrance fee.
Well-known to British school children as the "lady with the lamp" during the Crimean war. In fact this episode was only a two-year period in her 90-year life. The history of this remarkable woman and her nursing life. Opposite the Houses of Parliament on the other side of the Thames. Underground Westminster and walk over the bridge.

Foundling Hospital, (Coram Foundation) 40 Brunswick Square, London WC1N 1AZ. Telephone: 020 7841 3600. www. foundlingmuseum.org.uk. Open Tuesday-Saturday, 10-6pm. Sunday, 12-6pm. Entrance fee.
Founded in 1739 by Captain Coram for the care of destitute children. Hogarth painted the Captain's portrait and persuaded

artists to give works of art for sale. The Foundling's Court Room, with a series of paintings by Hogarth about children being rescued is on view by appointment at the Coram Foundation. The paintings include "The March to Finchley". Paintings by Gainsborough, Reynolds, Raphael, Millais, also Captain Coram's portrait. There was an upheaval when the charity tried to sell the paintings to the nation over 25 years to be housed in Bloomsbury and shown to the public for the first time. This was vetoed by the Attorney General. The new museum (2004) has an extension next door to Coram family which continues Thomas Coram's pioneering work with vulnerable children. Underground Russell Square.

Freud Museum, 20 Maresfield Gardens London NW3 5SX. Telephone: 020 7435 2002/5167. Website: www.freud.org.uk Open Wednesday-Sunday 12-5pm. Entrance fee.
Once the home of Sigmund Freud and his family, after escaping the Nazis in 1938. The library is the focus of the museum, where the founder of psychoanalysis centred his discoveries and research. 18th and 19th century Austrian furniture and Biedermeier chests. Underground Finchley Road.

The Geffrye Museum, Kingsland Road, London E.2. Telephone: 020 8739 9893. Open Tuesday-Saturday 10-5pm, Sunday 2 -5pm. It is worth making a special visit to this museum, set next to peaceful East London almshouses, dating from 1715. The museum specialises in furniture and furnishings and various rooms have been re-constructed to create the exact era. The chapel is also worth visiting. There are various children's activities and special courses and lectures throughout the year. Underground Liverpool Street. Buses 22, 67, 48, 149 and 243.

Geological Museum, Exhibition Road, South Kensington, London SW7. Open Monday-Saturday 10-6pm, Sunday 12-6pm. There are various displays to help visitors understand the Story of the Earth and the various rocks and minerals that make the earth so rich with colour and wealth. A piece of moon rock is on display. Special activities for children and temporary exhibitions throughout the year. The shop has minerals and jewellery for sale and an excellent selection of books. Undergound South Kensington.

Gilbert Collection, Somerset House, Strand London WC2R 1LA. Telephone: 020 7240 4080. Website: www.gilbert-collection.org.uk. Open Monday-Saturday 10-6, Sundays and Bank holidays 12-6. Shop and café.

Somerset House, designed by George III's architect Sir William Chambers (1723-1796) has now been restored. The Gilbert Collection is housed in the South Building of the Great Court. Silver items include a silver-gilt Elizabethan cup given by the Duke of Wellington as a christening gift in 1824, amongst thousands of other European silver objets d'art, golden snuff boxes, Italian mosaics and the magnificent silver gates presented by Catherine the Great to the monastery of Pechersk Lavra in Kiev in 1784. There are also portrait miniatures, chalices, ewers, clocks and cabinets. Sir Arthur Gilbert was there at the splendid opening and seemed such a charming man and a great collector who grew up in London and then moved to California, where he made his fortune. Sadly he died recently but his collection was a great coup for London and especially now that Somerset house has been restored in such a grand manner. There are many temporary exhibitions, both historical and contemporary. Underground Temple.

Gunnersbury Park Museum, Pope's Lane, London W.3. Telephone: 020 8992 1612. April-September open Monday-Friday 1-5pm, Saturday and Sunday 2-6pm. October-March daily 2-6pm. Once the home of part of the famous Rothschild family. Magnificent setting overlooking parkland, with a small classical temple. Various coaches and a Hansom cab are on display and local history items. Underground Acton Town.

Goldsmiths Hall, Foster Lane, London EC2. Telephone: 020 7606 8971. Ring the gallery for details and an appointment to see the collection. Largest collection of modern silver in the country. There are also temporary exhibitions of work by contemporary silversmiths. Underground St Paul's.

Gordon Medical Museum, St Thomas Street, London SE1. Telephone: 020 7407 7600. By application to the curator. Mainly used by medical students. Amazing collection of specimens of rare deformities and diseases. Not for the squeamish. Underground Waterloo.

Hogarth's House, Hogarth Lane, Chiswick, London W.4. Telephone: 020 8 994 6757. Open April-October Tuesday-Friday, 1-5pm, Saturday & Sunday, 1-6pm. October-March Monday-Saturday (except Tuesday), 11-4pm. Hogarth, the famous English painter's country house in Chiswick, now sadly next to a thundering motorway. Drawings, prints and other items related to Hogarth's life are on display.

The house was renovated in 1997 for the tercentenary of Hogarth's birth. His paintings can be seen at Tate Britain and various other galleries in London. Underground Hammersmith and bus 290.

Hampton Court Palace, Hampton Court, Surrey. Telephone: 020 8977 9441. Opening hours vary according to the time of the year. Italian masterpieces including Tintoretto and Titian. After the devastating fire, the Palace has been restored by contemporary craftsmen and women. Worth visiting to see what a magnificent job they have done. Famous in English history in the times of Henry VIII. There are now assistants in the costumes of the period who are especially popular with children and tourists. There are a variety of tours suitable for different age groups. Magnificent gardens and a maze to get lost in. Situated next to the River Thames. Ideal for family visits. Good cafés. Take the boat from Westminster pier for the most picturesque way to see the Thames. Rail to Hampton court.

Handel House Museum, 25 Brook Street, London W1K 4HB. (Entrance in Lancashire Court) Telephone: 020 7495 1685. Website: www.handelhouse.org. Open Tuesday-Saturday, 10-6 (late opening Thursday until 8), Sunday and Bank holidays, 12-6. Handel House museum was opened in 2001 in the former home of the famous 18th century composer George Frideric Handel. He lived here from 1723 until his death in 1759. Paintings of the period have been displayed throughout the museum complementing the objects in his bedroom, sitting room and the adjoining house, (where rock musician Jimi Hendrix lived in 1968/69) is used for temporary exhibitions and educational activities. A must for any Handel enthusiast. The squeaking floorboards add to the charm of the house. Small shop and explore the alleyways nearby with specialist shops and quiet restaurants. Hush, the restaurant next door to the museum, is owned by Roger Moore's son. Underground Bond Street or walk from Oxford Street.

Horniman Museum, London Road, Forest Hill, London SE23. Telephone: 020 8699 1872. www.horniman.ac.uk. Open daily 10.30-6pm. Sundays and Bank holidays, 7.15 or 8. Museum of Ethnography covering arts, crafts and religions worldwide. Collection of items relating to all these fields such as tools, dance masks and various musical instruments. Library, aquarium and a fascinating building. It has recently had £13 million spent on restoration. 16 acres of garden to explore. Rail to Forest Hill.

58

Imperial War Museum, Lambeth Road, London SE1. Enquiries: 020 7416 5000. www.iwm.org.uk. Open daily 10-6pm.
Museum recording visually the British Commonwealth forces in two world wars. Weapons, photographs, paintings by war artists such as Nash,J.D.Fergusson, Spencer, and more recently Peter Howson in Bosnia and Linda Kitson in the Falklands. The building was once "Bedlam", the famous Bethlehem hospital for the insane. Ideal gallery to take children to to show them the horrors of war and the misery that it brings with it. Major redevelopments opened in 2000 to house exhibitions about the Holocaust and Total War. Also new conference and teaching facilities. A cinema and gallery talks. Underground Lambeth North and Elephant and Castle.

Jewish Museum, (Camden) 129-131 Albert St, NW1. Telephone: 020 7284 1997. www.jewishmuseum.org.uk. Also The Jewish Museum Finchley 80 East End Rd N.3. Telephone 020 8349 1143. Two specialist museums with displays about all matters relating to the Jewish faith and way of life. Underground Camden and Finchley Central.

Kenwood House.

Kenwood House, Hampstead Lane, London NW3. Telephone: 020 7348 1286. www.english-heritage.org.uk. Open daily 10-7. Closes at 5 in October, February and March; at 4 in November-January. A beautiful setting, perhaps the best in London, looking down onto the city of London over rolling acres of trees and lush green fields. Robert Adam designed the house and the Iveagh

bequest collection of paintings, furniture and other works of art, is one of London's most enjoyable. Superb Adam library and drawing room. Paintings from English, Dutch and Flemish schools of art. Vermeer's "Guitar Player", Rembrandt's self-portrait, Gainsborough portraits, Van Dyck, Frans Hals, Romney and Boucher are all on display in this magnificent country house. There are also some excellent temporary exhibitions during the year. Kenwood is the setting for large open-air classical concerts in the summer. Best time to visit Kenwood House is on a Saturday or Sunday, when you can combine it with a visit to the Spaniards Inn, up the road, where Dick Turpin the highwayman is supposed to have stayed. Good restaurant and café by the old stables. Underground Archway then bus 210 or Golders Green and bus 210.

Doctor Johnson's House, 17 Gough Square, London EC4. Telephone: 020 7353 3745. Open May-September Monday-Saturday 11-5.30pm. October-April 11-5pm. Reductions for students and children.
A Queen Anne house quite near Fleet Street. First edition of his Dictionary on show. Doctor Johnson was a well-known literary figure in the 18th century. He spent ten years in this house compiling the first English Dictionary. His will is on display where he left everything to his black servant Francis Barber. He was famed for saying "If a man is tired of London, he is tired of life." Underground Blackfriars/Chancery lane.

Keats House, Keats Grove, Hampstead, London NW3. Telephone: 020 7435 2062. Open Tuesday-Saturday, 12-5pm (10-12 guided tours), Wednesday, 5-8pm, Sunday, 12-5pm. £3 entrance to the house, under 16 is free.
The famous English poet lived here in this pretty Regency house for two years, in an attractive Hampstead setting. The house has memorabilia connected with Keats' life, including love letters to Fanny Brawne and various manuscripts. The garden is covered in exotic flowers in the summer and it is here that Keats wrote "Ode to a Nightingale". The house was recently renovated after structural repairs. Keats was born in Moorgate. Combine a visit to Keats house with a tour of literary Hampstead to see where DH Lawrence lived. Underground Belsize Park or 24 bus to South End Green from Oxford Street or Trafalgar Square.

Leighton House, 12 Holland Park Road, London W.14 8LZ. Telephone: 020 7602 3316. Open Monday-Saturday, 11-5pm. Entrance free.

Keats House and garden, Hampstead.

A beautiful Victorian house with a very exotic interior, home of Lord Leighton the painter and one-time President of the Royal Academy. Persian 15th and 16th century tiles in a cool Arabic room with fountain. The upstairs rooms have a display of Lord Leighton's drawings and Pre-Raphaelite paintings by Burne-Jones, also exquisite De Morgan tiles. Lord Leighton's large Victorian sculptures can be seen in the rambling garden outside. Worth a visit to sample the kind of Victorian idealism of the period. A Leighton exhibition was slammed by the critics for the excesses and idealism of the period and it is true that his paintings are rather excessive. Whatever you feel about his paintings the house is worth a visit. There are also many temporary exhibitions throughout the year. Underground High Street Kensington.

Linley Sambourne House, 18 Stafford Terrace, Londson W8 7BH. Telephone: 010 7602 3316 ext 305/020 7371 2467. www.rbkc.gov.uk/linleysambournehouse. Open April-December and January-March. Ring to check opening times. Guided tours on Saturdays and Sundays 10/11.15/1/2.15/3.30. 12 visitors per tour. Entrance fee.

A beautiful well-preserved Victorian town house with almost all its original decoration. From 1875 the house was home to the Punch cartoonist, illustrator and photographer Edward Linley Sambourne (1844-1910) and his wife, Marion, and their two chil-

dren. There are now visitor facilities in the basement, including an audio-visual film about the house and family. Underground High Street Kensington.

London Transport Museum, Covent Garden, London WC2. Telephone: 020 7379 6344. Open daily 10-6pm. Entrance fee. The museum houses London Transport buses and trams, across the last two centuries of the city's transport system. Magnificent buildings next to the market, with spacious rooms and high ceilings. The shop sells books and London Transport posters. Underground Covent Garden.

Museum in Docklands, No. 1 Warehouse, West India quay, Hertsmere Road, London E14. Telephone: 0870 444 3855. A recent museum recording developments in the Docklands area. This Georgian warehouse next to canary Wharf's towers has a wealth of archives about London's docklands and its past history including photographs, objects, drawings, films and sound recordings. There are also temporary exhibitions on display regularly.

Museum of Immigration and Diversity, 19 Princelet Street, London EC2. www.19princeletstreet.org. A new museum. Underground Liverpool Street.

Museum of London, London Wall, London EC2. Telephone: 020 7600 3699 ext 240. www.museumoflondon.ac.uk. Open Monday-Saturday 10-5.50pm, Sunday 12-5.50pm. Recent developments have included the World City Galleries 1789-1914, which opened in 2001 with over 3000 objects on display. The £33 million development to celebrate the 25th anniversary of the Museum will be fully completed in 2006. The existing building will be extended to incorporate a 70% increase in gallery space, a glazed central court for community events, a new entrance at street level and a radical reshaping of the interior spaces including the bookshop and café. The London Archaeological Archive Research Centre at Mortimer Wheeler House opened at 46 Eagle Wharf Road in north London. Wheeler was once a director of the original Museum of London. In the Museum at present you can see the history of London through the ages. Conveniently set near the ruins of the original Roman London Wall. Various displays show pottery, tools, costumes, room settings and reconstruction of shops. The magnificent Lord Mayor's coach is on display here and is used

annually in November for the Lord Mayor's procession through the City of London. Also regular exhibitions of contemporary photography and exhibitions related to London life. The Roman London gallery is also of interest. Renovations have improved all galleries and facilities in recent years, including the bookshop and café. Underground for Museum of London Barbican, Moorgate.

National Army Museum, Royal Hospital Road, Chelsea, London SW3. Telephone: 020 7730 1717. Open Monday-Saturday, 10-5.30pm, Sunday, 12-5.30pm.
History of the British army from 1485 to the outbreak of the First World War. Displays of weapons,documents and battle plans. The art gallery has paintings by Lawrence, Reynolds, Gainsborough and Romney among others. Underground Sloane Square.

National Gallery, Trafalgar Square, London WC2. Telephone: 020 7747 2885. www.nationalgallery.org.uk. Open daily 10-6pm, Wednesday until 9. Exhibitions in the Sainsbury wing open until 9pm on Wednesdays, also the Brasserie and shop. Excellent brasserie Crivelli's Garden with Paula Rego murals of the same name, recently cleaned. Director Charles Saumarez Smith, previously Director of the National Portrait gallery.
The collection holds over 2300 paintings, (1250-1900) all on display, and these can now also be seen in the Multi Media

The Adoration of the Shepherds, Luca Signorelli (National Gallery).

Centre which opened in 2005, called ArtStart, housed at the Education centre. There will also be an ArtStart centre with a café in the basement soon. The latest touchscreen technology allows visitors to explore paintings, check artist biographies under Artists, Paintings, Themes and tours and Time and Place. The £21million revamp of the galleries has started with the new Getty entrance, the Annenberg court, also a new shop and café with an exit near the National Portrait Gallery. In 2005 the newly-restored portico at the entrance shows the original Crace ceiling and there is a new Central Hall. With the exchange of paintings between the Tate and the National Gallery, the National inherited 50 19th century paintings, while 14 early 20th century paintings have gone to the Tate. The arrivals at the National include more paintings by Monet, Pissarro, Degas, Seurat, Gauguin, Cézanne and Van Gogh. A magnificent collection of paintings through the ages, ranging from early Italian paintings in the Sainsbury Wing, the Spanish School, Flemish to Impressionist and Post-Impressionist paintings in the main building. Particularly worth mentioning are Rousseau's Tiger, Van Eyck's Arnolfini Marriage, Botticelli's Mars and Venus, Monet's Lilies and Vermeer's Woman standing at a Verginal. The North Galleries have been re-designd in a Franco-British venture with support from Yves Saint Laurent among others. The French collection paintings are dominated by Claude Lorrain and Nicolas Poussin, but paintings in the Dutch collection include several by Cuyp. The Rembrandt room is also worth visiting and Uccello's spectacular Rout of San Romano, which is near many other Italian masterpieces in the Sainsbury Wing. This wing also has major exhibitions such as Raphael, Caravaggio in the basement, often with videos on show about the painter or period. The bookshop is much larger now and has an excellent selection of art books, as well as cards and posters; well-informed staff are very helpful. Underground Charing Cross. Buses 12,15,23,6.

National Portrait Gallery, St Martin's Place, Trafalgar Square, London WC2. Telephone: 020 7312 2463. www.npg.org.uk. Open daily 10-6pm. Late on Thursday and Friday until 9pm. Excellent new bookshop and café. Director Sandy Nairne.

A historical collection of portraits of famous British men and women. Although many of the portraits are by famous painters such as Holbein, Hogarth, Lely, Romney, Van Dyck and Reynolds, they have often been chosen for their subject matter rather than the painting's merits, so are not necessarily the best examples of the painter's work. There are magnificent portraits showing the splendour of the 16th-19th centuries, but some of

Bridget Riley, by Jorge Lewinski (1964), National Portrait Gallery.

the most interesting portraits are downstairs of more recent writers, scholars and 20th century celebrities, including the film of David Beckham asleep, Paula Rego's portrait of Germaine Greer, Sam Taylor Wood's self-portrait and specialist sections on scientists, designers and recent people in the news. These galleries are also more lively, with temporary exhibitions on display, highlighting certain periods of the 20th and 21st centuries. There are many other major exhibitions in the gallery over the year, including prize awards of both painting and photography. The Oondatje wing has created a new entrance hall, spacious galleries, a rooftop café and lecture theatre, in the new extension between the National and the National Portrait Gallery. There is a modern café in the basement and a good bookshop. Underground Charing Cross.

National Maritime Museum, Romney Road, Greenwich, London SE10. Telephone: 020 8312 6700. www.nmm.ac.uk. Open daily 10-5pm.

Multi million pound renovations have now provided new galleries, including "The Future of the Seas" exhibition, monitoring ecology. The museum is set in the picturesque area of Greenwich and has on permanent display models of ships, nautical instruments, relics and a fine selection of marine paintings by artists such as Turner, Gainsborough, Reynolds, Romney and Lely. The library and print room are full of maritime historical information for students and enthusiasts. The Queen's House was built by Inigo Jones for James VI of Scotland James I of England's wife, Queen Anne of Denmark. This is a far more beautiful palace than the current royal residence. Period music is also sometimes played in summer. Extensive renovations have now created temporary exhibition space for contemporary art in the Queen's House. The Royal Observatory contains astronomical instruments and is near the Maritime Museum. It was built by Sir Christopher Wren in 1676. This is where Greenwich Meantime starts. The Dome can be seen from here. Rail to Maze Hill or boat from Westminster Pier in the summer months.

National Museum of Labour History, Limehouse Town Hall, Commercial Road, London E.1. Telephone: 020 8515 3229. Open Tuesday-Friday, 9.30-5pm.

The history of the development of the Labour movement in Britain. The Tolpuddle Martyrs, the Peterloo massacre, the foundation of the Fabian Society, the General Strike, the foundation of the Trades Union Congress (TUC) and the foundation of the first Labour Government, are all related in various displays. Underground Aldgate East then bus 5, 15, 23, 40. Rail to Stepney East.

National Postal Museum, London Chief Office, King Edward Street, London EC1. Telephone: 020 7432 3851. Open Monday-Thursday, 10-4.30pm.

Extensive collection of postage stamps in this museum, mostly from the Reginald Phillips collection of 19th century stamps. The Post Office's own collection of every stamp issue since1840 is also here. Reference library for philatelists. Underground St Pauls.

Orleans House Gallery, Riverside, Twickenham. Telephone: 020 8892 0221. www.guidetorichmond.co.uk/orleans.html. Open Tuesday-Saturday, 1-5.30pm, Sunday, 2-5.30pm.

Various loan exhibitions are held here every year, also contemporary art exhibitions. The famous Octagon was designed by

James Gibb in 1720. Orleans House was partially demolished in 1926. Louis Phillippe the French King lived here between 1815 and 1817. Underground Richmond or Rail to St Margarets.

Passmore Edwards Museum, Romford Road, Stratford, London E15. Telephone: 020 8519 4296. Open Monday-Friday 10-6 (Thursday -8), Saturday 10-1, 2-5.
A local museum specialising in the history of Essex, with archaeology, geology and local history. Bow porcelain was produced locally. Maritime history shows that Ilford was once a port instead of being inland as it is now. Underground Stratford.

Percival David Foundation, 53 Gordon Square, London WC1. Telephone: 020 8387 3909. Open Monday 2-5pm, Tuesday-Friday 10.30-5pm, Saturday 10.30-1pm.
Chinese porcelain from the Sung to Ch'ing Dynasties. Exquisite shapes and colours and a must for any ceramics or porcelain collectors. A specialist collection. Underground Russell Square.

Pollocks Toy Museum, I Scala Street, London W.1. Telephone: 020 7636 3452. Open Monday-Saturday 10-5pm. Entrance fee. Children free on Saturdays.
This museum is a real delight for parents and children. Collection of toys, dolls' houses, puppets, games and reconstructions of Victorian nurseries. Benjamin Pollock was a publisher of toy theatres, hence the museum's name. It is an Educational Charitable Trust. There is an excellent toy shop for presents for children. Underground Goodge Street.

Public Records Office Museum, Kew, Richmond. Telephone: 020 8876 3444. Open Monday-Friday, 1-4pm.
The nation's archives are held here. Signatures of English Royalty through the ages and also of Guy Fawkes and Shakespeare among others. The Domesday Book is here and visitors can look at a copy, made for reference. Wealth of interesting documents for historians. The Family Record centre is also here with records from the 14th century -1588 and nonconformist records. Opening hours vary according to what you wish to see at the National Archives for England and Wales or the Family Record centre. Underground Kew.

The Queens Gallery, Buckingham Palace Road, London SW1. Telephone: 020 7839 1377. www.royalcollection.org.uk. Open Tuesday-Saturday 11-5pm, Sunday 1-5pm.
The gallery re-opened in 2002, the Queen's Golden Jubilee.

£15 million was spent on extending the gallery to include a lecture theatre, a micro-gallery with electronic access to 500,000 works and a coffee shop. There is also an elegant new entrance and new gallery space. Situated at the back of Buckingham Palace, it was once the Palace Chapel Royal collection of paintings, with an especially good selection of Italian masters. Regular exhibitions of the Royal collection are held so that the public can see the wide range of work owned by the Royal family. The Dutch paintings are particularly noteworthy and have been on display here and in Edinburgh's Queen's gallery at Holyroodhouse as "The Enchanted Eye" exhibition. Underground Victoria.

Rangers House, Chesterfield Walk, Blackheath, London SE10. Telephone: 020 8348 1286/8530035. Open daily 10-5pm.
Built by Snape in 1694 and enlarged in 1749. Houses the Suffolk Collection of Jacobean and Stuart portraits, with a heavy emphasis on the costumes of the period. It has been completely restored at great expense to display the Wernher diamond millionaire family's large collection. Set near Greenwich Park with views across the River Thames. Underground New Cross, then bus 53.

Royal Academy, Burlington House, Piccadilly, London W1. Telephone: 020 7300 8000. Website: www.royalacademy.org.uk. Open daily 10-6pm. Entrance fee for temporary exhibitions.
The Royal Academy is the oldest society in Britain, founded 1768, and is devoted to the fine arts. It is famous for its annual Summer Exhibition of some1000 paintings, drawings, prints and sculpture. It holds a variety of major exhibitions throughout the year, some major world exhibitions touring the major art capitals. Apart from the vast galleries downstairs, the Sackler galleries upstairs have been added in recent years to show smaller exhibitions in a light airy venue. There is a good shop selling art books, cards, posters, t-shirts and jewellery or objets d'art related to specific shows. The restaurant in the basement is excellent and gives you a chance to look at some of the RA's permanent collection of paintings on the stairs. Recently the late Carel Weight donated his own art collection to the RA and Eduardo Paolozzi his entire archive of printmaking works since the early 1960s. The John Madejski Fine Rooms are open to the public on the 1st floor showing the RA's Collection of art. There are 1000 paintings, 350 sculptures, 16,000 prints, drawings and photographs, rare books, silver and architectural plaster casts.

www.royalacademy.org.uk/collection. Free tours of the collection are at 1pm, Tuesday-Friday. Friends of the RA can gain discounts and the RA magazine. Better management has led to a more modern 21st century approach at the RA recently, although disagreements seem to keep happening. The RA acquired 6 Burlington gardens and in 2006/7 the RA expanded into these premises providing new space for the RA Schools, new lecture theatres, conference facilities, a new gallery to show work by academicians and students, public access to the historic vaults of Burlington House and improved facilities in the front hall of Burlington House. Photo London is held here annually in May. Underground Piccadilly or Green Park.

Royal Air Force Museum, Hendon, London NW9. Telephone: 020 8205 2266. Open Monday-Saturday 10-6, Sunday 2-6.
Built on the site of Hendon aerodrome, this museum relates the history of the Royal Air Force. Exhibits show how far we have come from the days of the fragile airplanes that attempted to cross the Atlantic. Engines, weapons, uniforms, models are all on display for enthusiasts. Underground Colindale.

Science Museum, Exhibition Road, South Kensington, London SW7. Telephone: 020 7938 8000. Open Monday-Sunday, 10-5.50pm. Website: www.sciencemuseum.org.uk.
The Science Museum displays how science relates to industry and to our everyday life, showing a variety of trains, underground carriages, planes, boats, engines and all sorts of machinery to new technology. The Wellcome Wing has added new space and modern displays. A 10-year £75 million plan will completely transform the Science Museum, moving the Space gallery nearer to the Flight gallery on the top floor. The current site of the Space gallery will become a Great Court centred around existing engines. The Agriculture gallery will disappear; a rather sad indictment of the situation across the UK!! A new purpose-built climate-controlled gallery will be available for large world-class touring exhibitions. This is all part of the South Kensington plan for all museums in the area to revitalise the museum quarter. A new roof made from solar panels will become part of an exhibit. A moon buggy is also on display, relating to the Apollo 10 space capsule and man's historic landing on the moon. Ideal gallery for children, with special children's activities and exhibits. Underground South Kensington.

Sir John Soane's Museum, 13 Lincoln's Inn Field, London WC2A 3BP. Telephone: 020 7405 2107. Open Tuesday-Saturday 10-5pm. First Tuesday evening of each month, 6-9pm, parts of the museum are candlelit. Entrance fee.

As you will probably have already noted, Sir John Soane, the architect, designed quite a number of London's buildings. The collection of Sir John's artefacts range from paintings by Turner, Reynolds and the famous Hogarth Rake's Progress series, to Roman remains and furniture from the last few centuries. The house is a joy to visit. There are also 20,000 architectural drawings in the collection. A £1.3 million restoration of the museum has meant greater access and the restoration of the three courtyards. Underground Holborn.

Somerset House, The Strand, London WC2. Open daily 10-6 and Sundays, Bank holidays 12-6. Entrance to Somerset house is free but there are admission charges for the **Hermitage Rooms, Gilbert Collection** and **Courtauld Institute Gallery** (see separate entries). There is also talk of a Photography collection being based here eventually, but to date nothing concrete has emerged. The Edward J. Safra Fountain Court has fountains on all day in the courtyard. A special choreographed performance runs twice an hour and at night the fountains are lit with fibre-optic lights. In December-January the fountains are replaced with a skating rink which is very popular. You have to book tickets in advance, 020 7845 4670 or Ticketmaster, 020 7413 3399. Perfect for families and great fun. In summer there are concerts in the courtyard. The Hermitage Rooms have temporary exhibitions of paintings and drawings from the Hermitage Museum in St Petersburg, Russia. These have included Catherine the Great, Poussin to Picasso. Underground Temple (except Sundays), Charing Cross, Embankment and Covent garden or nearer still buses 6, 15, 23, 77.

South London Art Gallery, Peckham Road, Camberwell, London SE5. Telephone: 020 8703 6210. www.southlondon-gallery.org.uk. Open Monday-Saturday 10-6pm, Sunday 3-6pm. Variety of exhibitions held here during the year. Opened in 1891 and was apparently the first London gallery to be opened to the public on Sundays. See press for details of exhibitions. Underground Oval.

Spencer House, 27 St James's Place London SW1A 1NR. Telephone: 020 7499 8620. Website: www.spencerhouse.co.uk. Open to the public every Sunday (except during January and August) from 10.30-5.30 (last tour 4.45) Access is by guided tour which lasts about an hour. Maximum number on tour is 20.

Spencer House was built in 1756-66 for the first Earl Spencer, an ancestor of the late Diana, Princess of Wales. It is London's finest surviving 18th century town house and has undergone a 10-year restoration. Eight state rooms are now open to the public and are also available for private and corporate entertaining. The 18th century passion was for classical Greece and Rome and gilded furniture has been restored to the Painted Room by the V&A Museum and English Heritage. There is also a fine collection of 18th century paintings and furniture, including some by Benjamin West, lent by the Queen. Underground Green Park.

Olafur Eliasson installation, The Weather Project, Tate Modern.

Tate Britain, Millbank, London SW1. Telephone: 020 7887 8000 (24-hour information). Website: www.tate.org.uk. Tate online and BT now provide Explore Tate Britain www.tate.org.uk/britain/explore. Open daily 10-6pm.

Tate Britain only shows British Art from 1500 to the present day, including the Turner Bequest. The national collection holds a wealth of paintings by Turner, Gainsborough, Constable, Blake and many Pre-Raphaelite paintings. The new Centenary galleries designed by John Miller and Partners is a major development for Tate Britain. It has created a new side entrance, access for disabled visitors, Linbury exhibition galleries for temporary shows and the upper floor includes four new galleries and five refurbished ones reached by an elegant staircase. The re-arrangement of the galleries is superb, allowing for rooms on Constable, Blake and Hogarth and rehanging of some major British paintings. The Tate Café designed by John Miller and the Tate Espresso Bar were added to cope with Tate Britain's increased number of visitors, although latterly this has declined since the opening of Tate Modern. The restaurant has Rex Whistler murals. There are free films and lectures. Friends of the Tate membership includes invitations to major shows and the Tate magazine (excellent value). The Clore Gallery displays the Turner Bequest in a separate building. The Tate Liverpool and Tate St Ives are affiliated. The new **Tate Library and Archive (Hyman & Kreitman Research Centre)** opened in 2002 and holds archives from British artists, individuals and art organisations. The new Reading Rooms make it ideal for research and scholarship. There are 120,000 contemporary art catalogues and books from the Renaissance to the present day. Diaries, correspondence, photographs, drawings and manuscripts are included in the archives. Tate Britain is a must for anyone interested in British art. Excellent bookshop with friendly staff. Underground Pimlico or 88 bus from Oxford Circus or Trafalgar Square.

Tate Modern, Bankside, Sumner Street London SE1. Telephone: 020 7887 8000. Website: www.tate.org.uk. Open daily 10-6pm.

The Tate collection is a leading world collection of some 65,000 works, including 4572 paintings, 1693 sculptures, 181 installations, 12670 prints, 7074 works on paper and 605 miscellaneous works. The Tyler Graphics gift of 461 prints was added recently. A project "Building the Tate Collection" has secured loans from major contemporary artists including Auerbach, Kapoor, Damien Hirst, Louise Bourgeois, Richard Deacon,

Tate Modern entrance hall.

Lucian Freud, Sam Taylor-Wood, Tracey Emin, Rachel Whiteread and many others. This will help the collection keep up-to-date without major expenditure. Designed by Herzog and de Meuron, the Swiss architects, Tate Modern has regenerated this riverside part of the Borough of Southwark. A new pedestrian bridge, the Millennium Bridge, designed by Sir Norman Foster and Sir Anthony Caro also opened, to link the City and Southwark. There are seven levels at Tate Modern; three for galleries and varying kinds of space for display. There are also educational facilities, an excellent bookshop downstairs and

small upstairs shop, café, auditorium, film and seminar room. All international art from 1900 transferred from Millbank making Tate Modern a major world modern art museum. The Janet Wolfson de Botton Gift of 60 works by 29 artists joins the Tate Modern collection, including works by Clemente, Sherman, Warhol, Samaras, Andre and Gilbert and George. On level 3 the galleries are divided into Landscape/Matter/Environment on one side and Still Life/Object/Real Life on the other. On level 4 between a cinema and a Hard Place shows work by Cornelia Parker, Rebecca Horn, Mona Hatoum, Douglas Gordon and other contemporaries. On level 5 History/Memory/Society shows work by Picasso, Warhol, Mondrian and de Stijl. At the other end of level 5 Nude/Action/Body shows artists' approach to the body with videos by Steve McQueen and Sam Taylor-Wood and Francis Bacon paintings. Tate Modern has been such a success that many people just keep on going back to see more. Temporary exhibitions include major international shows. The new Tate Library and Archive (Tate Britain) opened in 2002. The Library holds some 120,000 contemporary exhibition catalogues and also covers Renaissance to today: the Archive collection of documents relates to British art since 1900 and the Tate's own records. Artists, organisations and societies have left their correspondence, manuscripts, diaries, photographs and press cuttings to the Tate. New Reading Rooms make research and scholarship easier now. Underground Southwark, Jubilee Line

Theatre Museum, 1E Tavistock Street,London WC2E 7PA. Telephone: 020 7836 7891. www.theatremuseum.ac.uk. Public entrance in Russell Street. Open Tuesday-Sunday 11-7pm. Closed Monday. Café and box office open 11-8pm, Sunday 11-7pm. Friends of the V&A free and children under 5. School parties also free.
With the transformation of Covent Garden's Flower Market the V&A's Theatre Museum was installed in this busy tourist area. Starting with a gift in1924 of Mrs Gabrielle Enthoven's collection of theatrical memorabilia, adding collections of the British Theatre museum and the proposed Museum of the Performing Arts, the final result became this fine museum in Covent Garden. There are two temporary galleries in honour of Sir John Gielgud and Sir Henry Irving. At the entrance the angel from the Gaiety Theatre at the Aldwych greets you. The lower foyer holds the painting collection, an Edwardian re-creation which acts as a foyer to the adjacent platform theatre, or performances and lunchtime lectures. There is also a café, shop, research facilities, studio theatre and rooms can be hired for receptions and conferences. Telephone 020 7938 8366. Underground Covent Garden.

Theatre Museum Angel from the Gaiety theatre.

Victoria and Albert Museum, Cromwell Road, South Kensington, London SW7. Telephone: 020 7942 2000. Recorded information 020 7942 2530. www.vam.ac.uk. Open daily 10-5.45pm, Wednesdays late and last Friday of the month until 10pm.

A new **Prints and Drawings Gallery** opened in 2005 with works by Freud, Sutherland, Nicholson, Hamilton Finlay, Paul Nash and others. The £75 million **Daniel Libeskind futuristic spiral** was agreed by Kensington and Chelsea council in late1998 but sadly will now not be built. In 2001 the renovated British galleries 1500-1900 re-opened, after a £31 million facelift. They tell the story of British Design from the Tudor period to the Victorian era

The Gamble Room, V&A Museum.

and include areas where visitors can try out gauntlets and clothes to try and experience those periods. On two floors the galleries are sumptuous and include the Great Bed of Ware, the Norfolk House Music Room, magnificent silks from Spitalfields, tapestries, paintings, Charles Rennie Mackintosh chairs and William Morris designs. The **Photography Gallery** is also very welcome. It includes early and recent photography in colour and black and white and holds regular temporary shows. A magnificent collection of decorative arts, including 7 acres to roam and admire jewellery, costumes, textiles, porcelain, armour, furniture, carpets, embroidery, musical instruments and much more. Interesting collection of prints and paintings by Constable, also

the famous Raphael Cartoons, English miniatures, Eastern art ranging from India to the art of Islam. The costume collection is fairly unique, ranging from Edward VII's hunting clothes to fashionable 1920s, 30s dresses by Schiaparelli, 50s by Chanel, 60s and 70s by Biba and Mary Quant and other interesting private gifts. Students of fashion and design can arrange to see specific items on request. The **Henry Cole Wing** houses the Frank Lloyd Wright room and the 20th-century galleries. The main wing has the Nehru Gallery of Indian art, the Samsung gallery of Korean art and other privately donated collections. At times the V&A seems like a fairytale princess, asleep for a hundred years; charming, but in need of some additional space to breathe. The **National Art Library, V&A Picture Library** and **Print Room** are all important services on offer to the public as well as lectures and there is also now a research and conservation of art centre. In 1998 the Photography gallery opened and the **Ironwork Galleries**, also the **Raphael Gallery** and the **Tsui Gallery of Chinese Art**. **The Silver Galleries** opened in 2000, the **British Galleries** in 2001, the Contemporary Galleries in 2003 and the **Architecture Gallery** in 2004, holding the RIBA and V&A collections. In 2005 a new **Portrait Miniatures Gallery** opened and in the summer the **Gardens** re-open after major works. All the more reason to visit this wonderful museum again and again. The restaurant is excellent and spacious and the shop has a selection of books, postcards, objets d'art and craft, also good children's toys. Underground South Kensington.

Wallace Collection, Manchester Square, London W1U 3BN. Telephone: 020 7563 9500. www.wallace-collection.com. Open Monday-Saturday, 10-5pm, Sunday, 12-5pm.
The house was built for the Duke of Manchester in 1776-88 and is set in a fine square behind Oxford Street. It is near Selfridges store and offers a peaceful break from busy Oxford Street for visitors. The collection includes French 18th century paintings by Fragonard, Watteau and Boucher, also Dutch paintings by Rembrandt, Van Dyck and Frans Hals' Laughing Cavalier. The clocks are exquisite and the furniture reflects the splendid lifestyle in which the owners must once have lived. The decorative arts include porcelain, French furniture, clocks, bronze sculpture, snuff-boxes, majolica, enamels, glass and silver. The house itself gives an idea of what life must have been like in this18th-century townhouse. The Wallace Centenary Project has given the ollection more space and a wonderful courtyard for the restaurant. The temporary exhibition spaces downstairs are used for small art exhibitions, usually of a very high standard and there are also

displays about 'boulle marquetry' for example or other interesting historical design details. Employees are very friendly. The Director of the collection is a very forward-looking lady and the collection has benefited from her ideas. Café Bagatelle is in the beautiful courtyard and open all day for coffee or lunch. Underground Bond Street.

Wellcome Historical Medical Museum, 183 Euston Road, London NW1. Telephone: 020 7611 8582. Open to the public, admission free. Part of the Wellcome Trust. Open Monday, Wednesday, Friday 9.45-5.15pm; Tuesday and Thursday 9.45-7.15pm. Saturday 9.45-1pm. Closed Bank Holidays.
Wide-ranging reference library of books, manuscripts, archives, paintings, prints from 1100BC to the present day, international in scope. In an elegant 1930s neoclassical building near Euston. Computer catalogue, videodisc and illustrated publications available. Useful resources for artists. Temporary exhibitions in History of Medicine Gallery.

Wesley's House, City Road, London EC1. Telephone: 020 7253 2262. Open daily 10-4pm. Free entry after 11am service. Open Sundays until 2pm. Closed Bank holidays. Adults £4, concessions £2, family £10.
The home of the famous Methodist preacher John Wesley from 1779-91. The chapel next door and the graveyard are also worth visiting and the famous Bunhill Fields across the road, where many famous London writers are buried; William Blake the artist was also buried here. Underground Old Street.

Westminster Treasures, Broad Sanctuary, London SW1. Telephone: 020 7222 5152. Open Monday-Saturday 10.30-4.30pm. Sunday (April-September) 10.30-4.30pm.
900 years of Abbey history are related in various plans, documents and costumes. Wax funeral effigies of various Kings and Queens and other famous historical figures such as Nelson. Combine a visit to the Abbey itself with the museum. Underground Westminster.

William Morris Gallery, Lloyd Park, Walthamstow, London E17. Telephone: 020 8527 3782. www.lbwf.gov.uk/wmg. Open Tuesday-Saturday 10-1, 2-5 and the first Sunday of each month, 10-1 and 2-5. Closed Mondays and Bank holidays.
William Morris, the Victorian artist/craftsman and writer lived here from 1848-56. Some of the many exquisite Morris designs can be seen here, also tiles and furniture. Work by contemporary Pre-Raphaelites such as Burne-Jones and Ford Maddox-Brown

can be seen. Worth visiting, especially after the V &A major exhibition in 1996. Gallery shop. The Changing Room Gallery nearby in Aveling Park shows work by contemporary artists and also sometimes related to William Morris. Underground Walthamstow Central, then a 15 minute walk.

Wimbledon Tennis Museum, The All-England Lawn Tennis Club, Church Road, Wimbledon, London SW19. Telephone: 020 8946 6131. Open Tuesday-Saturday 11-5, Sunday 2-5. Special opening times during Wimbledon fortnight (end June, beginning July). The development of lawn tennis with various items relating to the game; racquets, tennis fashion, atmosphere, films, documents about tennis photographs. Underground Southfields.

Whitechapel Art Gallery, Whitechapel High Street, London E.1. Telephone: 020 377 0107. www.whitechapelgallery.org.uk. Open Tuesday-Sunday 11-5, Wednesday -8. Closed Monday. A £10 million gallery development project includes new space in the adjoining library next door, an education and research centre as well as giving public access to its archives. This will be completed in 2007. The gallery celebrated its centenary in 2001, which gave the public a chance to re-assess the role that the Whitechapel gallery has played in London's contemporary art world. Bryan Robertson, Mark Glazebrook, Nicholas Serota, Catherine Lampert and now Iwona Blazwick have all been directors of this gallery and each has brought fresh ideas and some wonderful exhibitions. Helen Frankenthaler, Lucian Freud, Arshile Gorky, American, Australian, Russian, European artists have all been shown as well as contemporary British artists. Its advantage has been that it is free of government control, allowing a wider choice of work. Many artists live in the east end, so this gallery has a wide range of enlightening historical and contemporary exhibitions. The gallery organises open application shows occasionally. The East end houses some 30,000 artists! Good bookshop and a café. Underground Aldgate East.

Zandra Rhodes Fashion and Textile Museum, 83 Bermondsey Street London SE1 Telephone: 020 7403 0222. www.ftmlondon.org.
This museum opened in 2002 and is a showcase of permanent collections of influential modern British designers' work. They include Zandra Rhodes' collection of dresses among the 3000 pieces. Ossie Clark, Bill Gibb, Vivienne Westwood all have clothes on display. Zandra Rhodes herself is a legend in the London fashion world with her wonderful pink hair and her

amazing capacity for survival in the hard world of fashion. She dressed Bianca Jagger, Britt Ekland and Tina Chow in the 1970s and also made Princess Anne's white engagement dress as well as creating some of Lady Diana's wardrobe. In the early 1990s her company went into liquidation and she had to downsize. What she has decided to do by opening this enormous Bermondsey warehouse will be seen later as a very astute idea. Although the V&A museum has its costume section with limited space, this is the first modern fashion museum and students and the public alike love it. Underground Bermondsey

Many other museums have not been listed as they are either too specialised or just outside London. These include:

Battle of Britain
HMS Belfast
Bramah Tea and Coffe museum
Bruce Castle Museum
Chartered Insurance Institute Museum
Down House (home of Charles Darwin), Kent
Kew Bridge Engines
Kingsbury Watermill Museum
Martinware Pottery Collection, Southall
Mosquito Aircraft Museum, Herts.
Museum of the Royal Pharmaceutical Society
Museum of the Bargehouse
Old Operating Theatre
Osterley park
Ragged House Museum
Rotunda Museum
St Albans City Museum
Verulamium Museum
Vestry House Museum
Syon Park, Brentford
Ham House, Surrey
Osterley Park, Middlesex
Livesey Museum, London SE15
Marble Hill House, Twickenham
Museum of Fulham Palace
London Canal Museum
Wimbledon Windmill Museum

Yet to open:
Museum of Women's Art
Petrie Museum
Photography Museum
Nasser Khalili Museum

Art Galleries
Old Masters & Early 20th-century Art

This section is mainly for collectors, overseas dealers and people interested in prints, Old Master paintings and sculpture. Although many of these galleries vary in size and the kind of work they deal in, if you are interested in one particular area of art this list should help save time.

Many of these galleries are situated in St James's, London SW1, near Bond Street and Sotheby's, Bonhams and Christies auction rooms. The latter are worth visiting if at all interested in buying or selling art or just viewing to compare prices. Ring the galleries to check on opening hours if not listed.

St James's area is nearest to Green Park tube. Motcomb Street is near Knightsbridge. The Portobello Road area galleries, mainly Ledbury Road, are near Notting Hill Gate tube and walk down the hill towards Portobello Road. Many of these galleries do restoration work and framing. They also have an open week in July during **Master Drawings London week**. **www.master-drawingsinlondon.co.uk**. Private dealers also show at these galleries during this week. The British Antique Dealers' Association has details of other galleries and antique dealers in the UK. www.bada.org or enquiry@bada.demon.co.uk

Refer to main newspapers or Galleries magazine for exhibition listings.

Abbot and Holder, 30 Museum Street, London WC1A1LH. Telephone: 020 7637 3981. Open Monday-Saturday 9.30-6pm, Thursday -7pm.
Stock of over1000 pictures always on view. 19th and 20th century art. Underground Tottenham Court Road.

Ackermann and Johnson, 27 Lowndes Street, London SW1X 9HY. Telephone: 020 7235 6464. www.artnet.com/ackermann-johnson.html. E-mail: ackermann.johnson@btonternet.com. Open Monday-Friday 9-5pm, Saturday 10-12pm.
Sporting paintings. 18th-20th century British oil paintings and watercolours. Underground Knightsbridge.

Agnews, 43 Old Bond Street and 3 Albemarle Street, London W1S 4BA. Telephone 020 7629 6176. www.agnewsgallery.com. Open Monday-Friday 9.30-5.30pm,Thursday -6.30pm.
18th and 19th century prints and Old Master paintings, also

contemporary established British painters such as Bernard Dunstan. In the last few years Agnew's has branched out to show contemporary art including paintings and works by Jock McFadyen and Kate Whiteford. Underground Green Park.

Anthony Mould, 173 New Bond Street, London W.1. Telephone: 020 7491 4627. Open Monday-Friday 9.30-6pm. English portraits. Underground Bond Street.

Andrew Wyld, 160 New Bond Street, London W1S. www.andrewwyld.com Underground Green Park.

Archeus Fine Art, 3 Albemarle Street, London W.1. Telephone: 020 7499 9755. By appointment.
19th and 20th century paintings, prints and sculpture. Underground Green Park.

Artemis Fine Arts & C.G. Boerner, 15 Duke Street, St James's, London SW1Y 6DB. Telephone: 020 7930 8733. www.artemis-finearts.com. Open Monday-Friday 9.30-5.30pm.
Old master paintings, prints, drawings and watercolours. Impressionist paintings. Underground Green Park.

Axia, 21 Ledbury Road, London W11 2AQ. Telephone: 020 7727 9724. Open Monday-Friday 10.30-6pm.
East Christian and Islamic art. Underground Notting Hill Gate and walk down the hill.

Barnsbury Gallery, 24 Thornhill Road, London N1 1HW. Telephone: 020 7607 7121. Open Tuesday-Saturday 12-6pm.
Prints, maps, children's games and ephemera. Peepshows, panoramas and optical toys. Lassalle framing.

Baumkotter Gallery, 63A Kensington Church Street, London W.8. Telephone: 020 7937 5171. Open Monday-Friday 9.30-6pm.
17th-19th-century oil paintings. Restoration work available. Underground High Street Kensington.

Beaufort Gallery, 313 Kings Road, London SW3. Telephone: 020 7351 2077. Open Monday-Saturday 10-6pm.
19th and 20th-century English watercolours and drawings. Also limited edition prints.

Belgrave Gallery, 53 Englands Lane, London NW3. Telephone: 020 7722 5150. Open Monday-Friday 10-6pm.

Venus and Mars, Sandro Botticelli, National Gallery.

British Post-Impressionists and Moderns. 20th-century paintings, watercolours, prints and sculpture. Underground Belsize Park.

The Bloomsbury Workshop Ltd, 12 Galen Place, London WC1. Telephone: 020 7405 0632. Open Tuesday-Friday 9.30-5pm. Bloomsbury Group and Modern British.Paintings, drawings, prints, especially by Vanessa Bell and Duncan Grant. Also a stock of Bloomsbury Group books (first editions, secondhand and new). Underground Tottenham Court Road.

Bonhams, Auctioneers and Valuers since1793. 101 New Bond Street, London W1S1SR. Telephone: 020 7629 6602. Bonhams and Phillips merged and there are now four London salesrooms under the Bonhams name at Montpelier Street, Salem Road, Bayswater, New Bond Street and Lots Road, Chelsea. Underground Bond Street/Green Park.

Bonhams (previously Phillips), 10 Salem Road London W.2. Telephone: 020 7229 9090.
Textiles, clothes,memorabilia at reasonable prices. Underground Queensway/Bayswater.

Burlington Paintings, 10 Burlington Gardens, London W.1. Telephone: 020 7734 9984. Open Monday-Friday 9.30-5.30pm. Specialises in early 19th and early 20th-century oil paintings and watercolours. Underground Green Park.

Caelt Gallery, 182 Westbourne Grove London W.11. Telephone: 020 7229 9309.
Victorian paintings, landscape, marine, Arab horses and animals. Run by Edward Crawshaw. Underground Notting Hill Gate and walk down the hill.

Campbells of Walton Street, 164 Walton Street, London SW3. Telephone: 020 7584 9268. Open Monday-Friday 9.30-5.30pm, Saturday 9.30-1pm.
Post-Impressionist and Modern British oils and watercolours. Also a large selection of sporting prints. Trade and retail master framers; hand-finished, custom-made frames, restoration and gilding. Expert restoration of oils and watercolours. Underground South Kensington.

Chris Beetles, 8 & 10 Ryder Street, St James's, London SW1. Telephone: 020 7839 7551. Open daily 10-5.30pm.
England's largest stock of 19th and 20th-century British oils. Underground Green Park.

Christies, 8 King Street, St James's, London SW1. Telephone: 020 7839 9060. Open Monday-Friday 9-4.45pm.
Auctions and viewing daily of books, carpets, clocks, watches, porcelain, pictures, prints, sculpture, silver, stamps, wines. Free valuations of any work of art, given on the premises. Underground Green Park.

Colnaghi Gallery, 15 Old Bond Street, London W1S 4AX. Telephone: 020 7491 7408. Open Monday-Friday 9.30-6pm.
Old Master paintings, prints and drawings, also watercolours. Oriental department. 14th-19th-century art. Supplies many of the world's major museums. This is London's oldest art dealership but it was for sale and the previous director Jean-Luc Baroni set up his own gallery Jean-Luc Baroni Fine Art Ltd. Underground Green Park.

Collins and Hastie, 5 Park Walk, London SW10. Telephone: 020 7351 4292.
20th century and contemporary British and European paintings. Has also shown paintings by South American artists. Underground Fulham Broadway.

Connaught Brown, 2 Albemarle Street, London W1S 4HD. Telephone: 020 7408 0362. Open Monday-Friday 10-6pm, Saturday 10-12.30pm.
European Post-Impressionist, Modern British and contemporary paintings, drawings, watercolours and sculpture. Underground Green Park.

Cox and Company, 37 Duke Street, St James's, London SW1. Telephone: 020 7930 1987. Open Monday-Friday 10-5.30pm, Saturday by appointment.

19th and 20th-century paintings, watercolours and prints. English sporting and landscape paintings. Underground Green Park.

Christopher Mendez, Telephone: 020 7253 9699. By appointment. 16th-18th-century Old Master prints.

Daniel Katz Ltd, 59 Jermyn Street, London SW1. Telephone: 020 7493 0688. Open Monday-Friday 9-5.30pm.
European sculpture and works of art. Renaissance, 17th & 18th-century Old Master paintings. Underground Piccadilly.

Derek Johns, 12 Duke Street, St James's, London SW1 6BN. Telephone: 020 7839 7671/ 020 7274 7770. Open Monday-Friday 9.30-5.30pm.
Old Master paintings. Underground Green Park.

Didier Aaron, 21 Ryder Street, London SW1. Telephone: 020 7839 4716.
18th century French furniture,paintings. Old Master paintings and drawings. Participates in the Master Drawings London open galleries week in July. Underground Green Park.

Douwes Fine Art, 38 Duke Street, St James's, London SW1. Telephone: 020 7839 5795. Open Monday-Friday 9.30-5.30. Also in Amsterdam at 46 Rokin.
17th-century Dutch, Flemish and 19th-century French and Dutch paintings, drawings, prints and watercolours. Underground Green Park.

Duncan Campbell Fine Art, 15 Thackeray Street, Kensington Square, London W.8. Telephone: 020 7937 8665. Open Tuesday-Friday 11-6pm, Saturday 10-5pm.
19th and 20th-century paintings and watercolours. Duncan Grant, Cornelius Kuypers, Clement Quinton, Paul Mathieu, José de Zomora. Underground High Street Kensington.

Duncan Miller Fine Art, 17 Flask Walk, London NW3. Telephone: 020 7435 5462. Website: www.duncan-miller.com. Selection of British traditional and Impressionist paintings. Specialists in Scottish Colourist paintings and Scottish contemporary art now also. Underground Hampstead.

Duncan Miller Fine Art, 6 Bury Street, St James's, London SW1Y 6AB. Telephone: 020 7839 8806. Website: www.duncan-miller.com. Open Monday-Friday 11-6, Saturday 11-2. Sunday by appointment. Shows British and particularly Scottish artists. Larger gallery space than the Hampstead branch. Underground Green Park.

Eaton Gallery, 34 Duke Street, St James's, London SW1. Telephone: 020 7930 5950. Open Monday-Saturday 10-5.30pm and by appointment.
19th-century British and European paintings. Underground Green Park.

Editions Graphiques (Victor Arwas gallery), 3 Clifford Street, London W.1. Telephone: 020 7734 3944. Open Monday-Friday 10-6pm, Saturday10-1pm.
Art Deco, Art Nouveau fin de siecle prints, posters and paintings 1880-today. Underground Bond Street.

Eskenazi, 10 Clifford Street, London W1X 1RB. Telephone: 020 7493 5464. Open Monday-Friday 9.30-6pm.
Chinese and Japanese art. Underground Green Park or Bond Street.

Fine Art Society, 148 Bond Street, London W1S 2RL. Telephone: 020 7629 5116. Open Monday-Friday 9.30-5.30pm, Saturday 10-1pm.
19th and 20th-century British art. Emphasis also on Scottish paintings. Distinguished art dealers with a wealth of experience in the art world. Underground Bond Street.

Fleur de Lys Gallery, 227A Westbourne Grove, London W.11. Telephone: 020 7727 8595. Open Monday-Saturday 10.30-5pm. Decorative 19th century oil paintings. English, Dutch and European. Private, export and trade. Also English watercolours. Underground Notting Hill Gate and walk down the hill.

Frost and Reed Ltd, 2-4 King Street, St James's, London SW1Y 6QP. Telephone: 020 7839 4645. E-mail: frostandreed@btinternet.com. Open Monday-Friday 9-5.30pm. 19th and 20th-century English and French paintings. Underground Bond Street.

Galerie Besson, 15 Royal Arcade, 28 Old Bond Street, London W.1. Telephone: 020 7491 1706. Open Tuesday-Friday10-5.30pm. Modern pottery and Lucie Rie the great 20th-century potter. Underground Bond Street.

Gallery 19, 19 Kensington Court Place, London W.8. Telephone: 020 7937 7222. Open Sunday-Saturday 10-6pm. Original art and prints of Kensington. Underground Notting Hill Gate.

Garton & Co., exhibits at Pitcher/Brandt, 29 New Bond Street during Master Drawings London week in July. Deals privately otherwise.

Gavin Graham Gallery, 47 Ledbury Road, London W.11. Telephone: 020 7229 4848. Open Monday-Friday 10-6pm, Saturday 10-4pm.
17th-19th-century English and European oil paintings. Underground Notting Hill Gate and walk down the hill.

Green and Stone of Chelsea, 259 Kings Road, London SW3. Telephone: 020 7352 6521. Open Monday-Saturday 9-5.30pm.
19th century watercolours and drawings. Also fine art materials for sale. Underground Sloane Square and 19, 22 bus.

Hazlitt Gooden and Fox, 38 Bury Street, St James's, London SW1Y 6BB. Telephone: 020 7930 6422/6821.
French and English 19th-century paintings and drawings. Underground Green Park.

Historical Portraits Ltd (Philip Mould), 31 Dover Street London W1S 4ND. Telephone: 020 7499 6818
Old Master portraits. Philip Mould has appeared on television talking about the portraits. An expert on the subject. Underground Green Park.

Iona Antiques, PO Box 285, London W8 6HZ. Telephone: 020 7602 1193. By appointment only.
Largest selection of primitive 19th-century animal paintings in England.

James Hyman Fine Art, 6 Mason's yard, Duke Street, St James's London SW1Y 6BU. Telephone: 020 7839 3906. Fax: 020 7839 3907. Website: www.jameshymanfineart.com.
Modern and contemporary paintings, drawings and sculpture: Andrews, Auerbach, Epstein, Francis, Freud, Grosz, Hilton, Hume, Kossoff, LeBrun, Martin, Moore, Paolozzi, Riley, Roberts and Vaughan.

Japanese Gallery, 66 D Kensington Church Street, London W.8. Telephone: 020 7229 2934. E-mail: sales@japanesegallery.co.uk. Also at Camden Passage, London N.1. Open Monday-Saturday 10-6pm.
Japanese prints; Utamaro, Hiroshige, Toyokuni, Kunyoshi. Prints at reasonable prices from £20-£3000. Underground High Street Kensington.

Jean-Luc Baroni Ltd, 7-8 Mason's yard, Duke Street, London SW1Y 6BU. Telephone: 020 7930 5347. Open 10-6pm. Old Master paintings and drawings. Participates in Master Drawings London open galleries week in July. Underground Green Park.

John Bennett, 206 Walton Street, London SW3. Telephone: 020 7225 2223/4. Open Monday-Friday 10-6pm, Saturday 11-4pm. 17th and 19th-century paintings. Oils and watercolours. Prices from £200-£40,000. Underground South Kensington.

John Mitchell & Son, 160 New Bond Street, London W1S 2UE. Telephone: 020 7493 7567/020 7491 0820. Open Monday-Friday 11-5.30pm. Old Masters, 17th-century Dutch and Flemish, 18th-century English watercolours and paintings and French 19th-century. Underground Bond Street.

Johnny Van Haeften Gallery, 13 Duke Street, London SW1. Telephone: 020 7930 3062. Open Monday-Friday 10-5.30pm or by appointment. Dutch and Flemish 17th-century Old Master paintings. Underground Green Park.

Kufa Gallery, Westbourne Hall, 26 Westbourne Grove, London W.2. Telephone: 020 7229 1928. Open Tuesday-Saturday 10-5. Middle-Eastern arts; architecture, viusal arts, music and literature with changing traditional and contemporary art exhibitions. Underground Queensway.

Langton Street Gallery, 13 Langton Street, London SW10. Telephone: 020 7351 1973. Open Monday-Friday 11-7.30pm, Saturday 11-3pm. Late 19th-century English and French oils and watercolours. Good stock of original gilt and rosewood frames. Underground Fulham Broadway.

Lefevre Fine Art Ltd., 24 Bruton Street, London W1J 6QQ Telephone: 020 7493 2107. E-mail: office@lefevrefineart.com Open Monday-Friday 10-5,Saturday 10-1. The old Lefevre gallery closed and this has taken its place, run by Alexander and Desmond Corcoran, although past employee Martin Summers now deals (martins@ms-fineart.com) privately. Edward Burra and L.S. Lowry. 19th and 20th-century major European masters. Contemporary British artists. Underground Bond Street.

Lena Boyle, 20th Century Fine Art, 40 Drayton Gardens, London SW10 9SA. Telephone: 020 7373 8247. By appointment only. 20th century paintings and drawings.

Llewellyn Alexander (Fine Paintings) Ltd, 124-126 The Cut, Waterloo, London SE1. Telephone: 020 7620 1322. Open Monday-Friday 10-7.30pm, Saturday 2-7.30pm.
Director: Gillian Llewellyn Lloyd. British and early 20th-century, also contemporary British figurative and landscape painters. They also hold the annual alternative RA summer show exhibition. Underground Waterloo. Opposite the Old Vic Theatre.

Lucy B. Campbell, 123 Kensington Church Street, London W.8. Telephone: 020 7727 2205.
Watercolours, 17th-19th-century prints. Underground Notting Hill Gate.

MacConnal-Mason and Son Ltd, 14 Duke Street, St James's, London SW1. Telephone: 020 7839 7693/4. Open Monday-Friday 9.30-5.30pm, Saturday (Burlington) 9.30-1pm.
19th-century European paintings and contemporary British. Underground Green Park.

Manya Igel Fine Arts, 21-22 Peters Court, Porchester Road, London W.2. Telephone: 020 7229 1669/8429. By appointment only. 19th and 20th-century British oils and watercolours.

Maria Andipa's Icon Gallery, 162 Walton Street, London SW3. Telephone: 020 7589 2371. Open Monday-Friday 10.30-6pm. Greek, Russian, Serbian icons and Romanian 14th-19th century icons. 18th-century furniture. Underground Knightsbridge.

Martyn Gregory, 34 Bury Street, St James's, London SW1Y 6AU. Telephone: 020 7839 3731. e-mail:mgregory@dircon.co.uk. Open Monday-Friday 10-6pm.
Early English watercolours. Far East and Chinese paintings. Underground Green Park.

Mathaf Gallery, 24 Motcomb Street, London SW1. Telephone: 020 7235 0010. Open Monday-Friday 9.30-5.30pm.
Oriental paintings from the Middle East. Underground Knightsbridge.

Matthiesen Fine Art Ltd, 7-8 Masons Yard, Duke Street, London SW1. Telephone: 020 7930 2437. Open Monday-Friday 10-6pm. Late 19th and 20th-century prints and paintings. Italian, Spanish and French 13th-15th century paintings. Underground Green Park.

Medici Galleries, 7 Grafton Street, Bond Street, London W1S 3LQ. Telephone: 020 7495 2565 and 26 Thurloe Street, South Kensington. Telephone 020 7589 1363. Open Monday-Friday 10-5.30pm, Saturday 10-6pm (Thurloe St). British contemporary artists at Cork Street. Art books. Gallery now in Cork Street. Fine art publishers. Prints, old postcards and cards. Underground Bond Street and South Kensington.

Messum's, 40 Duke Street, St James's, London SW1Y 6DF. Telephone: 020 7839 5180.
Specialises in traditional and Impressionist paintings. The contemporary branch is at 8 Cork Street W.1. Telephone 020 7437 5545. Underground Green Park.

NR Omell, 6 Duke Street, St James's, London SW1. Telephone: 020 7839 6223. 18th and 19th-century paintings. Underground Green Park.

O'Shea Gallery, 120A Mount Street, London W1Y 5HB. Telephone: 020 7629 1122. E-mail: osheagallery@paston.co.uk Open Monday-Friday 9.30-6pm, Saturday 10-4pm.
Antiquarian maps, prints and atlases. Specialist dealers in 15th-19th-century maps, topographical, illustrated books. Framing and restoration. Underground Bond Street.

Paul Mason Gallery, 149 Sloane Street, London SW1. Telephone: 020 7730 3683. Open Monday-Friday 9-6.30pm, Wednesday 9-7pm, Saturday 9-1pm.
Specialist dealer in 18th and 19th-century marine, sporting and decorative paintings and prints. Restoration, conservation and framing. Underground Sloane Square.

Peter Nahum Ltd, (at the Leicester Galleries) 5 Ryder Street, London SW1. Telephone: 020 7930 6059. 18th-20th-century paintings, drawings and sculpture. Underground Green Park.

Parker Gallery, 28 Pimlico Road, London SW1. Telephone: 020 7730 6768. Open Monday-Friday 9.30-5.30pm.
Marine, military, sporting, topographical subjects. A large selection of 18th and 19th-century prints and oil paintings, some map and ship models. Underground Sloane Square.

Piano Nobile Fine Paintings, 26 Richmond Hill, Richmond. Telephone: 020 8940 2435. Open Tuesday-Saturday 10-6pm. Impressionist and Post-Impressionist British and continental oil paintings. Underground Richmond.

Portland Gallery, 9 Bury Street, St James's, London SW1.
Telephone: 020 7321 0422.
Scottish paintings 1880 to today. Underground Green Park.

Pruskin Gallery, 73 Kensington Church Street, London W.8.
Telephone: 020 7937 1994/73761285. Open Tuesday-Saturday
10-6pm and by appointment.
Art Nouveau, ArtDeco, post-war decorative arts. Underground
High Street Kensington.

Pyms Gallery, 9 Mount Street, London W1Y 5AD. Telephone:
020 7629 2020. www.pymsgallery.com. Open Monday-Friday
10-6pm.
British paintings and watercolours 1590-1930. Pre-Raphaelites.
Underground Bond Street.

Rafael Valls Gallery, 6 Ryder Street, St James's London SW1.
Telephone: 020 7289 4233. Open Monday-Friday 10-5.30pm,
Saturday by appointment.
Also at 11 Duke Street, St James's. Telephone 020 7930 1144.
www.rafalevalls.co.uk. e-mail: info@rafaelvalls.co.uk
Old Master paintings. 18th and 19th-century paintings. Dutch,
Flemish and Spanish schools. Underground Green Park.

The Three trees (1643), Rembrandt, British Museum print room.

Richard Day Ltd, 173 New Bond Street, London WIS 4RF. Telephone: 020 7629 2991. Open Monday-Friday 10-6pm. Participates in the Master Drawings London open galleries week in July. Underground Bond Street/Green Park.

Richard Green, 39 Dover Street, London W.1. Telephone: 020 7499 4738. Also 147 New Bond Street, 020 7493 3939 and 33 New Bond Street, 020 7499 5553. Open Monday-Friday 9.30-6pm, Saturday 10-12.30pm.
Fine Old Master paintings (33 New Bond Street) Impressionist, Post-Impressionist and Modern British, Sporting and Marine paintings (147 New Bond St). Victorian and European paintings (Dover Street). An important, major gallery in London. Turnover in 2003 was £95 million! (Business Ratio Report) Underground Green Park.

RMB Art, Stand 9, Alfie's Antique Market,13-25 Church Street, London NW8. Telephone: 020 7724 3437. Open Tuesday-Saturday 10.30-6pm. 18th-20th-century watercolours and drawings, also Modern British and contemporary art. Interest-free credit scheme.

Rossi & Rossi Ltd, 13 Old Bond Street, London W1S 4SX. Telephone: 020 7355 1804. E-mail: info@rossirossi.com
Tibetan and Eastern artefacts and paintings. Underground Green Park.

Royal Exchange Gallery, 7 Bury Street, St James's, London SW1Y 6AL. Telephone: 020 7839 4477. www.marinepictures.com. Open Monday-Thursday 10-6pm, Friday 10-5pm.
19th and early 20th-century watercolours and paintings of marine scenes.

Rupert Wace Ancient Art Ltd, 14 Old Bond Street, London W1S 4PP. Telephone: 020 7495 8495. www.pupertwace.co.uk. E-mail: info@rupertwace.co.uk
Sculptures from 3rd-1st century BC. Underghround Green Park.

Simon Dickinson, 58 Jermyn Street, London SW1Y 6LX. Telephone: 020 7499 0722. Open Monday-Friday 10-6pm.
Old Master drawings and paintings. Participates in the Old Master Drawings open galleries week in July. Underground Piccadilly.

Sladmore Gallery, 32 Bruton Place, London W.1. Telephone: 020 7499 0365. Open Monday-Friday 10-6pm,Saturday 10-1pm. Sporting paintings and prints. 19th and 20th-century sculpture. Underground Bond Street.

Sotheby's, 34-35 New Bond Street, London W1A 2AA. Telephone: 020 7293 5000. Open Monday-Friday 9-4.30pm. 24-hour recorded auction information Telephone 020 7293 5868. www.sothebys.com
Auctions held daily of antiquities, Asian art, paintings, drawings, watercolours, prints, Chinese, Japanese and Islamic works of art, 20th-century decorative arts, photographs, portrait miniatures, icons and Russian works of art, tribal art. Free advice and valuations, given on the premises. Underground Bond Street/Green Park.

Spink-Leger Pictures, 13 Old Bond Street, London W1X 4HU. Telephone: 020 7629 3538. Open Monday-Friday 9-5.30pm. British 17th to 20th Century paintings, drawings and watercolours. Old Master Drawings. Underground Green Park.

Stern Art Dealers, 46 Ledbury Road, London W.11. Telephone: 020 7229 6187. Open Monday-Saturday 10-6pm. 19th-century English and European oil paintings. Underground Notting Hill Gate and walk down the hill.

Stoppenbach & Delestre Ltd, 25 Cork Street, London W1S 3NB. Telephone: 020 7734 3534. Open Monday-Friday 10-6pm, Saturday 10-5pm.
Old Master paintings and drawings. Participates in the Master Drawings London open galleries week in July.
Underground Bond Street/Green Park.

Temple Gallery, 6 Clarendon Cross, London W.11. Telephone: 020 7727 3809. Open Monday-Friday 10-5pm.
Russian, Byzantine and Greek icons. Underground Holland Park.

The Taylor Gallery, 1 Bolney Gate, London SW7. Telephone: 020 7581 0253. Open Monday-Friday 10-5.30pm.
Specialists in English, Irish and American 19th and 20th-century paintings. Sir William Orpen, Sir Alfred Munnings, Stanhope Forbes, Roderic O'Connor, Jack B.Yeats.

20th Century Gallery, 821 Fulham Road, London SW6. Telephone: 020 7731 5888. Open Tuesday-Friday 10-6pm, Saturday 10-1pm.

The Vision of Saint Eustace, Pisanello, National Gallery.

Post-Impressionist and Modern British oils and watercolours. Underground Parsons Green.

The Greenwich Gallery, 9 Nevada Street, Greenwich. Telephone: 020 8305 1666. Open Monday-Saturday 10-5.30pm. 18th and 19th-century watercolurs and paintings. Also deals in Modern British paintings. Opposite the Greenwich Theatre. Rail Greenwich.

The Maas Gallery, 15A Clifford Street, London WS 4JZ. Telephone: 020 7734 2302/3272. Open Monday-Friday 10-5pm. 1800-1920 English paintings. Victorian artists and Pre-Raphaelites. Underground Green Park.

The Mark Gallery, 9 Porchester Place, London W2 2BS. Telephone: 020 7262 4906. www.antiquesportfolio.com. Open Monday-Friday 10-1pm and 2-6pm, Saturday 11-1pm.
Russian icons from the 16th-19th-century. Contemporary prints. Dalí, Chagall, Ecole de Paris prints. Underground Marble Arch.

The Totteridge Gallery, 61 Totteridge Lane, London N.20. Telephone: 020 8446 7896. Open Monday-Saturday 10.30-7pm. Continental British 19th and 20th-century paintings and water-colours. Russell Flint prints also on sale. Underground Totteridge and Whetstone.

Thomas Williams Fine Art Ltd, 22 Old Bond Street, London W1S 4PY. Telephone 020 7491 1485. Open 10-6pm.
Old Master drawings and paintings. Participates in master Drawings London open galleries week in July. Underground Green Park.

Trinity Fine Art Ltd, 29 Bruton Street, London W1J 6QP. Telephone: 020 7493 4916.
Old Master drawings and paintings. Participates in Master Drawings London open galleries week in July. Underground Bond Street.

Verner Amell, 4 Ryder Street, St James's, London SW1. Telephone: 020 7925 2759. Open Monday-Friday 10-5.30pm.
Old Master paintings. Underground Green Park.

Walpole Gallery, 38 Dover Street, London W.1. Telephone 020 7499 6626.
Old Masters gallery with splendid interior. Underground Green Park.

Waterhouse & Dodd, 26 Cork Street, London W1S 3ND. Telephone 020 7491 9293.
British and European paintings and watercolours 1850-1930. Includes paintings by Bastien-Lepage, Mucha, Edward Lear and others. Also deals in contemporary art now. Underground Bond Street.

Waterman Fine Art, 74A Jermyn Street, London SW1. Telephone 020 7839 5203. Open Monday-Friday 9-6pm, Saturday 10-4pm.
Modern British paintings. Underground Piccadilly.

Whitford Fine Art, 6 Duke Street, St James' s, London SW1. Telephone 020 7930 9332.
20th-century European paintings. Underground Green Park.

William Weston Gallery, 7 Royal Arcade, Albemarle Street, London W.1. Telephone 020 7493 0722. Open Monday-Friday 9.30-5pm, Saturday10.30.-1pm.
Etchings and lithographs from the 19th and 20th-century. Monthly catalogue available on subscription. Undergound Green Park.

Witch Ball, 2 Cecil Court, Charing Cross Road, London WC2. Telephone 020 7836 2922.
17th-19th-century engravings. Specialises in theatre, ballet and opera. Underground Charing Cross.

Jason Rhoades' Three Wheels Chandelier, Hauser & Wirth Gallery.

Galleries showing
20th Century & Contemporary Art

There are commercial galleries all over London, but some areas have attracted a large number of galleries such as the East end and Hoxton, Cork Street, Charlotte Street, where a variety of commercial galleries and restaurants exist side by side. Whereas Cork Street tends to exhibit established artists and 20th-century Master prints and paintings, areas such as the East end, where there are now many artist-run galleries and project spaces show multi media and experimental art; installations, Conceptual, Minimal, video and photography. The rise in the number of Art Fairs (**Frieze, Zoo, Melia, London, Fresh Art, Affordable, Art on Paper, Watercolours and Drawings**) has also seen a huge increase in interest in buying art and led to an increase in gallery numbers recently. London has become one of the major contemporary art capitals worldwide attracting international artists and collectors.

Damien Hirst's work, once seen as shocking, is now establishment and shown at the **White Cube Gallery** in Hoxton Square along with other YBAs (Young British artists) Tracey Emin, Sarah Lucas, Gavin Turk, Gary Hume, the Chapman brothers and Sam Taylor-Wood. **Hoxton** is the fashionable art area and many small galleries have moved there, or nearby; Standpoint in Coronet Street. Hales Gallery, Victoria Miro and others moved in the last few years. Flowers East moved from Richmond Road to new larger premises for both east end galleries at Kingsland Road, at the Shoreditch end, although Flowers Central remains in Cork Street. London has always been unconventional, eccentric and at the cutting edge of international art. **www.capri-art.org** gives details of all the more avant garde artist-run east end galleries and project spaces and how to find them.

The list below includes contemporary art galleries alphabetically and gallery-policy for artist-applications has been included as often as possible. Some galleries treat artists well and return work, others are notorious, so be prepared. It is best to visit the space first, also look at the website and essential to enclose a stamped addressed envelope when sending details and slides, although sending work by e-mail is quite common now. Check the gallery's website to see what kind of work they show before wasting time. Always check with the gallery first, before sending details blind. Be business-like. Some galleries prefer to be sent invitations to see your work at other galleries or at art project spaces.

For art buyers do read the interviews at the front, to gain some idea about first-time buying, or how to avoid making mistakes. Many galleries do sell work at the low end of the market as well as the top end. The interview with Ben Burdett of Atlas Gallery, photography dealer, gives an insight into buying photographs.

Galleries for hire include; **Air, Arndean, Artbank, Atrium, Bankside, Coningsby, Davies Street, Dundas Street, 54, Galery 47, Gallery in Cork Street and Gallery 27, Highgate, Lennox, Light Gallery, Mall galleries, Menier Chocolate Factory, Nine Clarendon Cross, 17 Ryder Street, Signatures, West-Eleven, Zizi.**

The art maps are at the front and the back of the guide.

Adam Gallery, 24 Cork Street, London W1S3NJ. Telephone: 020 7439 6633. www.adamgallery.com. E-mail info@adam gallery.com
Sells work by Francis Bacon, Alan Davie, Patrick Heron, Miro, Henry Moore, Paul Nash, Bridget Riley, Sean Scully, Andy Warhol and many other established artists. Underground Green Park or Bond Street.

Advanced Graphics London, 32 Long Lane, London SE1 4AY. Telephone: 020 7407 2055. Fax: 020 7407 2066. E-mail gallery@advancedgraphics.co.uk. www.advancedgraphics.co.uk Open Monday-Saturday 10-6pm.
Contemporary British artists; limited edition screenprints produced in their studio exclusively. Artists include: Craigie Aitchison, Basil Beattie, Neil Canning, Anthony Frost, Albert Irvin, Anita Klein, Matthew Radford, John Hoyland, Ray Richardson, Trevor Jones. Regular shows by gallery artists. Underground Borough

ACAVA (The Century Gallery), 1-15 Cremer Street, London E2 (off the south end of Kingsland Road). E-mail: people@fruit-de-mer.net. Website: www.fruit-de-mer.net Open Thursday, Friday, Saturday 11-6pm, or by appointment.
ACAVA runs studios too for some 300 artists.

A&D Gallery, 51 Chiltern Steet, London W1U 6LY. Telephone: 020 7486 0534. E-mail: A_Dgallery@mac.com. Open Monday-Saturday 10.30-7pm.
Contemporary artists. Has shown work by Derek Greenhalgh and Daryl Waller. Exhibited at London Art fair in the Art Projects section 2005. Underground Baker Street.

Africa Centre, 38 King Street, London WC2. Telephone: 020 7836 1973. Open Monday-Friday 10-5.30pm, Saturday 11-4pm. Exhibitions either by African artists or with themes related to Africa. Underground Covent Garden.

The Agency, 18 Charlotte Road, London EC2A 3PB. Telephone: 020 7729 6249. www.theagencygallery.co.uk. E-mail: info@theagencygallery.co.uk. Open Tuesday-Saturday 11-6pm, or by appointment.
A gallery interested in current trends in conceptual sculpture and installations. A programme of solo shows in a private space. Contact Bea de Souza and David Selden. Underground Old Street/Liverpool Street.

Agnew's, 43 Old Bond Street, London W1S 4BA. Telephone: 020 7629 9250. Fax 020 7629 4359. www.agnewsgallery.co.uk E-mail agnews@agnewsgallery.co.uk.
Open Monday-Friday 9.30-5.30pm, Thursday until 6.30pm.
Directors; Julian Agnew, Richard and Christopher Kingzett, Mark Robertson, Gabriel M. Naughton
Selection of 20th century British paintings, drawings, water-colours and prints by contemporary traditional artists such as Bernard Dunstan, John Wonnacott, Stephan Finer and Andrew Gadd. Also sells Old Master drawings. Established top London gallery. Has recently held contemporary art exhibitions of work by Jock McFadyen, Kate Whiteford and others. No applications considered. Underground Green Park.

Air Gallery, 32 Dover Street, London W.1. Telephone: 020 7409 1544. Open Thursday-Saturday 10-6pm.
Originally Davies and Tooth who have taken over this central gallery space. Contemporary art including paintings and draw-ings. They sell to corporate clients. Underground Green Park.

Alan Cristea Gallery, 31 Cork Street, London W.1X 2NU. Telephone: 020 7439 1866. Fax: 734 1549. Open Monday-Friday 10-5.30pm, Saturday 10-1pm. Director: Alan Cristea.
Alan Cristea purchased Waddington Graphics and the Alan Cristea gallery continues to publish prints by international artists, as well as deal in Master graphics and contemporary prints; Roy Lichtenstein, Mimmo Paladino, Howard Hodgkin, Jim Dine, Patrick Caulfield, Antoni Tapies, Joe Tilson, Mick Moon, David Hockney, Braque, Picasso, Matisse. The gallery holds excellent print shows, including an annual Matisse show, which is well worth visiting. Underground Bond Street/Green Park.

Stand at Frieze Art Fair.

Albemarle Gallery, 49 Albemarle Street, London W1S 4JR. Telephone: 020 7499 1616 Fax: 020 7499 1717. E-mail: alb-gall@aol.com. Website: www.albemarlegallery.com. Open Monday-Friday 10-6pm, Saturday 10-4pm.
Specialises in contemporary figurative, still life and trompe l'oeil work, together with urban and rural landscapes. On two floors in Mayfair. Holds 14 shows a year of work by UK, European and American established and emerging artists. Artists include Robbie Wraith, Maxwell Doig, Jeremy Barlow, Elena and Michel Gran, Roberto Bernardi amongst others.Underground Green Park

Albion Gallery, 8 Hester Road, London SW11 4AX. Telephone: 020 7801 2480. www.albion-gallery.com. E-mail: mhw@albion-gallery.com. Director: Michael Hue-Williams.
Norman Foster designed this wonderful new space in a shopping mall in Battersea. The space is ideal for large-scale experimental work in particular. Hue-Williams shows artists such as Andy Goldsworthy.

Alchemy Gallery, 157 Farringdon Road, London EC1R 3AD. Telephone: 020 7278 5666. Open Monday-Friday 9.30-6pm, Saturdays 10-4pm.
Contemporary British and European artists. Underground Farringdon.

Alison Jacques, 4 Clifford Street London W.1. Telephone: 020 7287 7675. Fax 020 7287 7574. www.alisonjacquesgalleryu.com. E-mail: info@alisonjacquesgallery.com. Open Tuesday-Friday, 10-6, Saturday, 11-5. Director: Alison Jacques.
Contemporary British and European contemporary art, including cutting-edge. Also shows photography occasionally such as the Robert Mapplethorpe show in 2005. Gallery artists include: Graham Little, the estate of Robert Mapplethorpe, Paul Morrison, Catherine Yass, Alessandro Raho, Jack Pierson. Underground Green Park/Bond Street.

Alternative Art Galleries, Top studio, Bethnal green Training Centre, Deal Street, Spitalfields, London E1S HZ. Telephone: 020 7375 0441. Fax: 7375 0484. Director; Maggie Pinhorn.
This organisation arranges a variety of exhibitions with support from London companies at venues around London. Artists can apply for exhibitions but ring first to check details. Ideal organisation for first-time exhibitors and artists recently out of art school. Artists invigilate their own shows, but they select the artists. Open 10-5 on Sundays, April-December each year. Up to 25 artists shown each week. Artists must apply with completed application form and slides/photos of their work. Alternative Arts selects each artist from their own 3-sided unit for exhibitions.Spitalfields has become quite an artists' area with studios and galleries near the old market. Underground Liverpool Street.

The Alton Gallery, 2A Suffolk Road, Barnes, London SW139TH. Telephone: 020 8748 0606.
Work by established young painters. 20th-century British art. Rail to Barnes.

Anderson O'Day Fine Art, 5 St Quintin Avenue, London W10 6NX. Telephone: 020 8969 8085. Fax: 020 8960 3641. Open by appointment only.

Prue O'Day once ran a lively contemporary art gallery in Portobello Road but now deals privately and curates cutting-edge shows either from her home or in other spaces, depending on the project. She has shown work by Tessa Robins and other contemporary British artists.

Andrew Mummery, Studio 1.04, Tea Building, 56 Shoreditch High Street, (entrance on Bethnal Green Rd), London E1 6JJ. Telephone: 020 7729 9399. E-mail: info@andrewmummery.com. www.andrewmummery.com. Open Wednesday-Saturday, 12-6pm or by appointment. Director: Andrew Mummery. Andrew Mummery had a good training working for the European Raab Gallery, before setting up on his own in 1996. International contemporary artists, including painting and sculpture, usually fairly cutting-edge.

Anne Berthoud, 4A Stanley Crescent, London W112NB. Telephone: 020 7229 8400. Fax: 020 7221 8185.
Anne Berthoud runs what she calls a "flying gallery", showing her artists regularly at different spaces. Artists include Stephen Buckley, Simon Lewty, Alison Turnbull, Michael Upton, Noel Forster and Robert Mason. She can be contacted by appointment.

Annely Juda Fine Art, 23 Dering Street, London W.1. Telephone: 020 7629 7578. Fax: 020 7491 2139. Open Monday-Friday, 10-6pm, Saturday, 10-1pm. Directors: Annely and David Juda, Ian Barker.
Professional artists may apply, but the gallery is fully committed for many years. Roger Ackling, Anthony Caro, Alan Charlton, Prunella Clough, Hamish Fulton, Yuko Shiraishi, Russian Constructivism, Christo, Eduardo Chillida, Al Held, David Hockney, Leon Kossoff, Edwina Leapman, Alan Green, David Nash, Alan Reynolds and other British and international established artists. Annely Juda is a very charming and well-respected dealer in the British art world. Staff are extremely courteous at this gallery. Now that Anthony D'Offay galleries have closed and Anthony Reynolds has moved, this quiet street has attracted new galleries. Underground Bond Street.

Anthony Reynolds, 60 Great Marlborough Street, London W.1. Telephone: 020 7729 9498. www.anthonyreynolds.com. E-mail: info@anthonyreynolds.com. Open Tuesday-Sunday 11-6pm. Director: Anthony Reynolds.
The gallery has 5 floors, 2 for gallery space, with exciting work by some of the best contemporary artists, especially recent conceptual and minimal art. Anthony Reynolds is a well-respected contemporary art dealer internationally. Underground Bond Street.

Anthony Wilkinson Gallery, 242 Cambridge Heath Road, London E2 9DA. Telephone: 020 8 980 2662. Fax: 020 8980 0028. Directors: Amanda and Anthony Wilkinson.
Contemporary art; Glen Baxter, Simon Callery, Edward Chell, Nicky Hirst, Dhruva Mistry, Mike Silva, Bob and Roberta Smith, Jessica Voorsanger.

The Approach, 1st floor, 47 Approach Road, London E2 9LY. Telephone: 020 8983 3878. Fax: 020 8983 3919.
Lively contemporary art by UK and international artists, usually reasonably established.

Archeus Fine Art, 3 Albemarle Street, London W1S 4HE, Telephone: 020 7499 9755. Fax: 020 7499 5964. E-mail: art@archeus.co.uk. Website: www.archeus.co.uk.
A well-established gallery which shows contemporary British artists and sells work by: Maurice Cockrill, Keith Coventry, Mary Fedden, Lucian Freud, Patrick Heron, Bridget Riley, Sean Scully. Also shows young British artists. Exhibits at the London Art fair. Underground Green Park.

Architectural Association, 34 Bedford Square, London WC1. Telephone: 020 7636 0974. Open Monday-Friday, 10-7pm, Saturday, 10-1.30pm.
Art and architectural exhibitions. Large gallery space. Bookshop and café. Underground Russell Square.

Arndean Gallery, 23 Cork Street, London W1S 3NJ. Telephone: 020 7589 7742. www.arndeangallery.com. E-mail: info@arndeangallery.com.
Gallery space that can be hired in Cork Street. Underground Green Park.

Art and Photographs, 13 Mason's Yard, St James's, London SW1. Telephone: 020 7321 0495 E-mail: info@artandphotographs.com. Website: www.artandphotographs.com
Deals in contemporary and historical photographs. Danny Newburg runs the prestigious Photo London fair annually at RA's Burlington gardens galleries. He also runs PLUK photo listings magazine and New Exhibitions of Contemporary Art. Underground Green Park.

Artangel, 31 Eyre Street Hill, London EC1R 5EW. Telephone: 020 7713 1400. E-mail: info@artangel.org.uk. www.artangel.org.uk Directors: James Lingwood/Michael Morris. Although not an actual gallery space, Artangel organises amazing, dynamic, site-

specific installations and video works all over London. Past artists have included Kutlug Altaman, Gregor Schneider, Mark Kidel, Douglas Gordon, Susan Hiller, David Toop, Jem Finer and a host of other artists over the years.

Artbank Gallery, 114 Clerkenwell Road, London EC1M 5SA. Telephone: 020 7608 3333 Fax: 020 7608 3060. E-mail: gallery@artbank.com. Website: www.artbank.com. Open Tuesday-Friday 11.30-6pm, Saturday 12-4pm. Directors: Ann Kathrin Durgé, Rick Goodale.
Shows contemporary artists including Gabriele Cappelli, Julia MacMillan, Rafal Olbinski, Jane Spencer, Mark Demsteader, Inna Kuligina. Gallery policy is for printed samples by mail first. Full details on the website. Underground Farringdon.

Art First, 1st floor, 9 Cork Street, London W1X 1PP. Telephone: 020 7734 0386. E-mail: artfirst@dircon.co.uk. Website: www.artfirst.co.uk. Open Monday-Wednesday, Friday 10-6, Thursday 10-8, Saturday 11-2. Directors: Geoffrey Bertram and Clare Stracey.
A friendly gallery with a range of gallery artists, both painters and sculptors covering Britain. Scottish artists include the late Wilhelmina Barns-Graham, Will Maclean and Barbara Rae. Other artists include Lino Mannocci, Clement McAleer, Eileen Cooper, Georgia Papageorge, Jack Milroy and Louis Maqhubela. Underground Bond Street/Green Park.

Art House, 213 South Lambeth Road, London SW8. Telephone: 020 7735 2192.
Monika Kinley runs the Outsider Archive based on the Outsiders exhibition, 1979, at the Hayward Gallery. Many interesting, unusual artists. By appointment only.

The Arthouse Gallery, 140 Lewisham Way, London SE14 6PD. Telephone: 020 8694 9011. www.arthouse.dircon.co.uk. E-mail: arthouse@dircon.co.uk. Open Wednesday-Sunday 12-6pm. Contemporary art exhibitions. Rail New Cross.

Artist Eye, 1st floor, 12 All Saints Road, London W11 1HH. Telephone: 020 7792 4077. expo@artisteye.com
Open Wednesday-Saturday 11-6pm.
Young emerging artists. Underground Ladbroke Grove or Notting Hill Gate and walk down the hill.

Artists Register, 110 Kingsgate Road, London NW6. Telephone: 020 7328 7878. Open Thursday-Sunday 2-6. Gallery within a studio context. Contact Stephen Williams. A selection panel meets every three months. Applications open to artists at any time of the year. Gallery walls 20x8 and 60x10. Contemporary artists. See Kingsgate Workshops also.

Art Lab, 7 East Vyner Street, London E2 9DG. Telephone: 020 8983 4568. E-mail jc@artlab.fsnet.co.uk
Art and science collaborations with assistance from technology institutions. Artists can apply but contact them first for details.

Arts Club, 40 Dover Street, London W.1. Telephone: 020 7499 8581. Open Monday-Friday 10-1, 3-6 for exhibition visitors. A private club that holds regular exhibitions mainly for members. Underground Green Park.

The Arts Gallery, 65 Davies Street, London W1. Telephone: 020 7514 8083. www.arts.ac.uk. Open Monday-Friday 10-8pm. Gallery within the context of the University of the Arts offices. Underground Bond Street.

Art Space Gallery, 84 St Peter's Street, London N1 8JS Telephone: 020 7359 7002. Open Tuesday-Saturday11-7pm and by appointment. Director: Michael Richardson.
Contemporary British art. Artists include; Ray Atkins, George Rowlett, Anthony Whishaw, Kevin O'Brien, Nigel Massey, John Kiki. Underground Angel.

Artsquare, 79 Fortis Green Road, London N10. Telephone: 020 8444 1717. www.artsquare.co.uk. Open Tuesday-Saturday 10-6pm. Local contemporary art gallery. Rail Muswell Hill.

Asia Contemporary Art, 49 Lambs Conduit Street, Bloomsbury, London WC1N 3NG. Telephone: 020 7611 5252. Fax: 020 7611 5253. E-mail: mail@asiacontemporaryart.com. Website: www.asiacontemporaryart.com.
Specialises in the promotion of a wide aspect of contemporary Asian art. It represents artists from mainland China, Taiwan, Korea, Japan, Thailand, Malaya and Singapore. Underground Tottenham Court Road

Association (AOP) Gallery, 81 Leonard Street, London EC2. Telephone: 020 7 608 1441. E-mail: general@aaophoto.co.uk . Website: www.aophoto.co.uk. Open usual gallery hours 9.30-6, Saturday 12-4.

A central photography gallery with a wide range of exhibitions of work on various themes or by groups of photographers, usually members of AOP. Underground Old Street.

Association of Illustrators Gallery, 1 Colville Place, off Charlotte Street, London. W.1.Telephone: 020 7739 6669. Open Monday-Friday 10-6pm.
The Association of Illustrators has its own gallery to act as a showcase for the work of its members. Applications open to appropriate illustrators. Members include artists such as Chloe Cheese, Sue Coe, David Gentleman, Sara Midda, Gerald Scarfe, Ronald Searle and many others. Worth a visit to see the wealth of illustration work being done in Britain today. Underground Goodge Street.

Atlas Gallery, 49 Dorset Street, London W1U 7NF. Telephone: 020 7224 4192. Open Monday-Friday 10-6pm, Saturday 12-5pm. www.atlasgallery.com. E-mail info@atlasgallery.com. Director: Ben Burdett. This gallery has expanded over the years from showing vintage travel photographs to works by Alvin Langdon Coburn, Leni Riefenstahl, Paul Strand, Imogen Cunningham and occasionally a contemporary photographer. Friendly, helpful assistants and prices are accessible for photogravures and prints. See interview at front of guide.

Atrium Gallery, Pricewaterhouse Coopers, 1 Embankment Place, London WC2N 6NN. Telephone: 020 7213 5983. www.dicksonrussell.com. Open Monday-Friday 10-5pm.
Art in a work context. Variety of shows from painting to photo installations. Underground Embankment/Charing Cross.

August Art, 31 Wenlock Rd, Islington, London N.1. Telephone: 020 7608 1252. www.augustart.co.uk. E-mail: info@august-art.co.uk
Shows work by recent lively artists. Exhibited in the Art Projects section of the London Art fair in 2005.

Austin Desmond Fine Art, 15A Bloomsbury Square, London WC1. Telephone: 0020 7242 4443. www.austindesmond.com. E-mail gallery@austindesmond.com. Open Monday-Friday 10.30-6.30pm. Director: John Austin.
This gallery is in a charming cul-de-sac, Pied Bull Yard (between Bury Street and Bloomsbury Street) with friendly local wine bar and other shops, near the British Museum. The gallery concentrates on dealing in contemporary artists, Modern British

and Irish art. Artists include Stephen Buckley, Prunella Clough, Timothy Hyman, Peter Archer. Worth a visit. Worth a visit. Accessible prices for small paintings, drawings and prints. Underground Tottenham Court Road/Holborn.

Avantgarde Gallery, 99 Boundary Road, London NW6 ORG. Telephone: 020 7624 7621. www.avantgardegallery.co.uk. E-mail: catherine@avantgardegallery.co.uk
Russian contemporary artists. Underground Maida Vale

BAC, Lavender Hill, London SW11.Telephone: 020 7223 6557/9. Open Wednesday-Friday, 5-9pm, Saturday/Sunday, 11-9pm.
Applications open to all artists and artists are often asked to show work by the Director. Run by an independent trust. Classes in drawing, pottery, photography. Theatre, cinema and café. The Battersea Art Fair is held here annually. Rail to Clapham Junction or 49 bus from South Kensington.

Baillie Gallery, 1A Copper Row, Tower Bridge Piazza, London SE1 2LH. www.bailliegallery.com. E-mail: enquiries@baillie-gallery.com. Open Wednesday-Sunday 12-6pm.
Recent contemporary art gallery near Gallery Different, Plateaux Gallery and McHardy Coombs by Shad Thames.

Bankside Gallery, 48 Hopton Street, Blackfriars, London SE1. Telephone: 020 7928 7521. Fax: 020 7928 2820. Open Tuesday-Saturday 1-5, Sunday occasionally 2-6.
Watercolours and prints. Home of the Royal Watercolour Society, Royal Society of Painter-Printmakers and the RWS Art Club. Mostly members only, exhibiting in regular exhibitions. Ideal place for conventional first-time buyers. Now in the heart of Bankside, near Tate Modern. Underground Blackfriars and walk over the bridge, or Southwark.

Barbara Behan Contemporary Art, 50 Moreton Street, London SW1V 2PB. Telephone: 020 7821 8793. Website: www.barbarabehan.com. Open Tuesday-Saturday 10-6pm. Barbara Behan is a specialist in Italian art, selling work from Futurism to Arte Povera. She also shows work by contemporary artists. Underground Pimlico.

Barbican Centre, Silk Street, London EC2. Telephone: 020 7638 4141 (administration) 020 7628 2326 (reservations and enquiries), 24-hour information: 020 7382 7272. Website:

Helen Chadwick exhibition, Barbican Art Gallery.

www.barbican.org.uk. Barbican Art Gallery (level 3) Telephone: 020 7638 4141 ext 306/346. Open Monday, Thursday-Saturday 10-6.45pm ,Tuesday 10-5.45pm,Wedneaday 10-7.45pm, Sundays, annual holidays 12-6.45. (gallery hours changeable). Sunday and Bank holidays, 12-6pm. Admission fee. Reduced admission fee after 5pm. Barbican Card £10 per annum means a 20% discount off full price tickets.

The arts centre has been much in the news over the years but John Tusa, its director provided stability to the centre. Opened in 1982 the centre houses the London Symphony Orchestra, Royal Shakespeare Company, Barbican Library, three cinemas, one major gallery on two levels, several exhibition spaces (Curve Gallery and there are smaller ones), the café, restaurant and coffee bar, a conservatory, conference centre and thousands of metres of corridor space to get lost in! There are many surprises including beautiful woodwork in the auditorium, a series of murals by Gillian Wise-Ciobotaru with mirrors and in pastel colours, on your way down to the cinemas. I have to admit to having rather a soft-spot for the centre, despite the crazy yellow lines to lead you to it. The fountains and lake are very relaxing after polluted, busy city streets and you can sit outside in summer and drink cappuccino enjoying the peace and quiet.

The gallery on level 3 has major exhibitions of historical interest, of photography or contemporary art. The Curve Gallery is often hired by galleries and artist-groups for large exhibitions and to reach a wider public. The space can be rented. Contact 020 7638 4141 ext 303 for details about the Curve Gallery or the foyer space. Exhibitors have to pay for any expenses and security costs. Excellent bookshops. Underground Barbican/Moorgate/ Liverpool Street.

108

Barrett Marsden Gallery, 17-18 Great Sutton Street, London EC1V ODN. Telephone: 020 7336 6396. Fax: 020 7336 6391. E-mail: info@bmgallery.co.uk. Open Tuesday-Friday 11-6, Saturday 11-4. Directors; Juliana Barrett,Tatjana Marsden, Nelson Woo. Contemporary ceramics, glass, metal, wood and furniture. Artists include; Gordon Baldwin, Alison Britton, Caroline Broadhead, Ken Eastman, Bryan Illsley, Maria van Kesteren, Robert Marsden, Steven Newell, Sara Radstone, Michael Rowe, Richard Slee, Martin Smith, Emma Wolfenden. Artists should visit the gallery then send slides and CV with an s.a.e.for their return.

Bartley Drey Gallery, (now Carlyle Gallery) 62 Old Church Street, London SW3 6DP. Telephone: 020 7352 8686 Fax: 020 7351 2921. Directors: Stephen Bartley, Catherine Toppenden. Contemporary British artists, mostly painters. Near the Chelsea Arts Club. Underground Sloane Square or buses 19,22

Basil Street Gallery, 8 Basil Street, Knightsbridge, London SW3 1AH. Telephone: 020 7385 3437. E-mail: info@basilstreet gallery.com. Website: www.basilstreetgallery.com. Open Thursday-Saturday, 11-5.30pm during shows only. Run by Laura Crofton-Atkins. Laura Crofton-Atkins scours art school graduate shows to find interesting painters, photographers and printmakers. Prices are very reasonable and she is friendly and helpful.

BBB Contemporary Art, 159 Kennington Lane, London SE11 4EZ. Telephone: 020 7735 2432. Fax: 020 7735 2627. E-mail: bbb@cwcom.net. Open Saturday, Sunday 12-6 or by appointment. Variety of contemporary artists and photographers. Underground Kennington

Beardsmore Gallery, 22-24 Prince of Wales Road, London NW5 3LG. Telephone: 020 7485 0923. www.beardsmore-gallery.com. E-mail: info@beardsmoregallery.com
Contemporary art gallery showing work by: Ian Brown, William Crozier, Michael Druks, Peter Feeth, Liam Hanley, Atta Kwami, Rebecca Salter, Sally Temple, Bob White, Lisa Wright. Shows at the London Art fair usually. Underground Kentish Town

Bearspace, 152 Deptford High Street, London SE8 3PQ. Telephone: 020 8691 2085. www.gallery.com. E-mail: bearspace @thebear.tv.
Exhibited in the Art Projects section at London Art fair in 2005. Contemporary space with unusual work.

Beaux Arts, 22 Cork Street, London W1S 3NA. Telephone: 20 7437 5799. Website: www.beauxartslondon.co.uk. E-mail: info@beauxartslondon.co.uk. Open Monday-Friday 10-5.30pm, Saturday 10-1.30pm. Director: Reg Singh.
Contemporary British paintings and drawings: John Bellany, Graham Crowley, Kathryn Faulkner, John Hoyland, Marilene Oliver, Terry Frost, Roger Hilton, Joe Tilson, Jonathan Leaman, Donna MacLean. Underground Bond Street/Green Park.

Bedford Hill Gallery, 202 Great Suffolk Street, London SE1. Telephone: 020 7403 4190.
The London Group of artists has shown here. Contemporary British painting. Underground Borough.

Ben Brown Fine Art, First floor, 21 Cork Street, London W1S 3LZ. Telephone: 020 7734 8858. www.benbrownfineart.com E-mail: info@benbrownfineart.com.
Contemporary art gallery showing Candida Hofer, Bernd & hilla Becher, Thomas Spruth, Thomas Ruff, Shirin Neshat, Sugimoto and Andreas Gursky. Underground Bond Street

Ben Uri Gallery, 108a Boundary Road, London NW8. Telephone: 020 7604 3992. Fax: 020 7604 3992 www.benuri.co.uk. E-mail: info@benuri.org.uk. Open Monday-Thursday 10-5.30pm, Friday 10-3pm, Sunday 12-4pm.
The London Jewish Museum of Art re-opened at its new gallery after six years in transit from its old home in Dean Street! They hold exhibitions of work by major Jewish artists.

Bernard Jacobson Gallery, 6 Cork Street,London W1X 1RF. Telephone: 020 7734 3431. Open Monday-Friday 10-6pm, Saturday, 11-4pm. www.jacobsongallery.com. E-mail: mailprints @jacobsongallery.com. Director: Bernard Jacobson.
20th-century British and American painting and sculpture. Artists include: Bomberg, Hitchens, King, Lanyon, Nicholson, Rauschenberg, Spencer, Stella, Sprawson, Sutherland, Tillyer, Vaux. Underground Bond Street/Green Park.

The Black Art Gallery, 225 Seven Sisters Road, Finsbury Park, London N.4. Telephone: 020 7263 1918. Open Tuesday-Thursday, 11-7pm, Friday, 11-9pm, Saturday, 11-7pm, Sunday, 2-7.pm. Director: Shakka Dedi.
Work by artists from Africa, Americas, Caribbean, Britain and Europe. All media exhibited. Groups or individuals should write for application details. Underground Finsbury Park.

Blackheath Gallery, 34 Tranquil Vale, London SE3. Telephone: 020 8852 1802. Open Monday-Saturday, 10-6 (closed Thursday). Contact: JV Corless.
Local gallery showing contemporary prints,paintings and sculpture. Participates in the local Lewisham Visual arts festivals.

Bloomberg Space, 50 Finsbury Square, London EC2A1HD. Telephone: 020 7330 7959. E-mail: gallery@bloomberg.net.
A huge space in the Bloomberg offices designed by Norman Foster, opened in 2002. A public art space with very contemporary art complementing their sponsorship programme recently. The new project is run by artist Graham Gussin, Stephen Hepworth former Jerwood Space curator, writer and curator Sacha Craddock. Underground Liverpool Street/Moorgate.

Bloomsbury Galleries, University of London Institute of Education, 70 Bedford Way, London EC1. Open Monday-Friday, 9.30-8pm, Saturday 9.30-12pm.
Recent work by contemporary artists. Underground Russell Square.

The Bloomsbury Workshop Ltd, 12 Galen Place, London WC1. Telephone: 020 7405 0632. Open Tuesday-Friday 9.30-5. Bloomsbury Group and Modern British art. Paintings, drawings and prints by Vanessa Bell and Duncan Grant. Also stock of Bloomsbury Group books (first editions, secondhand and new). Underground Tottenham Court Road.

The Blue Gallery, 15 Great Sutton Street, London EC1V OBX. Telephone: 020 7490 3833. Fax: 020 7490 5749. www.thebluegallery.co.uk. E-mail: info@thebluegallery.co.uk. Open Monday-Friday, 10-6pm, Saturday, 11-3pm. Contact Giles Baker-Smith or Philip Godsal.
Lively contemporary art gallery showing contemporary British art, often cutting edge. Artists include: Emily Allchurch, Veronica Bailey, John Carter, Mark Curtis, Sean Fairman, Helen Kincaid, Oliver Marsden, Nina Murdoch, Paul Riley, Valentin Valhonrat. Underground Farringdon/Barbican.

Bonhams, Auctioneers and valuers, 101 New Bond Street, London W1S 1SR. Telephone: 020 7629 6602. Open Monday-Friday 830-5pm.
Major auction house, often with paintings on show at viewings before they are sold. Bonhams merged with Phillips and there are now 4 salesrooms under the Bonhams name at Bayswater, Lots Road and Bond Street as well as Knightsbridge. Underground Bond Street.

Bookworks, 19 Holywell Row, London EC2A 4JB. Telephone: 020 7247 2536. E-mail: mail@bookworks.org.uk. Website: www.bookworks.org.uk.

Artists' book publishers mainly. They also organise contemporary artists' book exhibitions at other venues, mainly museums and galleries.

Boundary Gallery, 98 Boundary Road, London NW8 ORH. Telephone: 020 7624 1126. Fax: 020 7681 7663. E-mail: boundary@agikatz.demon.co.uk. Website: www.boundary gallery.com. Open Wednesday-Saturday 11-6pm. Director: Agi Katz

Near the Saatchi collection in NW8. Holds lively painting exhibitions of both historical and contemporary interest. Modern British (1910-60); Jacob Epstein, Jacob Kramer, Bernard Meninsky, Mark Gertler, David Bomberg, Alfred Wolmark, Morris Kestelman. Contemporary figurative Colourists. Josef Herman (retrospective 2004), Sonia Lawson (November 2002), Albert Louden, Peter Prendergast, June Redfern, Maria Pacheco, Anita Klein (October 2002), David Breuer-Weil (January 2003) Artists can apply. Underground St Johns Wood.

Bow Arts Trust, (seeThe Nunnery also) 183 Bow Road, London E3 2SL. Telephone: 020 8983 9737. Fax: 020 8980 7770.

An alternative space showing installations and events. Now called The Nunnery with a variety of curated shows.

Broadbent Gallery, 25 Chepstow Corner, Chepstow Place, London W2 4XE. Telephone: 020 7229 8811. Fax: 020 7229 8853. E-mail: info@broadbentgallery.com. Website: www.broadbent gallery.com. Open Tuesday-Saturday 11-6. Director: Angus Broadbent.

Interested in painting, sculpture, prints, contemporary art. Modern Masters and gallery arists. Shows regularly: Frank Bowling, Sam Francis, Alan Davie, Peter Griffin, Sally Heywood, Ingrid Kerma, Kate Palmer, Willard Boepple, Sally Heywood, Pierre Imhof. Underground Notting Hill gate. Buses 7, 23, 27, 28, 31, 70.

Browse and Darby, 19 Cork Street, London W1S 3LP. Telephone: 020 7734 7984/5. www.browseanddarby.co.uk. E-mail: art@browseanddarby.co.uk. Open Monday-Friday, 10-5.30pm, Thursday 10-8pm, Saturday 10.30-1pm.

British and French drawings. Late 20th-century paintings and sculpture. Contemporary English artists include Anthony Eyton, Christopher Bramham, Lucian Freud, Euan Uglow and Patrick George. Underground Green Park/Bond Street.

The Bruton Street Gallery, 28 Bruton Street, London W.1. Telephone: 020 7499 9747. Open Mon-Friday 10-6, Saturday 10-2. Variety of exhibitions throughout the year. Contemporary art as well as 20th-century art. Underground Bond Street/Green Park.

The Building Centre Gallery, 26 Store Street, London WC1. Telephone: 020 7637 1022. Open Mon-Friday 10-5, Saturday 10-1. Architectural and sculpture exhibitions. Underground Goodge Street.

Cab Gallery, outside A22 Gallery, 22 Laystall Street, London EC1. Telephone: 020 8203 4423 or 020 8968 4446. Website: www.cabgallery.com. Jason Brown runs his gallery in his black cab. All media are shown and he has shown paintings by Susie Hamilton, Donald Smith photographs and Simon Wood's list of dead Londoners! Artists' books, cassettes have also been included but nothing is for sale. A novel idea!

Cabinet, Apt 6, 49-59 Old Street, London EC1V 9HX. Telephone: 020 7251 6114. art@cabinetltd.demon.co.uk. Contact: Martin McGeown and Andrew Wheatley. Contemporary art by Tariq Alvi, Bonnie Camplin, Gillian Carnegie, Enrico David, Lucy McKenzie, Lily von der Stokker. Underground Old Street.

Cable Street Gallery, 566 Cable Street, London E.1. Telephone: 020 7790 1309. Open Thursday-Sunday 12-5pm. Cable street studios are based here and the gallery is in a studio setting. Cable street was once famous as the site of a battle between locals (often immigrants, including Jewish Londoners) and Mosleyite fascists in the 1930s. A nastier past than is the case at present, where artists work in peace. Underground Tower Hill.

Cadogan Contemporary Art, 108 Draycott Avenue, London SW3. Telephone: 020 7581 5451. Fax: 020 7589 3222. www.artcad.co.uk. E-mail: alight@artcad.co.uk. Open Monday-Saturday 10-6pm. Director: Christopher Burness. Colourful exhibitions of work by young professional artists both British and international,usually less well-known. Underground South Kensington.

Café Gallery Projects, Southwark Park, London SE16 2UA. Telephone: 020 7237 2170/1230. Open Wednesday-Sunday 10-4pm. Contact: Ron Henocq. Run by the Bermondsey Artists' Group, an active group of professional artists who live and work in the area. Contemporary painting and sculpture. They run an annual open exhibition for

members of the group. Worth joining if you live near the area. Underground Surrey Quays.

Camden Arts Centre, Arkwright Road, London NW3. Telephone: 020 7435 2643/5224. E-mail: info@camdenarts. org.uk. Open Monday-Sunday 11-6pm, Friday 11-8pm, Sunday 2-6pm. Director: Jenni Lomax.
A lottery grant of £204,750 has enabled the Centre to design and renovate the building which will be completed in 2003. Contemporary art centre showing major contemporary shows of art, photography, sculpture and installations. Two large galleries. Garden space used for sculpture shows. Art classes. Underground Finchley Road.

Carlyle Gallery, 62 Old Church Street, London SW3. Telephone: 020 7352 8686. Open Tuesday-Saturday, 11-6.30pm. Directors: Stephen Bartley, Catherine Toppenden
Small gallery off the Kings Road. Exhibitions every 2/3 weeks by a variety of artists. Friendly gallery owners. Near the Chelsea Arts Club. Underground Sloane Square and then bus.

Cass Sculpture Foundation, 3 & 4 Percy Street, London W1T 1DF. Telephone: 020 7637 0129. www.sculpture.org.uk. E-mail: info@sculpture.org.uk. Open Tuesday-Saturday, 11-6pm.
Variety of sculptures on show from this well-known sculpture foundation. Sculptures are also shown at Goodwood in West Sussex. Its aim is to advance the enjoyment of 21st century British sculpture. Near Charlotte street galleries and restaurants. Underground Tottenham Court Road/Goodge Street.

Catto Gallery, 100 Heath Street, London NW3. Telephone: 020 7435 6660. Open Tuesday-Saturday, 10-6pm, Sunday, 2.30-6pm. Director: Mrs Catto.
Contemporary figurative paintings. Open to applications from figurative professional artists. Underground Hampstead.

Cecilia Colman, 67 St Johns Wood, High Street, London NW8. Telephone: 020 7722 0686. Open weekdays 10-6pm, Saturdays 10-6pm.
Contemporary quality craft, jewellery, ceramics and prints. Work by top jewellery names and magnificent ceramics on display. Underground St Johns Wood.

Cell Project Space, 258 Cambridge Heath Road, London E2 9DA. Telephone: 020 7241 3600. www.cell.org.uk. E-mail: info@cell.org.uk

114

An artist-run space set up in 2001, run by Richard Priestley and Milika Muritu who supported many studios in the east end. They have worked with over 400 artists including Bob & Roberta Smith, Jessica Voorsanger, Grayson Perry, Reza Aramesh and many others.

thecentralhouse, Unit 12.1, 29 Fashion Street, London E1 6PX. Telephone: 020 7247 7552. www.thecentralhouse.com. E-mail: info@thecentralhouse.com
Exhibited at the Art Projects section, London Art fair in 2005. Lively cutting-edge space.

Central Space Gallery, 23-29 Faroe Road, London W14 OEL. Gallery within a studio complex.

Centre of Attention, 67 Clapton Common, London E5 9AA. Telephone: 020 8880 5507. www.thecentreofattention.org. E-mail: pierre@thecentreofattention.org. Contact: Pierre Coinde and Gary O'Dwyer.
Experimental contemporary art gallery, non-profit. No fixed premises although many shows have taken place at 15 Cotton gardens. Others are shown across London.

Century Gallery, 1-15 Cremer Street, London E2 8HD. Since 1977 innovative, experimental work has been shown here by artists such as Stuart Brisley, Tina Keane and Charlie Hooker. Performance art, site-specific work, digital art and installations. Ruin by ACAVA Studio complex.

Chapman Fine Arts, 39 Fashion Street, London E1. Telephone: 020 7247 6914. Open Thursday-Saturday 10-5 or by appointment. Contemporary art gallery in London's east end.

Chinese Contemporary, 21 Dering Street, London W1R 9AA. Telephone: 020 7499 8898. E-mail: ccartuk@aol.com. Open Monday-Friday 10-6pm, Saturday 10-4pm.
If at all interested in Chinese contemporary art this gallery and Asia Contemporary art are the places to visit. Large space, usually colourful paintings. Underground Bond Street.

Chisenhale Gallery, 64 Chisenhale Road, Bow, London E.3.5QZ. Telephone: 020 8981 4518. Fax: 020 8980 7169. Open Wednesday-Sunday 1-6pm.
Excellent shows by avant-garde up-and-coming contemporary artists, some even Turner-Prize winners or short-listed artists.

Consistently good exhibitions at this venue with top curators and cutting-edge work. Artists should not apply except for the annual exhibition New Work UK (applications in March). Underground Mile end/Bethnal Green.

The Church Gallery, Church of the Annunciation, 34 Bryanston Street, London W.1.
The gallery holds regular exhibitions of paintings, graphics by known and not so well-known artists. Framing and restoration service also available.

Clapham Art Gallery, Unit 02, 40-48 Bromells Road, London SW4 OBG. Telephone: 020 7720 0955. www.claphamart-gallery.com.
A lively contemporary art gallery based in Clapham. Rail Clapham Junction.

Clarges Gallery, 158 Walton Street, London SW3. Telephone: 020 7584 3022. Open Monday-Friday 10.30-5.30pm, Saturdays 10.30-1pm.
Paintings and watercolours by British artists. Fairly conventional. Underground Knightsbridge

Coleman Project Space, 94 Webster Road, Bermondsey London SE16 4DF. Telephone: 020 7237 9120. E-mail: infocoleman@yahoo.co.uk.
Organises site-specific works and contemporary art projects in this Bermondsey space. Underground Bermondsey.

Collyer-Bristow, 4 Bedford Row, London WC1R 4DF. Telephone: 020 7242 7363. By appointment Monday-Friday, 9-5pm.
Russian contemporary art. Underground Holborn.

Colville Place Gallery, 1 Colville Place, London W1P 1HN. Telephone: 020 7436 1330. Fax: 020 7436 1339. E-mail: kwatson@romanesque.source.co.uk.
This gallery is for hire. Contact Keith Watson by e-mail and send a photograph of your work or send graphic slides. The artist covers the cost of overheads, marketing and poster, invitation. Prices from £50 to £500.

Coningsby Gallery, 30 Tottenham Street, London W1 9PW. Telephone: 020 7636 7475. Fax: 020 7580 7017. Open 10-5.30.
Director: Andrew Coningsby. Contemporary art, photography and illustration. Artists can call or send in work but must not turn

up on the gallery doorstep. Artists include: Rubin Hazelwood, Paul Slater, David Downton, Steve Geary and many others. Underground Tottenham Court Road.

Connaught Brown, 2 Albemarle Street, London W.1. Telephone: 020 7408 0362. Open Monday-Friday, 10-6pm, Saturday 10-12.30pm.
Recent contemporary British art and European Post-Impressionism. Underground Green Park.

Contemporary Applied Arts, 2 Percy Street, London W.1. Telephone: 020 7436 2344. Director: Mary La Trobe Bateman.
Contemporary applied arts including the best of British glass, ceramics, silversmithing, and furniture. This organisation started 57 years ago as the Crafts Centre of Great Britain in 1948 in Mayfair. It moved to Covent Garden in the mid sixties and in the mid 90s to its current home. Underground Tottenham Court Road.

Corvi-Mora, 1a Kempsford Road, London SE11 4NU. Telephone: 020 7840 9111. E-mail: info@corvi-mora.com www.corvi-mora.com. Contact: Tommaso Corvi-Mora, Tabetha Langton-Lockton.
Contemporary artists: Andy Collins, Rachel Fernstein, Dee Ferris, Liam Gillick, Aisha Khalid, Jason Meadows, Tomoaki Suzuki and many others. Exhibits at Frieze Art fair in October.

Corridor Gallery, 136A Fortess Road, London NW5 2HP. Telephone: 020 7267 1500. www.corridor.eu.com E-mail: info@corridor.eu.com.
Artists who have shown there include: Ann Carrington, Leila Fahri, Kathryn Faulkner, David Fawcett, Caroline Leaf, Anthony Meyer, Bridget Orlando, Lucinda Ostreicher, Heather Reiod, Teresa Toms, Julian Villarrubi. Underground Tufnell Park.

Counter Gallery, 44A Charlotte Road, London EC2A 3PD. Telephone: 020 7684 8888. www.countergallery.com. E-mail: info@countergallery.com. Contact: Carl Freedman, Jo Stella-Sawicka. Gallery artist include; Armando Andrade Tudela, Michael Fullerton, Simon Martin, Peter Peri, Lucy Skaer, Fergal Stapleton. Exhibits at Frieze Art fair in October. Counter Editions is a web-based company.

Crafts Council Gallery, 44A Pentonville Road, London N.1. Telephone: 020 7278 7700. Website: www.craftscouncil.org.uk Open Tuesday-Saturday, 11-6pm, Sunday, 2-6pm. Closed Mondays. Contemporary quality British crafts and sometimes major inter-

national shows, but always lively. There are now two galleries and enlarged space within the Crafts Council, a slide library of some 20,000 slides, an Index of Selected Makers which is a register of 460 craftspeople in Britain arranged by area and kind of craft, a bookstall for magazines, postcards and craft books and a coffee bar. There is also an information centre for all craft queries about materials, courses, training, grants, galleries and assistance for conservation and commissions. Crafts Council exhibitions are toured nationally on many occasions. Underground Angel.

Crafts Council Shop at the Victoria and Albert Museum, 123 Cromwell Road, London SW7. Telephone: 020 7589 5070. Open Monday-Saturday, 10-5.30pm, Sunday, 2.30-5.30pm. Magnificent showcase for the best of British crafts. Underground South Kensington.

Conductors Hallway, 301 Camberwell New Road, London SE5 OTF. Telephone: 020 7274 7474. Fax: 020 7274 1744. They do invite submissions from fine artists/video/photographers. Contemporary art. 36 Bus from Victoria.

Contemporary Ceramics, Marshall Street, London W.1 Telephone: 020 7437 7605. www.cranekalman.com. E-mail: ckg.ltd@virgin.net. Open Monday-Friday, 10-5.30pm, Saturday, 10.30-5pm.
Craftsmen and women can apply. Selection committee meets 4 times a year. UK crafts mainly. Also a craft shop for reasonably priced work. Underground Oxford Circus.

Crane Kalman Gallery, 178 Brompton Road, London SW3 1HQ. Telephone: 020 7584 7566. Open Monday-Friday, 10-6pm, Saturday, 10-4pm. Directors: Andras and Andrew Kalman.
Another friendly, family-run gallery, established for many years. 20th-century established British, American and French artists. Regular colourful exhibitions. Also shows work by contemporary artists Jenny Franklin, Nicholas Jones and Jonathan Huxley. Participates in the 20th century Art Fair, London Art Fair, and other British art fairs. Underground Knightsbridge.

The Crest Gallery, Dollisfield Library, Totteridge Lane, London N.20. Telephone: 020 8361 9648. Open library hours.
Contemporary art shown in a library context with the support of Bartnet Borough Arts Council. Open to local artists to apply. Underground Totteridge and Whetstone.

Cubitt Gallery, 8 Angel Mews, London N1. Telephone: 020 7278 8226. www.cubittartists.org.uk. Open Wednesday-Saturday, 12-6pm.
Contemporary art. Underground Angel.

Curwen Gallery, 4 Windmill Street, off Charlotte Street, London W1P 1HF. Telephone: 020 7636 1459. Fax: 020 7436 3059. Open Monday-Friday 10-6pm, Saturday 11-5pm. Directors: John and Jill Hutchings.
Founded 1965. Monthly exhibitions of contemporary British art. Specialises in abstract and semi-abstract paintings, constructions and works on paper. Artists include: Paul Ryan, Thirza Kotzen, Yuji Oki, Glynn Boyd Harte, Kieron Farrow. Contemporary prints, painting, sculpture. Undergound Goodge Street.

The Cynthia Corbett Gallery, 15 Claremont Lodge, 15 The Downs, Wimbledon, London SW20 8UA. Telephone: 020 8947 6782. www.thecynthiacorbettgallery.com. E-mail: info@thecynthiacorbettgallery.com.
Contemporary art gallery showing: Andrew Burgess, Marco Crivello, Yvone de Rosa, Olivier Legrand, Phillippe Vasseur, Melanie Essex, Paul Ettedgui, Ghislaine Howard, Lev Vykopal, Gaby Wagner, Colin Wiggins and many others. Exhibits at the London Art fair annually. Underground Wimbledon.

Danielle Arnaud, 123 Kennington Rd, London SE11 6SF. Telephone:/Fax: 020 7735 8292. Open Friday, Saturday, Sunday 2-6pm, or by appointment. Director: Danielle Arnaud.
Young international artists showing painting, drawings,video and photography. Artists include: Effie Paleologou, Glauca Cerveira, Sophie Horton, Oona Grimes, Helen Maurer, Simon Granger, Georgie Hopton, Kirai Lau, Gerry Smith, Sarah Woodfine (drawings), David Bate, Amy Eshoo, Susan Morris, Marie-France and Patricia Martin (all photographers or video artists). The gallery is in a large Georgian house. Underground Kennington

Dash Gallery, Jack Dash House, 2 Lawn House Close, Marsh Wall, London E14. Telephone: 020 7247 9037. Open Monday-Friday 10-5.30pm.
Many local east end professional artists show at this gallery so the standard is often very high.

David Risley Gallery, 45 Vyner Street, London E2 9DO. Telephone: 020 7613 4006. www.artnet.com/davidrisley.html. E-mail: davidrrisley@btconnect.com. David Risley runs this lively

Danielle Arnaud.

space but is also involved in the Zoo Art Fair at London Zoo when Frieze Art fair is on in Regent's Park in October.

Davies and Tooth, (see AIR Gallery entry) 32 Dover Street, London W1S 4NE. Telephone: 020 7409 1516. Fax: 020 7409 1856. Website: www.davies-tooth.com. Open 10-6pm. Directors: Patrick Davies and Simon Mathews.
Contemporary British artists and art consultancy. Shows Hock Aun Teh, Kendra Haste, Adrian Hemming, Graham Brant, Oliver Wilson, Sam Hanson, Vivienne Foley, Anna Keen, Dann

Rowland. Gallery policy: send in images of work, cv, price list and a stamped addressed envelope. Exhibits at the London Art fair in January. Underground Green Park.

Davies Street Gallery, Davies Street, London W1. Telephone: 020 7499 7009. www.dsgallery.co.uk.
The gallery can be hired. Near Gimpel Fils Gallery and Berkeley Square. Underground Bond Street.

Delfina Project Space, 51 Southwark Street, London SE1. Telephone: 020 7357 6600. Open Monday-Friday, 11-6pm, Saturday 11-3pm.
Delfina artists' studios are next door. The gallery shows work by contemporary artists including paintings, sculpture, prints and works on paper. A large gallery space with a café/restaurant at the entrance to the gallery. There are some interesting paintings on display in the restaurant, but the work on show in the gallery varies. Not a central art venue but obviously popular with gallery clientele. Underground Bermondsey.

Dick Smith Gallery, 74 Buttesland Street, London N1 6BY. Telephone 020 7253 0663 e mail dicksmithgallery@hotmail.com Open Wednesday-Saturday 11-6.
Young, emerging artists;mauro Bonacina, Joel Croxson, Matthew Derbyshire,Edward kay, meiro Koizumi, Duncan Marquiss, Rupert Norfolkj, Natsuki Uruma.

Diorama Gallery, 34 Osnaburgh Street, London NW1 3ND. E-mail: admin@diorama-arts.org.uk. Website: www.diorama-arts. org.uk. This Regents' Park gallery is often used by various art organisations for exhibitions. Write to the gallery if interested. Underground Great Portland Street.

DomoBaal Contemporary Art, 3 John Street, London WC1N 2ES. Telephone: 020 7242 9604. Fax: 020 7831 0122. E-mail: domo@domobaal.com. Website: www.domobaal.com. Open Friday and Saturday 12-7 or by appointment. Director: Domo Baal. Interested in contemporary art, in particular drawings and has had solo shows of photography, drawing, anatomical wax sculpture, digital cube chrome prints and painting. Artists shown regularly include: Marina Schmid, Rebecca Stevenson, Si Sapsford, Paul Mettler-Tucakov, Bob Matthews, Sadie Murdoch, Gordon Cheung, Daiana Stanescu, Nina Papaconstantinou, Daniela Gullotta, Cathie Pilkington, Jeffrey Ty Lee, Rieko Akatsuka. Gallery policy; hates to be cold-called, so don't turn up at the

gallery! Prefers to be invited to look at exhibited or installed work and doesn't mind being approached about this. Friendly, lively gallery owner, with a good sense of humour, often lacking in the contemporary art world! Underground Chancery Lane.

Dominic Guerrini Fine Art, 18 Redburn Street, London SW3 4BX. Telephone: 020 7565 2333. www.originalprints.com. E-mail: sales@dominicguerrini.com
Exhibits original prints by Lucian Freud, Elisabeth Frink, Patrick Heron, Damien Hirst, David Hockney, Howard Hodgkin, Henry Moore, Victor Pasmore, John Piper, Bridget Riley, Kyffin Williams. Can be seen at the London Art fair in January annually.

The Drawing Gallery, 37 Duke Street, St James's London SW1. Telephone: 020 7839 4539. www thedrawinggallery.com. This is an excellent gallery concentrating on works on paper. Underground green Park.

The Drawing Room, Tannery Arts, Brunswick Wharf, 55 Laburnum Street, London E2 8BD. Telephone: 020 7729 5333. www.drawingroom.org.uk. E-mail: mail@drawingroom.org.uk Open Thursday-Sunday, 12-6pm.
Dedicated to the exploration of drawing in contemporary art. It is part of Tannery Arts studio complex and run by the founders Mary Doyle, Kate Macfarlane and Katherine Stout. Exhibitions tour to regional galleries. Work by national and international artists.

Duncan Campbell Fine Art, 15 Thackeray Street, Kensington Square, London W.8.5ET. Telephone: 020 7937 8665. Open Tuesday-Friday, 11-6pm, Saturday, 10-5pm. Director: Duncan Campbell. Regular shows of work by mainly figurative painters, some established, some not-so. Painting, watercolours and young and established artists. Artists include; the late Rowland Hilder, Eugene Palmer, Magda Kozarzewska, Ann Brunskill, Ralph Anderson, Francis Farmar, Geri Morgan, Jim Manley and others. Completely full for more than 2 years in advance. Underground High Street Kensington.

Duncan R Miller Fine Arts, 6 Bury Street St James's, London SW1Y 6AB Telephone:/Fax 020 7839 8806. E-mail: DMFinearts@aol.com. Website: www.duncan-miller.com. Open Monday-Friday, 11-6pm, Saturday, 11-2pm.
Exhibits contemporary Scottish/British painters mainly. Underground Green Park.
Also at **17 Flask Walk, Hampstead, London NW3 1HJ**.

Telephone: 020 7435 5462/020 7839 8806. E-mail and website as above. Open Monday-Friday, 11-6pm, Saturday, 11-2pm. Also shows Scottish paintings past and present in a small gallery space. Underground Hampstead.

The Eagle Gallery, EMH Arts, 159 Farringdon Road, London EC1R 3AL. Telephone: 020 7833 2674. E-mail: emmahilleagle @aol.com. Open Wednesday-Friday, 11-6pm, Saturday, 11-4pm. Contemporary art. Paintings and drawings, sculpture and limited edition prints. Underground Farringdon.

Eastern Art Gallery, 40 Bloomsbury Way, London WC1A 2SA. Telephone: 020 7430 1072. Fax: 020 8856 3558. Open Tuesday-Saturday, 10.30-5.30pm.
Specialises in contemporary Chinese brush paintings, woodcuts and woodblocks by leading Chinese artists. Underground Tottenham Court Road.

East 73rd Gallery, 73 Curtain Road, London EC2A 3BS. Telephone: 020 7739 5836. E-mail: info@east73rd.com. Website: www.east73rd.com. Open Tuesday-Saturday, 11-6pm. Directors: Nicki Makris and Brendan Finucane.
Contemporary paintings, sculpture and photography by up-and-coming artists. Gallery policy: send slides and photographs to the gallery for initial review. Review every six months. Underground Liverpool Street (exit 4)

East West Gallery, 8 Blenheim Crescent, London W111NN. Telephone: 020 7229 7981. E-mail: david@eastwestgallery.co.uk. Website: www.eastwestgallery.co.uk. Directors: Jill Morgan and David Solomon.
Paintings, drawings and prints by British and international artists. Friendly gallery with work on sale at accessible prices. In the heart of the Portobello Market area. Will consider looking at work, but artists must visit the gallery first and meet the directors. Most artists have at least 10 years experience as professional artists before applying. Underground Notting Hill Gate and walk down the hill/Ladbroke Grove.

The Economist Gallery, 25 St James's Street, London SW1A 1HG. Telephone: 020 7839 7000. Open office hours.
Applications can be made to use the spaces at the Economist, both outside and inside. Advisable to telephone: first to see if your work is appropriate. Shows sculptural works continuously in this public space in central London. Underground Green Park.

E1Gallery, Website: www.e1gallery.com. Also: www.e1art.com E-mail: enquiries@e1gallery.com. Telephone: 020 7721 8687. Fax: 020 7721 8688. Open Monday-Friday, 9-5pm.

E1 galleries are based at 10 White's Row E1 7NJ in Spitalfields and at Studio A, Florida Studios, 18-24 Florida Street, London E2 6A2 in Bethnal Green. E1's principal artists are: Fernando Velazquez, Ita Cormack, Nick Malone, Nigel Ellis, Gudrun Mertes-Frady, Mary Anne Francis, Axel Antas and Clare Wilson. These artists all share common values based on "the continuity of human experience and the threat to society represented by a fascination with change." Underground Liverpool Street (e1S) and Bethnal Green (e1BG)

Electrum Gallery, 21 South Molton Street, London W.1 Telephone: 020 7629 6325. Open Monday-Friday, 10-6pm, Saturday, 10-1pm.

Top British and international jewellers. Contemporary jewellery only. Two floors. Open to jewellers to apply. Underground Bond Street.

Elgin (Cassian de Vere Cole Fine Art), 50 Elgin Crescent, London W11 2JJ. (entrance on Ladbroke Grove) Telephone: 020 7221 9161. Fax: 020 7221 1082. Open Tuesday-Friday, 2-6pm, Saturday, 10-2pm. Director: Cassian de Vere Cole

Elgin specialises in contemporary and Modern British art, including recent work by graduates. Has had many lively shows in recent years and many locals in Notting Hill buy work there at affordable prices. Underground Holland Park/Ladbroke Grove.

Emily Tsingou Gallery, 10 Charles Street, London SW1. Telephone: 020 7839 5320. Open Tuesday-Saturday, 10-6pm. Director: Emily Tsingou

Contemporary young artists. Underground Piccadilly.

The Empire, The Empire Studios, 33A Wadeson Street, London E2 9DR. Telephone: 020 8983 9310. www.theempirestudios.co.uk.

Available to hire for exhobitions, performances, film location, rehearsals.

England & Co., 216 Westbourne Grove, London W11 2RH. Telephone: 020 7221 0417. Fax: 020 7221 4499. Open Tuesday-Saturday, 11-6pm. Director: Jane England.

20th-century Modern British paintings-1940s, 50s and 60s. Excellent selection of works from this period with a Director who does her background research well and is well-respected.

Catalogues available from past shows. Also contemporary art shows by young and established artists. Artists should phone the gallery before submitting work. Underground Notting Hill Gate or buses 27, 31, 328 to Westbourne Grove.

Enid Lawson Gallery, 46 Kensington Church Street, London W8 4DA. Telephone: 020 7937 8444. Fax: 020 7937 8150. E-mail: EnidLawson@aol.com. Website: www.enidlawsongallery. co.uk. Open Monday-Saturday, 10-6pm.
Colourful, affordable work by contemporary British potters and painters, but not by established, in fact by almost amateur artists. Underground High Street Kensington.

Eric Franck Fine Art, 7 Victoria Square, London SW1W OQY. Telephone: 020 7630 5972. E-mail: e.franck@btclick.com Open by appointment.
Eric Franck specialises in 20th century and contemporary photography and photographic literature. He is a major London photo dealer and was based in Geneva until 1994.

Essor Gallery, 57 Ewer Street London SE1 ONR. Telephone: 020 7928 3388. E-mail: info@essorgallery.com. Website: www. essorgallery. com. Open Monday-Friday, 9-6pm, Saturday, 10-5pm. Director: Caroline Essor
Set up by a previous employee of Lisson gallery, this space is well worth visiting. Very professional exhibitions. An important contemporary art gallery internationally. Near Tate Modern. Underground Southwark.

Eventnetwork, 96 Teedale Street, London E2 6PU. www.eventnetwork.org.uk
Opened in 2003 by Colm lally and Brian Reed and is a new media/digital art project space in a basement. Only open during events.

Experiment, Unit 39, Sapcote Trading Centre, Dudden Hill Lane, London NW10 2DJ. Telephone: 020 8830 1072. E-mail: ben.hanly@experimentuk.com
Exhibited at the Art Projects section, London Art fair in 2005. Lively contemporary space.

Eye Candy, 2A Crucifix Lane, Bermondsey, London SE1 3JW. Telephone: 07903 078488. www.eyecandygallery.co.uk. E-mail: mail@eyecandygallery.co.uk
Avant garde contemporary art gallery. Exhibits work by Karoly Keseru and Lee Mathias. Underground Bermondsey.

Eyestorm Britart, 18 Maddox Street, London W1S 1PL. Telephone: 020 7659 0860. www.eyestorm.com. E-mail: dave@britart.com.

After the failure of eyestorm in its original form, the gallery was taken over and now shows work by British artists such as Damien Hirst, Peter Blake, Mark Francis, Andy Goldsworthy, Marc Quinn, Stella Vine and international artists such as Sol LeWitt, Helmut Newton and Roy Lichtenstein. Exhibits at the London Art Fair in January. Underground Oxford Circus.

Fa Projects, 1-2 Bear Gardens, London SE1 9ED. Telephone: 020 7928 3228. E-mail: info@faprojects.com. Website: www.faprojects.com. Open Wednesday-Friday, 10-6pm.

Shows contemporary cutting-edge artists. Ugo Rondinone and Grazia Toderi have shown here. Another respected gallery on the international art scene. Underground Southwark.

Faggionato Fine Art, 49 Albemarle Street, London W1X Telephone: 020 7409 7979. Open 10-6pm.

Gallery showing paintings, drawings and sculpture by good contemporary artists. Accessible prices for first-time buyers. Underground Green Park.

FarmiloFiumano, 27 Connaught Street, London W2 2AY. Telephone: 020 7402 6241. Website: www.farmilofiumano.com Open Monday-Friday, 10-6pm, Saturday, 11-4pm.

Specialises in contemporary art with a variety of international artists. Underground Marble Arch.

Ferguson McDonald Gallery, 10 Princelet Street, London E1 6QH. Telephone: 020 7249 8711. Open Thursday-Sunday, 12-5pm.

Spitalfields has quite a few galleries now, with two in this street alone. This gallery shows paintings by good professional artists. Underground Liverpool Street.

Fine Art Society, 148 New Bond Street, London W.1. Telephone: 020 7629 5116. Open Monday-Friday 9.30-5.30, Saturday 10-1. Directors: Andrew McIntosh Patrick, Peyton Skipwith 19th and 20th-century art. Heavy emphasis on Scottish painting including the Scottish Colourists. (Peploe, Cadell, Hunter JD Fergusson) Ideal gallery for private collectors or for large collections. Good selection of past catalogues on sale. Also shows contemporary artist Emma Sergeant. Underground Bond Street/Green Park.

Fine Art Trade Guild, 16 Empress Place, London SW6 1TT. Telephone: 020 7381 6616.
Publishers of Art Business Today, a trade journal. Members include galleries, publishers, framers, artists and art suppliers.

The Finelot Gallery, 25 Bury Street, St James's, London SW1. Telephone: 020 7930 9864. Fax: 020 7930 9005. E-mail: info@finelot.com. Website: www.finelot.com. Open Monday-Friday, 10-6pm.
Shows contemporary artists such as Glynn Williams, Crawford Adamson, John Makepeace, Simone ten Hompel, Christie Brown and Neil Wilkin. Underground Green park.

Flaca, 69 Broadway Market, London E8 9PH. Telephone: 020 7275 7473. www.flaca.co.uk. E-mail: info@flaca.co.uk.
Set up in 2002 from what had been a small derelict shop. Flaca collaborates with artists/writers/curators.

The Fleming Collection, 13 Berkeley Street, London W1J 8DU. Telephone: 020 7409 5730. www.flemingcollection.co.uk.
Selina Skipwith is the curator of this wonderful collection of Scottish art. Originally the collection was part of Flemings Bank, but when the bank was sold the collection was moved and housed in Berkeley Street. There are regular curated exhibitions of work from the collection, covering everything from the Scottish Colourists to DY Cameron, Gillies, Redpath and contemporary artists. Friends of the Fleming Collection gain access also to private corporate collections and other events. There are also talks at the gallery and it can be hired for events and parties. Underground Green Park.

Flying Colours Gallery, 6 Burnsall Street, King's Road, London SW3 3ST. www.flyingcoloursgallery.com. E-mail: art@flying colours.com. Telephone: 020 7351 5558.
Shows work by Scottish artists across London in different venues. Stock of 300 works which can be seen by appointment. Alastair Gray, Catriona Campbell, Paul Martin, Anthony Scullion, Ethel Walker, Shona Barr, Peter White.

Five Princelet Street Gallery, 5 Princelet Street, Spitalfields, London E1 6QH. Telephone:/Fax: 020 7247 0601. E-mail: art.five@virgin.net. Website: www.art-five.co.uk. Open Wednesday-Friday, 12-6pm, Sunday, 2-6pm. Contact: Pascale Lacroix
Shows paintings by contemporary established artists, often curated by well-known art world names. Underground Liverpool Street.

Flow, 1-5 Needham Road, London W11 2RP. Telephone: 020 7243 0782. Fax: 020 7792 1505. E-mail: gallery.flow@ukgateway.net. Essentially a craft gallery with some very fine jewellery, ceramics, pottery and other craftwork. Underground Notting Hill Gate and walk, or buses 27, 31, 328 to Westbourne Grove.

Flowers East/Flowers Graphics, 82 Kingsland Road, London E2 8DP. (Shoreditch end) Telephone: 020 8985 3333. E-mail: gallery@flowerseast.com www.flowerseast.com. Open Tuesday-Saturday, 10-6pm.
Large gallery spaces for the many artists shown by Flowers East: Jack Smith, Prunella Clough, Carole Hodgson, Amanda Faulkner, Neil Jeffries, Lucy Jones, Peter Howson, Patrick Hughes, Tim Mara, Trevor Jones, John Loker, John Keane, John Gibbons, Nicola Hicks, Mikey Cuddihy, Alison Watt, Alan Gouk, Kevin Sinnott, Alan Stocker, Andrew Stahl, Henry Kondracki, John Kirby. In July every year they run an Artist of the Day show, with artists chosen by known names. There is a Graphics Gallery, a Print of the Month club and there are 200 shareholders in this growing concern. One of London's most dynamic galleries. Now runs a Flowers gallery in New York. Gallery policy: not seeking applications. Underground Old Street.

Flowers Central, 21 Cork Street, London W1X 1HB. Telephone: 020 7439 7766. Fax: 020 7439 7733. E-mail: central@flowerseast.com. Website: www.flowerseast.com. Open Monday-Friday, 10-5.30pm, Saturday, 10-1pm.
Angela Flowers opened Flowers Central in late 2000. It is a showcase space in central London's Cork Street for the 38 Flowers artists.The gallery is in the old Victoria Miro space. Most of the Flowers East stable of artists have now been shown there and Flowers galleries are always abreast of changes in the art world. There is also Flowers in New York. Angela Flowers is a key art dealer in London working with her son Matthew, who now runs Flowers in New York, which moved to 82 Kingsland Road, at the Shoreditch end, in September 2002, joining the rush to Hoxton which is the fashionable art area at present, although the east end galleries had been based until recently at Richmond Road for years, since 1988. Underground Bond Street/Green Park.

Fosterart, 20 Rivington Street Street, London EC2A 3DU. Telephone: 020 7739 1743. www.fosterart.net. E-mail: info@fosterart.net. Open Friday-Sunday, 11-6. Contact: LeAnn Barber. Fosterart is now specialising in art lending programmes.They

Angela Flowers at Flowers Central.

manage a growing network of public and profesional spaces, collaborating with galleries and artists, working with the NHS on sponsored schemes. New gallery space now shows some of the artists in these projects. These include some known names from established galleries as well as artists from project spaces. Underground Old Street (Exit 3).

Foundation for Women's Art, 55-63 Goswell Road, London EC1V 7EN. Website: www.fwa-uk.org. E-mail: admin@fwa-uk.org. Director: Monica Petzal.
Founded in 1992. It curates exhibitions at various venues.

Foundry, 84-86 Great Eastern Street, London EC2. Telephone: 020 7739 6900. Open Monday-Friday 1-11, Saturday 7-11, Sunday 2-10. An alternative art venue with rising stars.

Francis Kyle, 9 Maddox Street, London W.1. Telephone: 0120 7499 6870/6970. Open Monday-Friday, 10-6pm, Saturday, 11-5pm. Director: Francis Kyle
Contemporary young British artists. Also publish lithographs by British artists. Many of the paintings and prints have a colourful, decorative quality. Underground Bond Street.

Frank T. Sabin Fine Art Dealers, 46 Albemarle Street, London W1X 3FE. Telephone: 020 7493 3283. Website: www.ftsabin.com. Open Monday-Friday, 10-6pm, Saturdays by appointment.

The gallery now shows British contemporary painters and sculptors, mostly fairly conventional, under the eye of Mark Sabin the original owner's great-grandson. The hunting prints and lithographs for which the firm is famous will also be on sale here. Underground Green Park.

Fridge Gallery, based at the Fridge Arts Club, 40 Acre Lane, Brixton, London SW9. Telephone: 020 7326 5100. E-mail: info@fridgegallery.co.uk. Website: www.fridgegallery.co.uk. Open 1-9pm during exhibitions.
Gallery set in a fashionable club venue (Fridge Restaurant/Bar and Brasserie and the Fridge Arts Club opened in spring 2002) showing photographs, paintings and degree show works from St Martins and Chelsea. Andrew Czezowski and Susan Carrington owners of the Fridge nightclub were promoters of performance art in the 1980s and created the first video lounge showing videos by Derek Jarman, Jeffrey Hinton and John Maybury. Underground Brixton

Frith Street Gallery, 59-60 Frith Street, Soho, London W.1. Telephone: 020 7494 1550. Website: www.frithstreet gallery.co.uk. Open, 11-6pm. Director: Jane Hamlyn.
Set in the heart of Soho,this gallery has produced several Turner prize shortlisted artists. Works on paper, including prints, photographs and small paintings. Good innovative lively cutting-edge art. Exhibits at Frieze Art fair in October. Gallery artists include: Fiona Banner, Craigie Horsfield, Tacita Dean, Callum Innes, Cornelia Parker, Thomas Schutte, Fiona Tan, Marlene Dumas. Underground Tottenham Court Road.

Gagosian Gallery, 6-24 Britannia Street, London WC1X 9JD. Telephone: 020 7841 9960. www.gagosian.com. E-mail: info@gagosian.com.
The huge second London gallery space, at King's Cross, opened in 2004. Gallery artists include: Georg Baselitz, Glenn Brown, Francesco Clemente, Michael Craig-Martin, John Currin, Dexter Dalwood, Gilbert & George, Douglas Gordon, Arshile Gorky, Damien Hirst, Anselm Kiefer, Willem de Kooning, Jeff Koons, Ed Ruscha, Andy Warhol, Jenny Saville, Tim Noble and Sue Webster. Underground King's Cross.

Gagosian Gallery, 8 Heddon Street, London W1R 7LH. Telephone: 020 7292 8222. Fax: 020 7292 0220. E-mail: Info@gagosian.com. Website: www.gagosian.com. Open 10-6pm. Directors: Molly Dent Brocklehurst, Mark Francis.

Larry Gagosian set up the London gallery in 2000. He has three galleries in America; two in New York and one in Los Angeles. A major player in the international art world, he has already benefited from the closure of Anthony D'Offay galleries, by taking on Michael Craig-Martin the mentor of generations of Goldsmith artists and Howard Hodgkin: more may follow now that Mark Francis is a director at Gagosian. Gagosian galleries show work by Damien Hirst, Jenny Saville, Douglas Gordon and Francesco Clemente, Cy Twombly, Richard Serra, Anselm Kiefer and other major art world names. In London, shows have included lesser-known names as well. Next to Sadie Coles HQ. The Gagosian Gallery at Britannia Street, King's Cross opened in 2004. Underground Oxford Circus/Piccadilly.

The Gallery, 28 Cork Street, London W1X 1HB. Telephone: 020 7287 8408.
This gallery can be hired for exhibitions. Underground Green Park.

The Gallery@Oxo, South Bank Management Services, Oxo Tower Wharf, Bargehouse Street, South Bank, London SE1 9PH. Telephone: 020 7401 3610. Fax: 020 7928 0111. E-mail: sbms@coin-street.org. Website: www.oxotower.co.uk Open daily, 11-6pm.
Contemporary design, applied arts and photography. Gallery policy: applications subject to committee approval. Exhibitor is responsible for ensuring the gallery is staffed during his/her exhibition. Underground Waterloo.

Cy Twombly show at Gagosian Britannia Street, King's Cross.

Gallery Different, 45 Shad Thames, Tower Bridge Piazza, London SE1 2NJ. Telephone: 020 7357 8909. www.davidbegbie.com. E-mail: different@davidbegbie.com. Open Monday-Friday, 10-6pm, Saturday/Sunday, 12-6pm.
Shows work by David Begbie, the sculptor.

Gallery 33, 33 Swan Street, London SE1 1DF. Telephone: 020 7407 8668. E-mail: marvasol@btconnect.com.
Contemporary artists, usuallu lesser known ones. Underground Elephant & Castle.

Gallery One, 19 Station Road, Barnes, London SW13 OLF. Telephone: 020 8487 2144. Fax: 020 8487 2755. www.gallery-onelondon.com. E-mail: info@galleryone.ws. Directors: Judith Nicklin and Marian Orchard-Webb.
Has shown paintings by Catalan artist Ramon Lombarte, a painter and lithographer. Also shows Anna Dickerson, Karen Griffiths, Heidi Koenig, Lisa McLaren-Clark, Tina Sprratt, Zachary Walsh. Rail to Barnes.

Gallery Kaleidoscope, 64-66 Willseden Lane, London NW6 7SX. Telephone: 020 7328 5833. Open Tuesday-Saturday, 10-6pm.
Shows contemporary paintings, prints, sculpture and ceramics. Artists include: John Duffin, George Wiesbort, June Bartlett, Mark Clark, Roger Harris. They also sell some 19th century work. Gallery policy: slides or photographs sent first. Underground Kilburn.

The Gallery at Bird and Davis Ltd., 45 Holmes Road, Kentish Town, London NW5. Telephone: 020 7485 3797. Open shop hours.
A gallery in a materials-shop setting. Contemporary works on paper. Underground Kentish Town.

Gallery K, 101-103 Heath Street, Hampstead, London NW3. Telephone: 020 7794 4949. Open Tuesday-Friday, 10-6pm, Saturday, 11-6pm.
Variety of shows by Greek artists or artists with Greek connections. Usually paintings. Underground Hampstead.

The Gallery at John Jones, Unit 4, Finsbury Park Trading Estate, Morris Place, London N.4. Telephone: 020 7281 2380. Open Tuesday-Friday, 10-6pm, Saturday, 10-2pm, Sunday, 12-4pm.
This gallery space and materials store has continued to show work by unknown but promising artists, with some thought involved in the selection procedure. Underground Finsbury Park.

Gallery 27 & The Gallery in Cork Street, 27 and 28 Cork Street Lonmdon W1S 3NG. Telephone: 020 7287 8408. Fax: 020 7287 2018. E-mail: enquiries@galleryincorkstreet.com. Website: www.galleryincorkstreet.com. and www.gallery27.com. Both galleries are for hire with about 100sq metres of gallery space.They offer a mailing list and management support. Main attraction is the venue in Cork Street. Underground Bond Street/Green Park.

Gallery 47, 47 Great Russell Street, London WC1B 3PB. Telephone: 020 7637 4577. Fax: 020 7323 6878. E-mail: enquiries@agecare.org.uk.
This small gallery space is for hire opposite the British Museum. Busy venue with many passing BM visitors and tourists. Underground Tottenham Court Road.

The Gallery, 33 Swan Street, London SE1 4JB. Telephone: 020 8395 8549. Open Monday-Friday, 9.30-5.30pm.
Small gallery space that has shown cibachrome prints and contemporary art.

Gallery Fine 2, 7 Lower James Street, Soho, London W1F 9EJ. Telephone: 020 7434 2341. Fax: 020 7434 2342. E-mail: art@galleryfine.co.uk. Website: www.galleryfine.co.uk. Open Monday-Friday, 10-6pm, Saturday, 10.30-2pm.
A small gallery space that has shown work by artists such as Heinz Dieter Pietsch. Underground Piccadilly.

Gallery on the Green, 34 Markham Street, Chelsea Green, London SW3 3NR. Telephone: 020 7349 2908. Fax: 020 7351 5308. E-mail: gallery@felixr.com. Website: www.galleryonthe-green.co.uk. Open Monday-Saturday, 10-6pm. Director: Lucy McDowell.
Contemporary painting, sculpture and prints. Artists include: Spencer Hodge, Paul Evans, Anna Naumann, Marsha Hammel, Sara Hayward. Gallery policy: all work considered but send photos or colour copies by mail. No original artwork should be sent by mail. Enclose an s.a.e. Accessible prices for first-time buyers. Underground Sloane Square.

Gallery Niklas Von Bartha, 136B Lancaster Road, London W11 1QU. Telephone: 020 7985 0015. E-mail: info@vonbartha.com www.vonbartha.com. Open Thursday-Saturday, 11-5pm or by appointment. Shows photographs, ceramics and

contemporary art. Douglas Allsop, Takashi Suzuki, Eline McGeorge. Underground Gloucester Road.

Gallery 286, 286 Earl's Court Road, London SW5 9AS. Telephone: 020 7370 2239. E-mail: jross@gallery286.com. Website: www.gallery286.com. Open by appointment and on private view evenings. Director: Jonathan Ross.
Run from a private house the gallery shows paintings and constructions by artists such as Victoria Achache, Philippa Stockley, David Henderson, Olivia Stanton and others. Exhibits at art fairs. Underground Earl's Court.

Gasworks, 155 Vauxhall Street, The Oval, London SE11 5RH. Telephone: 020 7582 6848. Fax: 020 7582 0159. E-mail: gallery@gasbag.org. Website: www.gasworksgallery.org. Open Wednesday-Sunday, 12-6pm. Director: Peter Cross
Contemporary international art. Five exhibitions per year. Offsite projects. Proposals considered by the gallery. Ring first for details. Past exhibitions have included David Medalla, Javier Tellez, Roberto Obregon and Audry Lisseron-Monfils. Underground Oval.

Gillian Jason Modern & Contemporary, PO Box 35063, London NW1 7XQ. Telephone: 020 7209 5798. www.gillianjason.com. E-mail: art@gillianjason.com. By appointment only.
She continues to deal in 20th Century British and European Art and organise exhibitions for her group of contemporary artists. Exhibits at The London Art fair in January at Islington. Artists include John Plumb, Paul Storey, Rose Warnock, Trevor Bell, Richard Cook, Patrick Heron, Allen Jones, Julian Opie, Alan Reynolds, Bridget Riley, John Virtue.

Gimpel Fils, 30 Davies Street, London W.1. Telephone: 020 7493 2488. Website: www.gimpelfils.com. Open Monday-Friday 9.30-5.30pm, Saturday, 10-1pm. Directors: Peter Gimpel.
An established, well-respected top London gallery. The Gimpels have years of experience in art dealing. René Gimpel's "Dairy of an Art Dealer" is worth reading. Contemporary artists including Alan Davie, Gillian Ayres, Susan Hillier, Albert Irvin and other younger lesser-known names. Underground Bond Street.

Goedhuis Contemporary, 116 Mount Street, London W1K 4NB. Telephone: 020 7629 2228. Fax: 020 7629 5732. E-mail: Michael.Goedhuis@btinternet.com. Website: www.goedhuiscontemporary.com. Open Monday-Friday 9.30-6, Saturday by appointment.

Shows painting and sculpture and Chinese contemporary art. Artist shown include: Yang Yanping, Tong Yang-Tze, Fung MingChip, Li Chen and others. Gallery policy: welcomes applications from Asian artists. Underground Bond Street.

Goëthe Institut, 50 Princes Gate, London SW7. Telephone: 020 7 411 3400.
Contemporary German art including work by some top names such as Georg Baselitz. Also shows photography. Underground South Kensington.

Goldsmiths College Gallery, New Cross, London SE14 6NW. Telephone: 020 8692 7171 ext 264. Open Monday-Friday 12-5. Work by contemporary artists in an art school context. It is worth remembering that Goldsmiths' past artists are now some of London's most successful, so perhaps worth paying a visit to see what makes Goldsmiths such a special art school. Underground New Cross.

The Great Unsigned. Contact David Thorp at curatorcp@ hotmail.com or Soraya Rodriguez at soraya@dslpipex.com.
This agency first presented itself at the 2004 Zoo Art fair. It finds and creates platforms for its selected artists, unsigned artists, to be seen by gallerists, curators and collectors.There is a no-strings short-term commitment to the artists. No permanent base but operates at different venues.

Green and Stone of Chelsea, 259 Kings Road, London SW3. Telephone: 020 7352 6521. Open shop hours.
Stockists of fine art materials, but also holds occasional exhibitions at the back of the shop, of small works by local professional artists. Friendly artists work in the shop. Underground Sloane Square and then walk or bus.

Greengrassi, 1A Kempsford Rd, London SE11 4NU. Telephone: 020 7840 9101. www.greengrassi.com. E-mail: info@greengrassi.com. Contact: Cornelia Greengrassi, Holly Walsh, Megan O'Shea. Open Tuesday-Saturday, 11-6pm.
Contemporary cutting-edge art including installations, video, multi-media.
Exhibits at Frieze Art fair in October. Gallery artists include: Aleksandra Mir, David Musgrave, Tomma Abts, Jennifer Bornstein, Sean Landers. Underground Warren Street.

Greenwich Printmakers Association, 7 Turpin Lane, London SE10. Telephone: 020 8858 2290. Open daily 11-5pm. Closed Monday and Thursday.
A group of artist-printmakers. Regular Exhibitions of professional prints.

Greenwich Theatre Gallery, Crooms Hill, London SE10. Telephone: 020 8858 4447/8. Open Monday-Saturday, 10.30-10.15pm.
Professional artists can apply. Contemporary art. Contact Geoffrey Beaghen.

Grosvenor Gallery, 8 Albemarle Street, London W.1. Telephone: 020 7629 0891.
Published work by Gerald Scarfe as well as being the world representatives of Erté. Also work covering the Art Nouveau period, Mucha and 20th-century masters for sale. Underground Green Park.

Hackelbury Fine Art, 4 Launceston Place, London W8 5RL. Telephone: 020 7937 8688. Fax: 020 7937 8868. E-mail: reception@hackelbury.co.uk. Website: www.hackelbury.co.uk. Open Tuesday-Saturday 10-5. Directors: Sascha Hackel and Marcus Bury.
Contemporary photography gallery. Photographers include: Frank Horvat, Edouard Boubat, Marc Riboud, Martine Franck, Allan Jenkins, David Michael-Kennedy, Katia Liebman, Roman Vishniac, Pascal Kern. Photographers should call first to arrange a time to drop off their portfolio. Underground Gloucester Road/High Street Kensington.

Hackney Forge, 243A Victoria Park Road, London E9 7HD. Telephone: 07976 803 463. www.hackneyforge.com. Open Saturday/Sunday, 12-6pm.
East end professional artists. Underground Bethnal Green.

Hales Gallery, The Tea Building, 7 Bethnal Green Road, London E1 6LA. Telephone: 020 7033 1938 www.hales-gallery.com. E-mail: info@halesgallery.com. Open Wednesday-Saturday, 11-6pm. Director: Paul Hedge
Contemporary artists: Andrew Bick, Jonathan Callan, Ian Dawson, Judith Dean, Claude Heath, David Leapman, Martin McGinn, Tomoko Takahashi, Rachel Lowe, James Hyde, Claire Carter, Richard Woods. Channel 4 showed a film in spring '99 about a year in the life of this gallery. Saatchi buys here. The new gallery space is nearer other east end galleries. Underground Liverpool Street.

Hamiltons Gallery, 13 Carlos Place, London W.1. Telephone: 020 7499 9493/4. www.hamiltonsgallery.com E-mail: art@ hamiltonsgallery.com. Open Monday-Friday 10-6, Saturday 10-1. Fashionable photography gallery. Specialists in contemporary and vintage photographs. The gallery can be hired. Underground Bond Street.

Harlequin Gallery, 68 Greenwich High Road, London SE10 8LF. Telephone: 020 8692 7170. Website: www.studio-pots.com Open Thursday-Sunday, 11-5.30pm (Fridays late until 8). Specialises in pottery and ceramics.

Hart Gallery, 113 Upper Street, Islington, London N1 1QN. Telephone: 020 7704 1131.
Contemporary paintings, sculpture and ceramics. Artists; David Blackburn, Marzia Colonna, Gareth Edwards, Bryan Kneale, Kenneth Draper, Maxwell Doig, Richard Devereux, Tom Wood, David Blackburn and others. Exhibits at The London Art fair in January in Islington. Underground Islington

Haunch of Venison, 6 Haunch of Venison Yard, off Brook Street, London, W1K 5ES. Also at 23 Bruton Street, London W1J 6QH. Telephone: 020 7495 5050. www.haunchofveni-son.com. E-mail: info@haunchofvenison.com. Contact: Harry Blain, Charlie Phillips, Garham Southern, Pilar Corias.
Huge gallery space on three floors with interesting exhibitions by major American and British artists. Harry Blain and Charlie Phillips have been dealing in contemporray art for some years and exhibitions are always presented very professionally. Exhibits at Frieze Art fair in October. Gallery artists include: Thomas Joshua Cooper, Mark Alexander, Ed & Nancy Kienholz, Richard Long, Jorge Pardo, Bill Viola, Wim Wenders, Keith Tyson, Diana Thater. Underground Bond Street.

Hauser & Wirth, 196A Piccadilly, London W1J 9DY. Telephone: 020 7287 2300. E-mail: london@hauserworth.com. Contact: Iwan Wirth, Marc Payot.
This Zurich gallery opened in London a few years ago and has made its mark with major contemporary art exhibitions and shows at Frieze Art fair in October annually. Gallery artists include: Louise Bourgeois, Martin Creed, Dan Graham, Rodney Graham, the estate of Eva Hesse, Roni Orn, Guillermo Kuitca, Paul McCarthy, Jason Rhoades, Tony Smith, Diana Thater. Not open to applications. Underground Piccadilly.

Keith Tyson sculpture, Haunch of Venison gallery at Frieze Art Fair.

Havelock Gallery, 8 Havelock Walk, London SE23 3HG. Telephone: 020 8699 7138. E-mail: art@havelock-gallery. fsnet.co.uk. Open 10-6pm. Gallery manager: Charlotte Frost.
This gallery opened in 2001 in Forest Hill in a unique development in a warehouse mews, next to artists' studios in a live/ work environment for artists, designers and filmmakers. So far sculpture by Jeff Lowe and contemporary art have been shown.

Hayward Gallery, South Bank, London SE1. Telephone: 020 7960 4242. Fax: 020 7401 2664. Website: www.hayward-gallery.org.uk. Open daily 10-6, Tues and Wed until 8.
This is a major London art gallery, run by the South Bank Centre.

It concentrates on four areas: contemporary, other cultures, single artists, historical themes and artistic movements. A variety of major exhibitions are held here, ranging from contemporary British Art to major 20th-century Masters or touring shows. Check Time Out or main newspapers for details. The small bookshop is well-stocked and also sells cards and catalogues from past exhibitions. Hayward Members scheme for discounts and free entrance to shows. Underground Waterloo or Embankment and walk across the bridge.

Hazlitt Holland-Hibbert, 38 Bury Street, St James's, London SW1Y 6BB. Telephone 020 7839 7600. www.hh-h.com. E-mail: info@hh-h.com
Modern British artists including Lucian Freud, Howard Hodgkin, leon Kossoff, Henry Moore, Walter Sickert, Stanley Spencer, Keith Vaughan, Frank Auerbach, Bomberg, Andrews, Burra, Hilton, Hitchens, Lanyon, Nicholson, Scott, Tilson and Sutherland. Underground Green Park.

Helly Nahmad Gallery, 2 Cork Street, London W1X 1PB. Telephone: 020 7494 3200. Fax: 020 7494 3355. Open Monday-Friday, 10-6pm, Saturday, 10-1pm. Director: Helly Nahmad
A magnificent gallery space on two floors, showing Impressionist paintings, 20th century and contemporary art. The Nahmads are well-known art collectors and so far major shows have complemented Picasso and Impressionist exhibitions at the Royal Academy with superb catalogues. In '99 works by Damien Hirst, Marc Quinn, Keith Coventry, Gary Hume and Angus Fairhurst were shown. Artists should not apply for exhibitions. Underground Bond Street/Green Park.

Henry Moore Gallery, Royal College of Art, Kensington Gore, London SW7. Telephone: 020 7590 4444. Fax: 020 7590 4500. Open 10-6pm.
The enormous RCA galleries hold regular exhibitions of work by established artists, sometimes connected with the college, but often not. Check the press for details of current shows. The 20th/21st Century Art Fair is held here. Underground South Kensington or High Street Kensington, aslo 9, 52 buses.

Henry Peacock Gallery, 38A Foley Street, London W1P 7LB. Telephone: 020 7323 4032. www.henrypeacock.com. E-mail: info@henrypeacock.com. Open Wednesday-Saturday, 12-6pm. Mixed media installations and exhibitions. Underground Oxford Circus.

Herald Street, (see **Miller's Terrace** - previous name).

Hicks Gallery, 2 Leopold Road, Wimbledon, London SW19 7BD. Telephone: 020 8944 7171. E-mail: galleryhicks@aol.com Open Thursday-Saturday, 10-6pm, Sundays, 1.30-5pm.
Shows contemporary art mostly paintings, drawings and sculpture. Underground Wimbledon.

Highgate Fine Art, 26 Highgate High Street, London N6 5JG. Telephone: 020 8340 7564. E-mail: sales@oddyart.com. Website: www.oddyart.com. Open Tuesday-Saturday, 10-6pm. Shows paintings by contemporary British artists such as Philip Richardson, Teresa Lawton and Craig Wylie. Underground Archway.

Highgate Gallery, 11 South Grove, Highgate village, London N6 6BS. Telephone: 020 8340 3343.
This gallery can be hired.

Holland Park, Orangery Gallery, London W.8. Telephone: 020 7603 1123. Opening hours vary.
Artists can apply for exhibitions in this lovely light space in Holland Park. Artists have to organise their own publicity and security. Apply to the curator, Daniel Robbins at Leighton House Museum. Underground Holland Park.

Home, 1A Flodden Road, London SE5 9LL. Telephone/Fax 020 7274 3452. E-mail: Lgihome@aol.com. Website: www.Lgihome. co.uk. Open Thursday, 11-5pm or by appointment. Contact: Laura Godfrey-Isaacs.
Work by 80 contemporary artists for sale. An unusual exhibition space in a home showing 80 works of art in a constantly changing environment. Underground Oval or 36 bus to Camberwell.

Honor Oak Gallery, 52 Honor Oak Park, London SE23. Telephone: 020 8291 6094.
Contemporary art exhibitions. Participates in local Lewisham Visual Arts Festivals.

Hotel, 53A Old Bethnal Green Road, London E2 6QA. Telephone: 020 7729 3122. www.generalhotel.org. E-mail: info@generalhotel.org
An independent exhibition space in Darren Flook and Christabel Stewart's home. It opened in 2003. Flook is a curator/writer and Stewart is art editor of Showstudio and a freelance curator.

Artists from outside London stay at the space while producing the show.

Houldsworth Fine Art, 34 Cork Street, London W1X 1HB. Telephone: 020 7434 2333. Fax: 7434 3636. Director: Pippa Houldsworth.
Artists include: Richard Bray, Robin Connelly, Jonathan Delafield Cook, Richard Henman, Gavin Lockheart, Paul McPhail, Matthew Radford, Peter Randall-Page, Karl Weschke and Uwe Wittwer. Contemporary painting and sculpture. Shows at London Art Fair. Underground Green Park/Bond Street.

Hornsey Library New Gallery, Haringey Park Road, London N.8. Telephone: 020 8348 3351. Open Monday-Friday, 9.30-8pm, Saturday, 9.30-5pm.
Artists can apply for exhibitions.

IBID Projects, 210 Cambridge Heath Road, Unit 4, London E2 9NQ. Telephone: 020 8983 4355. www.ibidprojects.com. E-mail: info@ibidprojects.com. Open Thursday-Sunday, 12-6pm. Gallery directors: Vita Zaman, Magnus Edensvard.
Set up in 2002. An alternative project space.

ICA (Institute of Contemporary Arts), The Mall, London SW1. Telephone: 020 7930 3647 (Box Office) /0493 (General admin). Recorded information 020 7930 6393. E-mail: info@ica.org.uk Website: www.ica.org.uk. Open daily 12-9. The centre is open 12-11 every day for the theatre, cinema, bar and restaurant.
Membership scheme for details of events and free entry to shows. Three galleries. Not a submissions gallery but interested to see work if appropriate in form of slides/photos/documentation by professional artists. It is advisable to ring the visual arts department first. Restaurant, bookshop with good selection of art magazines and alternative reviews and catalogues. Video library. Art pass for students. Lively arts centre in central London with international visitors as well as British visitors. Recent shows have been of Berlin artists, French artists and Dutch artists. Philip Dodd has made the ICA a place worth going to again for visual arts, but he has now left. Ekow Eshun is the new director. Films shown here as part of the London Film Festival in November. Underground Charing Cross.

I-cabin, Clarendon Buildings, 11 Ronalds Road, London N5 1XJ. Telephone: 078 1376 4937. Open Friday-Sunday, 12-6pm. Installations and project space for art. Underground Highbury and Islington.

The Ice House, Holland Park, London W.8. Telephone: 020 7603 1123.
Artists can rent this unusual space for small exhibitions. Past exhibitors have been photographers, craftsmen and women, jewellery designers and painters. Underground Holland Park.

Indar Pasricha Fine Arts, 22 Connaught Street, London W.2 Telephone: 020 7724 9541. Open Monday-Friday, 10-5pm, Saturday, 10-1pm. Director: Indar Pasricha
Islamic, Anglo-Indian and Indian art, as well as European and American art. Underground Marble Arch.

Indo, 133 Whitechapel Road, London E1 1DT. Telephone: 020 7247 4926. www.indobar.com. E-mail: art_at_indo@hotmail.com
Open pub hours Mon-Sat, 11-11pm, Sunday, 11-10.30pm.
Pub venue with art on display by unknown and established names.

Ingrid Barron, 61 South End Road, London NW3 2QB. Telephone: 020 7435 7770.
This small gallery has some very good paintings for sale by British artists and Jamie Boyd, the Australian artist. The gallery also does picture framing for local purchases. 24 bus or South Hampstead

Interim Art/Maureen Paley, 21 Herald Street, London E2 6JT. Telephone: 020 7729 4112. Open Thursday-Sunday, 11-6pm and by appointment.
Run by the dynamic Maureen Paley. Exhibitions of work by contemporary cutting-edge artists, many who live in the East end. Maureen Paley's exhibitions have taken on legendary status over the years. She represents Wolfgang Tillmans, the Turner prize winner in 2000. Other gallery artists include: Mark Francis, Hamish Fulton, Karen Knorr, Paul Noble, David Thorpe, Rebecca Warren, Gillian Wearing, Paul Winstanley, Hamish Fulton, Kaye Donachie, Ross Bleckner. Underground Bethnal green.

Islington Central Library, 2 Fieldway Crescent, London N.5. Telephone: 020 8609 3051 ext 56. Open Monday, Tuesday, Thursday, 10-7pm, Saturday, 11-4pm.
Professional artists can apply. Underground Highbury and Islington.

Jaggedart Studio, 014 Westbourne Studios, 242 Acklam Road, London W10 5JJ. Telephone: 020 7575 3330. www.jaggedart.com. E-mail: info@jaggedart.com.

Shows lively contemporary artists regularly in a studio contect. Exhibited at the Art Projects Section, London Art fair in 2005. Underground Westbourne Park Road/Ladbroke Grove.

James Colman, Telephone: 015 0849 1840 Website: www.jamescoleman.com. E-mail: gallery@jamescoleman.com. Director: James Colman.
Contemporary artists from established to recent RCA graduates. Mainly painting but has shown other work. Stella Vine, Delaine and Damian Le Bas, Denis Clarke, Caroline Kent and others. **See interview at front of guide.**

James Hyman Fine Art, 6 Mason's Yard, Duke StreetSt James's London SW1 6BU. Telephone: 020 7839 3906. Fax : 020 7839 3907. www.jameshymanfineart.com. E-mail: mail@jameshymanfineart.com
Attends the 20th/21st Century Art fair and London Art fair. Deals in international modern and contemporary art and provides an art advisory service for individuals and businesses about building a collection. Specialises in international art since 1945 (Calder, Francis, Dubuffet, de Stael) 20th century British art (Camden Town group, School of London to YBAs), contemporary art (Cattelan, Goldin, Hirst, Gallaccio, Hume, Christopher Le Brun, Chris Ofili). **James Hyman's book on British figurative art is also worth buying, published by Yale University Press-The Battle for Realism: Figurative Art (1945-60).** Underground Green Park.

Jeffrey Charles Gallery, 34 Settles Street, Whitechapel, London E1 1JP. E-mail: info@jeffreycharlesgalery.co.uk. Open by appointment and Friday/Saturday 12-6. An artist-run space.

Jerwood Space, 171 Union Street, London SE1. Telephone: 020 7654 0171. Fax 020 7654 0172.www.jerwoodspace.co.uk E-mail: space@jerwoodspace.co.uk. Open daily 10-6pm. Excellent café. The gallery shows work by Jerwood prize artists, but also views applications from other artists. RAdical art with work by 6 ex RA Schools graduates was shown here, ROSL Travel Scholars and emerging artists. 25,000 square feet of magnificent gallery space near Bankside the new art area. Includes rehearsal space for several dance groups or theatre groups at a a time. The gallery is at the front of the building and shows the annual Jerwood Painting Prize, Jerwood sculpture prize and other shortlisted artists. Sculpture in the courtyard outside. There are also other Jerwood projects including the

Jerwood Space SE1; exhibits from all Jerwood prizes shown here..

Jerwood Gallery at the Natural History Museum, at Trinity Hall Cambridge, at Witley Park, Worcester and capital grants are being awarded for arts and educational projects. There are other prizes for fashion, dance, textiles and crafts and photography. Underground Waterloo and walk or Borough.

Jill George Gallery, 38 Lexington Street, London W1F OLL. Telephone: 020 7439 7319. www.jillgeorgegallery.co.uk. E-mail: jill@jillgeorgegallery.co.uk. Open weekdays 10-6pm, Saturday, 11-4pm. Director: Jill George.
The gallery deals in paintings and drawings by established artists. Recommended by an art collector for first time and regular buyers. Artists include: Michael Ajerman, Martyn Brewster, Jill Frost, David Mach, Alison Lambert, Chris Orr, Fraser Taylor, David Leverett, Alessandro Gallo. Underground Oxford Circus.

JiqJaq, 112 Heath Street, Hampstead, London NW3 1DR. Telephone: 020 7435 9300. www.Jiqjaq.com. E-mail: magnus@jiqjaq.com. A small gallery selling prints by unknown artists. Underground Hampstead.

John Martin Gallery, 38 Albemarle Street, London W1X 3FB. Telephone: 020 7499 1314. www.jmlondon.com. E-mail: info@jmlondon.com
Contemporary art gallery. Exhibits at London Art fair. Artists include: Andrew Gifford, John Caple, Melita Denaro, Caroline Hunter, Leon Morocco, Olivia Musgrave, Fred Yates, Gennadii Gogoliuk, Richard Cartwright. Underground Green Park.

Jonathan Clark Gallery, 18 Park Walk, London SW10 OAQ. Telephone: 020 7351 3555. Fax: 020 7823 3187. E-mail: jclark@jonathanclarkfineart.com. Website: www.jonathanclark-fineart.com. Open Monday-Friday, 10-6.30pm, Saturday, 11-3pm. Modern and contemporary British Art; St Ives, Camden Town Group, Euston Road School and School of London and occasionally contemporary artists. Underground Sloane Square, then bus.

Jonathan Cooper, 20 Park Walk, London SW10 OAQ. Telephone: 020 7351 0410. www.jonathancooper.co.uk
Artists include wildlife and landscape artists, often traditional in subject matter. Artists include: Tanya Brett, James Gillick, Rosie Sanders, Craig Wylie, Susan Ogilvy, Rebecca Campbell, Clariss Koch. Underground Sloane Square, then bus.

Julian Lax, Flat J, 37-39 Arkwright Road, London NW3. Telephone: 020 7794 9933. By appointment only.
Fine prints; Chagall, Colquhoun, Frink, Hockney, Hodgkin, Matisse, Miró, Moore, Nicholson, Pasmore, Picasso and Piper.

Kate MacGarry, 95-97 Redchurch Street, London E2 7DJ. Telephone: 020 7613 3909. www.katemacgarry.com. E-mail: mail@katemacgarry.com. Open Thursday-Sunday, 12-6pm or by appointment.
Opened in 2002 and shows 6 exhibitions a year. Has shown UK artists but is now showing international artists.

Keith Talent Gallery, 2-4 Tudor Road, London E9 7SN. Telephone: 020 8986 2181. www.re-title.com. E-mail: keithtalent@onetel.com.
Set up in 2001 in 4000 square feet of space in London Fields as artists' studios and a gallery space. Directors: Andrew Clarkin and Simon Pittuck, who met at the RA Schools. The gallery directors are ambitious and international in their outlook and have links with overseas galleries and project spaces. They launched an art magazine inviting artists to comment on themes. An interesting gallery with lively ambitious directors.

Kew Gardens Gallery, Royal Botanic Gardens, Kew. Telephone: 020 8332 5168.
Regular exhibitions of paintings on a botanical theme. Opening times vary, but are usually Monday-Saturday, 9.30-4.45pm. Underground Kew.

Kingsgate Gallery, see Artists Register.

Michael Ajerman in his studio (Jill George Gallery).

Kings Road Gallery, 436 Kings Road, London SW10 OLJ. Telephone: 020 7351 1367. Fax: 020 7351 7007. E-mail: tanya@kingsroadgallery.com. Website: www.kingsroadartgallery.com Has shown photography, with images for sale in limited edition prints.

Knapp Gallery, Regents College, Inner Circle, Regents Park, London NW1. Telephone: 020 7487 7540. Open Monday-Friday but check times.
Regular exhibitions by known and unknown artists. Often theme exhibitions or artists of one nationality. Artists can apply.
Underground Baker Street.

Kufa Gallery, Westbourne Hall, 26 Westbourne Grove, London W.2. Telephone: 020 7229 1928. Open 10-6pm.
Middle Eastern arts; visual arts, architecture, music and

literature. Changing exhibitions, sometimes traditional, sometimes contemporary art. Underground Queensway.

Lambert, 73 Lexham Gardens, London W 8 6JL. Telephone: 07808 731 682. Open Tuesday, 2-9pm or by appointment. Contemporary art. Underground High Street Kensington.

Lamont Gallery, The Organ factory, Swanscombe Road, Holland Park, London W11 4SU. Telephone: 020 7602 3232. Fax: 020 7602 9900. Open Friday/Saturday, 11-6pm, or by appointment. E-mail: andrea@lamontart.com. Website: www.lamontart.com Contemporary art. Paintings, prints and photographs. Underground Holland Park.

Laura Bennett Gallery, 22 Leathermarket Street, London SE1. Telephone 020 7403 3714. Website: www.laurabennettgallery.com. Open Wednesday-Saturday, 12-6pm.

Laurent Delaye, 22 Barrett Street, London W.1. Telephone: 020 7629 5905. Open Tuesday-Friday, 10-6pm, Saturday, 12-6pm. Director: Laurent Delaye.
Good contemporary British and European artists in this established gallery. Underground Bond Street.

Lawrence O'Hana Gallery, 35-42 Charlotte Road, London EC2A 3PD. Telephone: 020 7739 0245. www.ohanagallery.com. E-mail: infgo@ohanagallery.com. Open Wednesday-Saturday, 10-6pm or by appointment.
Opened in 2003 and now has an ambitious programme of work by international and UK artists.

Lefevre Fine Art/Thomas Gibson Fine Art, 31 Bruton Street, London W1J 6QQ Telephone: 020 7408 0045. office@lefevre-fienart.com. Open Monday-Friday, 10-6pm.
Contemporary art as well as 19th and 20th-century European art and British 20th-century artists such as Edward Burra and LS Lowry. The old gallery owners Alexander and Desmond Corcoran now deal privately.

Leighton House Museum,12 Holland Park Road, London W14 8LZ. Telephone: 020 7602 3316.
Artists can apply for exhibitions in the temporary exhibitions space. Ideal for several artists exhibiting together. Near Holland Park. The curator at Leighton House also organises the exhibition spaces at the Orangery in Holland Park and the Ice House Gallery. Underground High Street Kensington and walk.

Frieze Art Fair stand.

Lena Boyle Fine Art, 1 Earls Court Gardens, London SW5 OTD. Telephone: 020 7259 2700. www.lenaboyle.com. E-mail: lena.boyle@btinternet.com
Exhibits at the London Art fair. Artists include: Craigie Aitchison, Mary Fedden, Josef Herman, Tessa Newcomb, Ashley Davies, Jack Pender, Loraine Rutt, Roland Sudddaby. Underground Earls Court.

Lennox Gallery, 77 Moore Park Road, Fulham, London SW6. Telephone: 07900 681264. Website: www.lennoxgallery.co.uk
Contemporary artists, not established. Gallery for hire. Underground Fulham Broadway.

Le Salon for Art Collectors, Telephone: (France) 003 306 6809 5042; (USA) 001 347 879 1128. www.vanessasuchar.com. E-mail: art@vanessasuchar.com.
Vanessa Suchar holds salons for art collectors at a variety of venues in smart hotels and galleries across London. She shows contemporary art by young artists. She also arranges shows in Paris and America.

Lesley Craze, 34 Clerkenwell Green, London EC1. Telephone: 020 7608 0393. Open by appointment.

Contemporary jewellery and silverware. Wendy Ramshaw, Liz Tyler, Vicky Amber-Smith. The best of British silversmithing and design.

Liberty and Co Ltd., Regent Street, London W.1. Telephone: 020 7734 1234. Open Monday-Friday, 9-5.30pm, Thursday, 9-7pm, Saturday, 9.30-5.30pm.
Prints and paintings, also craftwork by young designers. Shows have been in the basement and on the top floor. Underground Oxford Circus.

Linda Blackstone Gallery, The Old Slaughterhouse (rear of 13 High Street), Pinner, Middlesex. Telephone: 020 8868 5765. Open Wednesday-Saturday, 10-6pm. Director: Linda Blackstone. British contemporary representational paintings and sculpture. Artists can apply in writing with cv and illustrations and then artists will be seen by appointment only. Underground Pinner (Metropolitan line).

Lisson Gallery, 52-54 Bell Street (also 27 Bell Street), London NW1 5DA. Telephone: 020 7724 2739. Fax: 020 7724 7124. E-mail: contact@lisson.co.uk. www.lisson.co.uk. Open Monday-Friday, 10-6pm, Saturday,10-5pm.
Chairman: Nicholas Logsdail. Chief Executive: Jill Silverman van Coenegrachts. Directors: Michelle D'Souza.
An important contemporary art gallery. Many of their artists have been shortlisted for the Turner Prize over the years, as well as winners. Conceptual, minimal, sculpture and other recent developments in art have been shown here. Contemporary art, including painting, photography, sculpture, video installations. Artists include: Ceal Floyer, Art & Language, John Latham, Donald Judd, Sol Lewitt, Dan Graham, Robert Mangold, Grenville Davy (Turner winner), Richard Deacon (Turner winner), Shirazeh Houshiary, Anish Kapoor, Tony Cragg, Julian Opie, Fernando Ortega, Juliao Sarmento, Richard Wentworth, Christine Borland, Jason Martin, Douglas Gordon (Turner winner), Jemima Stehli, Jane and Louise Wilson, Matt Colishaw, Jonathan Monk, Simon Patterson, Pierre Bismuth, Mark Hosking, Thomas Schütte, Jan Vercruysse, Lili Dujourie, John Murphy and others. Artists should not apply. Underground Edgware Road.

Loggia Gallery and Sculpture Gardens, 15 Buckingham Gate, London SW1. Telephone: 020 7828 5963. Open Monday-Friday, 6-8pm, Saturday and Sunday, 2-6pm.
Members of the Free Painters and Sculptors Group only. Ideal place for buyers looking for sculpture by established artists. Underground Victoria.

The London Institute Gallery, (now the Arts Gallery) University of the Arts, 65 Davies Street, London W1K 2DA. Telephone: 020 7514 8083. Fax: 020 7514 6131. Open Monday-Friday, 10-8pm. Admission free.
The University of the Arts is the body that runs a variety of art schools including Central, St Martins, Chelsea, Byam Shaw, London School of Fashion, London College of Printing and Communications. The exhibition space is used by contemporary artists and people connected with the art schools. High standard of work shown. Underground Bond Street.

London Print Studio Gallery, 425 harrow Road, London W10 4RE. Telephone: 020 8969 3247. Fax: 020 8964 0008. Open Tuesday-Saturday, 10.30-6pm. Director: John Phillips.
London Print Studio promotes innovative print work in the graphic arts. Has shown prints by some well-known names in the printmaking world. Gallery policy: exhibitions are selected from applications and by invitation by the gallery curator in consultation with an exhibitions advisory committee which meets twice yearly, spring and autumn. Underground Westbourne Park.

Long & Ryle, 4 John Islip Street, London SW1P 4PX. Telephone: 020 7834 1434. Fax: 020 7821 9409. Open Tuesday-Friday, 10-5pm, Saturday, 10-2pm. Director: Sarah Long
Near Tate Britain. Contemporary British and European artists. Colour is usually a key highlight in their exhibitions, paintings and sculpture. Artists include: Sophie Benson, Ricardo Cinalli, Mark Entwistle, John Monks, Sarah Stitt. Artists can send slides and a copy of their cv. Underground Pimlico.

Lynne Stern Associates, Telephone: 020 7491 8905/8906. By appointment only. Art consultancy run by Lynne Stern for companies and corporate collectors. Large selection of work on view by British contemporary artists including: Norman Adams RA, Jennifer Durrant, Jean Gibson, Adrian Heath, Howard Hodgkin, Michael Kenny ARA, William Littlejohn RSW, John Loker, Anthony Whishaw and others. Specialists in advising and assisting businesses with purchase, hire and commissioning.

Lyric Theatre, King Street, London W.6. Telephone: 020 7741 2311. Open Monday-Saturday, 10-11pm, Sunday, 12-11pm.
Gallery space within a theatre context. Painting, photography and print exhibitions. Professional artists can apply. Underground Hammersmith.

The Mall Galleries, The Mall, London SW1. Telephone: 020 7930 6844. Open 7 days a week 10-5pm.
Annual exhibitions of work by members of the various art societies belonging to the Federation of British Artists (see Useful addresses-artist organisations). For hire also: 510 square metres and mailing list available. Write to 17 Carlton House Terrace, London SW1Y 5BD.

The Market, 4 Bedale Street, London SE1 9AL. Telephone: 020 7378 0002. E-mail: themarket@artsource.co.uk. Directors: Elliot McDonald and Patrick Burrows.
Set in Borough Market area this relatively new space has already shown work by Roland Hicks, Jeff Ty Lee, Liz Johnson-Arthur and Rob and Nick Carter. Painting and photography.

M+R a Place to Fill, 15A Kingsland Road, London E2 8AA. Telephone: 020 7729 1910. www.mrplacetofill.co.uk. E-mail: rupert@mrplacetofill.co.uk. Open Thursday-Sunday, 1-6pm. Contact: Rupert Blanchard and Chung Kin.
They admit they are young and have much to learn but meanwhile present shows by young artist friends. East end recent project space.

Maureen Michaelson, 27 Daleham Gardens, Hampstead, London NW3. Telephone: 020 7435 0510. By appointment.
Ceramics and prints by established names.

Mafuji Gallery, 2nd floor, 28 Shacklewell Lane, London E8 2EZ. Telephone: 020 8567 8222. Open Thursday-Saturday, 1-5pm.
Runs the London Zoku art competition. Contact the gallery for further details. Rail to Dalston/Kingsland. North London line/Rail.

Magnani, 82 Commercial Street, London E1. Telephone: 020 7375 3002. Fax: 020 7375 3006. Open Tuesday-Saturday 10-6. Contemporary cutting edge art.

Manner, First floor, 10 Manor Road, London N16 5SA. Telephone: 020 8800 4834. Open Tuesday-Saturday, 12-6pm. Contemporary cutting deg art. Rail to Stoke Newington.

Manya Igel Fine Arts, 21-22 Peters Court, Porchester Road, London W.2. Telephone: 020 7229 1669/8429. Open Monday-Friday, 10-5pm by appointment only.
20th-century British paintings and watercolours. Participates in various British art fairs. Underground Queensway.

Mark Gallery, 9 Porchester Place, Marble Arch, London W.2. Telephone: 020 7262 4906. Open Monday-Friday, 10-1, 2-6. Saturday, 11-1. Director: Helen Mark
Specialises in Russian 16th century icons, but also Ecole de Paris and modern and contemporary prints. Underground Marble Arch.

Mark Adams, 11 Haydn Park Road, London W12 9AQ. Telephone: 020 8740 4400. www.mafineart.com. E-mail: mark.adams@mafineart.com.
Mark Adams deals in 20th century and contemporary British and Irish art. By appointment only.

Mark Jason Fine Art, First Floor, 71 New Bond Street, London W1S 1DE. Telephone: 020 7629 4080. www.jasonfinearts.com. E-mail: info@jasonfinearts.com
Exhibits at the London Art fair in January. Artists include: Melanie Barrett, Kate Brinkworth, Edward Hadddon, Sumiko Seki, Oliver Wilson. Underground Green Park.

Marlborough Fine Art, and Marlborough Graphics, 6 Albemarle Street, London W1S 4BY. Telephone: 020 7629 5161. Fax: 020 7629 6338. E-mail : mfa@marlboroughfineart.com Website: www.marlboroughfineart.com. Open Monday-Friday, 10-5.30pm, Saturday, 10-12.30pm. Directors; Geoffrey Parton, John Erle-Drax, Armin Sienger.
20th/21st century paintings, prints, sculpture, contemporary art. The Graphics gallery is also based here. 20th-century Masters, German Expressionists and contemporary artists: Auerbach, Arikha, Bramham, Campbell, Chadwick, Chen Yifei, Stephen Conroy, Couch, Davis, Enkaona, Freud Prints, Hacker, Hambling, Hubbard, Ken Kiff, Bill Jacklin, Christopher Le Brun, Mason, Thérèse Oulton, Pasmore, Celia Paul, John Piper, Raphael, Paula Rego, Kokoschka and Sutherland. A major international art gallery with branches in Tokyo and Madrid. Artists should not apply but send invitations to exhibitions to the Directors. Underground Green Park.

Martin Summers Fine Art, 90 Oakley Street, Chelsea, London SW3. Telephone: 020 7351 7778. martin@ms-fineart.com.
Previously at Lefevre Gallery which has now closed, Martin Summers is now dealing privately from Chelsea. 19th and 20th century paintings, drawings and sculpture and early 20th century British art.

Park Village East, 1997-98, Frank Auerbach, Marlborough Fine Art.

Matthew Bown Gallery, 1st floor, 11 Savile Row, London W1S 3PG. Telephone: 020 7734 4790. Website: www.matthew-bown.com. Open Thursday-Friday, 12-6pm, Saturdays 12-4pm. Underground Bond Street.

Matts Gallery, 42-44 Copperfield Road, London E3 4RR. Telephone: 020 8983 1771. Open Wednesday-Sunday 12-6. Closed Monday and Tuesday. Robin Klassnik.
1500 square feet of space. They do not encourage unsolicited material. All exhibitions are commissioned especially for gallery spaces (all media shown). Gallery artists include: Willie Doherty, Jaroslaw Kozlowski, Kate Smith, Mike Nelson, Melanie Counsell, Juan Cruz, Lucy Gunning, John Frankland, Mel Jackson.

Mayor Gallery, 22A Cork Street, London W.1. Telephone: 020 7734 3558. Fax: 020 7494 1377. Open Monday-Friday 10-5.30, Saturday 10-1 (except August when they are closed on Saturdays). Directors: James Mayor and Andrew Murray.
Please apply by sending photographs in the first instance. 20th-century Masters and contemporary British, American and European painting, and works on paper. British and European

Surrealists, British and American Pop Arts, Kitchen sink painters. Usually holds some interesting exhibitions and the atmosphere is friendly. Underground Green Park/Bond Street.

McHardy Coombs Sculpture Gallery, 31 Shad Thames, Butlers Wharf, London SE1 2YR. Telephone: 020 7378 7300. www.mchardy-sculpture.com. E-mail: enquiries@mchardy-sculpture.com. Open Monday-Friday, 11-5pm, Saturday-Sunday, 12-6pm. Run by Neville and Agi Cohen.
At least 100 works of sculpture on display. They sell to private collections, public areas, awards, interior and exterior design from distinguished names to new discoveries. Nicola Godden, Neil Williams, Patricia Volk, Glynis Williams. No applications please! Price range from £50-£15,000. Underground Bermondsey.

Merrifield Studios, 110 Heath Street, London NW3. Telephone: 020 7794 0343. Open Wednesday-Sunday, 10-6pm. Director: Blackie Merrifield.
Paintings and prints by contemporary British artists as well as sculpture and drawings by Tom Merrifield. In Hampstead village on the way to the heath. Underground Hampstead.

Menier Chocolate Factory Gallery, 51/53 Southwark Street, London SE1 1RU. Telephone: 020 7407 3222. www.menier.org.uk
Gallery within a restaurant/theatre/arts context. Gallery is for hire. There have been some very good shows here in recent years. Excellent restaurant too! Underground Borough.

Messum's, 8 Cork Street, London W1X 1PB. Telephone: 020 7437 5545.
Contemporary paintings and sculpture from artists all over Britain. Has shown 'Painters and Sculptors from the South West' and Cornish artists as well as London established artists. The traditional and Impressionist paintings branch is at 40 Duke Street, St James's. Telephone: 020 7839 5180. Underground Green Park/Bond Street.

Michael Goedhuis (also listed under Goedhuis), 116 Mount Street, London W1Y 5HD. Telephone: 020 7629 2228.
The gallery specialises in contemporary Chinese art. Interesting to see the Chinese response to Western Modernism. Underground Green Park.

Michael Hue-Williams, (see **Albion Gallery**).

Michael Richardson Contemporary Art, (Art Space Gallery), 84 St Peter's Street, London N1 8JS. Telephone: 020 7359 7002. www.artspacegallery.co.uk. E-mail: mail@artspacegallery.co.uk. Open Tuesday-Saturday, 11-6pm.
Established contemporary artists. Underground Angel.

Millers Terrace (now known as Herald Street), 19 Millers Terrace, London E8 2DP. Telephone: 0781 333 9225. www.millersterrace.com. E-mail: mail@millersterrace.com. Open Friday-Sunday, 12-6pm or by appointment.
A project space for solo and group shows. Rail Dalston/Kingsland Silverlink.

Millinery Works Gallery, 85/87 Southgate Road, Islington, London N1 3JS. Telephone: 020 7359 2019. www.millinery-works.com. Open Tuesday-Saturday, 11-6pm, Sunday, 12-5pm. Shows Modern British art and contemporary art. Book launches have also been held here in conjunction with exhibitions. Underground Angel.

Mobile Home, 7 Vyner Street, London E2 9DG. Telephone: 020 8983 4567 7575. www.mobilehomegallery.com. E-mail: info@mobilehomegallery.com. Open Wednesday-Saturday, 12-6pm. Contact: Ronnie Simpson
Contemporary art gallery specialising in cutting edge exhibitions, often installations and video. Artists include: Artlab, Nick Crowe, Mark Fairnington, Magali Fowler, Francesco Gennari, Marta Marce, Roxy Walsh.

Modern Art, 10 Vyner Street, London E2 9DG. Telephone: 020 8980 7742. www.modernartinc.com. E-mail: info@modernart-inc.com. Open Thursday-Sunday, 11-6pm.
Contemporary sculpture by British artists.

Moreton Street Gallery, 40 Moreton Street, London SW1V 2PB. Telephone: 020 7834 7773/4/5. Fax: 020 7834 7834. E-mail: sales@frasdco.co.uk. Website: www.frasco.co.uk.
Some interesting contemporary painters such as Lydia bauman who was born in Warsaw but now lives in England.

Morley Gallery, 61 Westminster Bridge Road, London SE1. Telephone: 020 7928 8501 ext 30. Website: www.morleycollege.ac.uk. Open 10-9pm college terms,11-6pm otherwise.
All forms of art and craft are considered.150 linear feet on one floor. Must provide own costs for publicity, private views and security. Underground Lambeth North.

MOT Gallery, Unit 54/5th floor, Regents Studios, 8 Andrews Road, London E8 4QN. Telephone: 020 7923 9561. E-mail: motlondon@yahoo.co.uk. Open Friday-Sunday, 12-5pm or by appointment.
Founded in 2002 by Chris Hammond, Floyd Varey and Molly Mallinson. It is run as an independent space and curatorial project. Artists who have shown there include Liam Gillick, Martin Creed, Sonia Boyce, Jeremy Deller.

Museum of Installation, 175 Deptford High Street, London SE8 3NU. Telephone: 020 8692 8778. E-mail: moi@dircon.co.uk. Website: www.moi.dircon.co.uk. Open Tuesday-Friday, 12-5pm, Saturday, 2-5pm.
Installation art and video art. Underground New Cross.

MW Projects, 43B Mitchell Street, London EC1V 3QD. Telephone: 020 7251 3194 www.mwprojects.net. E-mail: info @mwprojects.net. Open Thursday-Friday, 12-6pm, Saturday, 12-5pm. Director: Max Wigram
Exhibits at Frieze Art fair in October annually. Variety of interesting exhibitions ranging from experimental installations to video, painting and photography by international artists. Max Wigram is also an important curator for other major shows internationally and is involved with the Bornemisza Foundation. Underground Old Street.

Nairi Sahakian Contemporary Art, 34 Burton Court, London SW3 4SZ. Telephone: 020 7730 0432. Fax: 020 7831 9489.
Site-specific art, sculpture and contemporary art by young artists.

National Theatre, South Bank, London Se1. Telephone: 020 7928 2033. Open Monday-Saturday 10-11pm.
Professional artists can apply for exhibitions here. Underground Waterloo.

Neffe-Degandt Fine Art, 32A St George Street, London W1R 9FA. Telephone: 020 7493 2630/629 9788. Fax: 020 7493 1379. Open Tuesday-Friday, 10-5.30pm, and by appointment.
This gallery holds an annual Raoul Dufy exhibition showing some of his exquisite watercolours and drawings. Paul Poiret dress designs 1917-19 have also been shown. Underground Oxford Circus.

New Academy Gallery, 34 Windmill Street, London W.1. Telephone: 020 7323 4700. Fax: 020 7436 3059. Open Monday-Friday, 10-6pm, Saturday, 11-5pm. Closed Sunday and Bank

MW Projects stand at Frieze Art Fair.

holidays. Directors: John and Jill Hutchings.
Artists include: Jane Corsellis, Donald Hamilton-Fraser, Padraig MacMiadhachain and others. Northern Graduates show annually in August. Artists should not apply. Comprehensive art service to businesses,including hire scheme and commissions. Exhibitions of work by contemporary artists. Underground Goodge Street.

New Art Centre, (now The New Art Centre Sculpture Park and Gallery) at Roche Court, near Salisbury. Tel 01980 862244.
100 works by sculptors.

The New Gallery, 30 Exmouth Market, London EC1. Telephone: 020 7837 2632. Open Monday-Friday, 11-7pm, Saturday, 11-6pm. Directors: Kate and Lucy Holmes.
Applied Arts Agency's new gallery which shows small, one-off pieces by designers. Staff are available to help advise customers. Affordable prices for original craft and design work. Next to Moro's restaurant.

New Grafton Gallery, 49 Church Road Barnes, London SW13 8HH. Telephone: 020 8748 8850. Open Tuesday-Saturday, 10-5pm. Director: David Wolfers.
Professional artists can apply at any time of the year by post, including slides or photographs and cv. Send sae. Modern British figurative work only, 1900-2000. Artists include: Ken Howard, Fred Cuming, John Nash, Sir Hugh Casson, Tom Coates, Todd Warmouth, Ruth Stage, Richard Pikesley and others. One floor. Portrait painting centre. Rail to Barnes.

Nine Clarendon Cross Gallery, 9B Clarendon Cross, London W11 4AP. Telephone: 020 7792 0895. www.nineclarendon-cross.co.uk. This gallery space can be hired by artists. Underground Holland Park.

Northcote Gallery, 110 Northcote Road, Battersea, London SW11 6QX. Telephone: 020 7924 6741. Fax: 020 7223 4711. Open Tuesday-Friday, 11-7pm, Saturday, 11-6pm. Director: Ali Pettit. Contemporary paintings. Artists include: Robert McKellar, Shazia Mahmoud, Petrina Stroud, Debi O'Kehir. Rail to Clapham Junction.

Numbers Gallery, 17 Shoreditch High Street, London E2 8AA. Telephone: 07816858757. www.numbers-gallery.com. E-mail: press@numbers-gallery.com.
A curatorial collective in the east end with rising names. Not a fixed site.

The Nunnery, (see **Bow Arts Trust** entry).
Telephone: 020 8983 9737. Fax: 02 8980 7770. Thursday-Sunday, 12-6pm. Director: Stuart Glass. Unsolicited applications considered. Contemporary visual and performance art.

The October Gallery, 24 Old Gloucester Street, London WC1. Telephone: 020 7242 7367. Fax: 020 7405 1851. www.octobergallery.co.uk. E-mail: octobergallery@compuserve.com. To hire the gallery space, telephone: 020 7831 1618. Open

Rosella Namok at her exhibition at the October Gallery.

Tuesday-Saturday, 12.30-5.30pm. Café open 12.30-2.30pm.
Director: Chili Hawes. Artistic director: Elisabeth Lalouschek
Art centre with bookshop, theatre, coffee shop, photo lab and
lively gallery. Paintings, prints and sculpture from Africa, Asia, the
Americas, Australia, Oceania, Europe and the Middle East. This
gallery is a breath of fresh air if you want a change from exces-
sive conceptual art! The gallery celebrated its 25th anniversary
in 2004 showing that it still has a place in the London art world
and some of its artists were shown in the Africa Remix show at
the Hayward gallery in 2005. Artists include: Aubrey Williams,
Gerald Wilde, Koumy, Laila Shawa, Ruki Fame, Osi Audu, El
Anatsui, Pablo Amaringo, Juliete Rubio, Francesco Raimondi,
Wavy Gravy, Twins Seven Seven, contemporary art from Tibet
and many others. Applications are considered. Send 6 slides or
photos, a c.v. and self-addressed stamped envelope. One floor
of space 40x20. Variety of paintings, performance, mixed media
shows. Underground Holborn.

Offer Waterman & Co, 11 Langton Street London SW10 0JL.
Telephone: 020 7351 0068. Fax 020 7351 2269. www.water-
man.co.uk. E-mail: info@waterman.co.uk.
Shows Modern British artists, often figurative. Artists include:
Reg Butler, Prunella Clough, Bomberg, Burra, Lanyon, Sickert,
Vaughan, Wallis and other major Modern British artists.
Underground Sloane Square.

Oliver Contemporary, 17 Bellevue Road, London SW17 7EG. Telephone: 020 8767 8822. www.oliverart.co.uk. E-mail: mail@oliverart.co.uk. Artists include: Richard Ballinger, Gillian Beckles, Tony Scrivener, Catherine Armitage, Matthew Batt, Mary Ford, Ursula Leach, Julian Meredith, Philip Turner. Exhibits at the London Art Fair in January.

One in the Other, 4 Dingley Place, London EC1V 8BP. Telephone/Fax: 020 7253 7882. www.oneintheother.com. E-mail: oneintheother@blueyonder.co.uk. Open Thursday-Sunday, 12-6pm. Contemporary cutting edge art. Has shown work by Michael Raedecker, Paul Noble, Chantal Joffe and others. They moved here recently from central London.

Osborne Studio Gallery, 13 Motcomb Street, London SW1X 8LR. Telephone: 020 7235 9667. Fax: 020 7235 7608. Website: www.osg.uk.com. Open Monday-Friday, 10-6.30pm. Weekends by appointment.
Specialises in racing and sporting by contemporary and 19th century artists.They also deal in landscape and figurative works and publish prints. Artists include: Jonathan Trowell, Katie O'Sullivan, Donald Greig, David Hemmings, Martin Williams, Lucy Dickens, John King, Juliet Cursham. Underground Knightsbridge.

Osborne Samuel, 23A Bruton Street, London W1J 6QG. Telephone: 020 7493 7939. www.osbornesamuel.com. E-mail: info@osbornesamuel.com
In 2004 Scolar Fine Art/Gordon Samuel and Berkeley Square Galleries merged to form Osborne Samuel at the old Berkeley Square galleries address, as above. The gallery still deals in Modern British art; prints/books/paintings. Underground Green Park/Bond Street.

Panter & Hall, 9 Shepherd Market, Mayfair, London W1J 7PF. Telephone: 020 7399 9999. Fax: 0230 7499 4449. E-mail: enquiries@panterandhall.co.uk. Website: www.panterandhall.co.uk. Open Monday-Friday 10-6. Directors: Tiffany Panter and Matthew Hall. Scottish contemporary and Modern British painting. Artists include: Mary Fedden, Simon Laurie, Luke Martineau, Edward Seago, Alberto Morocco, Paul Maze, John Piper, Gordon Wyllie. Does not consider applications. Exhibits at the London Art Fair in January. Underground Green park.

Paper Mint Art, 70 Maxted Road, London SE15 4LF. Telephone: 020 7639 8214. Fax: 020 7639 6237. Website :

www.papermintart.co.uk. By appointment only. Directors: Eduardo Santanna and Gary Gatter.
Contemporary 20th century British and European prints and photography. Artists/photographers include: Fraser Taylor, Colin Halliday, Kirsty McLaren, Tania Britto, Justine Allison, Edmund de Waal, Anthony Donne. Does not consider applications. Shows at the Affordable Art air, Art London. Rail to Peckham Rye or East Dulwich.

Parasol Unit, 14 Wharf Road, London N1 7RW. Website: www.parasol-unit.org.
Opened in 2005 this non-profit space has 800 square metres of gallery space and an artist-in-residence space. Designed by Claudio Silvestrin, Ziba de Weck runs her new space.

Paragon Press, 108C Warner Road, London SE5 9HQ. Telephone: 0207 736 4024. www.paragonpress.co.uk.
Gallery artists: Peter Doig, Terry Frost, Marc Quinn, Damien Hirst, Michael Landy, Gary Hume. Exhibits at Fieze Art Fair.

Paul Stolper, 78 Luke Street, London EC2A 4PY. Telephone: 020 7739 6504. www.paulstolper.com. E-mail: info@paulstolper.com
Exhibits at the London Art Fair every year. A relatively recent gallery and the artists include: Jeremy Deller, Simon Hutcyhens, Chris Jones, Colin Lowe, Grace O'Connor, Simon Periton, Vinca Peterson, Gavin Turk, Martin Vincent.

Peeps, 2 Pepys Road, London SE14 5SB. Telephone: 020 7358 0429.
Contemporary south London art space.

Peer, 99 Hoxton Street, London N1 6QL. Telephone: 020 7739 8080. www.peeruk.org. E-mail: mail@peeruk.org. Open Friday-Sunday, 12-6pm.
An independent space, a registered charity that presents projects in a variety of media in a small Hoxton gallery. They commission work.

Percy Miller Gallery, 5 Vigo Street, London W1S 3HB. Telephone: 020 7734 2100. Open Tuesday-Friday, 11-6pm, Saturday, 11-3pm. www.percymillergallery.com. E-mail: info@percymillergallery.com. Interesting contemporary shows by British and international artists.

Peter Gwyther Gallery, 29 Bruton Street, London W1X 7DB. Telephone: 020 7495 4747. Fax: 020 7495 6232.
Contyemporary art. Past shows include prints by Peter Blake and Andy Warhol. Underground Bond Street/Green Park.

Peter Nahum at the Leicester Galleries, 5 Ryder Street, London SW1 6PY. Telephone: 020 7930 6059. www.leicester-galleries.com. E-mail: peternahum@leicestergalleries.com.
Peter Nahum is well known in the art world for his sales of Old Master paintings but he seems to be dealing in more Modern British and contemporary art now. Artists include: Eileen Agar, Sandra Blow, Scottish Colourists, Terry Frost, Man Ray, Lartigue, Gwen John, Julio Gonzalez, John Tunnard, Anne Redpath and Michael Rothenstein. Exhibits at the London Art Fair. Underground Green Park.

Petley Fine Art, 9 Cork Street, London W1S 3LL. Telephone: 020 7494 2021. wwwpetleyfineart.com. E-mail: info@petleyfion-eart.com. Open Monday-Friday, 10-6pm, Saturday, 11-4.30pm.
Contemporary art; paintings and drawings. Underground Green Park.

Photofusion Photography Centre, 17A Electric Lane, Brixton, London SW9 8LA. Telephone: 020 7738 5774. Fax: 020 7738 5509. Gallery open Tues/Thurs/Friday, 10-6pm, Wednesday, 10-8pm, Saturday, 12-4pm.
A wide range of contemporary and historical photography, video and multi-media installations. The gallery is available to hire for exhibitions, book launches and events. Picture library and agency with 100,000 images and represents 100 photographers. New Media Workroom, darkroom and studio facilities. Underground Brixton.

Photographers Gallery Ltd, 5 & 8 Great Newport Street, London WC2. Telephone: 020 7831 1772. www.photonet.org.uk. Open Monday-Saturday, 11-6pm.
Photographers can apply at any time but decisions are made in early March and early October. Variety of work ranging from political/social documentation to historical and avant-garde contemporary. A number of spaces at both buildings. At No. 5 there is a reference library with 3000 books, slide library with 5000 slides of prints, a viewing room for buyers (Print sales are Tuesday-Saturday, 12-6pm). The bookshop has over 1200 titles, 400 postcards, posters and the noticeboard gives details of competitions, prizes and awards available in Britain. The membership scheme is excellent value for private views and

discounts. The Deutshe Borse Photography prize is held here annually. Underground Leicester Square.

The Piccadilly Gallery, 43 Dover Street, London W1S 4NU. Telephone: 0020 7629 2875. Fax: 020 7499 0431. Website: www.piccadillygall.demon.co.uk. Open Monday-Friday 10-5.30. British figurative work. Adrian Berg, John Kelly, John Morley and Michael Murfin. Also drawings for sale by Gill, Richards, Minton, Spencer. Underground Green Park.

Piers Feetham, 475 Fulham Road, London SW6. Telephone: 020 7381 3031. Open Tuesday-Friday, 10-1pm and 2-6pm, Saturday, 10-1pm.
Contemporary British painting and drawing. Shows: Glynn Boyd Harte, William Packer, Mike Pope, Guy Roddon, Linda Sutton, Elisabeth Vellacott, Laetitia Yhap, Caroline McAdam Clark. Small exhibition space, also framing. Open to applications by post with transparenmcies/photos and c.v. Underground Fulham Broadway.

Pilgrim Gallery, 58 Lambs Conduit Street, London WC1N 3LW. Telephone: 020 7269 6980.
A gallery dealing in cutting edge contemporary art. Underground Bond Street.

Pilot, Old Limehouse Town Hall, 646 Commercial Road, London E14 7HA. Telephone: 078 0226 6669. www.pilotlondon.org. E-mail: info@pilotlondon.org. Contact: Colin Guillement, Doriane Laithen, Elizabeth MacAlpine, Rory Macbeth, Matthew Poole and Emily Wardill.
A non-profit independent space for contemporary art. Supported by the Arts Council England.

Pitshanger Manor Gallery (PMG), Mattock Lane, Ealing, London W.5. Telephone: 020 8567 1227. Webiste: www.ealing.gov.uk/pitshanger. Open Tuesday-Saturday, 11-6pm. Closed Monday and Bank holidays.
Subsidised by Ealing Education and Leisure Services. Applications open to West London artists. Underground Ealing Broadway.

Plateaux Gallery, 1 Brewery Street, Tower Bridge Piazza, Butler's Wharf, London SE1 2LF. Telephone: 020 7357 6880. www.plateaux.co.uk. Opening exhibition was of Huingarian Glass in 2005. Underground London Bridge/Bermondsey.

Platform, 3 Wilkes Street, London E1 6QF. Telephone/fax: 020 7375 2973. www.platform.dircon.co.uk. E-mail: sheila@platform.dircon.co.uk. Open Thursday-Sunday, 12-6pm or by appointment. Contact: Sheila Lawson

Contemporary cutting edge art. A project space for work ouptside the commercial art world. Proposals for exhibitions are considered from artists and curators.

Platform for Art, E-mail: Platform4Art@email.lul.co.uk. Website: www.lul.co.uk/Platform4Art.

Brings artwork to the underground. Gloucester Road gallery on the Circle and District line platforms, also Piccadilly Circus ticket hall (subway 2) and on the Piccadilly line 42 artists on one train for one month.

Plus 1 Plus 2 Galleries, 161-163 Seymour Place, London W1H 4PJ. Telephone: 020 7724 7304. Fax: 020 7724 5032. Website: www.plusonegallery.com. E-mail: info@plusonegallery.com. Open Monday-Friday, 10-6pm, Saturday, 10-2pm. Contact: Maggie Bollaert.

Contemporary artists based in London. It is also a full service gallery for international exhibitors in the city. Located near the new Paddington basin and paddington Central development. Offers a complete package for artists, dealers, galleries, embassies and institutions. Space rental, invitations, catalogues, framing, organisation of opening parties, contact with press, promotional events, mailing list, hanging of show, manned space and the gallery will, if required, take care of import of works and customs clearance. Apart from this the gallery has shown work by Mark Upton, Volker Kuhn, Dominic Rouse, Carl Laubin, Malcolm Poynter and Sarah Rossberg. Underground Paddington.

Posk Gallery, 238-246 King Street, Lodon W6. Telephone: 020 8741 1940. www.posk.org. Open daily, 11-9pm.

Local contemporary art gallery. Underground Ravenscourt Park.

The Prenelle Gallery, Dutch barge PRINS, Millwall inner dock, Opposite 189 Marsh Wall, London E.14. Telephone: 077 7972 4636. E-mail: preenelle@orange.net

This gallery is rather unusual in that it is in the converted cargo hold of a historic Dutch barge! It exhibits contemporary visual art, film and performance. Usually moored at Millwall inner dock adjacent to South Quay DLR.

Program, 1st floor, 2 New Burlington Place, London W1S 2HP. Telephone: 020 7439 1123. www.pro-gram.net. E-mail: info@pro-gram.net. Open Monday-Friday. 11-6pm, Saturday, 11-4pm. British and international contemporary art. Underground Bond Street/Green Park.

Pump House Gallery, Battersea Park, London SW11 4NJ. Telephone: 020 7871 7572. Fax: 020 7228 9062. Website: www.wandsworth.gov.uk/gallery. Open Wednesday-Sunday, 11-5pm, Saturday, 11-4pm. Director: Susie Gray. Contact the gallery for application details. Shows contemporay young British artists.

Purdy Hicks Gallery, 65 Hopton Street, Bankside, London SE1. Telephone: 020 7401 9229. Fax: 020 7401 9595. Website: www.purdyhicks.com. Open Monday-Friday, 10-5.30pm, Wednesday, 10-7pm, Saturday, 10-5pm. Directors: Jayne Purdy and Rebecca Hicks, Nicola Shane. Large gallery space in the fashionable area that is next to Tate Modern, also near the Globe Theatre. Artists include: Arturo di Stefano, Felim Egan, Estelle Thompson, David Hiscock, Rachel Budd, Michael Finch, Michael Porter, Andrez Jackowski, Mariannita Luzzati, Alice Maher, Katrharina Mayer, Hughie O'Donoghue, John Hubbard (Jerwood prizewinner). A dynamic gallery with refreshing shows. Underground Southwark or walk across the bridge from the other side of the Thames.

Portal Gallery, 43 Dover Street, London W.1. Telephone: 020 7493 0706. Website: www.portal-gallery.com. Open Monday-Friday, 10-5.45pm, Saturday, 11-2pm. Professional artists can apply at any time. Mainly 20th-century self-taught naive painters and figurative fantasy paintings. On two floors. Underground Green Park.

Portland Gallery, 9 Bury Street, St James's, London SW1. Telephone: 020 7321 0422. Open Tuesday-Friday, Saturday 9.30-5.30pm. Specialises in Scottish 20th-century art and also contemporary exhibitions. Exhibits at the London Art Fair. Artists include; George Devlin, Ann Oram, Jack Vettriano, Sophie MacPherson, Nick Botting, Ian Houston, Martin Mooney, Archie Forrest and many others. Underground Green Park.

Portobello Green, Portobello Road, at Westway under the bridge, London W.10.
24 small workshops run by professional craft, design and creative people. Worth a visit. Underground Westbourne Park.

Proof, Unit 6, The Glass House, Royal Oak Yard, 156B Bermondsey Street, London SE1 3TQ. E-mail: multiples@proof.demon.co.uk. Open Friday-Sunday, 12-6pm.

Proud Galleries, 5 Buckingham Street, London WC2. Telephone: 020 7839 4942. Open Monday-Friday, 10-6.15pm, Saturday/Sunday, 11-5pm.
Variety of contemporary art shows including mainly photographers although occasionally British artists. Proud Camden gallery too. See photo galleries section. Underground Charing Cross.

Quantum Contemporary Art, The Old Imperial Laundry, 71-73 Warriner Gardens, London SW11 4XW. Telephone: 020 7498 6868. www.quantumart.co.uk. E-mail: quantum.art@virgin.net
Artists represented include: Paul Bassingthwaite, Louise Bird, Atsuko Fujii, Cloe Cloherty, Jo Fox, Suzanne Roles, Yasmin Seaman, Sarah Wood and many others.

Rachmaninoff's, Unit 106, Kings Wharf, 301 Kingsland Road, London E8 4DS. Telephone: 020 7525 0757. www.rachmaninoffs.com. E-mail: info@rachmaninoffs. Open Wed-Sat, 11-6pm. Project space with work by international artists. Underground Old Street/Liverpool Street.

Railings Gallery, 5 New Cavendish Street, London W.1. Telephone: 020 7935 1114. Open Monday-Saturday, 9.30-6pm. Director: Geihle Sander.
Open to artists to apply, but ring the gallery first. Small contemporary art gallery. Recommended by an art collector as good for first-time buyers.

Rebecca Hossack Gallery, 35 Windmill Street, Fitzrovia, London W1. Telephone: 020 7436 4899 Fax 020 7323 3182. Open Monday-Saturday, 10-6pm. Director: Rebecca Hossack.
Contemporary artists (painting, prints, photography, ceramics) but also Australian Aboriginal art every summer and non-western art occasionally. Open to artists to apply in writing with slides and photos, but ring the gallery first, to see if your work is appropriate. Artists include: Lucy Casson, Ken Done, Helen Flockhart, Emma Haworth, Jilly Sutton, Mark Thompson, Alasdair Wallace,

Aboriginal writer at Rebecca Hossack Gallery in August.

Abigail McLellan, Christopher Wood and Cybele Young. Good place for art buyers. Rebecca also now runs 28 Charlotte Street Gallery nearby. Underground Goodge Street.

The Redfern Gallery, 20 Cork Street, London W.1. Telephone: 020 7734 1732. Open Monday-Friday, 10-5.30, Saturday, 10-12.30. Applications by professional artists should be made in the first six months of the year and an appointment should be made first. Contemporary art and established names include Sarah Armstrong-Jones, Janet Boulton, Elizabeth Butterworth, Ann Christopher, Paul Feiler, Adrian Heath, Paul jenkins, Linda Karshan, Brendan Neiland, Jo Self, Norman Stevens, Valerie Thornton,

David Tindle, Leon Underwood, Paul Wunderlich, Oxtoby, Preece, Kneale, Stevens and others. Eileen Agar the Surrealist artist's work is also on sale here. Underground Green Park.

Red Star Gallery, 14 Bowling Green Lane, London EC1R OBD. Telephone: 020 7251 3222. www.redstargallery.com. E-mail: info@redstargallery.com
Specialises in Russian art.Paintings, lithographs, works on paper. Underground Barbican.

Richard Green, 147 New Bond Street, London W1S 2TS. Telephone: 020 7491 3277. www.richard-green.com.
This gallery, one of 3, is one of London's most successful galleries according to sales figures annually. The other galleries deal in Old Master paintings. Mainly modern British art with artists such as JD Fergusson (Scottish Colourist), Terry Frost, Barbara Hepworth, Patrick Heron, Ivon Hitchens, George Leslie Hunter (Scottish Colourist), Lowry, Peploe (Scottish Colourist), Piper, Anne Redpath, Sickert, Vaughan, Christopher Wood. Contemporary artists include Allen Jones, Mary Fedden and Ken Howard. Underground Green Park/Bond Street.

Richard Nathanson, PO Box 515, London SW15 2WB. Telephone: 020 8788 2718. www.richardnathanson.com. E-mail: richard@richardnathanson.com. By appointment only.
Dealer in international major late 19th and early 20th century artists such as Bonnard, Modigliani, Redon, Renoir, Rouault and Sisley. Also shows contemporary artist Albert Houthuesen, an abstract colourist.

Ritter/Zamet, 2 Bear Gardens, London SE1 9ED. Telephone: 020 7261 9510. www.ritterzamet.com. E-mail: ritterzamet@ blueyonder.co.uk. Open Tuesday-Saturday, 10-6pm.
Contemporary project space. Underground Southwark.

RIBA, 66 Portland Place, London W.1. Telephone: 020 7580 5533. Open Monday-Friday, 10-6pm, Saturday, 10-2pm.
Exhibitions mainly of an architectural nature, but sometimes photographic. This is a wonderful spacious centre with an excellent restaurant and bookshop. Underground Regents Park/Oxford Circus.

Richard Salmon, Studio 4, 59 South Edwardes Square, London W.8 6HW. Telephone: 020 7602 9494. By appointment. International contemporary art and 20th Century Masters.

Riflemaker, 76 Beak Street, London W1. Telephone: 020 7439 0000. www.riflemaker.org. Open Monday-Friday, 10-6pm, Saturday, 11-6pm.
Contemporary artists. Exhibited at Zoo Art Fair in 2004. The owners met at Frieze Art Fair in 2003 and decided to set up this space in an old riflemaker's shop. Underground Oxford Circus.

Riverside Studios Gallery, Crisp Road, Hammersmith, London W.6. Telephone: 020 8237 1000. Fax: 020 8237 1001. Open 9-11. Closed Friday afternoons (seasonal). Sunday 12-10.30.
Contemporary, exciting, new young British multi-media artists. Selected applications. Please call ahead for further information. In a complex by the River Thames at Hammersmith, next to the famous Riverside Café. Underground Hammersmith.

Robert Sandelson, 5 Cork Street,London W.1. Telephone: 020 7439 1001. Fax: 020 7439 2299. Director: Robert Sandelson
In '99 Robert Sandelson opened a large new gallery at 5 Cork Street on two floors. Previously owner of the family gallery in Knightsbridge, Robert Sandelson deals in 20th century Modern and contemporary British and international art, including artists such as the international Louise Bourgeois and British artists Anne Rothenstein. On one floor he shows contemporary international (including Russian artists) and British artists also and on another 20th century Modern Art. A welcome addition to Cork street. Now the gallery has established itself as an important, lively, contemporary art venue. Underground Green Park/Bond Street.

Rocket Gallery, 130 Old Burlington Street, London W.1. Telephone: 020 7434 3043. Open Tuesday-Saturday, 11-7pm.
Innovative contemporary art, also books and photographs. Underground Bond Street/Piccadilly.

Rona Gallery, 1/2 Weighhouse Street, London W.1. Telephone: 020 7491 3718/499 8830. Open Monday-Saturday 10.30-5.30. Director: Stanley Harries.
Naive artists including Joe Scarborough, Margaret Loxton and Dora Holzhandler.

Rockwell, Top Floor, 230 Dalston Lane, London E8 1LA. Telephone: 079 7092 1237. E-mail: alex@therockwellproject. co.uk. Open Friday-Sunday, 10.30-6pm or by appointment.
An artist-run project space.Gallery, studios and home space.

Room & Art, 148 Curtain Road, London EC2A 3AT. Telephone: 020 7749 9338. An art consultancy that sells paintings, sculptures and photographs to corporations and individuals. By appointment only.

Rossi & Rossi Ltd, 91C Jermyn Street, London SW1Y 6JB. Telephone: 020 7321 0208. Fax: 020 7321 0546. E-mail: RossiRossi@compuserve.com.
This gallery has shown some wonderful photography exhibitions about Tibet and India by photographers such as Martine Franck. Also shows Tibetan and eastern sculpture. Underground Piccadilly.

Rosy Wilde, 139 White Cross Street, London EC1Y 8JL. Telephone: 020 7689 0304. www.rosywilde.com. E-mail: office@rosywilde.com. Open Friday/Saturday, 12-6pm.
Contemporary emerging artists. Underground Old Street (exit 6)/ Barbican.

Royal Academy, Burlington House, Piccadilly, London W.1. Telephone: 020 7300 8000. www.royalacademy.org.uk. Open daily, 10-6pm.
The Royal Academy is the oldest society in Britain, founded in 1768 and devoted to the fine arts. The Royal Academicians include many famous British artists but in recent years there have been disputes between the RAs and the management. It is famous for its annual summer exhibition of some 1000 paintings, drawings, prints and sculpture. It holds a variety of major exhibitions throughout the year and the Friends of the RA membership is very good value, to get maximum benefit from the RA. The magnificent Sackler Galleries upstairs have successfully combined modern architecture with historical. The lavish John Madejski Rooms, displaying the RA art collection, were opened a few years ago. Recently shows have been far more dynamic and contemporary, as well as major money-spinning blockbusters. The main galleries hold the major international touring shows and downstairs in the basement the RA schools hold degree shows in the summer as well as displays of prizewinning work, or other similar shows. There is an excellent shop/bookshop and the restaurant in the basement is well-worth visiting. The RA magazine is not just a house magazine but covers international and national art news and reviews. The RA expanded into 6 Burlington Gardens, old premises of the Mankind Museum. This has become a new space for the RA Schools, a conference area a lecture theatre and more gallery space. Photo London is held here annually in May. The Annenberg Courtyard

has become a stone-paved courtyard due to the generosity of the former USA Ambassador to London. Underground Piccadilly Circus/Green Park.

Royal Overseas League, Overseas House, Park Place, St James's Street, London SW1. Telephone: 020 7408 0214 ext 219 for visual arts exhibitions/cultural affairs. Fax: 020 7499 6738. As the ROSL is a club/hotel the gallery is open daily.
Commonwealth and UK artists are shown here and often tour to Edinburgh. There are now exhibitions all year round, usually by winners of ROSL annual exhibition, ROL travel scholars. Contact: Roderick Lakin. UK and Commonwealth artists under 35 selected by art travel scholarship. Further details ROSL Arts 0207408 0214 ext 219. E-mail: culture@rosl.org.uk. If you are looking for a comfortable London hotel facing onto Green Park it is well-worth joining the ROSL; the Edinburgh ROSL is very central too in Princes Street. Underground Green Park.

Royal College of Art Gallery, Kensington Gore, London SW7. Telephone: 020 7590 4444. Fax: 020 7590 4500. Open 10-6.
Now known as the **Henry Moore Galleries**. Also used by other organisations such as the **20th/21st Century Art Fair** in September. Often major shows, but watch Time Out or newspapers for details. Otherwise it is RCA graduate and postgraduate shows throughout the year. The RCA degree and postgraduate shows are essential viewing in June/July for anyone interested in up-and-coming artists. Underground High Street Kensington.

Royal Festival Hall, South Bank, London SE1. Telephone: 020 7928 3002. Open concert hall hours.
There are now a variety of exhibitions at Festival Hall using the large space down from the bar and one near the café, as well as upstairs. Applications are considered and exhibitions reach a far wider public than in most galleries. Underground Waterloo.

Royal Watercolour Society, see under **Bankside Gallery.**

Saatchi Gallery, County Hall, South Bank, London SE1. Telephone: 020 7823 2363 www.saatchi-gallery.co.uk. Open Sunday-Thursday, 10-8pm, Friday/Saturday, 10-10pm.
Charles Saatchi is one of Britain's most important contemporary art collectors. The collection is rotated and ranges from 1960s Pop Art to Damien Hirst, New Neurotic Realism and recent graduates of art school. Recently in 2005 he has decided to concentrate on painting (Marlene Dumas, Peter Doig and others).

Charles Saatchi donated 100 works by 64 artists to the Arts Council collection in 1999. These include many of the RA Sensation show artists. Charles Saatchi is one of the most important figures in the London contemporary art world. When he sells part of his collection the art world awaits with bated breath for the results. If he buys from certain galleries their future is assured for the near future. Saatchi has also recently given many paintings and sculpture to NHS hospitals; "Hymn" by Damien Hirst to Chelsea and Westminster hospital. Underground Waterloo/Westminster and walk over the bridge.

Sadie Coles HQ, 35 Heddon Street, London W1R 7LL. Telephone: 020 7434 2227. Fax: 020 7434 2228. Website: www.sadiecoles.com. Open Tuesday-Saturday, 10-6pm. Director: Sadie Coles.
Artists shown: Sarah Lucas, Elizabeth Peyton, Angus Fairhurst Don Brown, John Currin, Saul Fletcher, Nicola Tyson, Laura Owens, Gregor Schneider, Nicola Tyson, Andra Zittel. Sadie Coles was previously a director at Anthony d'Offay Gallery and also worked in New York. She is backed by Oliver Peyton, owner of the Atlantic Bar and Grill and Mash and selects art for the fashionable restaurants' walls, which encourages buyers to visit her central gallery in fashionable Heddon Street. Gagosian Gallery is next door. Artists should not apply. Exhibits at Frieze Art fair in October. Underground Oxford Circus/Piccadilly.

St John's Smith Square, The Footstool Restaurant Gallery, London SW1. Telephone: 020 7222 2168. Open Monday-Friday, 11.30-2.45pm.
Busy restaurant gallery setting near the Tate Gallery and often attended by politicians from the nearby Houses of Parliament and Conservatve Central Office. Underground Westminster.

Sarah Myerscough Fine Art, 15-16 Brooks Mews, off Davies Street, London W1K 4DS. Telephone: 020 7495 0069. Fax 020 7629 9613. www.sarahmyerscough.com. E-mail: info@sarah-myerscough.com. Open Monday-Friday, 10-6pm, Saturday, 11-2pm. Contemporary art gallery and consultancy. Has shown work by recent RA Schools graduates. Has also shown the DLA Art Awards for fine and applied arts graduates. Contact the gallery for details. Artists shown include: Nick Archer, James Lumsden, Alison Mills, Jenny Pockley, Tobit Roche, Patricia Rorie, Andy Stewart. Underground Bond Street.

Sara Pearce Fine Art, 14 Old Bond Street, London W1S 4PP. Telephone: 020 7499 6614. Fax: 020 7499 6615. E-mail: sara@spfa.clara.net. By appointment except when exhibitions are publicised. Director: Sara Pearce.

Painting, sculpture, pints, contemporary, photography, 20th century, design, USA/UK/Europe, worldwide. Artists include: Arabella Caccia, Joy Gerrard, Karl Maughan, Ross Neill, Emanuele Pantanella, Nicola Rae, Natasha Ramjoorawon. Gallery policy: send in c.v. and slides (no more than 10) for consideration. Underground Green Park/Bond Street.

Sartorial Contemporary Art, 101A Kensington Church Street, London W8 7LN. Telephone: 020 7792 5820. www.sartorialart.com. Open Monday-Friday, 1-6pm.

A variety of contemporary art and photography shows have been held here. Underground Notting Hill/Kensington High Street.

Scout Gallery, 1-3 Mundy Street, off Hoxton Square, London N1 6QT. Telephone: 020 7749 0909. www.scoutgallery.com. E-mail: mail@scoutgallery.com

International contemporary photography. Underground Old Street and walk.

Sculptastic, 9 New Quebec Street, Marylebone, London W1H 7RL. Telephone: 020 7224 8772. www.sculptastic.co.uk. Contemporary sculpture, ceramics and wood carvings. Underground Marble Arch.

Sesame Art, 354 Upper Street, Islington, London N1 OPD. Telephone: 020 7226 3300. www.sesameart.com. E-mail: info@sesameart.com

Artists include: Jan Braley, Maria Charlton, Jayne Jones, Marcus Nisbet, Henrijs Preiss, Matthew Small. Exhibits at the London Art fair. Underground Angel.

Selfridges, Oxford Street, London W.1. Website: www.inside-space.com. Managing Director of Inside Space: Helena Djurkovic.

Selfridges now has 2,500 square feet of art gallery space on the ground floor. Run by Inside Space so far there have been portraits taken by Rory Carnegie of Tracey Emin, the Chapman brothers, Jay Jopling and Sam Taylor-Wood; a film installation by Matt Collishaw; Abigail Lane. Art is accessible here and fashionable, as the YBAs predominate. Underground Bond Street.

Seven Seven Contemporary, 75-77 Broadway Market, London E8 4PH. Telephone: 07808 166215. www.sevenseven.org.uk. E-mail: sevenseven@gn.apc.org.
Non-profit artist-run gallery. Shows every three weeks. Works with international and national projects.

The Sheen Gallery, 245 Upper Richmond Road, London SW14 8QS. Telephone: 020 8392 1662. www.thesheengallery.com. E-mail: mike@thesheengallery.com
Exhibits at the London Art Fair annually in Islington. Modern British art and some contemporary art. Artists' work on sale include: Eileen Agar (the Surrealist), Cecil Collins, Bernard Dunstan, Dame Laura Knight, Sonia Lawson, Padraig MacMiadhachain, Conroy Maddox, William Roberts, Stanley Spencer, Sutherland, Anthony Whishaw, Charles Williams. Underground Richmond

The Ship, 387 Cable Street, London E1 OAH. Telephone: 07957114820. E-mail: theship@mail.com. Open by appointment only.
An independent space run by Nick Evans and Steve Asquith.

The Showroom, 44 Bonner Road, London E2.9JS. Telephone: 020 8983 4115. Fax: 020 8981 4112. E-mail: tellmemore@theshowroom.com. Website: www.theshowroom.com. Open Wednesday-Sunday, 1-6pm. Director: Kirsty Ogg
A showplace for lively contemporary art, often with installations. 6/7 shows a year. Open to artist applications but artists must ring the gallery first to see if their work is appropriate. Underground Bethnal Green.

Serpentine Gallery, Kensington Gardens, London W.2. Telephone: 020 7298 1520 /1515 (public information). Fax: 020 7402 4103. Website: www.serpentinegallery.org. Open daily, 10-6pm. Director: Julia Peyton-Jones.
The gallery was renovated and re-opened with a far higher standing in the art community and national and international sponsorship. Now one of London's leading galleries, showing Modern and contemporary art, often cutting-edge and provocative. Past shows since it re-opened have included Mariko Mori, Cornelia Parker, Chris Ofili ('98 Turner prizewinner), Louise Bourgeois and Andreas Gursky, the '98 Citibank photography prizewinner, Bridget Riley, William Kentridge, Tomoko Takahashi, the Wilsons and other contemporary leading YBAs (Young British Artists). Well worth visiting. The bookshop is now run by

Walther Koenig Books. Underground Lancaster Gate or High Street Kensington and 9, 10 buses, on one side of the park or 12, 94 on the Bayswater Road side.

Sheridan Russell Gallery, 16 Crawford Street, London W1H 1BS. Telephone: 020 7935 0250. Fax: 020 7935 1701.
This gallery is for hire and offers a mailing list and no commission. Has shown contemporary painters so far.

Shirley Day Gallery, 91B Jermyn Street, London SW1Y 6JB. Telephone: 020 7839 2804. Fax: 020 7839 3334. Director: Shirley Day.
Next to the Rossi & Rossi Gallery, this gallery has shown paintings and pottery by contemporary artists. Underground Piccadilly.

Simmons Gallery, 53 Lamb's Conduit Street London WC1N 3NB. Telephone: 020 7831 2080. Fax: 020 7831 2090. E-mail: info@simmonsgallery.co.uk. Website: www.simmonsgallery.co.uk. Open Monday-Friday, 10-5pm, Wednesday, 10-7pm. Director: Frances Simmons.
Shows sculpture, jewellery and numismatics. Has shown New Zealand sculpture and Pacific Rim. Underground Russell Square.

Simon Theobald, 180 New Bond Street, London W1S 4RL. Telephone: 020 7629 0629. www.simontheobald.com. By appointment.
Specialises in German Expressionist paintings. Underground Green Park.

Sketch Gallery, 9 Conduit Street, London W1S 2XG. Telephone: 0870 777 4488. www.sketch.uk.com.
Multi-functional gallery space showing video 10-5 Monday-Saturday in a large room with 12 projectors. Gallery space open to the public although this is a celebrity restaurant and bar. The more glitzy YBAs have shown here and post premiere parties have been held here.The interior is extraordinary and the loos are like something from outer space with low lighting, where you expect to disappear through the floor any minute upstairs and like spaceships downstairs. Worth visiting for the experience. Underground Bond Street.

Skylark, Studio1, Gabriel's Wharf, 56 Upper Ground, London SE1 9PP. Telephone/Fax 020 7928 4005. E-mail: info@skylark-gallery.com. Website: www.skylarkgallery.com. Open 11-6pm daily and 12-5 in winter.

Shows painting, sculpture and prints. Artists include: Gill Hickman, Carol Edgar, David Wagstaff, Saskia Ellis Holden. Artist-run gallery. Shows at the Affordable Art fair. Underground Waterloo.

Skylark 2, Unit 1.09 Oxo Tower Wharf, Barge House Street, London SE1 9PH. Telephone: 020 7401 9666. Open Tuesday-Sunday, 11-6pm.
Similar work to Skylark gallery. Artist-run space. Underground Waterloo.

Small Mansion Arts Centre, Gunnersbury Park, Popes Lane, London W.3.
Artists can apply for exhibitions. Ideal for large group shows or local artists. Underground Acton Town.

Sotheby's, 34-35 New Bond Street, London W.1. Telephone: 020 7293 5000. Open Monday-Friday, 9-4.30pm.
Auctions held daily of antiquities, Asian art, books, manuscripts, paintings, drawings, watercolours, prints (including contemporary art), photography, Chinese, Japanese and Islamic works of art, carpets, rugs, clocks, watches, coins, medals, arms and armour, costumes and textiles, silver, furniture and jewellery, stamps, tribal art, wine and vintage cars. Free advice and valuations given on the premises. Underground Bond Street/Green Park.

South Bank Centre, Royal Festival Hall, London SE1 8XX. See under **Royal Festival Hall.**

SouthBank Printmakers, Unit 12, Gabriel's Wharf, 56 Upper Ground, London SE1 9PP. Telephone: 020 7928 8184. www.southbankprintmakers.com. Open winter Monday-Friday, 11.30-5.30pm, Sat/Sun, 10-7pm. Summer Monday-Friday, 11.30-6.30pm, Sat/Sun, 10-8pm.
A co-operative of 37 of Britain's leading contemporary printmakers. Limited editions for sale with new shows every two months. Underground Waterloo.

South London Art Gallery, 65 Peckham Road, London SE5 8UH. Telephone: 020 7703 6120. www.southlondongallery.org. Open Tuesday-Friday, 11-6pm, Thursday, 11-7pm, Saturday/Sunday, 2-6pm.
An independent charitable trust. The new status was celebrated with a show of work by 100 artists in 2003. Exhibitions of

contemporary art, historical and retrospectives, also Live Art shows. Permanent collection also of British painting. The gallery was shortlisted in '96 for the Prudential Awards, as it is such a well-run and dynamic gallery. Underground Oval, then bus 36. Rail to Peckham Rye or Denmark Hill.

Space Station Sixty Five, 65 North Cross Road, London SE22. Telephone: 020 8693 5995. www.spacestationsixtyfive.com. Open Thursday-Sunday, 12-6pm.
Lively contemporary art gallery. Rail East Dulwich.

Space-twotentwo, Unit 2, 210 Cambridge Heath Road, London E2 9NQ. Telephone: 020 8980 5475. www. space-twotentwo.com. E-mail: info@space-twotentwo.com. Open Thursday-Sunday, 12-6pm. Contact: Lindsay Friend and Aidan McNeill.
Non-profit artist-run gallery showing work by emerging international artists in new media, video and photography.

Special Photographers Company, 236 Westbourne Park Road, London W.11 2EU. Telephone: 020 7221 3489. Open Monday-Saturday, 10-6pm. Directors: Chris Kewbank and Catherine Turner.
Stylish photography gallery near Portobello Road market, which sells photographs both to organisations and individuals, acting as agents for the photographers. Some interesting shows of fine art photography as well as commercial photography. Gallery, library and agency. Underground Ladbroke Grove or Notting Hill gate or buses 52, 7, 15, 23.

Spectrum Fine Art, 77 Great Titchfield Street, London W1W 6RF. Telephone: 020 7637 7778. www.spectrumlondon.co.uk. E-mail: info@spectrumlondon.co.uk. Open Monday-Friday, 10-6pm, Saturday, 10-4pm.
Theme exhibitions and work by contemporary artists, often recent graduates or emerging artists. Underground Goodge Street.

The Spitz Gallery (Element 3), 109 Commercial Street, Old Spitalfields Market, London E1 6BG. Telephone: 020 7392 934. Fax: 020 7377 8915. Gallery curator: Tris Dickin.
Contemporary photography, also live music venue, bar and bistro in the lively Spitalfields market. Includes hi-tech new information shows. Underground Liverpool Street.

Sprovieri, 27 Heddon Street, London W1. Telephone: 020 7734 2066. www.sprovieri.com. Open Tuesday-Saturday, 10-6pm. Contemporary art. Underground Piccadilly.

Spruth Magers Lee, 12 Berkeley Street, London W1J 8DT. Telephone: 020 7491 0100. www.spruethmagerslee.com. E-mail: info@spruethmagerslee.com. Directors: Simon Lee, Philomena Magers, Monika Spruth
A major contemporary art gallery that exhibits at Frieze Art fair annually. Artists shown include: John Baldessari, Alighiero e Botti, Bernd and Hilla Becher, Fischli/Weiss, Jenny Holzer, Andreas Gursky, Donald Judd, Cindy Sherman, Stephen Shore, Rosemarie Trockel, Christopher Wood, Barbara Kruger. Underground Green Park.

Stables Gallery, Gladstone Park ,Dollis Hill Lane, London NW2.6HT. Telephone: 020 8452 8655. Open Thursday-Sunday, 11-6pm. April-September, 11-6pm.
Open to artist applications but ring the gallery first as they are heavily-booked. Apply in spring for next year. Contemporary artists, especially recent graduates. Underground Dollis Hill.

Stables Gallery, Riverside, Twickenham TW1 3DJ. Telephone: 020 8405 2014.
Contemporary artists, usually young and up-and-coming. Underground Richmond.

Standpoint Gallery, 45 Coronet Street, London N.1. 6HD. Telephone/Fax: 020 7739 4921. Open Wednesday-Sunday 12-6. Contact: Rebecca Finney.
Contemporary art, usually paintings. One of several galleries in this area. There are studios upstairs, as its aim is to provide low cost studios and exhibition space. Studios set up in 1985 and the gallery in 1993. Underground Old Street.

Stark Gallery, 384-386 Lee High Road, Lee Green, London SE12 8RW. Telephone: 020 8318 4040. www.starkgallery.com. Open Tuesday-Saturday, 10.30-6pm, Sunday, 11.30-4.30pm.
Exhibitions of contemporary art and crafts. Also does framing. Rail Lewisham/Blackheath.

Start Gallery, 493 Fulham Palace Road, London SW6 6SU. Telephone: 020 7371 0909. Fax: 020 7736 9494. Open Monday-Friday, 12-5.30pm, Saturday, 12.30-6pm.
Has shown paintings by Tanzanian artists as well as other con-

Standpoint Gallery, Coronet Street, Hoxton.

temporary artists. Underground Putney Bridge.

Stephanie Hoppen Gallery, 17 Walton Street, London SW3 2HX. Telephone: 020 7589 3678. www.stephaniehoppen.com. E-mail: stephanie@stephaniehoppen.com
Better known as a designer, Stephanie Hoppen also runs a gallery and shows at the London Art fair. Her brother Michael Hoppen runs the successful Chelsea photography gallery. Her artists include: Lorioz, Sandrine Bihorel, Ronald du Pont, Stéphane Joannes, Andres Labaké, Francisco Luna, Martin La

Rosa, Ana Fabry, Patrizia Medail, Mark Brazier-Jones, Dal Webber, Louise Bobbe. Underground Knightsbridge.

Stephen Friedman Gallery, 25-28 Old Burlington Street, London W.1. Telephone: 020 7494 1434. Fax: 020 7494 1431. Open Tuesday-Saturday 10-6. E-mail: frie@dircon.co.uk. Director: Stephen Friedman.
A cutting-edge gallery near Cork Street, with interesting shows by contemporary artists from the international mainstream of conceptual and Minimal art. Artists can apply and submit ten slides and a c.v., as well as a stamped addressed envelope. The director goes through slides 2 or 3 times a year and he never looks at an artist's work in front of him/her. Gallery artists are: Anya Gallaccio, Kerry Stewart, Peter Fraser, Yinka Shonibare, Alexis Harding and Vong Phaophanit. Overseas artists include: Stephan Balkenhol, Jessica Stockholder, Betty Goodwin and Tom Friedman. An important contemporary gallery. Underground Bond Street/Green Park.

Stephen Lacey Gallery, 1 Crawford Passage, Ray Street, London EC1R 3DP. Telephone: 020 7837 5507. Fax: 020 7837 5549. E-mail: info@stephenlaceygallery.co.uk. Open Tuesday-Friday, 11-6pm, Saturday, 12-4pm.
Has shown a variety of contemporary painters including Graham Dean. Underground Liverpool Street.

Store, 92 Hoxton Street, London N1 6LP. Telephone: 020 7729 8171. www.storegallery.co.uk. E-mail: info@storegallery.co.uk. Open Wednesday-Saturday, 11-6pm. Contact: Louise Hayward and Niru Ratnam.
Opened in June 2003 as a gallery to show international artists at the start of their careers.

Studio A Gallery, Studio A, 50 Acton Mews, London E8 4EA. Telephone: 020 7241 1175. www.studiogallery.com. E-mail: info@studiogallery.com. Open Thursday-Sunday, 12-6pm.
Sound pieces and installations. Underground Liverpool Street/ Old Street.

Studio Sienko Gallery, 57A Lant Street, London SE1 1QN. Telephone: 020 7403 1353. Open Monday-Friday, 11-6pm.
Has shown work by printmakers including François Pont. Underground Borough.

Studio Voltaire, 1A Nelson's Row, London SW4 7JR. Telephone: 020 7622 1294. www.studiovoltaire.org. E-mail: info@ studiovoltaire.org. Open Thursday-Sunday, 1-6pm.
Interesting project space and gallery with solo and group shows of work by British artists. Underground Clapham Common.

Sutton Lane, 1 Sutton Lane, London EC1M 5PU. Telephone: 020 7253 8580 www.suttonlane.com E-mail: info@suttonlane.com. Directors: Gil Presti and Sabine Spahn.
Exhibits at Frieze Art Fair annually. Contemporary artists include: Ernesto Caivano, Camilla Law, Yuri Masnuj, Toby Paterson, Pavel Pepperstein, Christoph Ruckhuberle, Cheyney Thompson, Eric Wesley, Michael Wilkinson and others.

Swiss Cottage Library, 88 Avenue Road, London NW3. Telephone: 020 7278 4444 ext 2457. Open library hours.
Contemporary art by professional local artists. Artists can apply. Underground Swiss Cottage.

t1+2 artspace, 4 Steward Street, London E1 6AL. Telephone: 079 0387 6522. www.t12artspace.com. E-mail: info@t12art-space.com. Open Wednesday-Sunday, 12-6pm. Contact: Wolfe Lenkiewicz,
Artist-run non-profit gallery showing work by arists whose work is often difficult to show.

Tabernacle, (The Tablet Gallery) Powis Square, London W.11. Telephone: 020 7565 7890. Open Wednesday-Saturday 12-6.
This local Notting Hill gate arts centre has been transformed with an injection of lottery money into a lively, smart venue for the arts, with café, theatre group and gallery space for local artists. The directors of "Notting Hill" (the film in '99) even gave the centre money. Undergound Ladbroke Grove/Notting Hill gate and walk down the hill.

Tate Britain, Millbank, London SW1. Telephone: 020 7887 8000/ 8008. Website: www.tate.org.uk. Open daily 10-5.50pm. Director: Stephen Deuchar. Sir Nicholas Serota is the overall director of all four Tates.
The new Tate Gallery of British Art opened in summer 2001 and the centenary galleries in late 2001 with a wonderful new entrance on Atterbury Street. Downstairs there is a temporary space now for exhibitions and upstairs the British collection has been rehung in the new galleries, with specific rooms for Constable, Blake, Hogarth and starting with English Renaissance

Lyn Chadwick sculptures, Duveen galleries, Tate Britain.

art with Holbein and Nicholas Hilliard you can progress through the galleries learning more about British Art along the way. The survey is now portrayed historically instead of the previous post-modern approach, where new art was hung next to paintings several centuries earlier. There is access to the collection via the Internet. The Turner prize remains at Millbank, with an exhibition annually in October/November, as this comes under the British art remit. The new Tate Archives (Hyman Kreitman research Centre) are based here; magnificent archives of artists' diaries, photographs, manuscripts, letters etc. The Tate has an Espresso Bar in the basement to cope with the growing numbers of visitors, especially at Turner Prize time. The bookshop has an excellent selection of art books, catalogues, magazines and postcards, with knowledgeable staff. Discounts at the shop for Friends of the Tate. Underground Pimlico or 88 bus from Trafalgar Square or Oxford Circus.

Tate Modern, Sumner Street, Southwark, London SE1. Telephone: 020 7887 8000/8008 (central Tate number). Open daily 10-6. Late openings occasionally for special shows.
This old Power station designed by Sir Gilbert Scott, has been made into a Modern Art palace, by Swiss architects Herzog and de Meuron. A magnificent new museum, Tate Modern has become one of the three great modern art museums in the world since 2000. It became the national gallery of internation-al modern art, continuing where the National Gallery at Trafalgar

Square ends in the late19th century. As a landmark on riverside London at the Millennium, it attracted a large group of visitors from overseas as well as within Britain and London in particular. Although fine art is the main focus, architecture, design and film are on display and the decorative arts. Displayed in themes on each floor, avoiding a historical story of art, on level 3 east we have Still life/Reallife/Object with Marcel Duchamp, Léger, Bill Woodrow and photographs. On level 3 west Landscape/ Matter/Environment shows works by Ellsworth Kelly, Joseph Beuys, Richard Deacon, Mark Rothko and Richard Long. On level 5 east Nude/Action/Body has videos by Sam Taylor-Wood, sculpture by Giacometti, Louise Bourgeois, Henri Matisse and Bruce Nauman. On level 5 west History/Society/Memory includes Dan Flavin, Mondrian, Naum Gabo, Stanley Spencer, Fluxus, Andy Warhol and manifestoes. This postmodern approach to display is thought-provoking and has been a great success at Tate Modern with millions visiting since it opened. Some British 20th century art will move between the museums according to exhibitions and displays. The Janet Wolfson de Botton gift collection is based here. Other facilities include an information centre, auditorium, education centre, gift shops, a café with outdoor terrace and a restaurant with views across London. A new millennium bridge has been built with sculptures by Anthony Caro,designed by Norman Foster, to facilitate access to the Tate Modern, known as the "wobbly bridge" due to all the swaying when it first opened. A Bankside Browser open-exhibition is open to Southwark artists. Tate Modern has a strong programme involving local events at Southwark and with the Southwark community. It also holds major international shows such as the Matisse-Picasso in 2002, Edward Hopper 2004, Joseph Beuys in 2005. Dynamic international contemporary artists like Katharina Fritsch, Luc Tuymans have also been shown. Underground London Bridge/Blackfriars/Southwark or St Pauls and walk over the bridge.

The Taylor Gallery, 1 Bolney Gate, London SW7. Telephone: 020 7581 0253. Open Monday-Friday 10-5.
Annual exhibition of Irish art, which is usually worth visiting. Also deals in contemporary paintings. Underground South Kensington.

TemporaryContemporary, 2nd floor, Atlantic House, The Old Seager Distillery, Deptford Bridge, London SE8 4JT. Telephone: 07971 292 817. www.tempcontemp.co.uk. E-mail: info@temp-contemp.co.uk. Open Thursday-Sunday, 12-6pm. Contact: Anthony Grass and Jen Wu.

Opened in March, 2004 in a huge industrial space in a distillery in Deptford. Artist-run, studio complex, commercial gallery and social centre for other artists. Experimental space.

Thackeray Gallery, 18 Thackeray Street, Kensington Square, London W8 5ET. Telephone: 020 7937 5883. Fax: 020 7937 6965. www.thackeraygallery.com E-mail: thackeraygallery@aol.com. Open Tuesday-Friday, 10-6, Saturday, 10-4pm. Closed Sunday and Monday. Director: Anne Thomson
Open to applications with slides/photos and covering letter. Gallery closed January and August. Mainly British and contemporary art. Marj Bond, Kyffin Williams, Alberto Morocco, Gordon Bryce, Emily Young, Mark I'Anson, Victoria Crowe, Joanna Carrington and others. Ground floor and basement. Underground High Street Kensington.

Thomas Dane, 11 Duke Street St James's, London SW1V 6BN. Telephone: 020 7925 2505. www.thomasdane.com. E-mail: info@thomasdane.com Contact: Thomas Dane, Francois Chantala. Gallery artists: Hurvin Anderson, Anya Gallaccio, Stefan Kurten, Michael Landy, Steve McQueen, Albert Oehlen, Psul Pfeiffer. Exhibits at the prestigious Frieze Art fair in October.
Underground Green Park.

Thompson's Gallery, 76 Marylebone High Street, London W1U 5JU. Telephone: 020 7935 3595. www.thompsongallery.co.uk. E-mail: enquiries@thompsonsgallery.co.uk.
Modern British and contemporray paintings. Exhibits at the London Art fair. Artists include: Jessica Cooper, Mary Fedden, Terry Frost, Robert Kelsey, Jo Taylor, Peter Howson, Frederick Gore, Donald McIntyre, Piper, Russell-Flint, Glen Scouller, Carel Weight, Edward Seago. Underground Regent's Park/Bond Street.

Three Colts Gallery, 2nd floor, Greenheath Business Centre, Three Colts Lane, Bethnal Green, London E2. Telephone: 020 7790 0995. www.ethicalimaging.net/threecoltsgallery. E-mail: threecolts@ethicalimaging.net. Contact: Pat Harris, Arnat Taffell. Opened in April 2004. Non-profit space and artists can curate their own shows. A show roughly every month. Space is sponsored by Ethical Iamging Ltd.

Timothy Taylor Gallery, 1 Bruton Place, London W1J 6LS. Telephone: 020 7409 3344. Fax: 020 7409 1316. E-mail: mail@ttgallery.com. Website: www.ttgallery.com. Open Monday-

Friday, 10-6pm, Saturdays by appointment only. Directors: Timothy Taylor and Terry Danziger-Miles.

Interested in contemporary international and British art, including painting, sculpture, photography and a wide selection of prints. Artists include: Craigie Aitchison, Michael Andrews estate, Miquel Barcelo, Jean-Marc Bustamante, Philip Guston estate, Roni Horn, Guillermo Kuitca, Jonathan Lasker, James Reilly, Julian Schnabel, Sean Scully, Joel Shapiro, Juan Usle. Exhibits at Frieze Art fair. Underground Bond Street/Green Park.

Tom Allen Arts Centre, Grove Crescent Road, Stratford, London E15. Telephone: 020 8519 6818. Open Monday-Friday, 12-7pm, Saturday, 12-5pm.

Contemporary, young and often struggling artists.

Tom Blau Gallery, 21 Queen Elizabeth Street, London SE1 2PD. Telephone: 020 7378 1300.

Photography exhibitions mainly from Camera Press photographers and Focal Point. Underground Tower Bridge and walk over the bridge.

Toni Heath Gallery, 10 Lambs Conduit Passage, London WC1R 4RH. Telephone: 020 7831 3002. www.toniheath.com. E-mail: toniheath@msn.com. Open Monday-Friday, 11-7pm, Saturday, 12-5pm.

Contemporary paintings. Underground Holborn.

Transition, 110A Lauriston Road, London E9 7HA. Telephone: 020 8533 7843. www.transitiongallery.co.uk. E-mail: transition@huntergather.com. Open Friday-Sunday, 1-6pm. Contact: Cathy Lomax.

Artist-run space set up by Cathy Lomax in October 2002. Shows leftthinking, anti-establishment work.There is now a shop selling limited edition publications and artist-made objects and works.

Transit Space, 1st floor, 24 Tudor Grove, London E9 7QL. Telephone: 020 7359 3885. E-mail: art@transitspace.com. Website: www.transitspace.com. Open Saturday and Sunday, 1-6pm during shows.

A variety of events and installations. Underground Bethnal Green/ Hackney Central / London Fields then buses D6, 55, 106, 253.

Tricycle Theatre Gallery, Tricycle Theatre, 269 Kilburn High Road, London NW6.7JR Telephone: 020 7372 6611. Fax: 020 7328 0795. Open theatre hours, 11-11.

Exhibitions by young, unknown local contemporary artists. Good selling outlet. Artists must be studying at or recently graduated from a recognised art school and that this will be their first exhibition, or, that the artist is resident in the London Borough of Brent. Also shows disabled artists, artists from ethnic minorities within the local communities—Asian/Irish/Afro-Caribbean, work from local schools and occasional exhibitions by artists of national or international stature. Underground Kilburn.

Trolley, 73A Redchurch Street, London E2 7DJ. Telephone: 020 7739 5948. www.trolleybooks.com. E-mail: gigi@trolleybooks.com Specializes in art and photography books. Exhibitions are related to book projects.

Unrealised Projects, Telephone: 07946701590 www.unrealiseprojects.org. E-mail: unrealisedprojects@hotmail.com. Collects submitted proposals from artists.

Union, 57 Ewer Street, London SE1. Telephone: 020 7928 3388. www.union-gallery.com. Open Monday-Friday, 10-6pm, Saturday, 12-6pm. Independent project space and gallery. Exhibited in the first Zoo Art Fair in 2004. Underground London Bridge.

Unit 2 Gallery, Central House, 59-63 Whitechapel High Street, London E1 7PF. Telephone: 020 7320 1970. Open Tuesday-Friday, 12-6pm. Project space for a variety of art. Underground Aldgate East.

Vanessa Suchar, Le Salon for Art Collectors (galeriste sans galerie), 5 Rye des gate-ceps, 92210 Saint Cloud, France. Telephone: (France) 00330 668095042 ; (USA) 001 347 879 1128. www.vanessasuchar.com. E-mail: art@vanessasuchar.com. Vanessa shows work in London, Paris and America at changing venues and by contemporary artists. She moves from country to country.

Vertigo, 62 Great Eastern Street, London EC2A 3QR. Telephone: 020 7613 1386. www.vertigogallery.co.uk. E-mail: info@vertigogfallery.co.uk Contemporary painting by recent graduates and emerging artists. Underground Old Street.

Victoria Miro Gallery, 16 Wharf Road, London N.1. Telephone: 020 7336 8109. Fax: 020 7251 5596. Open Monday-Saturday, 10-6pm, Sunday, 1-6pm. Director: Victoria Miro.

Painting, sculpture and conceptual art by top British and European artists. Artists include: Doug Aitken, Verne Dawson, Peter Doig, Ian Hamilton Finlay, Chantal Joffe Abigail Lane, Tracey Moffatt, Chris Ofili, Francesca Woodman and Stephen Willats among others.

Vilma Gold, 25B Vyner Street London E2 9DG. Telephone: 020 8981 3344. Fax: 0208981 3355. www.vilmagold.com. E-mail: mail@vilmagold.com. Open Thursday-Sunday, 12-6pm.

Set up by an ex RA Schools graduate Stephen Pippet. The gallery shows British and American artists including: Dan Attoe, Jemima Brown, Brian Griffiths, Daniel Guuzman, Ben Judd, Colin Lowe, Mark Titchner, Markus Vater, Vinogradov & Debossarsky.

VOID, 511 Hackney Road, London E2 9ED. Telephone/Fax: 020 7729 9976. E-mail: jennifer.mehra@voidgallery.com. Open Thursday-Sunday, 12-6pm.

Contemporary artists, usually painters. Underground Bethnal Green or buses 26, 48, 55.

VTO, 96 Teesdale Street, London E2 6PU. Telephone: 020 7729 5629. www.vtogallery.com. E-mail: infoi@vtogallery.com. Open Friday-Sunday, 12-6pm.

Video installations and cutting edge explorations. Underground Bethnal Green.

Waddington Galleries Ltd, 11 Cork Street, London W1S 3LT. Telephone: 020 7851 2200. Fax: 020 7734 4146. Website: www.waddington-galeries.com. E-mail: mail@waddington-galleries.com. Open Monday-Friday, 10-5.30pm, Saturday, 10-1.30pm. Thursday open until 7pm. Directors: Leslie Waddington, A.Bernstein, Sir Thomas Lighton, Lord McAlpine, Hester van Royen, S. Saunders.

The galleries have consolidated to concentrate on contemporary artists and dealing in 20th-century Masters such as Picasso and Matisse. This is one of London's most important galleries, run by Leslie Waddington and associates. Many of the owners of smaller contemporary art galleries centrally, have spent some time working at Waddington's in the past, so he deserves some credit for the expansion of contemporary art in London. With

White Cube and the rise of more avant garde galleries the importance of Waddington Galleries has waned but financially they are still in the top league behind Richard Green. Regular shows introduce less well-established and recently established names. Other artists: Josef Albers, Peter Blake, Patrick Caulfield, Barry Flanagan, Peter Halley, Ivon Hitchens, Axel Hutte, Mimmo Paladino, Lisa Milroy and William Turnbull. Underground Bond Street/Green Park.

WAGDAS, 210 Cambridge Heath Road, London E2 9NQ. Telephone: 07765692560. Website: www.wagdas.co.uk. E-mail: info@wagdas.co.uk. Open Wednesday-Sunday, 12-6pm. Artists can show work in all media at this project space.

Barry Flanagan sculpture, Waddington Galleries.

The Wapping Project, Wapping Hydraulic Power Station, Wapping Wall, London E1W 3ST. Telephone: 020 7680 2080. Fax: 020 7680 2081. E-mail: info@wapping-wpt.com. Open Monday-Thursday, 12-11pm, Friday, 12-12pm, Saturday, 10-12pm, Sunday, 10-6pm. Director: Jules Wright, who organised the transformation of the building.
This magnificent space opened in late 2000 at the Wapping Hydraulic Power Station, built in 1890, which was a model for power stations across the world once. It closed in 1977 and has been transformed into a wonderful gallery space, restaurant, design venue and centre for the Womens Playhouse Trust. WPT has commissioned women writers, poets, artists and filmmakers, composers and designers and before the project opened it had been the venue for extraordinary works by artists Anya Gallaccio and Lea Anderson. The opening installation was by artist Jane Prophet with amazing light effects on water. The restaurant is first class with a good choice of Australian wines.
Underground to Canada Water, then East London line to Wapping. Opposite the Prospect of Whitby pub.

Waterhouse & Dodd, 26 Cork Street, London W1S 3ND. Telephone: 020 7734 7800. Website: www.european-paintings.com. E-mail: gallery@european-paintings.com.
Contemporary European artists. Underground Bond Street/Green Park.

Waugh Thistleton, 47 Great Eastern Street, London EC2A 3HP. Stuart Brisley and Mustafa Hulusi have shown here as part of The Great Unsigned's project to show unsigned artists. Project space.

Werst, 627a Roman Road, London E3 2RN. Telephone: 020 8981 0012. Website: www.werstgallery.com E-mail: info@werst-gallery.com. Open by appointment.
Contemporary art. Opened in 2005. Underground Mile End.

White Cube, 48 Hoxton Square, London N1 6PB. Telephone: 020 7930 7450. www.whitecube.com. E-mail: enquiries@white-cube.com. Open Tuesday-Saturday, 10-6pm. Director: Jay Jopling. This magnificent new gallery space opened in 2000 starting a move to Hoxton for smaller galleries and Flowers East's new galleries opened nearby at 82 Kingsland Road in September 2003. Artists as above; Young British Artists. The opening show had works by Gary Hume, Gavin Turk, Marcus Harvey, Damien Hirst, Gilbert and George, Marc Quinn, Tracey Emin, Antony

Gormley, Jake and Dinos Chapman, Darren Almond, Mona Hatoum. The gallery has attracted celebrities despite its situation on the edge of a dilapidated area, but now hotly fashionable. The building had belonged to publishers Duckworths in the 1990s and before that it was a firm of kitchen manufacturers. Now it has been transformed into a light airy space by architects Mike Rundell & Associates, who designed the Pharmacy restaurant which Damien Hirst once owned. Other artists include: Miroslaw Balka, Ashley Bickerman, Koen van den Broek, Sophie Calle, Brian Eno, Katharina Fritsch, Gilbert & George, Antony Gormley, Franz Ackermann. White Cube west end space will open in the next few years. Underground Old Street or 55 bus from Oxford Street.

White Cube Gallery, Mason's Yard St James's, London SW1. www.whitecube.com. Director:Jay Jopling.
A phenomenally successful gallery dealing in cutting-edge art. The new space will open in the next few years, an electricity substation that has been acquired and is being renovated to house a major new White Cube west end space. The old Duke Street space no longer exists. Jay Jopling introduced the legendary Damien Hirst, once "enfant terrible" in the contemporary art world, to a wider international public. He deals in other cutting-edge artists, although Damien is one of his star artists. Gallery artists include (see also White Cube Hoxton Square): Darren Almond, Ashley Bickerton, Sophie Calle, Tracey Emin, Brian Eno, Antony Gormley, Marcus Harvey, Mona Hatoum, Gary Hill, Damien Hirst, Gary Hume, Sarah Lucas, Sarah Morris, Richard Prince, Marc Quinn, Jessica Stockholder, Hiroshi Sugimoto, Marcus Taylor, Sam Taylor-Wood, Cerith Wyn Evans, Gavin Turk, Jeff Wall and others. Underground Green Park.

Whitechapel Art Gallery, 80-82 Whitechapel High Street, London E.1. Telephone: 020 7 522 7888. Fax: 377 1685. Open Tuesday-Sunday, 11-5pm, Wednesday, 11-8pm. Closed Monday. Director: Iwona Blazwick.
The gallery has just been awarded a huge lottery grant to expand into the next door building, a library and the Whitechapel Gallery archives will eventually be open as well as more gallery space. The gallery shows major exhibitions of 20th-century and contemporary art. Two floors of gallery space with educational facilities. Artists should not apply, except for any local open application shows. Underground Aldgate East.

Jay Jopling showing a collector work at the White Cube stand, Frieze Art Fair.

Whitechapel Project Space, 20 Fordham Street, London E1 1HS. Telephone: 020 7377 6289. E-mail: uctxmtk@ucl.ac.uk. Open Saturday/Sunday, 1-6pm.
Artists and curators can show work here.

White Space Gallery, 7 Turnpin Lane, Greenwich, London SE10 9JA. Telephone: 020 8858 2290. www.white-space-gallery.co.uk
Huge gallery space with exhibitions changed every few months. Rail Greenwich.

Wilkinson Gallery, 242 Cambridge Road, London E2 9DA. Telephone: 020 8980 2662. www.wilkinsongallery.com E-mail: info@wilkinsongallery.com. Open Thursday-Saturday, 11-6pm, Sunday, 12-6pm. Directors: Amanda and Anthony Wilkinson.
Exhibits at Frieze Art fair annually. A well-known East end gallery showing international and British artists. Artists include: David Batchelor, Tilo Baumgartel, Geraint Evans, Julie Henry, Matthew Higgs, Nicky Hirst, Paul Housley, Olav Christopher-Jensen, Joan Jones, Lisa Lounila, Silke Schotz, Johnny Spencer, Matthias Weischer, Olav Westphalen.

Will's Art Warehouse, Unit 3, Heathmans Road, London SW6 4TJ. Telephone: 020 7371 8787. www.wills-art.com. E-mail: info@wills-art.com. Open Monday-Sunday, 10.30-6pm.
Contemporary painting,prints and sculpture. All work for sale under £3000. Organiser of the Affordable Art fair. Underground Parson's Green.

Wilson Stephens Fine Art, 11 Cavendish Road, London NW6 7XT. Telephone: 020 8459 0760. By appointment only.
Modern British and contemporary art; Simon Averill, Duncan Grant, Roger Hilton, Bryan Ingham, Graham Murray, Richard Winkworth, Ben McLaughlin, Daphne McClure, Andrew Johnstone. Exhibits at the London Art fair annually.

Wiseman Originals, 34 West Square, Lambeth, London SE11.4SP. Telephone: 020 7587 0747. Open by appointment. Directors: Caroline and Garth Wiseman.
The directors open their Georgian house as a gallery. The Modern Art Collectors Club enables visitors to browse through original prints and works on paper by international Masters such as Miró, Picasso, Matisse. They also sell British Master prints and works by artists such as Eileen Cooper and Peter Howson. Underground Lambeth North.

Wolseley Fine Arts, 12 Needham Rd, London W.11 2RP. Telephone: 020 7792 2788. Fax: 020 7 792 2988. Website: www.wolseleyfinearts.com. E-mail: info@wolseleyfinearts.com. Open Wednesday-Saturday, 11-6pm (Saturday, 5pm).

Jake and Dinos Chapman's sculpture, Turner Prize 2003.

Drawings and prints specialist in 20th century art, also contemporary still life painting. Exhibits at the **Art on Paper Fair/ London Art Fair**. Sells work by Bonnard, Vuillard, Roussel, Marquet, Dobson, Gill, Jones, Buckland Wright, also Leon Underwood, Madeleine Strobel, Michael Ayrton, Fiore de henriquez, Volkert Olij, Mariko Kratohvil. Underground Notting Hill Gate and walk/ buses 7, 15, 23, 52, 27, 328, 31.

Woodlands Art Gallery, 90 Mycenae Road, Blackheath, London SE3 7SE. Telephone: 020 8858 5847. Open Monday-Thursday, 11-5.30pm, Saturday, 11-5pm, Sunday, 2-5. Closed Wednesday and Friday.
Anthony Eyton and Peter Clossick have shown here and other contemporary established artists. Rail Westcombe Park.

Woolff Gallery, 17 Phipp Street, London EC2A 4NP. Telephone: 020 7729 6592. www.woolffgallery.co.uk. E-mail: info@woolffgallery.co.uk
Contemporary paintings. Artists include: Oona Hassim, Andrew Hood, Michael Maly, Anne Podbieski, Michael Speller, Paul Wadsworth, David Wheeler. Exhibits at the London Art Fair.

Workhouse Gallery, 250 Kings Road, London SW3 5UE. Telephone: 020 7352 2888. Open Monday-Friday 10-5 during shows. Contact: Ian Irvine.
This gallery is for hire on the Kings Road, Chelsea. It has been used successfully by many artist members of the Chelsea Arts Club. Small space but good selling position. Underground Sloane Square and buses 11, 19, 22.

Workplace Art, Studio G1, Tea Building, 56 Shoreditch High Street, London E1 6JJ. Telephone: 020 7739 7500. www.wcart.com. E-mail: enquiries@wcart.com. Open Monday-Friday, 10-6pm.
Paintings and limited edition prints. Underground Old Street/Liverpool Street.

World's End Gallery, 17 Langton Street, World's End, Chelsea, London SW10 OJL. Telephone: 020 7352 5523. Open Monday-Saturday, 11-5pm.
This gallery opened in 2004 and shows contemporary art; painting, sculpture and ceramics by British artists from across the country.

Zelda Cheatle Gallery, Ground Floor, Rivington Place, 81 Rivington Street, London EC2A3BA. Telephone: 020 7729 2422. Website: www.zeldacheatle.com. E-mail: photo@zelda cheatle.com. Open daily, except Sunday, 11-6.
Zelda Cheatle runs this friendly photography gallery in a larger space in Mount Street, after moving from Cecil Court. Zelda has a wealth of experience behind her and holds regular exhibitions of work by top names and recent contemporary photographers.

Prints are reasonably priced and her knowledge and expertise are invaluable. Also sells photography catalogues and books. Underground Old Street.

198 Gallery, 198 Railton Road, Herne Hill, London SE24 0LU Telephone: 020 8978 8309. Fax: 020 8652 1418. E-mail: gallery@198gallery.co.uk. Website: www.198gallery.co.uk. Open Mon-Friday 11-5.30, Saturday 12-4. Gallery manager: Lucy Davies. Run as a charity the gallery provides access for artists of African, Caribbean or Asian descent. Culturally diverse exhibitions. Two gallery spaces. Print and darkroom facilities. Contact the manager for details about exhibiting. Artists may send exhibition proposals to the exhibition committee. Underground Brixton. Buses 3, 37, 68, 196.

1000,000 mph project space, 59 Old Bethnal Green Road, London E2 6QA. Telephone: 020 7729 6557. www.1000000mph.com. E-mail info@1000000mph.com Open Friday-Sunday 12-6pm. Run by Kate Grieve and Dallas Seitz. They offer artists and curators a chance to be artists/curators in residence. About 6-8 projects a year.

39, 39 Mitchell Street, London EC1V 3QD. Telephone: 020 7253 8930. www.39london.com
Set up in 2003, this gallery space has asked artists to collaborate in a variety of projects. The opening show asked 78 artists to design an A4 leaflet. Following exhibitions have included photographs, building a birdhouse and one on pub crawls. MW Projects is nearby at 43B on the same street.

291 Gallery, 291 Hackney Road, London E2 8NA. Telephone: 020 7613 5676. Fax: 020 7613 5692. E-mail: admin@gallery291. demon.co.uk.
They run ArtMart at Christmas time which is a showcase of cutting edge art and design, showcasing some good artists.

Internet Art Galleries

This is an area that has mushroomed in recent years. Below are some of the internet art galleries on the web. In the galleries section websites are also listed under each gallery alphabetically.

www.artisteye.com

www.artituk.com
Aims to cut the cost of art to the public, to support charities, and to promote their sponsors. Run by Robert Mileham with work by a variety of artists.

www.art-exchange.com
This site has apparently made 400+ art sales worth $800,000.

www.artface.com
French English-language site with art that can be bought from 400 dealers in France.

www.art-connection.com
Started in 1996, this site has 85 good art dealers including Richard Green and Marlborough Fine Art. Run by Nick Chapman.

www.artlondon.com
You can commission your own portrait by one of six prestigious painters.

www.artmarketnet.com
Smart site with quality work for sale.

www.artnet.com
Run by Toby Clarke Artnet has 1300 galleries, 36,000 works of art, 2.4 million auction results. 750,000 visitors per month.

www.art-online.com
Art history/Art market/Art venues/Artists /Education/Employment/Events/Galleries/Governments/Legal/ Museums/Professionals/Resources/Rewards/Shopping.

www.art-online.org.
For £2.30 a week artists can have up to six images put on this website. Galleries and art consultants can do the same for £3.56 a week. Art buyers are put in contact with artists or

Anya Gallaccio sculpture, Turner Prize 2003.

galleries direct and there is a virtual gallery with participating artists. A site that is well visited apparently! Managed by Chris Jones, an RCA lecturer.

www.artprints.ch
Aboriginal art for sale. 120 items for sale on the site. Reasonably successful sales site.

www.artscouncil.org.uk
Buy art with an interest-free loan from the Arts Council England. Any work of art or craft from a participating gallery. £100-£2000 over 10 months. Over 250 galleries in England participate.

www.artshopper.com
500 artists on this website.

www.artupdate.com
3000 subscribers in galleries, museums and media organisations receive this free fortnightly art listings service.

www.bonhams.com
Bonhams auction house site. Phillips has now merged with Bonhams.

www.christies.com
Christies auction house site.

www.commissionaportrait.com
For portrait commissions.

www.britart.com
British artists: Fred Crayk, Denis Bowen, Minnie Fry, Maggi Hambling, Peter Howson, Jim Kavanagh, Richard Libby, Tony Lawrence, Ian Welsh and many others. Britart/Eyestorm Gallery is at 18 Maddox Street, London W1S 1PL. Artists can submit work and a decision is taken within two weeks.

www.canadian-art.com
Specialise in Inuit and Eskimo art.

www.easyart.com
2000 prints to browse through from £2 to £500 and choose your own frame.

www.galleriesofscotland.net
Prints sold from £100 by artists such as Charles Rennie Mackintosh, Monet and Degas. Obviously not limited editions!

www.londonart.co.uk
More than 300 artists are represented with prices from £35 to £50,000. Art for sale/art search/artists' index/magazine/exhibition/kids' art/listings/galleries A-Z of artists on London Art.

www.PortfolioCity.com
Promotes new emerging artists

www.printportfolio.com
A portfolio of five signed prints by Paula Rego, Susan Hiller, Nicola Hicks, Sonia Lawson and Jo Self for £1500, or individually at £300.

www.sothebys.com
Sothebys auction house site.

www.worldgallery.co.uk
Sells prints by Kandinsky, Matisse, Van Goigh and Dalî. Prices start at £5 to many thousands.

National
Centres&Institutes

This section has been included so that overseas visitors can see that there are various centres throughout London that specialise in art from one particular country. Many are still affiliated to Embassies, with government support, but others are quite separate.

In many cases artists from the appropriate country or with work associated with that country, may be considered for exhibitions. Contact the gallery director first to find out.

Africa Centre, 38 King Street, London WC2. Telephone: 020 7836 1973. Open Monday-Friday and weekends, ring gallery for times. An educational charity that runs a very lively arts centre in Covent Garden. Classes in dance, literature, movement and evening meetings. The gallery upstairs has a variety of shows covering painting, sculpture, weaving, masks and craft. Africa Centrepoint, a monthly newsletter gives updated information about the centre. Variety of prices for membership. The Calabash restaurant is well-worth a visit. Underground Covent Garden.

Asia House, 63 New Cavendish Street, London W1G 7LR. Website: www.asiahouse.org. E-mail: enquiries@asiahouse.co.uk. This wonderful, central Robert Adam style Grade II listed building, a business and cultural centre, opened in autumn 2005. It has a gallery in the basement for contemporary art, photography and craft shows as well as installations. In phase 2 of the development a larger gallery, double the space, will open at the back of the building as well as artist-in-residence studios in Weymouth Mews. A major business and cultural centre with a café, themed events, membership, talks and rooms can be hired for events. Katriana Hazell is the Cultural Director. Underground Oxford Circus/Regent's park.

Austrian Cultural Institute, 28 Rutland Gate, London SW7 1PQ. Telephone: 020 7584 8653. Fax: 020 7225 0470. E-mail: art@austria.org.uk. Website: www. austria.org.uk/art. Open during exhibitions to the public. See press for details or click on their website. Vargas organisation runs a variety of exhibitions at the Austrian Cultural Institute ranging from drawins to paintings and prints.

Tobias and the Angel, Andrea del Verrocchio, National Gallery.

Canada House, Trafalgar Square London SW1. Telephone: 020 7258 6600 9492. Contact Michael Regan, 020 7258 6537 about visual arts information and exhibitions. Telephone: 020 7258 6366 (Artsnews magazine) edited by Gillian Licari.
Canada House Cultural Centre re-opened in 1998 with magnificent restoration work on the building designed by Sir Robert Smirke in 1824. The visual arts programme means about four major exhibitions a year and links to Canadian music and film events in London. The gallery has lost the charm it had when Griselda Bear ran it in the1980s and the help that she gave to so many artists, art writers, art dealers, curators was invaluable for Canada. Artnews magazine covers all details of Canadian events in London. Underground Bond Street.

Canning House Centre, 2 Belgrave Square, London SW1X 8PJ. Telephone: 020 7235 2303. Closed at weekends.
The centre holds a number of exhibitions throughout the year to promote the arts and culture of Latin America, Spain and Portugal. Artists and organisations can apply to the Culture and Education Department. £150 booking fee payable. Ideal for painting, photography, textiles and craft.

The Czech Centre, 95 Great Portland Street, London W.1. Telephone: 020 7291 9920. Open Monday-Friday, 10-6pm.
A variety of events and exhibitions with a Czech connection. Underground Great Portland Street.

Daiwa Anglo-Japanese Foundation, 13-14 Cornwall Terrace, London NW1 4QP. Telephone: 020 7486 4348. Open Monday-Friday 9-5.
A variety of exhibitions have been held here recently including work by British artists connected with Japan and Japanese artists visiting Britain. Underground Baker Street.

French Institute, Cultural Centre, 17 Queensberry Place, London SW7. Telephone: 020 7838 2144. www.institut-francais. org.uk To book classes or films E-mail: box.office@ambafrance.org.uk. Open 10-10pm, Saturday, 12-10pm. (Hours vary for the cinema, library and other facilities.) Closed Sunday and Monday. Language Centre for French classes, 020 7581 2701.
A cinema, library, theatre, concerts, lectures, and now a café/bistro open from 8.30am with newspapers to read while you wait for friends.There are even wine tasting classes. Ciné Lumiere has a regular programme of French films and also talks by authors and film-makers. During the London Film Festival in November many French films are shown here. Underground South Kensington.

Goethe Institut, 50 Princes Gate, Exhibition Road, London SW7. Telephone: 020 7581 3344/7. Open Monday-Friday, 12-8pm, Saturday, 10-1pm.
The gallery has exhibitions by top German artists such as Kiefer, Baselitz and artists known to the art world. There have also been many photography shows rceently due to the increase in interest in that area. The newsletter gives details of other German films, books and events. Underground South Kensington.

Foundation for Hellenic Culture, 60 Brook Street, London W.1. Telephone: 020 7499 9826.

This centre has some excellent exhibitions of Greek art, both historical and contemporary. Also a centre for Greek contacts and language classes. Underground Bond Street.

Instituto Cervantes, (Spanish Cultural Institute) 102 Eaton Square, London SW1W 9AN. Telephone: 020 7201 0754.

It held an exhibition "Madrid: Movida and Beyond" which was a great success and invaluable for Spanish enthusiasts who live in London. Watch press for details of further lively exhibitions and events. They provide a booklet from February-September with all details of events. Underground Sloane Square.

Italian Cultural Institute / Istituto Italiano di Cultura, 39 Belgrave Square, London SW1X 8NX. Telephone: 020 7235 1461. www.italcultur.org.uk. E-mail: ici@italcultur.org.uk. Open Monday-Friday, 10-5pm.

There have been some interesting exhibitions of Mario Merz and other artists and photographers and talks here by Jannis Kounellis, to coincide with his show at MOMA Oxford.The library has all the latest Italian publications (fiction, visual art, criticism and current affairs), reference books, newspapers and magazines. Café Fellini also shows small exhibitions. The staff are extremely friendly and helpful. Underground Hyde Park Corner.

New Zealand House, Haymarket, London SW1. Telephone: 020 7930 8422. Open Monday-Friday, 9-5pm.

New Zealand High Commission has a large area for concerts, theatre productions, recitals and a gallery on the mezzanine floor. New Zealand professional artists can apply to the Cultural Affairs Department all year round. Underground Charing Cross/Piccadilly.

Polish Institute, 34 Portland Place, London W.1. Telephone: 020 7636 6033/4. Open Monday-Friday, 10-6pm.

The gallery shows work by Polish artists ranging from painting to posters. They also publish a regular booklet about events. Underground Oxford Circus.

La Hija de los Danzntes, Manuel Alvarez Bravo (Zelda Cheatle Gallery).

Photo London photography fair set up by **Danny Newburg of Art and Photographs** opened in May, 2004 at Burlington Gardens and was a great success. They also publish **PLUK**, the monthly photo listings magazine. Photography has mushroomed in London in recent years and the V&A's photography collection, **The Photography Gallery**, gives the public a chance to see

203

many of the photographs from the **Henry Cole Wing**, that had never been on display, through lack of space. Sadly the space has been cut back in recent years though. Commercial photography galleries show a complete range of photographs now from reportage, social documentation to fine art, advertising and even collage. See **Collecting Photographs** at the front of the guide, as well as the interview with **Ben Burdett of the Atlas Gallery**, to see the range of photographs for sale. The **Special Photographers Company**, off Portobello Road is well-worth a visit, **Zelda Cheatle Gallery, Atlas Gallery, Michal Hoppen, Art and Photographs, Hackelbury Fine Art, Hulton Getty Collection, Proud Galleries, Tom Blau Gallery** and of course the **Photographers Gallery**, is a must with its excellent bookshop, galleries and print advice and viewing room. The increase in the number of photography galleries in London shows the increase in sales in this area, especially in limited editions. I have only listed the ones that deal primarily in photography or major photo-artists. Other galleries that occasionally deal in photography are listed in the contemporary section. **Photomonth** takes place across London in October and November annually. For details, www.alternativearts.co.uk.

AOP Gallery, 81 Leonard Street, London EC2. Telephone: 020 7739 6669. Open Monday-Friday, 10-6pm, Saturday, 12-4pm. Variety of shows, mainly by members. Participates in Photomonth in October/November annually. Underground Old Street.

Atlas Gallery, 49 Dorset Street, London W1U 7NF. Telephone: 020 7224 4192. www.atlasgallery.com. E-mail: info@atlas-gallery.com. Open Monday-Friday, 10-6pm, Saturday, 12-5pm. Director: Ben Burdett. **See interview at front of the guide.**
Specialised in travel photography, but now has major shows of photographers such as Alvin Langdon Coburn and Rodchenko. They have had some wonderful exhibitions of Tibet, India, China. Well-run gallery and has staff to advise on collecting. They exhibit at Photo London.

Barbican Centre Art Gallery, Silk Street, London EC2. Telephone: 020 7638 4141 ext 306. www.babican.org.uk. Open Tuesday-Saturday, 11-7pm, Sunday, 12-6pm.
Major gallery on two floors. Ansel Adams, French photography, Eve Arnold, Blumenfeld, Picasso's Photography and other photography shows have been seen here. See Galleries section for full details about the centre. Underground Barbican/ Moorgate/Bank.

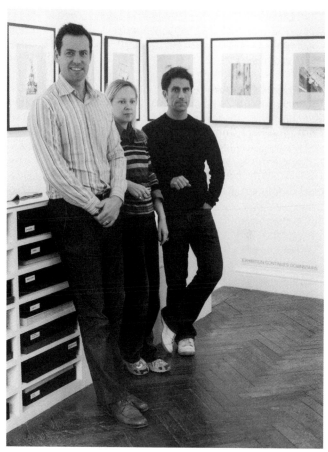

Ben Burdett, Louise Proud, Taufiq Kassir, Atlas Gallery.

Ben Brown Fine Arts, 21 Cork Street, 1st floor, London W1S 3NA. Telephone: 020 7734 8888. www.benbrownfinearts.com. Open Monday-Friday, 10-5pm. Saturdays by appointment.
This relatively recent gallery has shown work by Lucio Fontana but also photography occasionally. Underground Green Park

Camden Arts Centre, Arkwright Road, London NW3. Telephone: 020 7435 2643/5224. www.camdenartscentre.org. E-mail: info@camdenartscentre.org. Open Tuesday-Sunday, 10-6pm, Wednesday, 10-9pm. Director: Jenni Lomax.
Arts centre with occasional photo shows. The galleries were renovated in 2004. Underground Finchley Road.

The Camera Club, 16 Bourden Street, London SE11. Telephone: 020 7587 1809. Open Monday-Saturday, 11-11pm. Facilities for photographers to take classes and access to other useful information.

Eric Franck Fine Art, 7 Victoria Square, London SW1W OQY. Telephone: 020 7630 5972. E-mail: e.franck@btclick.com. Open by appointment only.
An important photo dealer who has run a gallery in Geneva 1982-94, also in Berlin 1990-2000. He is now based in London. Exhibits at the Photo London show in May.

Getty Images Gallery, 46 Eastcastle Street, London W1W 8DX. Telephone: 020 7376 4525. www.hultonarchive.com. E-mail: gallery.information@gettyimages.com. Open Monday-Friday, 10-6.30pm,Thursday, 10-7.30pm.
This major archive is used internationally and there are regular exhibitions from the Hulton Archive. Underground Oxford Circus.

Hackelbury Fine Art, 4 Launceston Place, London W8 5RL. Telephone: 020 7937 8688. www.hacklebury.co.uk. E-mail: gallery@hacklebury.co.uk. Open Tuesday-Saturday, 10-5pm, (Saturday, open at 11).
They have had major shows of photos by Marc Riboud, Berenice Abbott, Roman Vishniac as well as more contemporary work. They exhibit at Photo London. Underground Gloucester Road.

Hamiltons Gallery, 13 Carlos Place, Grosvenor Square, London W1 2EU. Telephone: 020 7499 9493. www.hamiltons-gallery.com. E-mail: info@hamiltonsgallery.com. Open Tuesday-Friday, 10-6pm, Saturday, 11-4pm. Run by Tim Jeffries.
Represents top commercial photographers and the gallery is often attended by celebrities. Exhibits at Photo London in May. Underground Bond Street.

Haunch of Venison, 6 Haunch of Venison Yard, London W1K 5ES. Telephone: 020 7495 5050. www.haunchofvenison.com. E-mail: info@haunchofvenison.com. Open Monday-Friday, 10-6pm, Thursday, 10-7pm, Saturday, 10-5pm.
Thomas Joshua Cooper's huge monumental photographs are shown here but they are seen as major works of art.The gallery has a huge space on two floors and it is a popular gallery in a west end position. They show at Frieze art fair but do not specialize in photography. Underground Bond Street

Hofer Printroom, 43 Museum Street, Bloomsbury London WC1A 1LY. Telephone: 020 7930 1904. www.hofer-photo.com E-mail: info@hofer-photo.com. Open Wednesday-Saturday, 12-6pm or by appointment.
Manuela Hofer runs this small gallery in the old Focus Gallery space. They specialize in contemporary photography in both black and white and colour. Underground Tottenham Court Road.

Hoopers Gallery, 15 Clerkenwell Close, London EC1R OAA. Telephone: 020 7490 3908. www.hoopersgallery.co.uk. Open Tuesday-Friday, 11-4.30pm, Thursday, 11-7pm.
Photographers: John Blakemore, Chris Cheetam, Michael English, Chip Forelli, Gavin Frankel, Roger Hooper, Paul Mellor, David Steen, David Wheeler, Colin Wilson. Underground Farringdon.

Imperial War Museum, Lambeth Road, London SE1. Telephone: 020 8735 8922.
Photography exhibitions in relation to war. Underground Lambeth North.

Institute of Contemporary Arts, Nash House, The Mall, London SW1Y 5AH. Telephone: 020 7930 0493. www.ica.org.uk. E-mail: info@ica.org.uk. Open 12-7.30pm. Closed Mondays.
Interested to see work in the form of slides/photos/documentation by professional artists and photographers. Photography exhibitions regularly in the corridor near the restaurant and upstairs. Very good central venue visited by international and national public. Video library, cinema, theatre as well as a restaurant and bar. Good bookshop. Underground Charing Cross.

The London Picture Centre, 287/9 Hackney Road, London E2 8NA. Telephone: 020 7739 6624. www.londonpicturecentre.co.uk. E-mail: enquiries @londonpicturecentre.co.uk. Open 10-6pm.
They have branches at 709 Fulham Road SW6, 18 Crawford Street W.1. and 75 Leather Lane EC1. and sell prints and posters at 152 Hackney Road. They participate in Photo London in May. Sells a variety of photographs.

Lupe Gallery, 7 Ezra Street (off Columbia Rd), London E2 7RH. Telephone: 020 7613 5576. www.lupegallery.com. E-mail: info@lupegallery.com. Open Sunday, 10-3pm or by appointment. Lupe photographers: Stuart Redler, Rachel Fish, Perou and others. Underground Old Street/Liverpoll Street.

Marlborough Fine Art, 6 Albemarle Street, London W1S 4BY. Telephone: 020 7629 5161. www.marlboroughfineart.com. E-mail: info@marlboroughfineart.com.
Primarily a top fine art dealer, but has shown photographs, sometimes connected with book launches. Underground Green Park.

Michael Hoppen Photography, 3 Jubilee Place, London SW3. 3TD. Telephone: 020 7352 3649. The Contemporary gallery is on the 2nd floor. Telephone: 020 7352 4499. www.michael-hopen-photo.com. E-mail: gallery@michaelhopen-photo.com. Open Tuesday-Saturday, 12-6pm. Director: Michael Hoppen
The gallery opened in 1994 and shows 19th and 20th century photography. Excellent shows, such as the Lartigue one in '99. Upstairs he now has a contemporary gallery as well. They represent Guy Bourdin, Nadav Kander, Annie Leibowitz, Helen Binet, Desirée Dolron and others. His shows at Photo London are very impressive and he brings new names and interesting ideas to the London photo world. Underground Sloane Square and walk.

National Portrait Gallery, St Martin's Place, London WC2H OHE. Telephone: 020 7306 0055/0056. www.npg.org.uk. Open Daily, 10-6pm, Thursday-Friday, 10-9pm.
Quite a number of photography exhibitions recently and holds the exhibitions for the Scweppes photography awards. They now have a far larger collection of 20th and 21st century photo portraits. Underground Charing Cross.

National Theatre, South Bank, London SE1.
Photography shows in a busy theatre complex, reaching a wide public. Underground Waterloo.

Photofusion, 17A Electric Lane, Brixton, LondonSW9 8LA. Telephone: 020 7738 5774 www.photofusion.org. E-mail: gallery@photofusion.org. Open Tuesday-Saturday, 10-6pm, Wednesday, 10-8pm.
This gallery shows work by contemporary photographers and is well-worth a visit. They have been in existence for 15 years and shown photographers such as Koudelka, Melanie Manchot, Mario Giacomelli. Their education programme includes digital photography and chemical-based practical training courses. The picture library has a comprehensive collection of social and environmental issue-led photography. It is a non-profit company reliant on funders and sponsors such as Canon UK and Arts Council England. Underground Brixton.

The Photographers Gallery, 5 & 8 Great Newport Street, London WC2H 7HY. www.photonet.org.uk. E-mail: info@photonet.org.uk. Telephone: 020 7831 1772. Open Wednesday-Friday, 10-6pm and by appointment. Director: Paul Wombell. Photographers can apply at any time, but decisions are made twice a year in March and October. Exhibitions cover the complete spectrum of photography from commercial to social documentation, fine art, reportage. At No. 8 there is an excellent bookshop and gallery space and at No. 5 there is a gallery downstairs with a café and upstairs a slide library with 5000+ slides, a reference library with 3000+ books and a viewing room for buyers, where advice can be given about particular photographs. The staff are well-informed and helpful. Membership scheme. Renovated in 2005. Shows the Deutsche Borse photography prize. Underground Covent Garden/ Leicester Square.

The Photography Store, An online photo gallery. Website: www.photographystore.com.

Proud Central, 5 Buckingham Street, London WC2N 6BP. Telephone: 020 7839 4942. www.proud.co.uk. E-mail: info@proud.co.uk. Open Monday-Thursday, 10-7pm, Sunday, 11-6pm. Both Proud Galleries show commercial or highly topical photography, often of the rock, fashion, celebrity worlds, or documentary. Underground Embankment

Proud Camden Moss, 10 Greenland Street, London NW1 OND. Telephone: 020 7482 3867. Website, e-mail and address as above. Open Monday-Thursday, 10-7pm, Friday-Sunday, 11-6pm. Underground Camden Town

Robert Hershkowitz, 3 Sloane Avenue, London SW3. Telephone: 0144448 2240. E-mail: prhfoto@hotmail.com. By appointment only. He deals in major works of early European photography.

Scout Gallery, 1-3 Mundy Street, off Hoxton Square, London N1 6QT. Telephone: 020 7749 0909. www.scoutgallery.com. E-mail: mail@scoutgallery.com. Open Tuesday-Saturday, 12-5pm, Saturday, 12-4pm. Dedicated to international contemporary photography. Exhibits at Photo London annually in May. Represents: Christopher Doyle, Rainer Eistermann, Ali Mahdavi, Susan Meiselas, Red Saunders, Andreas Schmidt, Ben Watts, Marc Wayland, Koto Bolofo. Underground Old Street.

Serpentine Gallery, Kensington Gardens, London W.2.3XA. Telephone: 020 7402 4103/ 020 7298 1515 (recorded information). Website: www.serpentinegallery.org. Open daily 10-6.
After a massive £4million renovation programme the gallery is now an important space for major London shows. Julia Peyton-Jones, the dynamic director has worked hard to make this a key London contemporary art venue. The lawn holds site-specific works. Photography and video shown in a contemporary art situation. The bookshop is now run by Walter Koenig Books and specialises in art criticism and theory, holding evening lectures and events. Underground Lancaster Gate or South Kensington.

Special Photographers Company, 236 Westbourne Park Road, London W11 1EL. Telephone: 020 7221 3489. Website: www.specialphotographers.com. Run by Chris Kewbank and two assistants.
The gallery acts as an agency for photographers, a library and as a gallery. Commercial and fine-art photography. Underground Notting Hill Gate or Ladbroke Grove. See Portobello Arts Map.

Stock Exchange Visitors' Gallery, Threadneedle Street, London EC2.
Occasional photography shows here, mostly of a financial nature and by financial photojournalists. Underground Bank.

Tom Blau Gallery, 21 Queen Elizabeth Street, Butlers Wharf, London SE1 2PD. Telephone: 020 7940 9171. Fax: 020 7278 5126. Website: www.tomblaugallery.com. E-mail: info@tomblaugallery.com. Open Monday-Friday, 10-6pm, Saturday, 12-5pm. Director Keith Cavanagh.
They sell modern, secondary and contemporary photographs. It now has a membership scheme for £15 per annum for invitations and discounts on prints. Tom Blau founded Camera Press and the gallery is named after him. Underground Tower Hill/London Bridge.

Victoria and Albert Museum (Photography Gallery), South Kensington, London SW7. Telephone: 020 7942 2000. Open daily 10-5.45pm, Wednesday, 10-10pm. www.vam.ac.uk
The Photography Gallery opened with a historical show and contemporary photography. Gradually we have been shown parts of the collection in small interesting exhibitions. The collection began in 1852 and now holds 300,000 images from 1839 to the present day. Visual display units allow visitors to look at works not on display to see the extent of the V&A's collection.There are now separate major photo shows in larger

galleries in the V&A as well. Sadly lack of sponsorship recently has led to a reduction of space, which in the light of the growth of photography is quite bizarre. Let's hope new sponsors can be found as Mark Haworth-Booth has done a wonderful job for photography in Britain to date. He has now retired but is visiting Professor at the University of the Arts. Underground South Kensington.

Zelda Cheatle Gallery, Ground Floor, Rivington Place, 81 Rivington Street, London EC2A 3BA. Telephone: 020 7729 2422. Website: zeldacheatle.com. E-mail: photo@zeldacheatle.com. Open Tuesday-Friday, 10-6pm, Saturday, 11-4pm. Directors: Zelda Cheatle, Ian Shipley.

Friendly photography gallery. Zelda shows contemporary unknowns and top world names. Exhibitions by invitation only. Zelda is one of the most established photo dealers in London, surviving through the difficult years when photos were hard to sell. Represents major and contemporary photographers nternationally. Underground Leicester Square.

Art Project Spaces

In the last six years there has been a rapid growth in art project spaces all over London as conceptual and minimal work, installations and site-specific work became fashionable and popular. Many are possibly temporary so check before visiting, as by the very nature of being alternative they are not run along conventional lines and are often in spaces that are temporarily vacant. **Artangel**, is a well-known organisation that arranges unusual events and exhibitions in public spaces all over London, often by top British or international artists. **Alternative Arts** organises events across London for artists as well as Photomonth for photographers. **www.alternativearts.co.uk**. **Deptford X** is an annual arts festival in late June and early July. **www.deptfordx.org**. **Camberwell Arts** week is another local London arts festival. Wandsworth has an **artists' open house weekend** in November. www.wandsworth.gov.uk. **www.capri-art.org** lists all the east end art project spaces. These include: **39, 1000000mph, Artlab, David Risley, Dick Smith, The Drawing Room, EventNetwork, Flaca, IBID Projects, Keith**

Talent, Kate MacGarry, MOT, Peer, Pilot. Numbers Gallery, Platform, The Ship, Temporay Contemporary, Trailer, Transition and many others, listed in the **gallery section (see Contemporary Galleries section)**.

Alternative Arts, Top studio, Bethnal Green Training Centre, Deal Street, London E1 5HZ. Telephone: 020 7375 0441 www.alternativearts.co.uk. E-mail: info@alternativearts.co.uk. They organize events across London in Spitalfields, the East end, the West end for both painters/sculptors and photographers during Photomonth in October/November.

Artangel, 31 Eyre Street Hill, London EC1R 5EW. Telephone: 020 7713 1401. www.artangel.org.uk. Run by James Lingwood. A high profile organisation that arranges innovative events and exhibitions in public spaces. Well-funded.

Bishop's Wharf, 49 Parkgate Road, London SW11. Telephone: 020 7978 7878. Open Monday-Friday, 10-5pm. British Rail Battersea Park.

Bow Arts,181-183 Bow Road, London E.3. Telephone: 020 8981 0744. Open Thursday-Sunday, 1-6m. Gallery known as The Nunnery.

Central Space, ACAVA, 23-29 Faroe Road, London W14 OEL.

The Conductors Hallway, 301 Camberwell New Road, London SE5. Telephone: 020 7703 8385. Open Thursday-Sunday, 11-5pm. Installations, video and sound shows.

Curtain Road Arts, 96A Curtain Road, London EC2. Telephone: 020 7613 5303. Open Thursday-Sunday, 12-6pm. Installations and other exhibitions. Underground Old Street.

Gasworks,155 Vauxhall Street, London SE11. Telephone: 020 7735 3445. Open Friday-Sunday, 12-6pm. Exhibitions of paintings in a studio context.

Hackney Forge, 243A Victoria Park Road, London E9. Small exhibitions and events are held here.

t1 + 2 artspace, 4 Steward Street, Spitalfields, London E1 6AL. Telephone: 0790387 6522. www.t12artspace.com. Variety of events and exhibitions. Underground Liverpool Street.

Museum of Installation, 71-175 Deptford High Street, London SE8 3NU. Telephone: 020 8692 8122. E-mail: moi@dircon.co.uk. This is a major venue for contemporary art in London and has held events by German artists in the Berlin-London exchange in 2003 as well as work by UK artists.

Many of the above also operate as venues for Performance/Live Art. Instead of listing a separate section for Live Art the following may be useful;
BAC
Camden Arts Centre
Chisenhale
ICA
London Musicians Collective
Riverside Studios
Serpentine Gallery
Tate Modern and Tate Britain
Whitechapel Gallery
Studio spaces across London

Addresses of the above are in the Galleries section.

Studios

There are many open studios events throughout the year. These include the annual deptford x www.deptfordx.org.uk, also South Thames Art (October-January annually).

SPACE Studios, www.spacestudios.org.uk. See useful addresses (artist' organisations) for details. Studio space for artists,but not living accommodation.

Space Place, 43-45 Dace Road, London E3 2NG Telephone: 020 8986 5998. E-mail: spaceplace@spacestudios.org.uk. Digital art suite workstations and moving image workstations.

SPACE Studio sites:
16 Belsham Street, London E.9.
Britannia Works, 80 Dace Road, Old Ford, London E.3.

16 Belsham Street, London E.9.
Britannia Works, 80 Dace Road, Old Ford, London E.3.
15 Milborne Street, London E.8.
199 Richmond Road, London E.8.
49 Columbia Road, London E.2.
282A Richmond Road, London E.8.
10 Martello Street, London E.8.
7 Winkley Street, London E.2.
142 Vauxhall Street, London SE11.
142D Leabridge Road, London E.5.
Eastway Studios, 80 Eastway, London E.9.
Deborah House, Retreat Place, London EC1.
Sara Lane Studios, 60 Starway Street, London N.1.

All phone numbers of the above studios are in the phone book under SPACE Studios.

ACME Housing Association, (main office), 44 Copperfield Road, London E.3. Telephone: 020 8981 6811. Fax: 020 8 983 0567.
www.acme.org.uk email: mail@acme.org.uk
Set up in 1972 by David Panton and Jonathan Harvey to house artists, mainly in the east end. They also ran ACME Gallery in the late 1970s and early 1980s in Shelton Street Covent Garden, giving many artists such as John Bellany, Bert Irvin, Helen Chadwick, Gary Wragg their first shows. They also showed performance art and installations by Stuart Brisley, Richard Layzell and many others. At the time it was a very important avant garde gallery and also had international links. Some 350 studios at 11 buildings. It has a waiting list. Contact them for an application form (available in print, large print and audio tape).

ACME Studios, also at Brixton, Camden, North Shoreditch and Stratford East.

Childers Road

Old Church Hall Studios, Redhill Street, London NW1.

105 Carpenters Road, London E.15.
Telephone: 020 8519 5240/5808.

2 & 3 Jubilee Terrace, London E.1.

Bonner Road Studios, 44 Bonner Road, London E.2.
Telephone: 020 8980 0189.

Larnaca Works, Grange Walk, London SE1.
Telephone: 020 7252 2027.

11-31 Orsman Road, London N.1 5RA.
Telephone: 020 7739 5976.

Ring the main office for details of the latest studio space and to be put on the waiting list after an interview. They have also joined with Barratt Builders to build 50 living/working spaces for artists.

ACAVA, Telephone: 020 8960 5015. E-mail: post@acava.org
Palace Wharf, 56 Rainville Road, W.6.
54 Blechynden Street, W.10.
23-29 Faroe Road, W.14.
142 Charing Cross, WC2H.

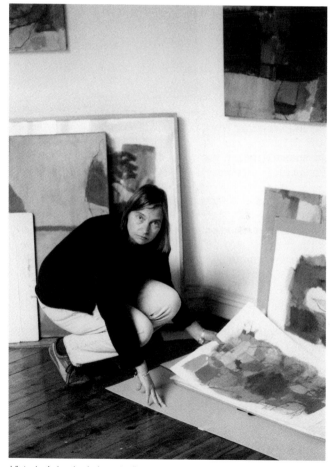

Victoria Achache in her studio.

62 Hetley Road, W.12.
Impress House, Vale Grove, W.3.
11 Colville Road, W.3.
7 Churchfield Road, W.3.
Hawke House, 35 Horn Lane, W.3.
1-15 Cremer Street, E.2.
203-213 Mare Street, E.8.

Independent Studio Blocks

A2 Arts, 143A Greenwich South Street, London SE10, also 101 Blackheath Road, SE10.

ACAVA, 1-15 Cremer Street, London E.2. Telephone: 020 8960 5015. E-mail: post@acava.com. ACAVA has 50 studios, 300 contemporary artists.

Arbutus Studios, 1A Arbutus Street, London E.8.4DT.

Arch 339 Studio, 337 Medlar Street, London SE5.

Art in Perpetuity Trust, 6 Creekside, London SE8.

Artsplace Trust, Chisenhale Works, Chisenhale Road, Bow, London E.3. Telephone: 020 8981 4518. 38 studios.

ASC Studios, 6-8 Rosebery Avenue, London EC1R 4TD.

Baches Street Studios, 10-12 Baches Street, London N.1. 6D.

Barbican Arts Group, 12/14 Hertford Road, London N.1. Telephone: 020 7241 0651. 25 studio spaces.

Bow Arts Trust, 181-183 Bow Road, London E.3 2SJ.

Cable Street Studios, Thames House, 566 Cable Street, London E1 9HB.

CBA, The Enterprise Centre, Dolben Court, Foreshore, Deptford, London SE8 3AW. Telephone/Fax: 020 8691 0374. E-mail: corblimey@lineone.net.

Chisenhale Art Place Studios, 64-84 Chisenhale Road, London E3 5QZ. Telephone: 020 8981 1916. www.chisenhale.com. E-mail: mail@chisenhale.com. 37 artists' studios.

City Studios, 40 Underwood Street, London N1 7QJ.

Clapham Studios, 590 Wandsworth Road, London SW8. Telephone: 020 8 720 7817.

Colosseum, 1A Beechwood Road, London E.8.

Cubitt Studios, 2-4 Caledonia Street, London N1 9DZ.

Delfina Studios, Maryland Works, 22 Grove Crescent Road, London E.15. Telephone: 020 8519 8814. Run by the same organisation that owns the Delfina Gallery in Bermondsey.

Euroart Studios, Unit 22F, 784/788 High Road Tottenham, London N17 ODA. E-mail: nayoung@euroart.co.uk.

Faroe Road, London W.12. Waiting list.

Fashion Street Studios, 11 Fashion Street, London E.1.

Framework, 5-9 Creekside, London SE8.

Florence Trust Studios, St Saviour's, Aberdeen Park, Highbury, London N5 2AR. Office Telephone: 020 7354 4771. Studio Telephone: 020 7354 0460.

Fulham Studios, 101 Farm Lane, London SW6. Telephone: 020 7381 4000. For hire commercially for photography or exhibitions.

Globe Studios, 62A Southwark Bridge Road, London SE1. Telephone: 020 7261 9066.

Greenwich Murals Workshop, MacBean Centre, MacBean Street, London SE18. Telephone: 020 8854 9266. Contact: Steve Lobb. Publishes a useful murals handbook.

Hanbury Street Studios, Top Floor, 49 Hanbury Street, London E.1 5JP.

Hartley House Studios, Hartley House, Green Walk, London SE1.

Hertford Road Studios, 12-14 Hertford Road, London N1 5SH.

Hetley Road, London W.12. Telephone: 020 8743 1843. Studios and a gallery.

Jasmine Studios, The Old School House,186 Shepoherd's Bush Road, London W.6.

Kingsgate Workshops, 110-116 Kingsgate Road, London NW6. See Artists Register Galleries section for details. 35 studios and a waiting list.

Left Bank, 84-86 Great Eastern Street, London EC2.

Lewisham Art House, 140 Lewisham Way, London SE14 6PD.

Limehouse Arts Foundation,Towcester Road, London E3 3ND.

Maryland Studios, 22 Grove Crescent, Road, London E15.

Not Cut, Not Cut House, 36 Southwark Bridge Rd, London SE1.

The Paper Bag Factory, 165 Childers Street, Deptford, London SE8. Telephone: 020 8694 9112.

Park Studios, 34 Scarborough Road, Finsbury Park, London N4 4LT. Telephone: 020 7272 1501 / 6778.

Pixley Street Studios,14 Pixley Street, London E.14.

Regents Studios, 8 Andrews Road, London E8 4QN.

Southgate Studios, 2-4 Southgate Road, London N1 3JJ.

Standpoint Studios, 45 Coronet Street, London N1 6HD. Telephone: 020 7739 4921. standpoint@btopenworld.com Gallery and studio space set up in 1985, the gallery in 1993. Also runs educational projects with the community.

Tram Depot Studios, 38/40 Upper Clapton Rd, London E.5.

Westbourne Studios, 242 Acklam Road, London W.10. www.westbournestudios.com

Wimbledon Arts Studios, Holman and Williams House, Riverside Yard, Riverside Road, London SW17 OBA. Telephone: 020 8947 1183. www.wimbledonartsstudios.co.uk

Print Publishers

The list below covers print publishers that publish limited editions of etchings, silkscreens, lithographs, photo-silkscreens and occasionally woodcuts. Many of them are also listed under the contemporary galleries section.Flowers gallery runs a print-of-the-month club to encourage print buyers. Some also publish artist' books.

Advanced Graphics, 32 Long Lane, London SE1 4AY. Telephone: 020 7407 2055. www.advancedgraphics.co.uk. E-mail: gallery@advancedgraphics.co.uk.
Print artists' books as well as prints.

Alan Cristea, 31 Cork Street, London W.1. Telephone: 020 7439 1866. Fax: 020 7734 1549. Open Monday-Friday, 10-5.30pm, Saturday, 10-1pm (except August). Alan Cristea took over Waddington Graphics and publishes European and American prints by most of the top names: Hockney, Lichtenstein, Jasper Johns, Mimmo Paladino, Stella, Warhol, Tapies, Dine, Picasso, Matisse, Léger, Braque, Nicholson. The gallery holds some excellent shows.

Anderson O'Day Graphics, 5 St Quintin Avenue, London W.10. Telephone: 020 7969 8085. Open by appointment. Norman Ackroyd, Mandy Bonnell, Michael Carlo, Yvonne Cole, JD Winter, Delia Delderfield, Brendan Neiland, Alison Neville, Carl Rowe, Donald Wilkinson.

Bernard Jacobson, 6 Cork Street, London W.1. Telephone: 020 7734 3431. Two branches in New York and Los Angeles. Ivor Abrahams, Maggi Hambling, Denny, Auerbach, Heindorff, Smith, Tucker and others.

Enitharmon Editions, 36 St George's Avenue, London N& OHD. Telephone: 020 7482 5967. www.enitharmon.co.uk. E-mail: books@enitharmon.co.uk.
Publishes editions and books of Paula Rego's work, Harold Pinter's "The Disappeared and other poems" with images by Tony Bevan. Usually exhibits at London Art fair in January.

Marlborough Graphics, 6 Albemarle Street, London W.1. Telephone: 020 7629 5161. See Marlborough Fine Art (Galleries section) for details. A top, major international art gallery with overseas branches.

New Academy Gallery, 34 Windmill Street, London W.1. Telephone: 020- 7323 4700. Prints by a variety of established contemporary artists.

Studio Prints, 159 Queens Crescent, London NW5. Telephone: 020 7485 4527. Ayrton, Trevelyan, Wilkinson, Wight, Greaves and Chris Penny among others.

Print Studios

Some of these studios have either a membership scheme or access for professional printmakers.

London Print Studio, 425 Harrow Road, London W10 4RW. Telephone: 020 8969 3247. Website: www.londonprintstudio.org.uk Print studio courses, gallery space, digital studio courses, silkscreen printing, etching, lithography.

London Contemporary Art, 132 Lots Road, London SW10ORJ. Telephone: 020 7351 7696. 300 new editions a year.

Pauperspress, 45 Coronet Street, London N1 6ND. Telephone: 020 7729 5272. Website: www.pauperspublications.com.
The Paupers Press is a fine art print and publishing studio which works with leading artists, galleries and publishers. Based in the Hoxton area. Facilities for etching, lithography, silkscreen and relief printing. Produces monoprints, multiple image editioned prints, artists' books and ephemera from hand drawn, photo-graphic and digital techniques of image production.

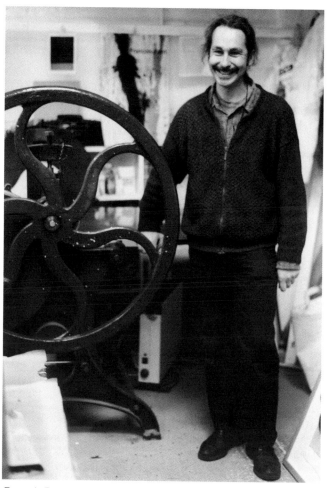

François Pont, printmaker, The Studio SE1.

Greenwich Printmakers, 1A Greenwich Market, London SE10 9HZ. Telephone: 020 8858. www.greenwichprintmakers.org.uk E-mail: etch1a@greenwichprintmakers.org.
A gallery space in the market but also a printmakers association.

Half Moon Printmakers, 10 Beckwith Road, London SE24. Telephone: 020 7733 9166.

South Hill Park Arts Centre, Bracknell, Berkshire. Telephone: 01344 27272.

Printers Ink and Associates, 27 Clerkenwell Close, Unit 355, London EC1. Telephone: 020 7251 1923. Etching workshops and Printmakers Association.

Studio Prints, 159 Queens Crescent, London NW5. Telephone: 020 7485 4527. Studio facilities for etching editions.

Useful Addresses

Artists' Organisations

Alternative Arts, Top Studio, Bethnal Green Training Centre, Deal Street, Spitalfields, London E.1. Telephone: 020 7375 0441. www.alternativearts.co.uk.
This organisation is truly amazing, having started in West Soho where it set up exhibitions in shops and alternative West end outlets. Now it operates from Spitalfields and continues to set up alternative temporary venues all over London. They organise Photomonth in October/November annually too.

SHAPE, 356 Hollywood Road, London N.7.
Shape introduces professional visual artists, musicians, actors and dancers, also puppeteers to hospitals, prisons, youth centres, day centres and to elderly, mentally and physically-handicapped people and to homeless, disturbed adolescents and offenders.

ACME Housing Association, 44 Copperfield Road, Bow, London E.3. Telephone: 020 8981 6811. Fax 020 8983 0567. www.acme.org.uk.Directors: Jonathan Harvey and David Panton. A non-profitmaking charity that houses artists, mainly in the East end of London. Currently has some 380 studios. Waiting list after the artist has been interviewed and if accepted. See Studios section for details.

a-n The Artists Information Company, 7-15 Pink Lane, Newcastle upon Tyne, NE1 5DW. Telephone: 0191 241 8000/8001. Fax: 0191 241 8001. www.a-n.co.uk E-mail:

info@a-n.co.ukco.uk. There is an a-n visual arts information service. They also sell lists of contact addresses, recommend publications and offer resource packs- not free of course. Phone 10-12 or 2-4 Tuesday-Friday. Send an sae if writing. a-n magazine is published monthly.

SPACE Studios, 129-135 Mare Street, Hackney, London E.9. Telephone: 020 8525 4330. E-mail: post@spacestudios.org.uk. www.spacestudios.com
Space Studios was set up in 1968 by Bridget Riley, Peter Sedgewick and others to help artists find cheap studio space. See studios section for details. Waiting list and interview for studios first.

National Artists Association, 21 Steward Street, Spitalfields London E1 6AJ. Telephone: 020 7426 0911.
Membership organisation with an access point for practising artists. Handbook and Code of Practice for Artists available.

Artists' Agency, 18 Norfolk Street, Sunderland, SR1 1EA. Telephone: 0191 510 9318.
Offers advice to artists about setting up residencies and placements.

Axis/Visual Associations, 8 Queen Square, Leeds LS2 8AJ. Telephone: 0870 443 0701. www.axisartists.org / www.openfrequency.org / www.smudgeflux.org / www.visualassociations.org
Multimedia text and image database holding the work of visual artists, craftspeople and photographers in England, Scotland and Wales. 5 images per artist. It costs £40 to join and first year's membership. After that you pay an annual subscription of £20 and can add two visuals. It costs £8 per extra viusual image.They exhibit at London Art fair in January so well worth seeing what they can help you with. www.visualassociations.org a new information source from AXIS. Smudgeflux is a new resource for teachers of Art and Design students aged 14-18.

INIVA (Institute of New International Visual Arts), 6-8 Standard Place, Rivington Street, London EC2A 3BE. Telephone: 020 7729 9616. www.iniva.org. E-mail: institute@iniva.org. The INIVA archive documents the organisation's programme since 1994. It includes images, texts, audio and video materials. www.iniva.org/archive.
Development project with the Arts Council which has led to a major visual arts organisation to promote contemporary artists worldwide. Promotes the creative possibilities of cross-cultural aspects in the visual arts.

Autograph, 74 Great Eastern Street, London EC2A 3JG. Telephone: 020 7729 9200. www.autograph-abp.co.uk. E-mail: indra@auto.demon.co.uk
The Association of Black Photographers' organisation.

Federation of British Artists, 17 Carlton House Terrace, London SW1. Telephone: 020 7930 6844.
A Federation of British Art Societies, including many Royal Art Societies. Leases the Mall Galleries where members have the opportunity to submit work for exhibitions. Membership by subscription.

National Society of Painters, Sculptors and Printmakers, 17 Carlton House Terrace London SW1.

Industrial Painters Group, (as above)
Also the following:
Royal Institute of Oil Painters
Royal Institute of Painters in Watercolour
Royal Society of British Artist
Royal Society of Marine Artists
Royal Society of Miniature Artists
Royal Society of Portrait Painters
Senefelf Group of Artist Lithographers
Society of Mural Painters
Society of Women Artists
United Society of Artists
Society of Architect Artists

The Florence Trust, St Saviours Church, Aberdeen Park, London N.5. Telephone: 020 7354 4771.
A trust that provides artists' studios and sells work at auction occasionally, to help keep them going.

New English Art Club, 17 Carlton House Terrace, London SW1.

Women Artists Slide Library, Fulham Palace, Bishops Avenue, London SW6. Telephone: 020 7731 7618.
Register of slides of work by British women artists, in all media. They also have a library of catalogues and books by women artists and about them. Their magazine is well-edited and in full colour.

Organisation for Black Arts Advancement and Leisure Activities (OBAALA), 225 Seven Sisters Road, London N.4. Telephone: 020 8263 1918.

A non-profit organisation to promote Black African art and artists. Membership.

The Organisation for Visual Artists, 4 Bellefields Road, London SW9 9UQ. Telephone: 020 7652 3937. Fax: 020 7652 3941. E-mail: info@ovas.demon.co.uk. Website: www.ovas.demon.co.uk

Film and Video Umbrella, 52 Bermondsey Street, London SE1 3UD. Telephone: 020 7407 7755. Fax: 020 7407 7766. E-mail: info@fvu.co.uk website www.fvumbrella.com
Curates and produces film, video and new media projects by artists.

Video as Urban Condition, www.video-as.org

Mario Merz sculpture, Tate Modern.

Landscape and Art Network, info@landartnet.org. Concerned with the quality of the urban and natural environment. Quarterly newsletter and reduced prices for books, events and site visits.

Free Painters and Sculptors, 15 Buckingham Gate, London Sw1.

Royal Society of British Sculptors, 108 Old Brompton Road, London SW7. 230 sculptors are members.
The Sculpture Company, also at this address. It advises on corporate and private commissions.

Society of Industrial Artists and Designers, 12 Carlton House Terrace, London SW1.

Society of Designers and Craftsmen, 6 Queen Square London WC1.

Royal Society of Painters in Watercolours, Royal Society of Painters, Etchers and Engravers, c/o Bankside Gallery, 48 Hopton Street, Blackfriars, London SE1. Telephone: 020 7928 7521.

Royal Academy of Arts, Burlington House, Piccadilly, London W.1 Telephone: 020 7300 8000.
RA membership is by election only. Membership scheme for Friends of the Royal Academy for discounts on private views, materials, magazines.

Greenwich Printmakers, 7 Turpin Lane, Greenwich, London SE10. Telephone: 020 8858 2290.

Printmakers Council, 31 Clerkenwell Close, London EC1. Telephone: 020 7 250 1927.
Regular bulletin and promotion of printmakers' interests. Professional membership. Publishes the Handbook of Printmaking Supplies, a must for printmakers.

The London Group, Box 447, London SE22. www.thelondon-group.com. E-mail: enquiries@thelondongroup.com.
An exhibition association of artists. Exhibitions annually in London with occasional cash prizes. The group celebrated its 90th birthday in 2003 with an exhibition in Cork Street and a magnificent book that is worth buying if there are any left in stock. Founded in 1913 by Sickert, Epstein and Wyndham Lewis the group emerged a month after a meeting of members of the Fitzroy Street Group and the Camden Town group in 1913. Members included Bomberg, Gertler, Jack Yeats, Kokoschka, Victor Pasmore and more recently Craigie Aitchison, Anthony Eyton, David Hockney, Leon Kossoff and even more recently Albert Irvin, Gary Wragg, Anthony Green, Julie Held, Lucy Jones, Janet Patterson, Peter Clossick, Suzan Swale,

Frank Bowling, Moich Abrahams, Marc Vaux, Eric Moody, Laetitia Yhap, Trevor Frankland, Victoria Bartlett and many others; 89 members at present.

Bermondsey Artists' Group, bag.office@virgin.net. Based at the Café Gallery Projects where many exhibitions are held. There is an annual open-entry exhibition.

Artists General Benevolent Institution, Burlington House, Piccadilly, London W.1. Telephone: 020 7744 1194.
Artist-run to provide financial assistance to professional artists in old age or in times of misfortune. Also Artists' Orphan Fund.

Artists' League of Great Britain, c/o Bankside Gallery, Hopton Street, London SE1. Telephone: 020 7928 7521.

VARS, Visual Artists Rights Society, 108 Old Brompton Road, London SW7. Telephone: 020 7373 3581.

Audio Arts, 6 Briarwood Road, London SW4. Telephone: 020 7720 9129. Bill Furlong has been documenting contemporary art since 1973. Beuys, Duchamp, Richter and Long and sound art works.

Design and Artists' Copyright Society (DACS), 2 Whitechurch Lane, London E1 7QR. Telephone: 020 7247 1650.

Art Agencies

Common Ground, The London Ecology Centre, 45 Shelton Street, London WC2H 9HJ.Telephone: 020 7379 3109.
A charity to encourage works of art in public places.

Other Useful Art Addresses

Arts Council of England, 14 Great Peter Street, London SW1. Telephone: 0845 300 6100. www.artscouncil.org.uk. E-mail: enquiries@artscouncil.org.uk
The Arts Council of England merged with the regional arts boards in 2002.

Artists' Lives, National Life Story Collection. The British Library national sound archive. http://cadensa.bl.uk This is a major project attempting to interview as many famous artists in Britain as possible, also some art critics and art dealers.

The Art Loss Register, 13 Grosvenor Place, London SW1. Telephone: 020 7235 3393. If you have had art stolen then they will help trace whatever is missing and give advice.

British Council, 11 Spring Gardens, London SW1. Telephone: 020 7930 8466.

Fine Art Department, 11 Portland Place, London W.1. Telephone: 020 7389 3043.
Organises British exhibitions overseas. Awards several scholarships and publishes a booklet on scholarships, available from Spring Gardens address above for approximately £4.

Visting Arts Unit, Bloomsbury House, 74-77 Great Russell Street, London WC1B 3DA. Telephone: 020 7291 1600.
Funded by the Foreign office,Calouste Gulbenkian Foundation and the British Council.

Central Bureau for International Education and Training, 10 Spring Gardens, London W.1. Telephone: 020 7389 4596/4004.
Assists educational exchanges overseas. Art teachers should enquire about art exchanges in Europe.

Association of Business Sponsorship for the Arts, Nutmeg House, Gainsford Street, London SE1. Telephone: 020 7378 8143.
They have a list of companies that sponsor the arts. Congratulates large companies for sponsoring the arts with awards.

Seymour Management, 63A South Audley Street, London W1K 2QS. Telephone: 020 7493 2662. E-mail: spencer.ewen @seymourmanagement.co.uk.
Manages fine art collections. Valuations for insurance. Restoration and framing. Transport of art. Inventories. Planned acquisition and disposal of assets.

Scottish Arts Council, 12 Manor Place, Edinburgh, EH3 7DO. Telephone: 0131 226 6051.

Welsh Arts Council, Holst House, Museum Place, Cardiff. Telephone: 012222 394711.

The Arts Council of Northern Ireland, 181A Stranmillis Place, Belfast. Telephone: 01232 663591.

Sorting work at an art competition.

Arts Council in Eire, 70 Merrion Square, Dublin 2. Telephone: Dublin 764695.

Artsource, Greencoat House, Francis Street, London SW1P 1DH. Telephone: 020 7932 9522. E-mail: patrick@art-source.co.uk A photography and art consultancy.

Association of Art Historians, 70 Cowcross Street, London EC1M 6EJ. Telephone: 020 7490 3211. Fax 020 7490 3277. E-mail: admin@aah.org.uk
Professional association for art historians. Annual conference, book fair, bulletin, access to a professional network of advice and support.

Centre for Creative Communities, 116 Commercial Street, London E.1 6NF. Telephone: 020 7247 5385. Website: www.creativecommunities.org.uk. E-mail: info@creativecommu-nities.org.uk. Director: Jennifer Williams.
Useful organisation for artists needing information on scholarships, art schools and overseas advice. Jennifer ran the British American Arts Association for many years and this is the new name and covers new ground.

British Chinese Artists Association, Dalby Street, London NW5. Telephone: 020 7267 6133.

Insight Arts Trust, 9 Islington Green, London N.1. 2XH. Telephone: 020 7 359 0772.
An arts organisation for ex-offenders and people on probation. Contact: Bernardine Evaristo.

Gulbenkian Foundation, 98 Portland Place, London W1N 4ET. Telephone: 020 7636 5313.

British Film Institute, 21 Stephen Street, London W1P 1PL. Telephone: 020 7255 1444.

Chelsea Arts Club, 143 Old Church Street, London SW3. Telephone: 020 7376 3311. Secretary Dudley Winterbottom. Private club open to arts world people to apply for membership. Many famous artists are members here, but you will also see the BBC and Channel4 arts-mafia. Lovely garden in summertime. The yearbook shows work by Arts Club artists.

The Arts Club, 40 Dover Street, London W.1 Telephone: 020 7499 8581.
Established private arts club. Open to arts world people for membership. Gracious dining and drawing room and garden at the back. They run regular exhibitions.

International Association of Art Critics, www.aica-uk.org.uk Membership open to art critics in the UK. Meets regularly and discusses problems relating to art criticism. The Bernard Denvir AICA Prize for art critical journalism is awarded to a critic every 3/4 years. So far three have been held: 1994, 1999, 2003 and the next one has a deadline of January 31st 2006, prize awarded in April 2006. 4 copies of articles published in the year before should be sent. See website for details. The international AICA Congress was held in London in 2000 in September. Membership provides a press card for use internationally at museums and galleries for free entry. £30 annual fee. There are annual congresses held every year in a different country.

Contemporary Art Society, Bloomsbury House, 74-77 Great Russell Street, London WC1B 3DA. Telephone: 020 7612 0730 www.contempart.co.uk. E-mail: cas@contempart.co.uk. Director: Gill Hedley. Acquires works by living artists so that they can be given to public galleries. They run an annual Art Market, in November. Members are also invited to join visits to private collections and member events. Membership £40 per annum.

Council for National Academic Awards, 344-354 Grays Inn Road, London WC1. Telephone: 020 7278 4411.
Lists courses currently being offered by colleges and polytechnics throughout the UK.

Crafts Council, 44 A Pentonville Road, London N.1. Telephone: 020 7278 7700. www.craftscouncil.org.uk.
Advises craftsmen and women and gives awards annually. Holds a register of craftsmen and women. Gallery next to the offices. Useful information service.

Museums Association, 34 Bloomsbury Way, London Wc1. Telephone: 020 7404 4767.

National Art Collections Fund, 7 Cromwell Place, London SW7 2JN. Telephone: 020 7225 4800. www.artfund.org. E-mail: artfund@mgtlimited.com.
Helps galleries and museums acquire works of art of historical interest. Membership scheme, £33 or life £680. Free Art Quarterly magazine for members.

National Association of Decorative and Fine Arts Societies, c/o Secretary, 8A Lower Grosvenor Place, London SW1. Telephone: 020 7233 5433.

National Society for Art Education, Champness Hall, Drake Street, Rochdale, Lancashire.
Represents the interests of teachers of art and design.

Royal Society of Arts, 6-8 John Adam Street, London WC2. Telephone: 020 7839 2361.
Holds occasional art exhibitions, but acts as a link between the practical arts and the sciences.

Foundation for Women's Art, 55-63 Goswell Road, London EC1V 7EN. Telephone: 020 7251 4881. www.fwa-uk.org.
Aimed at the promotion of Women's Art.

Hidden Art Open Studios, www.hiddenart.com.
Takes place across London in November annually and is a huge event of great help to artists and crafts people. Very well organised with maps and booklets to find everybody and every studio/home.

Foundation for Art and Creative Technology, www.fact.co.uk

IXIA, 1st floor, 321 Bradford Street, Biurmingham, B5 6ET. www.ixia-info.com. E-mail: info@ixia-info.com.

Commission a Craftsman, www.commissionacraftsman.com Set up in 2003. Enables access to crafts people, designers and applied artists.

The Society of London Art Dealers, 91A Jermyn Street, London SW1Y 6JB. Website: www.slad.org.uk.
Founded to uphold the good name of the art trade.

Sotheby's, Fine Art Courses, 34-35 New Bond Street, London W.1. Telephone: 020 7408 1100. www.sothebys.com.
Variety of specialised courses open to students.

The City University, Centre for Arts and Related Studies, St John Street, London EC1. Telephone: 0 20 7253 4399.
Arts administration courses. Applicants should be 21 or over and hold a degree or equivalent.

Association of Art Historians, c/o Peter Fitzgerald, Dept. of Art History, University of Reading, London Road, Berkshire. Annual subscription which includes 4 issues of Art History magazine.

Art Fairs

Frieze Art Fair, 5-9 Hatton Wall, London EC1N 8HX. Telephone: 020 7692 0000 www.friezeartfair.com. E-mail: info@friezeartfair.com.
This fair opened in October 2003 for the first time in a huge marquee designed by David Adjaye, in Regent's Park. The difference with this fair is that it is international and very prestigious. Over 30,000 visitors and increasing each year. Set up by the owners of Frieze art magazine it has been very successful and joined by other smaller art fairs nearby to coincide with the influx of international art collectors to London. See various photos in this guide of exhibitors at the 1st and 2nd Frieze Art fairs.

Photo London, www.photo-london.com. E-mail: info@photo-london.com. Telephone: 020 7839 9300.
First one was held in 2004 and was a great success, long overdue. Danny Newburg of Art and Photographs and PLUK

photo magazine set the fair up in 2004, knowing that there was a huge interest in photography in London and the UK.

London Artists' Book Fair, Marcus Campbell Books, 43 Holland Street, London SE1 9JR. Telephone: 020 7261 0111 www.marcuscampbell.co.uk E-mail: lab@marcuscampbell.co.uk Held in November every year since 1993, usually at the ICA.

The Affordable Art Fair, Telephone: 020 7371 8787. Website: www.affordableartfair.co.uk.
Annual event in Battersea Park.

London Art Fair, Business Design Centre, 52 Upper Street, Islington, London N.1. 0QH. Telephone: 020 7359 3535. Website: www.londonartfair.co.uk.
The largest contemporary art fair in the UK which takes place in January every year. Over 100 leading galleries and a variety of special exhibitions featuring topical artists.

ArtLONDON, Website: www.artlondon.net. Held annually in early June.

Battersea Art Fair, Battersea Arts Centre. Telephone: 020 76423 5318.

Chelsea Art Fair, PO Box 114, Haywards Heath RH16 2YU. Telephone: 01444 482514. E-mail: info@penman.fairs.co.uk. Website: www.chelseartfair.com. Held annually in Chelsea Old Town hall in April.

Collect, Organised by the Crafts Council at the V&A Museum every February. Website: www.craftscouncil.org.uk/collect. E-mail: collect@crfatscouncil.org.uk.
Launched in 2004, this new crafts fair displays work by the country's leading craftsmen and women.

Fine Art Antiques Fair, Website: www.olympia-antiques.com Held annually in February at Olympia. Angus Stewart holds an annual exhibition (Burra, Vaughan) usually of great interest.

Grosvenor House Art and Antiques Fair, Website: www.grosvenor-antiquesfair.co.uk.
Held in June each year when many collectors visit London. It is a leading world art and antiques fair but how things have changed

in the last 10 years! There are now so many contemporary and affordable art fairs in London.This one is very establishment.

20/21 British Art Fair, Telephone: 020 8742 1611. E-mail: organisers@artfairs.demon.co.uk. website www.britishartfair.co.uk. Takes place every September at the Royal College of Art and is the only fair covering British Art from 1900 to today. About 60 leading dealers take part and contemporary and Modern British art are both on view.

Art on Paper Fair, Telephone: 020 8742 1611. Website: www.artonpaper.co.uk. E-mail: organisres@artfairs.demon.co.uk. Held in early February annually at the Royal College of Art 20th century and contemporary British Art, European, Japanese and Chinese contemporary art, prints, watercolours, Old Master drawings, photography and sculpture.

The London Original Print Fair, Website: www.londonprint-fair.com. Held annually at the Royal Academy in April.

The Watercolours and Drawings Fair, Telephone: 07000 785 613. www.watercoloursfair.com.
Held in early February annually at the Royal Academy, 6 Burlington Gardens, London W1.

Auction Houses

Bonhams, Telephone: 020 7629 6602. www.bonhams.com
Christies, Telephone: 0207930 6074. www.christies.com
Sotheby's, Telephone: 020 7292 5000. www.sothebys.com

Art Teaching Courses

Goldsmiths College, Lewisham Way, London SE14. Telephone: 020 7919 7171. www.goldsmiths.ac.uk
Secondary education.

Middlesex, Trent Park, Cockfosters, Herts. 020 8411 5000. www.mdx.ac.uk
Secondary and Higher education.

University of London, 1 Malet Street, London WC1.

Print production at a factory, Winsor and Newton.

Artists' Materials

Painting Materials

A.P. Fitzpatrick, 142 Cambridge Heath Road, Bethnal Green, London E1 5QT. Telephone: 020 7790 0884.
Sax oil paints, acrylic paints, Lascaux brushes.

Brodie and Middleton, 68 Drury Lane, London WC2. Telephone: 020 7836 3289. website www.brodies.net.
Excellent paint materials.

London Graphic Centre, 16-18 Shelton Street, London WC2. Telephone: 020 7759 4500. Also at 13 Tottenham Street W.1 Telephone: 020 7637 2199.
Variety of art materials.

A.S.Handover Ltd, 37 Mildmay Grove, London N.1. Telephone: 020 7359 4696. Brushmakers.

Cornelissen & Son Ltd, 105 Great Russell Street, London WC1. Telephone: 020 7636 1045. Fax: 020 7636 3655.
Materials for painters, printmakers, gilders, also pastel tints. Direct mail orders also. Ring for details.

Daler-Rowney, 12 Percy Street, London W.1. Telephone: 020 7636 8241. Most art materials.

Bird and Davis, 45 Holmes Road, London NW5 3AN. Telephone: 020 7485 3797. www.birdanddavis.co.uk. E-mail: birdltd@aol.com.
Stretchers, machinist-joiners. Stretchers have to be ordered.

Russell and Chapple Ltd, 68 Drury Lane, London WC2B. Telephone: 020 7836 7521. Canvas suppliers.

Ploton Supplies, 273 Archway Road, London N.6. Telephone: 020 8348 0315.

Tiranti, 27 Warren Street, London W1P. Telephone: 020 7636 8565. Sculpture materials specialist.

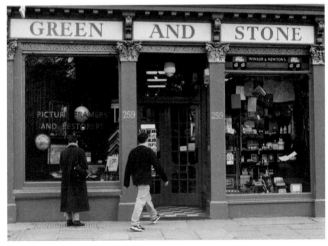

Green and Stone art materials shop, Kings Road SW3.

Binney and Smith (Europe) Ltd, Ampthill Road, Bedford. UK wholesalers for liquitex.

C.Roberson and Co. Ltd, 1A Hercules Street, London N.7. Telephone: 020 7272 0567.
Recommended by a reader as the "best art supply shop in London." Stretchers, paint, paper etc.

Green and Stone, 259 Kings Road, London SW3. Telephone: 020 7352 0837. All materials.

Cass Arts, 17 Charing Cross Road, London WC2H. Telephone: 020 7930 9940. All materials.

General

John Purcell, 15 Rumsey Road, London SW9 0TR. Telephone: 020 7737 5199. Paper.

Artpost, www.artpost.co.uk. Specialises in bargain basement art supplies. You have to e-mail orders.

Artdiscount, www.artdiscount.co.uk. Sells paint and art materials for up to a 50% discount, compared to High Street prices.

Brodie and Middleton, 68 Drury Lane, Covent Garden, London WC2. Telephone: 020 7836 3289. Website: www.brodies.net

Turnham Arts & Crafts, 2 Bedford Park Corner, Turnham Green Terrace, Chiswick, London W4 1LS. Telephone: 020 8995 2872. They also run **The Print Gallery**, 22 Pembridge Road, London W11 3HL. Telephone: 020 7221 8885. Also **Ealing Arts and Crafts**, 26C Broadway, West Ealing, London W13 0SU. Telephone: 020 8567 6152.
All branches sell a complete range of art and graphic materials.

Ryman, 96 and 227 Kensington High Street, London W.8. Telephone: 020 7937 1107. www.ryman.com.
Branches throughout London. Stationers, office equipment and general office supplies.

Lyndons Art & Graphics, 197 Portobello Road, London W11 Telephone: 020 7727 4357.

Millers Art, www.millers-art.co.uk. Materials for professional artists. Huge range to chose from.

Morse, 264 Lee High Road, London SE13. Telephone: 020 8852 4183. Artists' materials and framing.

Winton, 36 Earls Court Road, London W.8. Telephone: 020 7937 2024. Hardboard, picture glass etc.

Cowling and Wilcox, 26-28 Broadwick Street, London W.1. Telephone: 020 7734 9556. Graphics specialists.

Rymans, 66 Tottenham Court Road London W.1. Telephone: 020 7636 7306.

Green and Stone, 259 Kings Road London, SW3. Telephone: 020 7352 0837. All art materials and friendly staff.

Art and Design Installations, Telephone: 020 7729 8073. Hangs pictures professionally.

Lamley Art Supplies, 25-28 Thurloe Place, London SW7. Telephone: 020 7589 1276.

Wheatsheaf Graphics, 56 Baker Street, London W1M. Telephone: 020 7935 5510.

Fine Digital Print, Telephone: 01672 871284. Website: www.finedigitalprint.co.uk. E-mail: ch@finedigitalprint.co.uk. Scanback camera photographs artists' work and print on fine papers using light-fast inks.

Art Transport

Rees Martin Art Services, Unit 4, 129-131 Coldharbour Lane, London SE5 9NY. Telephone: 020 7274 5555.
Storage, transport and packing.

Art Move, Unit 3,Grant Road, London SW11 2NU. Telephone: 020 7585 1801. Transport, hanging and shipping.

Transnic, 434 Gordon Grove, London SE5 9DU.Telephone: 020 7738 755. Transport, picture hanging and storage.

Insurance

Crowley Colosso, Ibex House, Minories, London EC3. Telephone: 020 7782 9782. Art world specialists.

Windsor Insurance Brokers, 160-166 Borough High Street, London SE1 1JR. Telephone: 020 7407 7144. Art specialists.

Framing

Abbey Frames, 26-28 Abbey Business Centre, Ingate Place (off Queenstown Road), London SW8 3NS. Telephone: 0171(0207 from 4/2000) 622 4815.
Established trade framers specialising in decorative mounts.

Framework, 5-9 Creekside, Deptford, London SE8 4SA. Telephone: 020 8691 5140.

Green and Stone of Chelsea, 259 Kings Road, London SW3. Telephone: 020 7352 6521. Specialist picture framers, carvers, gilders and artists' colourmen.

Sebastian d'Orsai, 39 Theobalds Road, WC1. Telephone: 020 7405 6663. Also 8 Kensington Mall, London W.8. Telephone: 020 7229 3888.

Frame, Set and Match, 113 Notting Hill Gate, London W.11. Telephone: 020 7229 7444. Open Monday-Saturday 9.30-6, Thursday-7. Good local framers.

John Jones Frames Ltd., 4 Morris Place (off Stroud Green Road), Finsbury Park, London N.4.3JG. Telephone: 020 7281 5439. Fax 020 7281 5956. The UK's most comprehensive framing service. Mouldings, manufactured and hand-finished to order. Gilding, studio, art photographic service. In-house conservator, collection and delivery. Parking facilities. Also Fine art photographic service. They also hold exhibitions regularly.

Frame Store, 33 Great Pulteney Street, London W.1. Telephone: 020 7439 1267.

Frame Factory, 132 Talbot Road, London W.11. Telephone: 020 7229 8263. Branches elsewhere also.

Railings Gallery, 5 New Cavendish Street, London W1G 8UT. Telephone: 020 7935 1114. E-mail: trg@railings-gallery.com.

Many galleries also do framing if you buy work from them.

Shipping

Momart, Telephone: 020 8986 3624. Fax: 020 8533 0122. E-mail: enquiries@momart.co.uk. Art specialists.

OI Fine Art Services, 282 Richmond Road, London E.8. Telephone: 020 7533 6124.

Featherston Shipping, 24 Hampton House, 15-17 Ingate Place, London SW8. Telephone: 020 7720 0422. Arts specialists.

Printers

Ranelagh, Park End, South Hill Park, London NW3. Telephone: 020 7435 4400. Invitations, publicity cards, catalogues, posters and limited edition prints.

Z Cards, 1-2 Great Chapel Street, London W.1. Telephone: 020 7437 1533/1544. Fine art print and design company. Invitations, postcards, brochures, catalogues, posters.

Abacus, Lowick House, Lowick, Near Ulverston, Cumbria. Telephone: 01229 885361. Good printers, but note that they are out of London.

Paper

John Purcell, 15 Rumsey Road, London SW9 OTR. Telephone: 020 7737 5199. Recommended by a reader.

Paperchase, 213 Tottenham Court Road, London W.1 Telephone: 020 7580 8496. Excellent variety of cards, paper etc.

Falkiner Fine Papers, 6 Southampton Row, London WC1B 4AR. Telephone: 020 7831 1151. Good variety of handmade papers. Also sell art books and magazines.

RK Burt, 57 Union Street, London SE1. Telephone: 020 7407 6474. Large quantities of handmade paper.

GF Smith, 2 Leathermarket, Weston Street, London SE1. Telephone: 020 7407 6174.

Barcham Green and Co. Ltd, Hayle Mill, Maidstone, Kent.

Photography and Film

Check the **Photographers Gallery** noticeboard for useful addresses , also photographic magazines.

Aperture, 44 Museum Street, London WC1A 1LY. Telephone: 020 7242 8681. www.aperture.co.uk.
They sell spare parts for Nikon, Leica, Canon and Olympus. Secondhand cameras and lenses.

Process Supplies, 13-21 Mount Pleasant, London WC1. Telephone: 020 7837 2179.
General photo supplies. Excellent for darkroom equipment.

Vic Oddens, 5 London Bridge Walk, London SE1. Telephone: 020 7407 6833.
Cameras, film, enlargers. Good secondhand selection (speaking from experience).

Brunnings, 133 High Holborn, London WC1. Telephone: 020 7831 2846.
Secondhand equipment. Photo dealers.

Leeds Camera Centre, 20-26 Brunswick Centre, Bernard Street, London WC1. Telephone: 020 7833 1661.

Fox Talbot Cameras, 154 Tottenham Court Road, London W.1. Telephone: 020 7387 7001. Also at 443 Strand WC2. Telephone: 020 7379 6522.

Main Nikon Retailers, Good range of quality used equipment.

ETA Labs, 216 Kensington Park Road, London W.11. Telephone: 020 7727 2570.
Colour and b/w processors. Reliable and good.

Chris Kewbank at the Special Photographers Company.

Sky Photographic Services, 2 Ramillies Street, London W.1. Telephone: 020 7434 2266. Also branches elsewhere in London. B/w and colour processors. They do extra-large contact sheets. Mounting, framing and display services. Used by top professional and commercial photographers.

Dark Side, 4-8 Helmet Row, London EC1. Telephone: 020 7250 1200. B/w and colour processing.

Jessop, 67-69 New Oxford Street, London WC1. Telephone: 020 7240 6077.
Large shop with variety of films, photo paper, chemicals and also secondhand cameras.

KJP Soho, 175 Wardour Street, London W1V 3FB. Telephone: 020 7434 1848.
Professional film, paper, filters, darkroom accessories, batteries.

The Camera Clinic, 26 North End Crescent, London W14. Telephone: 020 7602 7976. Camera repairs. Recommended as the best in London but I have to also recommend Sendean in Oxford Street.

Joe's Basement, 113-117 Wardour Street, Soho, London W1V 3TD. Telephone: 020 7439 3210. Website: www.joesbaseemnt.co.uk. Other branches at Hammersmith and two other locations. Traditional and digital services.

Darkside, Telephone: 020 7250 1200. E-mail: art@darkside-photo.co.uk. High quality b/w prints, also colour, processing and C41 films.

City Camera Exchange, 43 Strutton Ground, London SW1. Telephone: 020 7222 0521. Excellent secondhand camera shop.

Sendean Shop No. 2, 9-12 St Anne's Court, London W1V 3AX. Telephone: 020 7734 0895 E-mail: sendeancameras@aol.com Repair service at reasonable rates. Advice given but the previous owners were infinitely better and more obliging, when it was on OXford Street.

Quicksilver, 8 Flitcroft Street, London WC2. Telephone: 020 7836 7420. Good cibachrome processing.

Superchrome, 154 Drummond Street, London NW1. Telephone: 020 7388 6303/7779. Cibachrome prints.

Flash Photographic, 6-8 Colville Mews, London W.11 2DA. Telephone: 020 7727 9881. All photo services.

West End Cameras, 168 Tottenham Court Road, London W.1. Telephone: 020 7387 0787. Small photo shop with second hand and new cameras and batteries for old cameras.

Wimbledon School of Art print workshop.

Printmaking

Printmakers would be well-advised to buy *the Handbook to Printmaking Supplies* published by the Printmakers Council, Clerkenwell Close (if it's not out of print). See Useful Addresses for details.

L. Cornelissen, 105 Great Russell Street, London WC1. Telephone: 020 7636 1045.
Printmaking and fine art supplies. Beautiful shop. Near the British Museum.

TN Lawrence and Son, 119 Clerkenwell Road, London EC1. Telephone: 020 7242 3534.

C. Roberson and Co Ltd, 1A Hercules Street, London N.7. Telephone: 020 7272 0567.
Plates cut to order on the premises. Charbonnel distributor.

Intaglio, (Printmakers) 62 Southwark Bridge Road, London SE1. Telephone: 020 7928 2633/2711.

Sculpture Materials

General
Alec Tiranti, 7 Warren Street, London W.1. Telephone: 020 7636 8565. Tools, waxes, plasters, Gelflex, flexible mouldmaking materials.

Metals
Lazdan, 218 Bow Common Lane, London E.3. Telephone: 020 8981 4632.

Strand Glass and Co Ltd., 524 High Road, Ilford, Essex.

Fibreglass Resins
McKechnie Metal Powders, PO Box 4, Widnes, Cheshire WA8 OPG.

Hecht, Heyworth and Alcan Ltd., 70 Clifton Street, London EC2. Telephone: 020 7377 8773. Resins and rubbers.

Tools
Parry and Son (Tools) Ltd, 329 Old Street, London EC1. Telephone: 020 7739 8301.

Charles Cooper, 23 Hatton Wall, London EC1. Telephone: 020 7405 5928.

Stone
Stone Firms, 10 Pascal Road, London SW8.

Plaster Merchants
Bellman Ivy & Carter, 358-374 Grand Drive, Raynes Park, London SW20. Telephone: 020 8540 1372. Plasters, latex and wax.

John Myland Ltd., 80 Norwood High Street, London SE27. Telephone: 020 8670 9161. Also at 128 Stockwell Road, London SW9. Telephone: 020 8274 2468.

EF Burke and Sons, Unit 12, Newlands End, London North Industrial area, Basildon. Telephone: 0126841 5071. Plaster of Paris.

Sculpture waxes
Poth Hille and Co Ltd., 37 High Street, London E.15. Telephone: 020 8534 7091. Waxes.

Plasterers Merchants
A. Randall, Supremacy House, Hurstwood Road, Golders Green, London NW11. Scrim, brushes, mixing bowls.

Timber
Moss, 104 King Street, London W.6. Telephone: 020 8748 8251. Hardwoods.

CF Anderson and Son Ltd., Harris Wharf, 36 Graham Street, London N.1. Telephone: 020 7226 1212.

Buck and Ryan Ltd., 101 Tottenham Court Road, London W.1. Telephone: 020 7636 7475. Machine tools.

British Museum Great Court.

Art Magazines

The main international art magazines include **Artnews USA, Flash Art international, Artforum, Frieze** among others. In Britain the following are useful. There are also many small art magazines that come and go; check the gallery bookshops in London. Frieze art magazine is so successful that it set up the annual **Frieze Art fair** in October, in Regent's Park; a huge event with international galleries.

Apollo, 20 Theobalds Road, London WC1X 8FF. Telephone: 020 7430 9200. Glossy monthly art and antiques publication for collectors.

a-r-c, 22 Drayton Grove, London SE15 2NX. Telephone: 020 7277 6074. E-mail: a-r-c@gold.ac.uk. Website: a-r-c.gold.ac.uk. art-research-curating is the journal of those three subjects and is an online art magazine. Editor Poli Cardenas.

Arts Research Digest, Research Services Unit, University of Newcastle, 1 Park Terrace, NE1 7RU. Telephone: 0191 222 5220. Published three times a year. Information on the arts.

The Artists and Illustrators Magazine, 6 Blundell Street, London N.7. Telephone: 020 7609 2222.
Buyer's guide, artsnews and practical projects. For amateurs and professionals. They run an Art Materials Fair in July annually.

Artists Newsletter (now a-n magazine), The Artists' Information Company, The Turner Building, 7-15 Pink Lane, Newcastle, NE1 5DW. Telephone: 0191 241 8000. Fax: 0191 214 8000. Helpline: 0191 241 8008. www.a-n.co.uk. E-mail: info@a-n.co.uk. Published by The Artists' Information Company and grant-aided by many Regional Arts Associations. Magazine for artists listing suppliers, news on awards, competitions, art events, book reviews and an art information service. They also publish a very useful series of artists' books. Keeps up-to-date with what artists require.

Art Monthly, Suite 17, 26 Charing Cross Road, London WC2. Telephone: 020 7240 0389. Fax: 020 7497 0726. E-mail: subs@artmonthly.co.uk. Website: www.artmonthly.co.uk
10 issues per annum. Art news magazine with news, reviews, interviews, criticism, artlaw and correspondence from the art world.

The Art Newspaper, 70 South Lambeth Road, London SW8 1RL. Telephone: 020 7735 3331. Fax: 020 7735 3332. E-mail: subscribe@theartnewspaper.com. Website: www.theartnews-paper.com.
Part of the Umberto Allemandi publishing business in Italy. 10 issues per annum covering art news internationally, features, reviews in newspaper format, also auction news. Essential reading for anyone in the art world. They also publish The Year Ahead ever January listings exhibitions internationally.

The Artist, 102 High Street, Tenterden, Kent. Telephone: 015806 3673.
Art magazine mainly for amateur artists, but could be useful also for professionals. Technical art articles and reviews.

ArtReview, Hereford House, 23-24 Smithfield St, London EC1A 9LF. Telephone: 020 7236 4880. Fax: 020 7236 4881. www.art-review.com. Subscriptions: 01858 438803. Editor Rebecca Wilson.
Art reviews in Britain and an Art under £1000 section. They also publish an Art Buyer's Guide booklet annually, Print supplement and an Art Directory. Huge changes in this magazine as it strives to be the UK's leading art magazine.

Arts and The Islamic World, 144-146 Kings Cross Road, London WC1X 9DH. Telephone: 020 7833 8275. Editor Jalal Ahmed. Extensive coverage of the arts in the Islamic world with colour photographs.

Audio Arts, 6 Briarwood Road, London SW4. Telephone: 020 8720 9129. Bill Furlong has been documenting contemporary art since 1973. Audio cassettes available on subscription.

The British Art Journal, 46 Grove Lane, London SE5 8ST. Telephone: 020 7787 6944. Editor: Robin Simon.
It runs the annual William M.B.Berger Prize for British Art History, a £5000 prize for excellence in British art history. The magazine is the research journal of British art studies, first published in 1999. 3 issues a year with original research, book reviews, exhibition reviews and views and opinions.

The British Journal of Aesthetics/Oxford Art Journal, Oxford University Press, Great Clarendon Street, Oxford OX2 6DP. Telephone: 01865 556767. Website: www.art.oupjournals.org. Four different academic art journals.

The Black Art Magazine, 225 Seven Sisters Road, Finsbury Park, London N.4. Telephone: 020 7263 8016.
Art news, reviews, exhibitions, interviews and interaction. Published quarterly by OBAALA, an organisation for Black Arts Advancement and leisure activities.

Block, Art History Department, Cat Hill, Cockfosters, East Barnet, Herts. Telephone: 020 8440 7431 ext 224.
Articles on art historical research, live art and exhibitions.

British Journal of Photography, 58 Fleet Street, London EC4. Telephone: 020 7583 0175.
Established weekly photographic magazine with listings of photographic exhibitions every fortnight and reviews, technical news and features.

Burlington Magazine, Telephone: 020 7388 1288. Website: www.burlington.org.uk.
Monthly art journal for art historians and students. Academic.

Camera, Bretton Court, Peterborough. Telephone: 01733 264666. Editor Richard Hopkins. Articles on equipment and portfolios in black and white of work by British photographers. Practical Photography, also at this address.

Ceramic Review, 25 Foubert's Place, London W1F 7QF. Telephone: 020 7439 3377. Website: www.ceramicreview.com. Subsciptions e-mail: subscriptions@ceramicreview.com.
The international magazine of ceramic art and craft.

Contemporary, Suite K101, Tower Bridge Business Complex, 100 Clements Road, London SE16 4DG. Telephone: 020 7740 1704. E-mail: info@contemporary-magazine.com. www.contemporary-magazine.com. An excellent readable contemporary art magazine. Reviews, previews, book reviews and feature articles.

Crafts, 44A Pentonville Road, London N.1. Telephone: 020 7278 7700.
Published every two months with reviews and book news. Annual subscription UK and overseas.

Eye, Tower House, Lathkill Street, Market Harborough, LE16 9EF. Telephone: 01853 438872.
Uk graphic design magazine with criticism and reviews.

Flash Art, UK contact: Telephone: 020 7351 5981. www.flashartonline.net.
Available at newsagents and art bookshops. Published in Italy by Giancarlo Politi and covers international art reviews, news and up-to-the-minute features on the latest art trends. Also publishers of Art Diary which lists artists and art galleries worldwide.

frieze, 5-9 Hatton Wall, London EC1N 8HX. Telephone: 020 77025 3970. E-mail: admin@frieze.com website www.frieze.com.
A contemporary culture and art magazine. Frieze also set up the Frieze Art Fair in October 2003, an annual event with international and national galleries exhibition in Regent's Park. The Yearbook lists all the artists who exhibit at the fair with photographs and details of which galleries sell their work.

Galleries, 54 Uxbridge Road, London W12 8LP. Telephone: 020 8740 7020. E-mail: art@galleries.co.uk.co.uk. Website: www.galleries.co.uk
Monthly guide to London and British exhibitions. Free at galleries. Art features and reviews at the front, otherwise a listings magazine. Executive editor Andrew Aitken. Features editor Nicholas Usherwood.

Impress, 31 Clerkenwell Close, London EC1.Telephone: 020 7250 1927.
Printmakers Council publishes this magazine at their Clerkenwell workshop.

London Art and Artists Guide, www.hwlondonartandartists-guide.com
Books/photographs/art consultancy/ art magazine. About 13-15 art reviews about London, Scottish, Parisian, European, New York and Australian art shows. Free!

Modern Painters, 52 Bermondsey Street, London SE1 3UD. Telephone: 020 7407 9247. Website: www.modernpainters.co.uk. Editor: Karen Wright. Louise Blouin MacBain has taken over this art magazine as well as Art & Auction in America.
A glossy quarterly set up by the late Peter Fuller. Features, reviews, interviews, often by people outside the art world with

views on art. The board includes writer William Boyd, who now writes about art as well as writing fiction and film scripts.

Museums Journal, Museums Association, 24 Calvin Street, London E1 6NW. E-mail: info@museumsassociation.org.
Covers all museum and gallery issues. Reviews, features, interviews, jobs.

NewArch, Papadakis Publishers, London SW1X 7HH. Telephone: 020 7823 2323. www.newarchitecture.net. E-mail: info@newarchitecture.net.
Architecture, art, design, media and fashion. Contributors include Issey Miyake, Zaha Hadid, David Hockney and Jenny Holzer.

Portfolio, 43 Candlemaker Row, Edinburgh EH1 2QB. Telephone: 0131 220 1911. www.portfoliocatalogue.com. E-mail: info@portfoliocatalogue.com
A contemporary photography magazine with reviews, quality reproductions published in June and December. Back issues are also available.

Printmaking Today, Farrand Press, 50 Ferry Street, Isle of Dogs, London E14 3DT. Telephone: 020 7515 7322.
Quarterly magazine for the printmaking world.

Public Art Journal, Manchester M4 9BY. Telephone: 01237 470 440. A twice-yearly new art journal, in March and October, with features/reviews for professionals with an interest in art and the public domain. Writers include Sacha Craddock, Jonathan Darke, Brian Catling and Paul Bonaventura.

RA Magazine, Burlington House, Piccadilly, London W.1. Telephone: 020 7300 8000. www.royalacademy.org.uk.
Publisher Nick Tite. Art magazine for Friends of the Royal Academy. One of the largest circulation UK art magazines. Interesting art features, reviews and news.

Source Magazine, PO Box 352, Belfast BT1 2WB. Telephone: 02890 329691. www.source.ie.
A photography magazine.

The Jackdaw, 88 Leswin Road, London N16 7ND. Telephone: 020 7254 4027. www.thejackdaw.co.uk. Run by David Lee who has independent views on the art world and is brave enough to stand up against the current waves of thought!

Brian Sewell (Evening Standard), David Lee (The Jackdaw) and Angus Stewart at an (AICA) art critics' seminar, Olympia Art ands Antiques Fair.

TATE ETC, 20 John Islip Street, London SW1P 4RG. Telephone: 020 7787 8724. www.tate.org.uk/tateetc E-mail: tateetc@tate.org.uk. Editorial Director: Bice Curiger. Editor: Simon Grant.
After a dreadful period when Tate magazine became a Condé Nast offshoot the magazine has settled back to being a good quality art magazine again.

Transcript, School of Fine Art, Duncan of Jordanstone College, Perth Road, Dundee, DD1 4HT. Telephone: 013 8222 3261.
An art magazine in catalogue format with interviews and features on contemporary art.

Untitled, 29 Poets Road, London N.5. 2SL. Telephone: 020 7359 6523. Editor John Stathatos.
Excellent reviews and unpretentious art features.

Women's Art, Women's Art Library, Fulham Palace Road, Bishops Avenue, London SW6 6EA. Telephone: 020 7731 7618. Features on women's art, reviews and interviews in full colour magazine.

Press Contacts

Daily Express, Ludgate House, Blackfriars Road, London SE1 9UX. Telephone: 020 7928 8000.
Features editor.

Daily Mail, Northcliffe House, 2 Derry Street, London W.8. Telephone: 020 7938 6000.

The Daily Telegraph, South Quay Plaza, 181 Marsh Wall, Isle of Dogs, London E.14 9SR. Telephone: 020 7538 5000
Art critic: Richard Dorment

The Sunday Telegraph, address as above.
Art critic: John McEwen.

The Financial Times, Number One, Southwark Bridge, London SE1. Telephone: 020 7873 3000.
Art critic: Bill Packer, Martin Hall, Nigel Andrews.

The Guardian, 119 Farringdon Road, London EC1. Telephone: 020 7278 2332.
Art critic: Adrian Searle.

The Observer, 119 Farringdon Road, London EC1. Telephone: 020 7278 2332.
Arts Editor: David Benedict

The Times, 1 Virginia Street, London E.1. Telephone: 020 7782 5000.
Art critics: John Russell-Taylor, Rachel Campbell-Johnston, Richard Cork Amber Cowan. Arts correspondent: Dalya Alberge.

The Sunday Times, address as above.
Art critic: Waldemar Januszczak.

The Independent, 191 Marsh Wall Canary Wharf, London E14 9RS. Telephone: 020 7005 2000.
Art critic: Tom Lubbock. Art for Sale: Sue Hubbard.

The Independent on Sunday, address as above.
Art critic: Charles Darwent

253

Marco Livingstone, Annemarie Norton and Tim Sayer at the Anthony Caro show at Kenwood House, 2004.

The Evening Standard, 2 Derry Street, London W.8. Telephone: 020 7938 6000.
Art critic: Brian Sewell. (New Art) Andrew Renton. Nick Hackworth.

The Friday ES magazine (Hot Tickets), is also useful for listings, but check the front of it as the listings are done elsewhere i.e.don't send them to the ES office! PA Listings, PA Newscentre, 292 Vauxhall Bridge Road, London SW1V 1AE. Telephone: 020 7963 7707. Fax: 020 7963 7800/7801. Make sure that you make it clear which section you wish the details to go in.

Time Out Magazine, 251 Tottenham Court Road, London WC1. Telephone: 020 7813 3000.
Art critic: Sarah Kent. Other regular reviewers include Martin Coomer.

Apart from the art side there may well be a possible news angle, in which case you must work out whether you have a feature or news story to sell and contact the appropriate editor. Newspapers are frenetically busy, so be prepared to talk at high speed if you ring them direct. E-mailing can work out or be lost, depending how efficient the department is. It is also best to send a press release and possibly a b/w photo to the arts editor as well as the critic. The Arts editor runs all the arts pages, whereas the art critic is often freelance and works from home. If you have a photo that could be useful for the picture editor, contact him/ her separately. Now of course you can e-mail newspapers, with attachments and jpgs.

Television and radio

BBC Radio 4, Portland Place, London W1A 1AA. Telephone: 020 7580 4468.
Future events unit send 12 copies of a press release well in advance.Today and Woman's Hour are at this address. www.bbc.co.uk

BBC World Service, Bush House, The Strand, London WC2. Telephone: 020 7240 3456.
Any story with international appeal, especially third world, could be of interest.

BBC TV, TV Centre, Wood Lane, London W.12 7RJ. Telephone: 020 7743 8000. www.bbc.co.uk
David Sillito and Nick Higham cover arts news and features on

Bruice Nauman press conference Tate Modern, 2004.

the main news. Any other arts programmes are also at this address.

Capital Radio, 30 Leicester Square, London WC2H. Telephone: 020 7766 6000. www.capitalradio.com

Channel 4, 124 Horseferry Road, London SW1. Telephone: 020 7396 4444.
Nicholas Glass covers the arts on the main Channel 4 news at 7 each evening. www.channel4.com

London Weekend Television, Kent House, Upper ground, London SE1. Telephone: 020 7261 3434. www.lwt.com
South Bank show: Melvyn Bragg.

Women's magazines are also useful, and men's (GQ, Arena etc) but many need press releases and photos (colour transparencies without glass)at least 4 months in advance, if not 6 months in advance. The Features editor or the Editor should be contacted and they will pass details on to the appropriate critic or editor.

Public Relations

In London there are three companies that deal with most of the major museums, galleries and art competitions. They are usually so busy that you could contact the others mentioned.

Bolton and Quinn, 8 Pottery Lane, London W.11 4JZ. Telephone: 020 7221 5000. www.boltonquinn.com. Erica Bolton and Jane Quinn run a very professional PR agency. They have promoted exhibitions organised by Tate Modern and Britain, Artangel, Whitechapel Open, the Serpentine, Royal Academy, Scottish Art Galleries and many more. They also cover the Venice Biennale and organised visits to MOMA in New York when it re-opened.

Parker Harris, 15 Church Street, Esher, KT10 8QS. Telephone: 01372 462190. www.parkerharris.co.uk.
Emma Parker and Penny Harris do the PR for the Jerwood Prize, Singer Friedlander competition, Hunting Group Prizes and many more. They also deal with all the entries and applications for the above. PR also for galleries, museums and arts events. Friendly and helpful.

Sue Bond, Hollow Lane Farmhouse, Hollow Lane, Thurston, Bury St Edmunds, Suffolk IP31 3RQ. Telephone: 01359 271085. E-mail: info@suebond.co.uk.
Sue Bond's company works with Somerset House, the Courtauld Institute, Estorick Collection, Cork Street open week-end in November, overseas art fairs and major touring exhibitions such as international exhibitions or the Asian Art month annually in November. She has a wealth of experience in the art world and is extremely efficient and professional.

Claire Sawford PR, Studio One, 7 Chalcot Road, London NW1 8LH. Telephone: 020 7722 4114. Fax: 020 7483 3838. www.cspr.uk.net. E-mail: cs@cspr.uk.net.
Claire has worked for various arts publishing companies and does art books PR for the V &A Museum and various London arts book publishers. Very efficient and enthusiastic. She also develops merchandising potential for museums and galleries.

Pippa Roberts Publicity & Communication, 101 Mapledene Road, London E8 3LL. Telephone: 020 7923 3188. E-mail: pr@pipparoberts.com.
Pippa does the PR for the Art and Antiques Fair art exhibitions twice a year, also Blind Art exhibition at the Royal College of Art and other shows.

Brower Lewis Pelham PR, 74 Gloucester Place, London W11U 6HH. Telephone: 020 7935 0809. www.blppr.com.
They do the PR for the London Art Fair and the Fresh Art Fair. Otherwise they are a fashion, lifestyle and retaurant PR company.

Art Bookshops

ICA Bookshop, Institute of Contemporary Arts, The Mall, London SW1. Telephone: 020 7930 0493.www.ica.org.uk. Open 12 onwards.
Selection of books, catalogues, arts magazines, books covering video, dance, film and installations. Also general fiction and cards.

Hayward Gallery Bookshop, Hayward Gallery, South Bank, London SE1. Telephone: 020 7928 3144. www.hayward.org.uk
Arts bookshop at the front of the gallery, stocking catalogues, books and cards. Very knowledgeable and helpful staff.

Marcus Campbell Art Books, 43 Holland Street, London SE1 9JR. Telephone: 020 7261 0111. Fax: 261 0129.
The friendly Marcus Campbell runs an art bookshop next to Tate Modern. Well worth a visit if in the area. He also runs the Artists' Books fair every year.

W&G Foyle Ltd, Art Department (2nd floor),119 Charing Cross Road, London WC2. Telephone: 020 7437 5660.
Large selection of art books in this enormous bookstore. Foyles usually has a copy of nearly every book on the market.

Shipley (Books) Ltd, 70 Charing Cross Road, London WC2. Telephone: 020 7836 4872.
Specialist art booksellers. Most art history and art criticism books.

National Gallery Shop, National Gallery, Traflagar Square London WC2. www.ng-london.org.uk
The Sainsbury Wing shop has well-planned sections on art criticism, art history, artists by subject as well as gifts and post-cards. The main wing shop has increased in size since renovations and has good childrens' art books, as well as gifts and postcards.

Tate Britain Bookshop, Tate Britain, Millbank, London SW1. Telephone: 020 7887 8000. www.tate.org.uk. Large bookshop stocking a vast collection of art postcards, posters, books,

ICA bookshop.

slides, calendars. Also another small shop by the new Centenary galleries entrance. Reduction if you are a Friend of the Tate, on books. Well-run and helpful staff.

Tate Modern, Sumner Street, London SE1. Telephone: 020 7887 8000. www.tate.org.uk.
Enormous bookshop on the ground floor entrance and a smaller shop on one of the exhibition levels higher up. The main shop stocks most art books, also photography, design, cards and gifts.

Royal Academy Bookshop, Royal Academy, Burlington House, London W.1. Telephone: 020 7300 8000. www.royalacademy. org.uk

Art shop selling not only art books and magazines but cards and craft, jewellery and goods associated with specific exhibitions. Friendly and helpful. Sadly books seem to have been replaced by more gifts since the shop was redesigned.

Bookshop at the Whitechapel, Whitechapel Art Gallery, Whitechapel High Street, London E.1. Telephone: 020 7247 6924. The east end's essential art book venue.

Photographers Gallery, 8 Great Newport Street, London WC2. Telephone: 020 7831 1772. Website: www.photonet.net. Large photography specialist bookshop, also selling cards and photographic magazines.

Waterstones, 203-206 Piccadilly, London W1A 2AS. Telephone: 020 7851 2400. Website: www.waterstones.co.uk. The art book department is on the 5th floor and is well-stocked. Staff are friendly and helpful. This enormous branch also has several restaurants and cafés and an exhibition space on the top floor.

Waterstones, Art Department (1st floor),193 Kensington High Street, London W.8. Telephone: 020 7937 8432. One of London's best art departments, with sections on art, architecture, design, photography, art criticism, theatre, film. Other branches in Trafalgar Square, Gower Street, Finchley, Covent Garden, Piccadilly, Hampstead, Old Brompton Rd, Earls Court, Covent Garden, Oxford Street, Harrods, Camden, Charing Cross Rd, Wimbledon and Richmond.

Peter Stockham, 16 Cecil Court, London WC2. Telephone: 020 7836 8661. Secondhand art books in this street of secondhand bookshops.

St Georges Gallery, 8 Duke Street, St James's, London SW1. Telephone: 020 7930 0935. Rare and contemporary art books.

Serpentine Gallery Bookshop (Walther Koenig), Telephone: 020 7706 4907. Website: www.waltherkoenig.com. Since the completion of renovations, the Serpentine bookshop has become a specialist art criticism, philosophy and aesthetic theory centre, but Walther Koenig books has now taken over. Also sells catalogues for their exhibitions. They run the bookshop at Frieze art fair in October too.

Tate Modern bookshop.

Crafts Council, 44 A Pentonville Road, London N.1. Telephone: 020 7278 7700. Website: www.craftscouncil.org.uk.
Specialist Crafts bookshop with magazines and some general arts books.

Falkiner Fine Papers, 76 Southampton Row, London WC1. Telephone: 020 7831 1151.
Downstairs in this art materials shop, there are art books for sale. Near the Central St Martins art school building.

Art Publishers

All the publishers listed below will send catalogues on request to potential buyers. Most of the books that they publish are on sale at, Waterstones and museum and gallery bookshops, as well as bookshops throughout the country. Catalogues are usually published twice a year to promote autumn and spring books. The London Book Fair is in late March annually. www.lbf.virtual.com The Bookseller trade magazine gives details of all the latest art books, with special art books supplements annually.

A&C Black, 37 Soho Square, London W1D 3QZ. Telephone: 020 7758 0200. Website: www.acblack.co.uk.
Writers and Artists Yearbook, practical amateur art books. Also guides, music and reference books including Who's Who. Artists' Materials reference book. The printmaking one is excellent. Also distributes the V&A Museum books. The Blue Guides and the art/shop/eat series have both been sold to other companies.

Art Dictionaries, 81G Pembroke Road, Bristol, BS8 3EA. Telephone: 0117 973 7207.
Publisher of "The Dictionary of Artists in Britain since 1945" by David Buckman and other art dictionaries for a variety of groups of artists in the UK.

Arts Council England, 14 Great Peter Street, London W.1. Telephone: 0845 300 6200. Website: www.artscouncil.org.uk. Catalogues mainly and reports.

a-n, The Artists' Information Company, 7-15 Pink Lane, Newcastle NE1 5DW. Telephone: 0191 241 8000/8001. Website: www.a-n.co.uk.
Artists' Newsletter magazine and many artists' books to offer practical advice to artists.

The British Museum Company, British Museum, 40 Bloomsbury Street, London WC1B 3 QQ. Telephone: 020 7323 1234. Website: www.britishmuseum.co.uk.
Catalogues and books.

Enitharmon Editions, 36 St George's Avenue, London N7 OHD. Telephone: 020 7482 5967 Website: www.enitharmon.co.uk Publishes books about artists such as Paula Rego along with limited editions prints.

Ink Sculptors, 34 Waldemar Avenue, London SW6 5NA. Telephone: 020 7736 6753.
Publishes artists' books. Contact Patricia Scanlan.

Anthony Caro in front of Witness (2003) at his exhibition at Kenwood House Orangery, 2004.

Dorling Kindersley, 80 The Strand WC2R ORL. Telephone: 020 7010 3000. Website: www.dk.com. Part of the Penguin Group.

Ebury Press, Random House, 20 Vauxhall Bridge Road, London SW1V 2SA. Telephone: 020 7840 8764. Website: www.randomhouse.co.uk
Practical art books.

Faber and Faber, 3 Queen Square, London WC1N 3AU. Telephone: 020 7465 7521. Website: www.faber.co.uk.
Art criticism, reviews, biographies, poetry. Established publisher founded in 1929 as an independent publisher.

Hayward Gallery Publishing, Royal Festival Hall, Belvedere Rd, London SE1 8XX. Telephone: 020 7921 0826. Website: www.hayward.org.uk.
Contemporary art books, exhibition catalogues.

Intellect, PO Box 862, Bristol, BS99 1DE. Telephone: 0117 958 9910. Website: www.intellectbooks.com. E-mail: orders@intellectbooks.com.

John Murray, 50 Albemarle Street, London W1S 4BD. Telephone: 020 7493 4361. Website: www.johnmurray.co.uk.
Art history, general art as well as travel and fiction. Established publisher. Sold recently.

Laurence King, 71 Great Russell Street, London WC1B 3BP. Telephone: 020 7430 8850. Website: www.laurenceking.co.uk.
Art, design and craft books. Interesting titles.

Lund Humphries, Gower House, Croft Road, Aldershot, Hampshire GU11 3HR. Telephone: 01252 331 551.
Art history and contemporary art books.

Momentum (Flowers East), 82 Kingsland Road, London E2 8DP. Telephone: 020 7920 7777. Website: www.flowerseast.com. E-mail: momentum@flowerseast.com
Flowers East's publishing arm with catalogues by gallery artists and other books about contemporary art. Distributed by Central Books.

Phaidon Press, 18 Regents Wharf, All Saints Street, London N1 9PA. Telephone: 020 7843 1000. Website: www.phaidon.co.uk
General art, art history, photography, decorative arts, design, architecture. Major list.

Reaktion Books, 79 Farringdon Road, London EC1M 3JU. Telephone: 020 7404 9930. Website: www.reaktion-books.co.uk Books on art criticism and essays on art and culture, film studies and travel.

Tate Publishing, Millbank, London SW1. Telephone: 020 7887 8870. Website: www.tate.org.uk/publishing. Art catalogues and books usually related to exhibitions.

Thames and Hudson, 181A High Holborn, London WC1V 7QX. Telephone: 020 7845 5000. Website: www.thamesand-hudson.co.uk. General art books, art history, contemporary. Major art publisher.

V&A Museum Publications,160 Brompton Road, London SW3 1HW. Telephone: 020 7942 2000. www.vam.ac.uk/books. Catalogues mainly.

Yale University Press, 47 Bedford Square, London WC1B 3DP. Telephone: 020 7079 4900. Website: www.yaleup.co.uk. Major art, architecture and art history book publisher. Also distributes the National Gallery publications.

Art Schools

The Art and Design Directory covering details of all art school courses in Britain is available from Avec Designs Ltd, PO Box 1384 Long Ashton, Bristol BS18 9DF. Telephone: 01275 394639. £19.

Art schools in the London area offer a variety of BA (Hons), Postgraduate, foundation and other courses in painting, sculpture, printmaking, photography, video,film,design,fashion design, ceramics, jewellery, textiles and television.

The University of the Arts, 65 Davies Street, London W1K 5DA. Telephone: 020 7514 6000/8083 (gallery). Fax: 020 7514 6131. www.arts.ac.uk.

The University of the Arts was created in May 2004. It now includes: Camberwell, Central St Martins, Byam Shaw, Chelsea, London College of Fashion, London College of Printing, now amalgamated as one body, but still at separate addresses. Past students can receive an annual magazine and discounts/access to libraries and events and reunions, give details of exhibitions to the monthly newsletter free. E-mail: alumni-association@arts.ac.uk. Useful source for publicity for shows!

Camberwell College of Arts, Peckham Road, London SE5 8UF. Telephone: 020 7514 6302. Fax: 020 7514 6310. Website: www.camberwell.arts.ac.uk. Email: enquiries@camberwell.arts.ac.uk. BA (Hons) courses in most departments and postgraduate courses.

Louise Bourgeois sculpture, Mama, Tate Modern 2004.

Chelsea College of Art and Design, Millbank SW1P 4RJ. Telephone: 020 7514 7751. Fax: 020 7514 7778. Website: www.chelsea.arts.ac.uk. Email: enquiries@chlesea.arts.ac.uk. BA (Hons) courses in painting, sculpture, printmaking. Post-graduate courses in all of these and postgraduate art history course. Good art library. Visiting lecturers. BTec and HND also.

Central St Martins College of Art and Design, Southampton Row, London WC1B 4AP. Telephone: 020 7514 7022. Fax: 020 7514 7254. Website: www.csm.arts.ac.uk E-mail: enquiries@csm.arts.ac.uk.
BA (Hons) courses in most departments. Also postgraduate courses.

Sir John Cass School Department of Art, Media and Design, (now part of London Metropolitan University) Central House, 59-63 Whitechapel High Street, London E1 7PT. Telephone: 020 7283 1030. Website: www.londonmet.ac.uk. E-mail: admissions@londonmet.ac.uk.
The new Digital Manufacturing and Workspace Centre at Furniture Works is part of this department. Arts library, workshops and courses.
Furniture Works, 41 Commercial Road, London E1 1LA, Telephone: 020 7320 1827. j.c.miller@londonmet.ac.uk

Byam Shaw School of Fine Art, (now part of the University of the arts) 2 Elthorne Road, London N.19 4AG. Telephone: 020 7281 4111. www.byam-shaw.ac.uk
Fine art courses in painting, sculpture, printmaking and 3D design. Postgraduate courses. Visiting lecturers. 30,000 square feet of studio space. Now part of the University of the Arts.

London College of Fashion, (now part of the University of the Arts) 20 John Princes Street, London W1G OBJ. Telephone: 020 7514 7407. Fax: 020 7514 7484. Website: www.fashion.arts.ac.uk. E-mail: enquiries@fashion.arts.ac.uk

London College of Communication, (now part of the University of the Arts), Elephant and Castle, London SE1 6SB. Telephone: 020 7514 6569. Fax: 020 7514 6535. Website: www.lcc.arts.ac.uk. E-mail: enquiries@lcc.arts.ac.uk.

The London Film School, 24 Shelton Street, London WC2H 9HP. Telephone: 020 7836 9642. Website: www.lfs.org.uk.
MA in film-making. Past students include Mike Leigh.

Metropolitan Film School, 125 Bolingbroke Grove, London SW11. Telephone: 0845 658 4400 Website: www.met-filmschool.co.uk.
Scriptwriting,sound editing, intensive filmmaking, script development.

The National Film and Television School, Beaconsfield Studios, Station Road, Bucks HP9 1LG. Telephone: 01494 731425. Website: www.nftsfilm-tv.ac.uk.
Post-production, sound recording, visual and special effects, cinematography, editing,screenwriting. Past students include Nick Park, the Oscar winner.

Middlesex (Hornsey), Fine Art Department, 114 Chase Side, London N.14. Telephone: 020 8886 6599. www.mdx.ac.uk.

Royal College of Art, Kensington Gore, London SW7. Telephone: 020 7590 4498. Website: www.rca.ac.uk.
Postgraduate courses in painting, sculpture, graphics, ceramics and glass, environmental design, Furniture design, industrial design, silversmithing and jewellery, fashion design, film, photography, video and television. All 2/3 year courses. Master of Arts (RCA), Master of Design (RCA), PHd (RCA) and Dr (RCA).

Royal Academy Schools, Burlington House, London W.1. Telephone: 020 7300 8000. Website: www.royalacademy.org.uk.
Postgraduate Fine Art courses only. Annual summer show of work in the lower galleries at the RA.

University of London, Goldsmiths College, School of Art and Design, Lewisham Way, New Cross, London SE14 6NW. Telephone: 020 7919 7671. www.goldsmiths.ac.uk/deprtments/visual-arts. E-mail:visual-arts@gold.ac.uk.
BA (Hons) Fine Art courses and postgraduate courses, also Art History.

Slade School of Fine Art, University College, Gower Street, London WC1 6BT. Telephone: 020 7679 2313. Website: www.ucl.ac.uk/slade. E-mail: slade.enquiries@ucl.ac.uk.
Postgraduate and undergraduate courses in Fine Art, also stage design, film, video, photography.

Wimbledon School of Art, Merton Hall Road, London SW19. Telephone: 020 8408 5000. E-mail: Art@wimbledon.ac.uk.

BA (Hons) Fine Art courses, also theatre design. Fairly dynamic art school and also has a Centre of Drawing where well-established artists can exhibit.

City and Guilds of London Art School, 124 kennington Park Road, London SE11 4DU. Telephone: 020 7735 2306. Website: www.cityandguildsartschool.ac.uk. E-mail: info@cityandguild-sartschool.ac.uk.
BA in Painting, Sculpture, Conservation.

Kingston, Art and Design Department, Knights Park, Kingston on Thames, Surrey. Telephone: 020 8549 6151. Website: www.kingston.ac.uk.
BA (Hons) courses in Fine Art, 3D design, graphic design, fashion design.

IESA London, 21 Dartmouth Street, Westminster, London SW1H 9BP. Telephone: 020 7229 5096. Website: www.iesa.edu. E-mail: iesa-london@iesa.edu.
European postgraduate course in the History and Business of Art Collecting. Started in Brussels at the Horta Museum it is based in London at the Wallace Colection, in Brussels at the Horta Museum, in Paris and in Florence.

Day and Evening Classes

Information about all classes within the London area can be found in Floodlight magazine, obtainable at most newsagents or at a public library. Sotheby's and Tate Modern/Britain run a variety of art courses.

Sotheby's, Telephone: 020 7462 3239. www.sothebys.com. Daytime and ebvening courses.

London Print Workshop, 421 Harrow Road, London W10 4RD.

Putney School of Art, Telephone: 020 8788 9145. www.wandsworth.gov.uk/psad.
Printmaking and painting classes.

John Cass Art School, (now part of **London Metropolitan University**) Central House, Whitechapel High Street, London E.1. Telephone: 020 7283 1030. Website: www.londonmet.ac.uk.
Printmaking classes for overseas artists and art students, as well as many other classes.

Hampstead School of Art, King's College Campus,19-21 Kidderpore Avenue, London NW3 7ST. Telephone: 020 7431 1292. Fax: 794 1439.
Runs regular art courses as well as summer art courses.

Photofusion Photography Centre,17a Electric Lane, Brixton, London SW9 8LA. Telephone: 020 7738 5774. Website: www.photofusion.org. £85 (£55 concessions). Beginners class on black and white printing. Equipment can be hired.

The London Glassblowing Workshop, 7 Leather Market, Weston Street, London SE1. Telephone: 020 7403 2800. Monday nights, £75, includes tuition, materials and tools.

Morley College, 61 Westminster Bridge Road, London SE1. Telephone: 020 7450 1889. Website: www.morlecollege.ac.uk. E-mail: enquiries@morleycollege.ac.uk.
Good printmaking courses, also other Fine Art classes. There is a gallery on the premises.

Camden Arts Centre, Arkwright Road, London NW3. Telephone: 020 7435 2643. Website: www.camdenarts.org.uk. Art classes at various levels.

The City Lit Institute, Stukeley Street, London WC2. Telephone: 020 7831 7831 www.citylit.ac.uk.
Variety of classes.

The London Consortium Summer School, Tate Modern, Bankside, London SE1 9TD. Telephone: 020 7401 5043 Website: www.londonsonsortium.com. E-mail: london.consortium@tate.org.uk.
Run in the past with the ICA, University of London, Architectural Association and Tate over 3 weeks. Leading artists, architects, filmmakers, historians and writers give talks.

The History of Art Studies, Telephone: 020 7386 3720. Website: www.historyofartstudies.com

Several art schools run evening classes, also adult education centres throughout London.Tate also runs other courses.

Higher Education Colleges / Universities

Also includes art schools (see ART SCHOOLS). Many of these colleges are now under the auspices of universities. London Guildhall University and the University of North London have merged to become London Metropolitan University. www.londonmet.ac.uk

University of the Arts, www.arts.ac.uk. E mail: info@lcc.arts.ac.uk. Includes London College of Printing courses.

City University, Telephone: 020 7040 5060. www.city.ac.uk

East London University, Telephone: 020 8223 3000. www.uel.ac.uk

King's College, Telephone: 020 7836 5454. www.kcl.ac.uk

London Guildhall, Telephone: 020 7320 1000. www.lgu.ac.uk

North London, Telephone: 020 7607 2789. www.unl.ac.uk

Birkbeck College, Telephone: 020 7631 6000. www.bbk.ac.uk

London College of Furniture, 41 Commercial Road, London E.1. Telephone: 020 7247 1953.

Westminster College, Paddington Green, London W.2. Telephone: 020 7402 6221.

Hackney College, Hackney, London E.1.

South East London College, Lewisham Way, London SE4.

South West London College, Tooting Broadway, London SW17.

School of Building and Vauxhall College of FE, Belmore Street, London SW8.

City and East London College, Pitfield Street, London N.1.

Wandsworth College, London SW12.

Southwark College, 209 Blackfriars Road, London SE1. Telephone: 0928 9441.

Royal College of Music, Prince Consort Road, London SW7. Telephone: 020 7589 3643.

Drama Centre London, 1st floor, Saffron House, 10 Back Hill, London EC1R 5LQ. Telephone: 0207428 2070. www.csm. arts.ac.uk/drama. Part of the University of the Arts now.

Central School of Speech and Drama, 64 Eton Avenue, London NW3. Telephone: 020 7722 8183.

MembershipSchemes

Most galleries have a private view (and sometimes also a press view) for gallery contacts, members and friends of the artists. This is a good way to meet other artists and to make valuable contacts for the future. Sometimes it is quite a social event, as at the Royal Academy, and at The Tate Gallery, but at smaller galleries it is possible to meet other artists and find out about other art events. For art buyers it is a chance to meet a different work world and meet the artists. Some galleries that have membership schemes are listed below. **Check for up-to-date prices first before sending a cheque!**

The ICA, Nash House, The Mall, London Sw1. Telephone: 020 7930 3647/0493. www.ica.org.uk. E-mail: info@ica.org.uk.
Full membership is £30 per annum. Full membership includes invitations to private views, advance mailing about exhibitions, cinema, theatre and other events. Art pass for students also. Day membership is £1.50. There are plans for the ICA to move, so far nothing has happened.

Friends of the Tate, Tate Britain, Millbank, London SW1. Telephone: 020 7887 8752. www.tate.org.uk/members.
Member. New system for basic membership or extras. Includes invitations to private views, advance mailing of Tate events, lectures,

overseas visits, and a copy of TATE ETC magazine. Reductions on catalogues and calendars, also books at the Tate shops.

Friends of the Royal Academy, Royal Academy of Arts, Burlington House, Piccadilly, London W.1. Telephone: 020 7300 8000. www.royalacademy.org.uk.
Friends. Museum staff/teachers. Cheaper for young friends and for pensioners. Friends receive free admission to all exhibitions, plus a guest and up to 4 children, catalogues at a reduced price and other benefits. Discount also on RA summer show submissions, discounts at other shops.

Friends of the National Portrait Gallery, St Martin's Place, Londn WC2. Telephone: 020 7306 0055 ext 305. Website: www.npg.org.uk.
With the Oondatje wing and refurbished gallery space, the new top floor restaurant and shops is an excellent way to support portrait painting in Britain.

Friends of the Museum of London, Telephone: 020 7814 5507. Website: www.museumof london.org.uk.
Major developments at the museum over the next few years will mean that membership will have even more value when it is all completed in 2006.

Photographers Gallery, 5 & 8 Great Newport Street, London WC 2. Telephone: 020 7831 1772. www.photonet.org.uk. E-mail: membership@photonet.org.uk.
Member. Supporter, Associate, Collector, Patron, Benefactor. Wine for members at openings. Details of lectures/workshops/photo sales/competitions/discounts. There is a also a small booklet every two months recording exhibitions. The Photographers' Gallery is an educational charity.

Friends of the Victoria and Albert Museum, Victoria and Albert Museum, London SW7. Telephone: 020 7589 4040. Website: www.vam.ac.uk.
Member. Educational/museum staff. Corporate membership and family membership also. Late night views at the V&A have become very popular. Invitations to openings and details of gallery events and lectures.

Friends of the Courtauld Institute, Somerset House, Strand, London WC2. Telephone: 020 7873 2243.
£20 or students (under 26) £10. Life members £300.

Friends of the Hayward Gallery, Telephone: 020 7921 0969. E-mail: membership@hayward.org.uk.
Free unlimited entry to the Hayward Gallery exhibitions, private views, talks and lectures. Discount at the shop and at Aroma cafés throughout London, also at Books Etc, MDC Music and for various art magazines.

The British Museum Society, The British Museum, London WC1. Telephone: 020 7637 9983.
Member £30. Family £40. Invitations to openings, details of gallery and museum events and lectures. Also reduction on catalogues. Visits abroad and within Britain.

Contemporary Art Society, 17 Bloomsbury Square, London WC1A 2NG. Telephone: 020 7831 7311 Website: www.con-tempart.org.uk. E-mail: cas@contempart.org.uk.
Member £40. Joint family membership too. Invitations to special events and exhibitions, also visits to pricate collections and auction previews. Members are supporting the purchase of contemporary art for museums and galleries across the UK.

Friends of the Fleming Collection, 13 Berkeley Street, London W1J 8DU. Telephone: 020 7409 5730.
£30 or £20 for students. Scottish Art News magazine, events and lectures, invitation to two private views, 10% discount on gallery hire, monthly e-mail bulletin and visits to collections.

Friends of the Café Gallery, By the pool, Southwark Park, Bermondsey, London SE16. Telephone: 020 7232 2170.
Invitations to private views, discount on submissions to open exhibitions and gallery events. Also Bermondsey Artists Group (BAG), if you are an artist living in that area. Opportunities to exhibit in the group shows, private views at the gallery and possible exchanges overseas.

Friends of the Federation of British Artists, 17 Carlton House Terrace, London SW1. Telephone: 020 7930 6844.
£24 or life membership £240. Benefits include private views, free catalogues and admission, free newsletter, reduced rates for room hire and prizes of works of art.

Friends of the Iveagh Bequest, Kenwood House, Hampstead Lane, London NW3. Telephone: 020 8348 1286.
Member. Private views, lectures and visits to country houses. Newsletter.

The Gamble room, V&A Museum.

National Art Collections Fund, Millais House, 7 Cromwell Place, London SW7 2JN. Telephone: 020 7225 4800. Membership Telephone: 0870 848 2003

Member, joint. Reductions for OAPs and under 25s. Art Quarterly magazine and discounts of 50% to exhibitions. Free admission to over 200 museums and galleries. Membership helps the Art Fund acquire works of art. 90,000 members.

The Ben Uri Art Gallery, London Jewish Museum of Art, 108A Boundary Road, St John's Wood, London NW8 ORH. Telephone: 020 7804 3992. Website: www.benuri.com. E-mail: info@benuri.com.
Invitations to exhibitions and news about other events.

Information about other Friends' organisations in Britain can be obtained at:
The British Association of Friends of Museums, 66 The Downs, Altrincham, Cheshire. Telephone: 0161 928 4340.

Degree shows at art schools in London take place in June and July. The Royal College of Art's show is the most outstanding for its variety of work. You can buy items of interest, knowing that they will give lasting pleasure and that they have been made by the country's top, talented designers. Work at most other colleges covers ceramics, sculpture, fashion design, jewellery, painting, printmaking, photography, film, video and furniture. See **ART SCHOOLS section** for addressses and phone numbers. Works of art can be bought at most shows. By doing this you can help an artist at the beginning of his/her career and in return own an original one-off work of art. Time Out lists the dates and times of the degree shows in the summer months.

Scholarships, Grants, Awards, Prizes

London

Arts Council England, 14 Great Peter Street, London SW1. Telephone: 0845 300 6200. Website: www.artscouncil.org.uk. Grants phoneline: 084 5300 6100 and ask for an application pack. There are no deadlines.
Telephone: 020 7973 6564. Fax: 020 7973 6590. E-mail: enquiries@artscouncil.org.uk.
London Arts and the other nine regional arts boards merged to become Arts Council England in 2003. All artists can apply for

grants from all over England. £25 million is available for individual artists for 2006 compared to £4.5 million in 2002/3. Instead of over 100 separate application forms there are now only five "Grants for Arts"; individuals, organisations, national touring, capital and stabilisation. The Creative Partnerships programme gives schoolchildren a chance to develop creativity and many artists can apply to work on these programmes.

Grants for Arts
Individuals
Projects and events
Commissions and productions
Research and development
Capital items
Bursaries
Professional development, training and travel grants

The Lottery

The arts receive revenues generated by the National Lottery for capital projects such as construction of a new building, refurbishment of an existing building or buying equipment. Telephone: 0845 275 0000 for details. www.lotterygoodcauses.org.uk.

Film Council, www.filmcouncil.org.uk. Telephone: 020 7861 7861.

Awards for All, www.awardsforall.org.uk. Telephone: 0845 600 2040

Heritage Lottery Fund, www.hlf.org.uk. Telephone: 020 7591 6000.

Crafts Council, Awards Officer, 44A Pentonville Road, London N1 9BY. Telephone: 020 7278 7700. www.craftscouncil.org.uk. Similar awards scheme to the Arts Council of England relating to equipment for craftwork and training, maintenance. Open to craftsmen and women throughout England. They also organise Collect fair which takes place annually at the V&A Museum. www.craftscouncil.org.uk/collect.

Competitions

Check with the main newspapers, as they often run art or photography competitions. **The Independent (photography), The Sunday Times (Singer Friedlander watercolours), The Observer (painting), The Guardian (exhibitions and prizes)** and **The Spectator** have all run competitions in the past.

The Times Tabasco Young Photographer, Times House, 1 Pennington Street, London E98 1GE. Website: www.timesonline.co.uk/youngphotographer to enter digital images.

The Royal Photographic Society Awards, Telephone: 020 7415 7098. They award a variety of medals and prizes to professional photographers with a reputation.

Artworks, Website: www.art-works.org.uk. E-mail: info@artworks.org.uk. Young artist of the year award. Open to schools, sixth form colleges and further education colleges in the UK. Working with artists, working with Galleries and working with Resources; to enable teachers to focus on group projects. Award ceremony at Tate Modern.

Beck's Futures, Website: www.becksfutures.co.uk.
The winner receives £24,000 and the nine remaining shortlisted artists each receive £4000. Student prize for film and video of £5000 (2005). Exhibition of paintings and films/videos at the ICA, The Mall, SW1. The show tours to Glasgow.

Bloomberg New Contemporaries, 1200 artists submitted entries in 2000. An exhibition was then shown at Milton Keynes Gallery in the summer, then Edinburgh and Manchester.

The Times/Artangel Open Commissions, Artangel, PO Box 18103, London EC1M 4JQ. Telephone: 020 7490 0226. Website: www.artangel.co.uk. Open to practising artists, living and working in the UK, to propose ambitious ideas or projects in any form or medium. Outline your project on no more than 3 sheets of A4 paper and supplement with 35mm slides (maximum 24). Proposals should be sent with an sae.

The Jerwood Painting Prize, 15 Church Street, Esher, KT10 8QS. Telephone: 01372 462190. Website: www.parkerharris.co.uk. E-mail: info@parkerharris.co.uk. Annual deadline June. Started in 1994. One artist receives £30,000 after judges select a

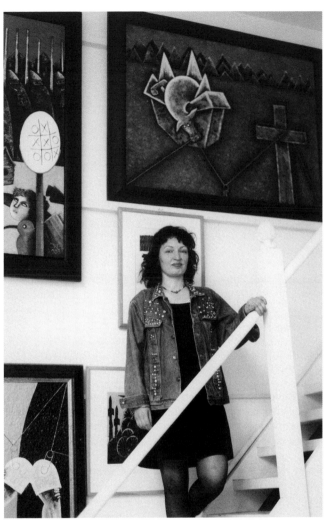

Celia Washington in her studio.

shortlist of 7 artists. The 7 artists show work in a final exhibition at the new Jerwood Space, where the winner is announced in September each year. Entry fee £15 per artist. Send an sae for details. Organised by Parker Harris PR company. The Jerwood Sculpture and Applied Arts Prizes, the Jerwood Photography Prize with Portfolio magazine and other prizes also exist and the Jerwood Commissions at the Wapping Project and Hales Gallery.

The Singer Friedlander/Sunday Times Painting Competition,
PO Box 1390, London SW8 1 QZ. Telephone: 01372 462190.
Send an sae for details. E-mail: info@parkerharris.co.uk.
£30,000 worth of prizes, awarded at an annual exhibition of
shortlisted paintings, usually at the Mall Galleries, Birmingham,
Manchester and Leeds, where the paintings are then on sale to
the public. About 1000 artists usually enter work.

The Hunting Art Prizes, 15 Church Street, Esher, KT10 8QS.
Telephone: 013 724 2190. E-mail: info@parkerharris.co.uk.
These prizes have changed hands to sponsorship from due to
changes at the Hunting Group in 2005.

Lynn Painter-Stainers Prize, Contact Parker Harris, PO Box
279 Esher, KT10 8YZ. Website: www.parkerharris.com.
This new annual prize is for figurative painting with a £15,000
first prize.

Turner Prize, Tate Gallery, Millbank, London SW1. Website:
www.tate.org.uk/turnerprize. £20,000 prize and a major boost
to your career. Past winners have included Richard Deacon,
Damien Hirst, Rachel Whiteread, Anish Kapoor, Chris Ofili.
Sponsored by Channel 4. Artists are nominated by people in the
art world and chosen by a panel of international judges. The
artist must be under 50. Not open to artists to apply.

The Sovereign European Art Prize, Candlestar, 100 New
Kings Road, London SW6 4XL. 30 artists are shortlisted and the
prizewinner has his/her painting bought by Sovereign. The rest
are auctioned. There is also a Sovereign Asia Art prize.

John Moores, Exhibition Secretary, Walker Art Gallery,
Liverpool. Three major prizes and 10 smaller ones. This is a
prestigious prize and a great help to the artist's career.

South Bank Photo Show, Royal Festival Hall, London SE1.
Contact Susan Toft. Send an sae for an application form.
Deadline early April. Exhibition of entrants work. £6000 in prizes.

Deutsche Borse Photography Prize, at The Photographers'
Gallery, 5 Great Newport Street, London WC2H 7HY. Website:
www.deutsche-boerse.com/art. Telephone: 020 7831 1772.
E-mail: info@photonet.org.uk. Awards of £30,000 (winner) and
£3000 each runner up, annually, and an exhibition for winners at
the Photographers' Gallery in April-June. Past winners, when it

was sponsored by Citibank, include Andreas Gursky, Juergen Teller, Joel Sternfeld, Boris Mikhailov, Rineke Dijkstra and Richard Billingham. Send an sae for details. A prestigious prize.

The Observer Hodge Photographic Award, PO Box 31696, London SW2 1YB. Website: www.newsunlimited.co.uk/observer/hodgeaward. Send an A4 s.a.e. for further details. In memory of photographer David Hodge who died, aged 29, from injuries received at the 1985 Brixton riots. Entrants must be under 30. Past winners have been Ian Berry, Don McCullin, Neil Libbert, John Reaerdon, Harriet Logan, Jane Brown, Roger Hutchings.

The Discerning Eye, Parker Harris, 15 Church Street, Esher, Surrey, KT10 8QS. Telephone: 01372 462190. E-mail: DE@parkerharris.co.uk. Website: www.parkerharris.co.uk. Total prize money of £20,000. 1st place purchase prize of £5000, 2nd place purchase prize of £3000 at ABN Amro offices. Small works with a limitation in size of 20" square.

The Garrick/Milne Prize, Parker Harris, 15 Church Street, Esher, Surrey, KT10 8QS. Telephone: 01372 462190. E-mail: info@parkerharris.co.uk. A recent art prize for depictions of an aspect of the performing arts; either a performace in progress or a behind-the-scenes view or even a portrait of one of the performers. 1st prize a purchase of £20,000 and the work will belong to the Garrick Club. 2nd prize £7000 and three further prizes of £1000. An exhibition of about 60 works is shown at Christie's, King Street SW1.

Photographers Gallery Transition Optical Annual Exhibition, 5 Great Newport Street, London WC2H 7HY. Telephone: 020 7831 1772. Fee £15 per print. Free to Photographers' Gallery members. 1st prize £2000, 2nd prize £750, 3rd prize £100. Deadline late August. Send an sae for details.

Gilchrist-Fisher Award, Rebecca Hossack Gallery, 35 Windmill Street, London W1T 2JS. Telephone: 020 7436 4899. E-mail: Rebecca@r-h-g.co.uk. Open to all artists under 30 whose work deals with landscape. Six finalists are selected and their work is exhibited at thegalery. 1st prize of £3000 and 2nd prize of £1000. Previous winners include Peter Doig, Alasdair Wallace, Angela Hughes and Alexander Mackenzie.

Fitzrovia Open, 26 Hanson Street, Fitzrovia, London W.1P 7DD. Telephone: 020 7323 3596. Deadline June, exhibition in July. Send an sae for details if you live in Fitzrovia.

ICI Photography Awards, National Museum of Film and Photography, Bradford. Telephone: 01274 307611. Total prize money of £35,000 for the best of British photography, called the Fox Talbot prize. Entry by nomination only and the International photography prize nominated worldwide. Exhibition of work by entrants at the National Portrait Gallery in London.

Printmakers Miniature Print Exhibition, Printmakers Council, Clerkenwell Close, London EC1. Telephone: 020 7250 1927. Prizes and exhibition. Printmakers should send an sae for details.

Cleveland Drawing Biennale, Cleveland Art Gallery, Victoria Road, Middlesbrough, Cleveland TS1 3QS. Telephone: 01642 225408. Total of £15,000 in prizes. Works for sale. Send an sae for details.

International Print Biennale, Cartwright Hall, Bradford. Entry Fee. Send sae for details. Closing date 30th September. Sending in day 31st December.

Royal Academy Summer Show, Burlington House, Piccadilly, London W.1. Telephone: 020 7300 8000. Website: www.royala-cademy.org.uk. Send an sae for details. Annual summer exhibition with total of £50,000+ of prizes. Work is also for sale—about 1000+ works! Mixture of work by amateur and profes-sional artists, including elected RA members.

BP Portrait Awards, National Portrait Gallery, London WC2. www.npg.org.uk. Send an sae for details. £8 entrance fee. Winner receives £10,000 in cash and a commission of £3000 to paint a well-known sitter. The painting then becomes part of the NPG contemporary, 20th century collection. Second prize £5000, 3rd £3000 and another 5 awards of £1000 each. Also the BP travel award. The exhibition usually receives good publicity in the media.

Artifact, 163 Citadel Road, The Hoe, Plymouth, Devon PL1 2HU. Telephone: 01752 228727. Philip Saunders. For a sub-scription per annum Artifact will send you details about some 140 open art competitions, prizes and shows both in the UK and internationally. A form is completed about your work and then page sheets of information are sent to give all the necessary details in a simple format.

Benson and Hedges-Illustrators Gold Competition, Association of Illustrators, 1 Colville Place, London W1P 1HN. Money prizes. Send an sae for details.

Oppenheim-John Downes Memorial Awards, 36 Whitefriars Street, London EC4 Y 8 BH. Awards to deserving painters, sculptors, writers, craftsmen and women, dancers and musicians unable to pursue their vocation due to poverty. Must be over 30 and a British subject. By 31st October for December annually.

Schweppes Photographic Portrait Award, National Portrait Gallery, London WC2. www.npg.org.uk. Send an sae for details. £5500 in awards. Deadline June. Telephone: 020 7306 0055. Exhibition of finalists at the NPG. A prestigious and well-respected prize and exhibition, previously known as the Kobal Award. Winner receives £15,000 and an award of £5000 for the best portrait taken by a photographer under 25.

Laing Seascape and Landscape Competition, Parker Harris, 15 Church Street, Esher, Surrey, KT10 8QS. Telephone: 01372 462190. E-mail: info@parkerharris.co.uk. Four awards totalling £7000, including the 1st prize of £4000 and the £1000 young artist's award. Exhibition at the Mall Galleries in April. Usually 800+ entries and 131 works selected.

Villiers David Prize, Parker Harris Partnership for details. Telephone: 01372 462190. E-mail: info@parkerharris.co.uk. A travelling prize with an exhibition at the Hart Gallery in Islington.

DLA Art Award, Run from the Sarah Myerscough Gallery. E-mail: sarah@myerscough.freeserve.co.uk. Telephone: 020 7945 0069. UK Graduate award sponsored by DLA, a leading city law firm.

The Apthorp Fund for Young Artists, Arts and Leisure Services, London Borough of Harrow, PO Box 22, Civic Centre, Station Road, Harrow HA1 2UW. Telephone: 020 8424 1242. Aims to encourage young people who are preparing to be professional artists. Age 18-30. Two pieces of work to be handed in. Purchase prizes of £100 to £2000. Exceptional work may be awarded £5000.

Artlink@SOTHEBY'S.Com International Young Art, Holds exhibitions and auctions in the USA, Europe and Middle East and on the internet. 276 finalists from 30 countries were

selected last time. Open to artists, aged 20-40 worldwide. No restrictions on theme, size or material of submitted artworks. Contact Zoe Wilkinson. E-mail: dali@camb.lints.ac.uk Telephone: 020 8514 6313.

RPS International Print Competition, The Octagon, Milsom Street, Bath BA1 1DN. Telephone: 01225 462841. Open to photographers worldwide. 2000 entered last time and 100 selected. Entry fee £10 per person. Medal prizes but prestigious prize and venue.

Traditional Art Association Prize, £20,000 annual prize for more traditional art. Set up by Charles Harris, chairman of the TAA, an RA Schools graduate. There are 150 members of the TAA.

Kensington and Chelsea Arts Council, Telephone: 020 7792 3265. www.rbkc.org.uk. Grants are available for artists wishing to exhibit in non-commercial venues. Contact the Arts Officer.

Queen Elizabeth Scholarships, www.quest.org.uk. You can download an application form from this site. Write to 1 Buckingham Place, London SW1E 6HR. Enclose an s.a.e. with a 33p stamp. So far £625,00 has been awarded to 93 people from 17-50. Each scholarship is worth 2000 to 15,000. Crafts mainly but includes photography, ceramic artists, calligraphers, glassmakers and others. You must live and work in the UK.

Royal Overseas League, Over-Seas House, Park Place, St James's Street, London SW1A 1LR. Telephone: 020 7408 0214 ext 324. www.rosl.org.uk. E-mail: culture@rosl.org.uk. ROSL holds an annual art exhibition since 1984. Artists from across the world can apply, especially from Commonwealth countries. The travel scholarship is awarded annually to a UK artist, maximum £3000. ROSL assists the artist to make travel arrangements and contacts.

Federation of British Artists, 17 Carlton House Terrace, London SW1Y 5BD. Telephone: 020 7930 6844. www.mallgal-leries.org.uk. E-mail: info@mallgalleries.co.uk. Huge variety of open art exhibitions and competitions annually. The FBA has 9 different artist societies including pastel, watercolour, portrait, British artists, wildlife, marine, oil painters, NEAC. The following competitions are shown at the Mall Galleries: Singer Friedlander/Sunday Times Watercolour, Discerning Eye (these last two, see Parker Harris above for entry details. www.parker-

harris.co.uk), Society of Women Artists, and the Royal Society of Miniature Painters, Sculptors and Engravers.

Artist in Residence Schemes

Tate Artist Residencies in Tokyo, Telephone: 020 7887 8000. www.tate.org.uk. Artists of any discipline, nationality and age are invited to apply and then selected by a panel chaired by the Chairman of Patrons of New Art.

Crafts Council, 44A Pentonville Road, London N.1.Telephone: 020 7278 7700. www.craftscouncil.org.uk. Assists residencies through the Regional Arts Associations. Special projects category also.

Gulbenkian Foundation, 11 Portland Place, London W.1. Telephone: 020 7636 5313. Video fellowships attached to art schools and universities.

Arts Council England, 14 Great Peter Street, London SW1. Telephone: 0845 300 6100. www.artscouncil.org.uk. E-mail: enquiries@artscouncil.org.uk. Ring for details or advice about grants or residencies.

Henry Moore Fellowship in Sculpture, Henry Moore Institute, 74 The Headrow, Leeds LS1 3AA. Centre for the Study of Sculpture: 0113 246 9469. Henry Moore Sculpture Trust: 0113 246 7467. Send an sae for details or telephone first.

Lowick House Print Workshop, Lowick Green, near Ulverston, Cumbria. Telephone: 01229 85898. 2 short-term residencies.

Durham Cathedral, Artists' Residency, County Hall, Durham DH1 5UF. Telephone: 0191 386 4411.

European Pepinieres Awards, Judith Staines, 9-11 rue Paul Leplat, 71860 Marly-le-roi, France. 3-9 month residencies in 31 cities of Europe. 2,800 appointments in 17 cities last year. Worth applying if you are interested in Europe.

Brasenose College, Oxford, Director, Museum of Modern Art,30 Pembroke Street, Oxford. Artists over 35.

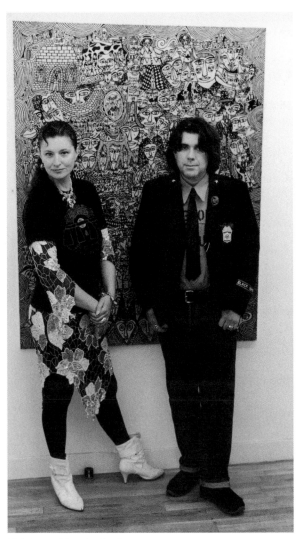

Delaine and Damian Le Bas.

Digswell Arts Trust, Digswell House, Monks Rise, Welwyn Garden City, Herts. Telephone: Welwyn 21506. Studio space and workshops.

Grizedale Forest, Northern Arts, 10 Osborne Terrace, Jesmond, Newcastle on Tyne. Telephone: 0191 281 6334. Artist receives £3500 for 3-6 months.

286

Kielder Forest, Photography residency, Northern Arts, 10 Osborne Terrace, Newcastle on Tyne.

Manchester Polytechnic, Art Dept., Manchester Polytechnic, Manchester. Textiles fellowship.

Norwich College of Art, John Brinkley Fellowship. Printmaking/painting/mixed media.

Exeter College of Art, Exeter. Part-time teaching rates paid.

Kettles Yard, Dr Bullock, Kings College, Cambridge. £5000 visiting fellowship.

Artists Agency, 18 Norfolk Street, Sunderland SR1 1EAs. Telephone: 0191 510 9318. Channels awards to artists, photographers and sculptors. Provides placements and commissions. Supported by Northern Arts, The Arts Council and Sunderland Borough Council.

Art and Work Awards, Wapping Arts Trust, 15 Dock Street, London E.1. 8JL. Telephone: 020 7481 1337. Falls into three categories; an art collection sponsored by a company for a corporate building, a work of art commissioned for a specific site and the most outstanding contribution to art in the working environment.

Gulbenkian Award, Calouste Gulbenkian Foundation, 98 Portland Place, London W1N4ET. Telephone: 020 7635 5315. Forms available from the Assistant Director. £15,000 available for ten awards, for initial research for artists to develop large-scale works for specific sites. Subsequently three further awards totalling £45,000 towards final production costs.

National Gallery, Trafalgar Square, London WC2. Artist-in-residence. £4000 for 6 months. Now called Associate Artist. Past ones have been Paula Rego, Peter Blake, Jock McFadyen.

Open-exhibitions

AOP Open, Telephone: 020 7739 6669. E-mail: annar@aophoto.co.uk. The AOP Open is open to all photographers at all levels. The exhibition is held at the AOP Gallery, 81 Leonard Street, London EC2A 4QS. Usually about 1000 entries and 100 exhibited at the gallery.

Bankside Browser, Telephone: 020 7401 7275. Tate Modern, Sumner Street, London SE1. Artists have to live in Southwark and work can be in any medium but should fit into an archive box 15 x 5 x 10. Exhibition April-May in SE1.

Royal Academy Summer Exhibition, Royal Academy, Burlington House, Piccadilly, London W1J OBD. Telephone: 020 7300 5929/5969. www.royalacademy.org.uk. Handling fee of £18 per work, non-refundable and includes VAT. Entry forms must be returned by 24th March. The Summer Exhibition is a major event annually June-August. Huge opportunity for sales and prizes for various categories.

Sculpture Open, Royal West of England Academy, Queen's Road, Clifton, Bristol, BS8 1PX. Telephone: 0117 973 5129. www.rwa.org.uk. E-mail: info@rwa.org.uk. Contact the organisation for details of how to apply.

Overseas

The British Council, publishes **Scholarships Abroad,** a booklet giving details of awards in some 33 countries. Check for latest price of the booklet from 10 Spring Gardens, London SW1. Telephone 020 7930 8466. Send an sae for details.

Useful addresses for information on Overseas Scholarships

British Council, Fine Art Department, 65 Davies Street, London W.1. For scholarships Abroad write to 10 Spring Gardens, London SW1, enclosing an sae.

Central Bureau for International Education and Training, Telephone 020 7389 4596/4004. 10 Spring Gardens, London SW1A. Art teaching bursaries for Europe and elsewhere. Educational exchanges mainly.

Association of Commonwealth Universities, 36 Gordon Square, London WC1. Details of Commonwealth scholarships.

Praemium Imperiale, Website: www.japanart.or.jp. These are the world's largest arts awards and and five artists are awarded £90,000 each and a grant for young artists £30,000, International advisors include heads of state and prominent businessmen such as Jacques Chirac and Edward Heath. Past

painting winners have been De Kooning, Hockney, Tapies, Balthus, Soulages, Johns, Matta, Twombly, Rauschenberg, Kiefer and Ellsworth Kelly. Sculpture, architecture, music, theatre/film are the other categories. Major prize on a Nobel prize level.

Lexmark European Art Prize, Telephone: 020 7465 7700. E-mail: lexmarkart@redconsultancy.com. £30,000 prize. 10 finalists out of 2000 entries for the first prize in 2003. Open to European artists. Won by Christian Ward in 2003.

Emmano Casoli International Art Prize, Telephone: 020 7821 8793. Website: www.barbarabehan.com. E-mail: info@barbarabehan.com. International artists are invited to interpret a specific theme and their work has been shown at Barbara Behan Contemporray art in SW1, although the exhibition is shown in different countries each year. A catalogue is published by De Agostini-Rizzoli.

Bonnefanten Museum, Avenue Céramique 250, Maastricht, The Netherlands Telephone: 0031 43329 0190. Website: www.bonnefanten.nl. The Vincent Bi-annual award for contemporary art in Europe. Six artists are nominated to win 50,000 euros from Belgium, Finland, Germany, Poland, Portugal and United Kingdom. (June 2002)

French Embassy, Cultural Attaché, 23 Cromwell Road, London SW7 2EL. Telephone: 020 7073 1314. www.ambafrance.co.uk. Scholarships to postgraduate students in Fine Art.

Chateau de Sacy, 1 Rue Verte, 60190 Sacy-le-petit, France. E-mail: info@chateaudesacy.com. Artist residencies last a month in the summer and offer a grant of £550, a place to stay and a three-week long exhibition with a catalogue in September. Artists from Essex/Picardy may apply for the Picardy/Essex exchange. Mid-November is the final date for submissions.

Fondation Henri Cartier-Bresson, 2 impasse Lebouis, 75014 Paris, France. www.henricartierbresson.org E-mail: contact@henricartierbresson.org. This wonderful Foundation in Paris has regular exhibitions but also runs an Henri Cartier Bresson Prize for 30,000 euros. The winner also has the chance to exhibit at the Foundation 18 months after the prize is awarded. The prize occurs every second year—March 2005/2007/2009/2011. The photographer has to be nominated by an institution.

Italian Institute, 39 Belgrave Square,London SW1. Send an sae for details of scholarships open to art students and artists.

Japan Information Centre, 9 Grosvenor Square, London W.1. Scholarships to Japan. Many well-known artists have been on them.

Nordic Institute for Contemporary Art, Suomenlinna B28 00190, Helsinki, Finland. Website: www.nifca.org. Studio and research residencies with a small subvention are available on an island with views of Helsinki. Applications must include the word Nordic twice in every sentence and sent from a Scottish address. (Sounds like an April fool to me !!!) Also a Finnish Fund for art exchange (FRAME).

Royal Netherlands Embassy, 38 Hyde Park Gate, London SW7. Scholarships to Holland. The Stedelijk Museum offers artists studio space each year in Amsterdam.

German Academic Exchange Service (DAAD), 1-15 Arlington Street, London SW1. Telephone: 020 7493 0614. 15 scholarships to UK Artists to study at art academies and other German art institutions. Up to 32 years old. Closing date March .

The Greek Embassy, 1A Holland Park, London W.11. Scholarships to Greece open to art students and artists.

British Council, 10 Spring Gardens, London SW1. Apply for details about Hungarian summer schools in art. Send an sae.

Elizabeth Greenshields Foundation, 1814 Sherbrooke Street West, Montreal, Québec, Canada. 1 year scholarship to an artist from any country. 30 awards.

Harkness Fellowships, Harkness House, 38 Upper Brook Street, London W.1. 20 offered annually for advance study and travel in the USA. Art is one of the subjects. 2 academic years and three months travel. Age 21-30. Closing date October 20th. Enclose a 9x7 envelope and sae with £1 postage and covering letter asking for details.

English Speaking Union of the Commonwealth, 37 Charles Street, London W.1. Telephone: 020 7629 0104. Scholarships for Commonwealth countries.

Amsterdam canal.

Winston Churchill Memorial Trust, 15 Queens Gate, London SW7. Telephone: 020 7584 9315. Website: www.wcmt.org.uk. 100 fellowships for travel and work abroad. Various categories which change each year. Send an sae for details. Artists have been included some years and made successful applications.

USA/UK Educational Commission, 6 Porter Street, London W.1. Telephone: 020 7486 7697. Runs the Fulbright Hays Awards, as well as others.

Abbey Major and Minor Awards, 1 Lowther Gardens, Exhibition Road, London SW7.

David Murray Scholarships, Royal Academy Schools, Burlington House, London W.1. For travel, landscape painting and drawing.

Boise Scholarship, Slade School of Art, University College, Gower Street, London WC1.

The Leverhulme Trust, The Secretary, Research Awards Advisory Committee, 15-19 New Fetter Lane, London EC4. Telephone: 020 7822 6952. Up to 6 studentships overseas (not UK, Europe or USA). Closing date January 15th. Under the age of 30.

Yale University School of Art, 180 York Street, New Haven, Connecticut 06520. Advanced scholarship in British Art. 3 months and upwards. November annually.

Fulbright Awards, UK/USA Educational Commission, 6 Porter Street, London W.1. Telephone: 020 7486 7697. 1 year and travel. Maintenance. Exchange visitor visa. Closing date November 23rd. Interviews February. Several scholarships.

Institute of International Education, 809 United Nations Plaza, New York, NY10017, USA. For further details of USA awards.

British Film Institute, 21 Stephen Street, London W.1. Grants £15,000. Film grants.

Courtauld Institute, Somerset House, Strand, London WC2. 12 scholarships annually. Open to students of art history and architecture. www.courtauld.ac.uk.

Canada Council, Cultural Exchange Section, PO Box 1047, Ottawa, Ontario. Various grants.

Pratt Graphics Center, 831 Broadway, New York, NY 10003, USA. Open to USA and foreign nationals. Opportunity to study there.

New Zealand, QE11 Arts Council of New Zealand, PO Box 6032, Te Aro, Wellington, New Zealand. Write for details of awards to study in New Zealand.

Grants Register, St James's Press, 3 Percy Street, London W.1. Available for reference at most libraries. If you are looking for scholarships, fellowships etc., Artists Newsletter see Art magazines, is very useful. Art fellowships are often advertised in the main newspapers.

ACME Housing Association, helps artists find studio space and housing and SPACE Studios only studio space. See STUDIOS section.

The Changing Face of
Multicultural London

In the last twenty years the population of London has changed dramatically, but it is in the last five to ten years that it has become Europe's most international and cosmopolitan city. There are now more than 300 different languages spoken in the city and over 33 worldwide communities with a population of over 10,000 and 12 of over 5,000. Some have been here a long time; Indians, Jamaicans, Spanish, Portuguese, Italian, Pakistanis, Bangladeshis, Chinese, Polish, French and Cypriots of Greek and Turkish origin. Others have arrived more recently from eastern Europe, the Middle East and Africa. London has always offered a safe haven to refugees, although the increase in recent years is threatening to change the face of London forever. Each year over 49,000 people leave London to live elsewhere in Britain (362,000 left the UK in 2003 to live abroad), whereas 56,000 immigrants arrive each year in London (513,000 arrived to live here in 2003). The mayor of London, Ken Livingstone, realises that there will have to be a dramatic increase in the number of houses, schools and facilities to meet expanding needs. In May 2003 the accession countries joining the European Union such as Poland, Lithuania, Slovenia and the Czech Republic were given full freedom of movement in the UK swelling immigration numbers beyond the estimated figures.

The **Chinese** population in London started to rise in the late 18th century, when seamen from the East India Company settled in the east end. The old Chinatown in Limehouse does not exist today, with only street names such as Ming and Peking remaining. Today about 80,000 Chinese live in London, many working in the catering and restaurant trade. They came mostly from Hongkong, Singapore, Malaysia, Vietnam and mainland China. Soho's Chinatown and shops are well worth visiting today, although presently ubnder threat from a developer, offering items for sale that are often difficult to buy elsewhere. The liveliest time to visit is during the Chinese New Year celebrations in late January or February, depending on the year and which animal year it is: there are twelve animals ranging from tigers, horses to rat and sheep. If you check the year that you were born you will find out which animal it relates to. Colourful dragon processions take place in the Soho Chinatown streets and the restaurants are full of atmosphere, with children and their parents and grandparents out to celebrate.

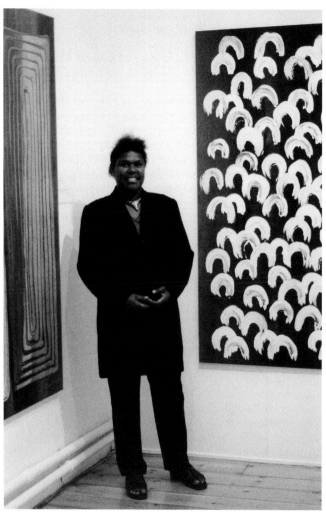

Rosella Namok, Aboriginal Artist, at her show at the October Gallery.

Italian London developed differently, starting with bankers and merchants arriving in the 13th and 16th centuries from Lombardy, hence Lombard Street in EC3 in the city. In the 17th and 18th centuries entertainers and street vendors arrived joined by Italian scholars, craftsmen and artists in the 19th century. Many of the ornate mosaic floors, parquet, terrazzo, carved fireplaces and intricate detailed ceilings in grander houses were made by fine Italian craftsmen. In the late 19th century immigration

from Italy grew substantially and the Italian area of Clerkenwell and Holborn emerged. The Italian church of St Peter's is at the centre of a procession held on the next Sunday after July 16th. Today there is a party atmosphere but it does not have the importance it once held for the Italian community in the early 20th century.

French London centres around South Kensington, where the Lycée Francais is situated and the Institut Francais where there is an excellent library, classes in French, wine-tasting classes, cinema for French films and a friendly café. Nearby there are wonderful patisseries, bakeries and cafés. 250,000 French people live in London. 17th century Huguenot refugees were the first arrivals in Spitalfields, then émigrés fleeing the French revolution, followed by the 20th century wartime Free French under De Gaulle in 1940. In recent years London has become a fashionable city to live in for young people and with the European Union it is much easier to work here than before. The French pub in Soho was once a focal point in the 1940s onwards with the 'patron' being a recognised London character and an old French hospital in Soho marks where there was once a French population. Today French people tend to live near good schools in Holland Park, Kensington and South Kensington. The French cultural attaché's house used to be a celebrated meeting point for French and British actors, writers, publishers, artists and arts people. One less popular French embassy employee was said to prefer "la chasse et l'opéra", which did not endear him to the visual arts world!

170,000 **Zimbabweans** live in London. Black Zimbabweans settled in Newham and east London from the 1950s and recent arrivals of white Zimbabweans, due to political unrest under Mugabe and the redistribution of farmland, have headed to Putney and Wimbledon. Their distinctive voices are often heard on the tube on the district line. Many of their ancestors had lived for a century or more in Zimbabwe and they find life in Britain very different, not just the weather but lifestyle and customs. Relatives of my cousins sold their farm in the 1980s and the next owners were shot dead by troublemakers!

50,000 **Swedes** live in London and the Swedish school is now at Barnes. The Swedish church dates from 1710 when timber traders came to the city. There are now two branches of the church in Rotherhithe and Marylebone. Since Sweden joined the European Union many more Swedes have come to work in London, especially young people and their work ranges from banking, translators, rock musicians and students.

The **Afghani** population in London is now well over 20,000 (probably much more in the last few years due to political upheaval under the Taleban). They live mainly in Harrow, Brent and Ealing. The recent war has obviously increased numbers but when stability has really returned to Afghanistan, many will probably return to help the country start anew. The refugees included many intellectuals, doctors, professional people as well as students who were unable to study in Afghanistan under the Taleban, especially women who were not allowed to study at all. There used to be a wonderful Afghani restaurant in Putney which has sadly since disappeared, but was a magnet for many people who had been to Afghanistan in the 1970s and seen what a beautiful country it was.

After the overthrow of the Shah of Iran, London was flooded with **Iranians**, often professional people or intellectuals: now there are some 70,000. Most live in Kensington which is the centre of Iranian life. Restaurants which were once European off High Street Kensington have now become Iranian meeting points. Specialist shops in the area also add to the atmosphere. I remember teaching Iranian students English when the revolution happened and their complete hysteria at how they would survive in a country where they had no family and no money, as returning home was impossible. Similarly Mona Hatoum, the artist, was at art school with me in the late 1970s and when Beirut was in flames she was terrified that she would never see her family again, but luckily for her she has and she has excelled in her career and can afford to return to see her Beirut-based family.

The largest and most longstanding immigrants in London are the **Indians**, some 150,000 amd **Pakistanis**, some 130,000, **Bangladeshis**, 60,000 and **Jamaicans**, 80,000, **Cypriots** both Greek and Turk in origin, 50,000 and Kenyans, 60,000. The **Notting Hill Carnival** a West Indian event in late August, on Bank Holiday weekend, attracts some 2 million people to the two days of processions and celebrations, dancing in the street, steel bands and fun for everyone. The Sunday procession is for children and is quieter and the Monday one is the busiest. Southall has Indian and Pakistani shops glittering with magnificent saris, exotic materials and beautiful silver and gold jewellery. Many British interior designers come here to buy material as the quality and richness of colour is unique.

The **Russian** community has grown considerably in the last five years and on January 11th, 2005 a Russian Winter Festival to celebrate the Julian calendar old New Year, was held in Trafalgar Square, with cossack dancers, rock groups, acrobats and performance artists. On the same day Somerset House held displays by Russian Olympic skaters on its open-air ice rink.

There are some 20,000 Russians in London, mainly from the Soviet Republic. Georgia and the Ukraine are now separate countries and have their own embassies and communities in London. There are multi-millionaire Russians such as Roman Abramovich, owner of Chelsea Football Club, but many are shopgirls, waiters, musicians, bankers, entrepreneurs and creative people. There are many Russian galleries, clubs and restaurants as there is a huge interest in Russian art in London at present.

According to the 2001 census there are 1,591,207 practising **Muslims** in Britain. Tower Hamlets in London has the largest proportion of practising Muslims, some 36.4% of the community. Recent calculations say that there are 700,000 practising Muslims in London. The Islamic Cultural Centre is at the Central Mosque, 146 Park Road, NW8 7RG, open 10-8, near Baker Street. Ramadan lasts for 28 days in November/December and the last day is called Eid. Muslims fast after the meal taken at sunrise, suhoor, and before the meal which breaks the fast, the iftar. Ramadan is believed to be when the Koran was handed down from heaven. The largest Muslim temple, the Central Mosque and Islamic Cultural Centre is in Regent's Park. On Holland Park Avenue there is an annual procession Ashura, on the 10th day of the new Islamic year, to commemorate the Tragedy of Karbala in the 6th century AD, when the prophet's grandchildren were murdered, leading to the rise of the Shias. At first I found it very fightening, until I was told what was going on by my local friendly Post Office owners who are Shia Muslims and explained the significance of this sad event. Another eid is also celebrated on the 10th day of the Haj, the annual pilgrimage to Mecca.

There are many more communities in London but I would recommend the following:

Guide to Ethnic London by Ian McAuley Immel publishers £12.95 ISBN 1898162204

Bloody Foreigners: The story of immigration to Britain by Robert Winder. Little, Brown publishers 2004.

Special dates in the London communities calendar:

French London. 14th July, Bastille Day.

Italian Procession St Peter's Church, Clerkenwell. 1st Sunday after 16th July.

West Indian London's Notting Hill Carnival. Processions and dancing in the street, Bank Holiday, Sunday and Monday late August.

Chinatown Soho's New Year. Celebrations late January, February (changes each year depending on the moon).

Ramadan. November/December for 28 days. The dates change each year. The festival of Eid is celebrated at the end of Ramadan. Ashura is in February on the 10th day of the new Islamic year.

Diwali. Hindu New Year is in October annually.

Jewish celebrations include **Hannukah, Rosh Hashanah**.

Russian Winter Festival for the old (Julian calendar) New Year, on 11th January in Trafalgar Square. Music, dancing and free food.

Freedom Day. 27th April in Trafalgar Square to celebrate the end of apartheid in South Africa.

Irish London's St Patrick's Day. Celebrations Trafalgar Square. Also the **Fleadh,** 1st Sunday in July; Van Morrison, the Corrs and other good Irish musicians and singers in a park, north London.

Scottish London - Hallowe'en, October 31st (a Celtic celebration). 'Guising' (disguising), jumping for treacle scones and ducking for apples. **Burns Night,** 25th January. Poetry by Robert (Rabbie) Burns accompanied by whisky, haggis, tatties (potatoes) and neeps (turnip). **New Year's Day** first-footing by dark-haired people first, clutching a lump of coal and a present (fair-haired were the Viking enemy originally so they come last).

English London - Shrove Tuesday, day before Ash Wednesday in February when pancakes are tossed and races held sometimes in Covent Garden. Also **St George's Day** April 23rd. Morris dancing, sometimes at pubs in Hampstead, Richmond and outer, more English suburbs

Many communities have their own newspapers and magazines, available through local newsagents or direct from the publishers.

Riverside London

In the last decade the Riverside East end of London has changed dramatically, with many new wharfside developments around **Docklands** and the **Isle of Dogs** and downriver towards Greenwich. Old warehouses, once storage for spices or clothes, have been converted in **Wapping** and Limehouse into luxurious, spacious loft apartments. Designer studios and architects' homes and offices predominate, in what were once in the 70s and 80s artists' studios. Professional warehouse dwellers are living side by side with poorer council house tenants and the areas are gradually changing. Docklands is now an area with city offices at **Canary Wharf**, surrounded by wine bars and fashionable restaurants and nearby small town houses for young families.

Some of London's oldest and most quaint pubs are situated next to the River Thames and in summertime visitors flock to them to cool off and taste ale that the Pilgrim Fathers might have quaffed, prior to embarkation for America. The **Mayflower Pub** in **Rotherhithe** was named after the pilgrims' ship and many of the crew came from the area. Outside the pub, next to the tidal Thames, you can sit and watch barges or pleasure boats passing by. Nearby visit St Mary's Rotherhithe, which was built in 1715. At that time the area was a shipbuilding village and the church has examples of work by skilled shipwrights. The new Jubilee line makes these areas more accessible for tourists.

Across from Rotherhithe is **Wapping**, once an artists' area with warehouses chock-a-block with artists, designers and creative people, trying to make a living and often paying exorbitant rents. Some studios looked out onto the Thames and had superb views, but now these are mostly only owned by successful designers and photographers, or celebrities.

On leaving the studios on Wapping High Street, wander down to the **Prospect of Whitby**, which dates back to Henry VIII. Smugglers, thieves and the infamous hanging Judge Jeffries drank here, at one time or another. Judge Jeffries used to execute criminals by tying them to stakes in the river, where the rising tide slowly drowned them. Upstairs today in the pub, taste the pancakes or scampi provencale and you might even meet a famous face or two. Cher has stayed nearby when in London and David

View upriver from the London Eye.

Owen the politician lives along the road. The **Wapping Project** is now a centre for art, design and an excellent restaurant and bar, opposite the Prospect of Whitby. The area has sadly become full of modern houses and lost part of its charm.

Further down Wapping High Street, visit the **Town of Ramsgate Pub**, a 17th century tavern with a riverside garden. Nearby on Wapping Old Stairs Captain Blood was caught running away with the Crown jewels. This area is often used by British and American film crews for Dickensian London settings.

Back over on the south side at **Bermondsey**, the 16th century **Angel Pub** also has a few tales to relate. Samuel Pepys is reputed to have drunk here, as did Captain Cook. Bermondsey is still very much an area where 'real' Londoners live, though at times it is hard to know who real Londoners are these days. Cockneys seem to have moved to outer London suburbs and immigrants and refugees replace previous immigrants in the east end of London. The east end has always been a fascinating mix of ethnic minorities, dating from London's early days as a port. Immigrants have often lived here in appalling conditions until they find work: wandering along Brick Lane today, it would appear that times have not really changed.

Heading back towards London, **St Katherine's Dock**, across the river, has become a fashionable city dockside, with cafés and restaurants near the Tower Hotel. New yachts nestle close to old sailing ships with rigging and make an attractive sight for city workers on their lunch break.

St Katherine's Dock.

By the riverside in the city, employees can escape to pubs such as the **Bouncing Banker**, while upriver the scenery begins to change from industrial warehouses to leafy, attractive white-washed houses at **Hammersmith, Putney, Richmond** and **Twickenham**. A boat trip upriver from Westminster to Kew Gardens or Hampton Court is as worthwhile as one downriver to Greenwich to visit the Cutty Sark.

At Hammersmith, walk along the Mall to t**he Old Ship, the Dove, the Rutland** and **the Blue Anchor**. There are several rowing clubs here and hearty, strapping crews often stop here for a drink, before skimming down river. On the way to **Chiswick**, where **Hogarth's House** can be seen, pass by scented jasmine, lilac, wisteria and crisp pink and white magnolia trees, next to 17th and 18th century houses. **Kelmscott House** in Chiswick Mall, built in 1790, was once the home of **William Morris**, the great textile designer. Kelmscott Press produced many very fine mediaeval-inspired designs with birds, flowers and trees. This area makes a good walk along the river to the bridge which crosses over to **Barnes**, where there is a farmer's market every Saturday.

Queen Elizabeth I visited the Keeper of the Great Seal at Kew in 1594. Queen Anne gave money for building a church at **Strand on the Green** and George III's sons were tutored here in Kew. The painters Zoffany and Gainsborough lived at Strand on the Green, which was once a fishing village and is now luckily a conservation area. The **City Barge Pub** was built in 1497 in Henry VII's reign and the **Bull's Head** is reputed to be the scene of a council meeting, held by the Roundhead leader Oliver Cromwell, during the Civil War. There are cricket matches on the green in summer nowadays.

Both in London and outside there are many attractive pubs and restaurants. At Twickenham, visit the **White Swan**, at Isleworth, the **Londoner's Apprentice**, at Teddington, **The Angler**. Outside London visit **Windsor, Egham, Marlow** and **Henley on Thames**, where the annual July regatta takes place.

General Information

There are numerous guides to help tourists and visitors to London. Perhaps the best of these are the **Time Out** guides and the **Evening Standard** guides. Time out is published weekly and covers virtually everything you could think of needing to know about, with features appropriate to that particular week. The Evening Standard paper is a daily and has restaurant and pub reviews weekly, as well as art, theatre, music and dance reviews and a Hot Tickets listings magazine on Thursdays.

Specialist Guides

Stanfords Bookshop, Long Acre, Covent Garden, has an excellent selection of maps and guides to London and world-wide, also the **Britain Visitor Centre**, 1 Regent Street, London SW1Y 4NX has a useful bookshop and information centre. Piccadilly Circus tube station. www.visitbritian.com.

Time Out
London Guide
Restaurant Guide
Shopping Guide
London Walks
Time Out also publishes excellent guides to Berlin, Amsterdam, Paris, New York, Barcelona and other cities.

Evening Standard
The Best of London Guide
Childrens London (with discount vouchers)
Restaurant Guide by Fay Maschler
Pub Guide by Andrew Jefford

Guide to Ethnic London by Ian MacAuley. Immel Publishers. This guide covers the following communities: Italian, Irish, Greek and Turkish, Black, Asian, Chinese and Jewish. Recommended.

Information about London

London Tourist Board, Telephone: 0870 588 7711 (general enquiries). 24 hour hotline 0906 2015151. www.londontourist-board.com. Travel information in London 0870 957 6006. Waterloo International Terminal, Arrivals Hall, London SE1 7LT. Open 8.30-10.30. Also LTB centres in Camden, Greenwich, Lewisham, Liverpool Street Underground concourse and Southwark. **The London Tourist Board** runs a hotel booking service. For a booking fee and a deposit they will book you into a London hotel immediately on request. They will also send you a list of hotels. **Telephone: 0906 201 6666** for the **booking service**. An information pack is also available for British tourists on accommodation and attractions, **Telephone: 0906 201 6666**. Overseas, contact the local British Tourist Authority in major cities. Also LTB (now Expotel-run) offices at Heathrow Central station, London airport, Waterloo and Liverpool Street stations. The London line number (60p a minute) gives information on all sorts of London details, **Telephone: 0906201 5151**. LTB also does theatre and tour bookings. Book a bed scheme for the rest of England. For London bookings enquire in person at Waterloo or write at least 6 weeks in advance. Write to: **London Tourist Board, 1 Warwick Row, London SW1E 5ER. Telephone: 0870 588 7711. website www.londontouristboard.com**

Britain Visitor Centre, 1 Regent Street, Piccadilly Circus, London SW1Y 4NX. Website: www.visitbritain.com Telephone: 0208 846 9000. Open Monday, 9.30-6.30, Tuesday-Friday, 9-6.30, Saturday/Sunday, 10-6. In June-October, Saturdays, 9-5. Central point for booking UK accommodation, buying guide books, maps and theatre tickets. **Scottish Tourist Board: 020 7930 8661. www.visitscotland.com. Welsh Tourist Board: 0870 1211 251. www.visitwales.com. Northern Ireland and Eire: 0207 518 0800.**

Cheap accommodation in London
Easy Hotel, www.easyhotel.com has cheap hotels from £5 a night. **The Youth Hostel Association,** www.yha.org.uk has a hostel in Holland Park, a wonderful woodland setting. Membership costs £14 and offers discounts with Eurolines bus company and National Express.

City of London Information Centre, St Paul's Churchyard, London EC4. Telephone: 020 7606 3030. Open 9.30-5.

Daily Telegraph Information Bureau, Telephone: 020 7353 4242. Open 9.30-5.30. General information (not tourist information).

Information about Britain

Britain Visitor Centre, Website: www.visitbritain.com
1 Lower Regent Street, Piccadilly Circus, London SW1. Telephone: 0208 846 9000.

Scottish Tourist Office, 19 Cockspur Street, London SW1. Telephone 020 7 930 8661. Website: www.visitscotland.com Also at Britain Visitor Centre, Regent Street.

Welsh Tourist Office, 087 0121 1251.

Northern Ireland Tourist Office, 087 555 250.

Travel in London

Buses. London Transport publishes free bus maps covering all London areas with details of bus routes. The bus states on the front where it is going (stating the obvious, but it's amazing how many tourists don't bother to look). It is wise to check first. If you are unsure about the exact amount for the fare ask the conductor (or check on the ticket machine now by most central London bus stops) and if necessary ask to be put off the bus at your destination. London conductors are often very friendly and full of useful information, but sadly only the 13, 14 bus routes have them still. Try and remember the British obsession with queues at bus stops, as people get very fraught if you jump queues.
Travelcards for the day, week, month or year, are good value. Now there is the carnet system for 10 tickets and a weekend travelcard, so check what is best for you. The Oyster card is excellent which you just touch against specific markings at entry and exit from the tube. This saves much travel time. www.tfl.gov.uk

London sightseeing tours. Start from Marble Arch, Piccadilly, outside the National Gallery and outside the Trocadero at

Japanese Gardens, Holland Park.

Piccadilly Circus/Leicester Square, Victoria. wwwthebigbus.com It's really much cheaper to take the local buses and hop on and off where you want (hence the value of a travelcard). The bus routes 88 to the Houses of Parliament via Trafalgar Square, 24 from Trafalgar Square via Bloomsbury to South end Green, Hampstead and 137 to Knightsbridge are some good ones to take and the 23 to the Tower of London via the city.

The Big Bus Company. 020-8944 7810. Victoria, Green Park or Marble Arch starting point for up to 30 stops to hop-on or off at across London. www.thebigbus.com.

Duck Tours. County Hall, South Bank London SE1. Telephone: 020 7928 3132. Monday-Sunday, 10-6. £13, children £7, family £34. Renovated 30-seater DUKW amphibious vehicles run tours around centre London and then into the Thames for a waterside view. Unusual and fun.

Westminster Passenger Services (upriver). Telephone: 020 7930 2062. Trips upriver to Kew Gardens and Hampton Court and downriver to Greenwich. www.tfl.gov.uk. For other riverboat information: 020 7222 1234.

Tate Boat. Travels between Tate Modern and Tate Britain stopping at the London Eye (also the stop for the Saatchi Gallery, Hayward Gallery, National Film Theatre, IMAX, London Aquarium, Shakespeare's Globe and Vinopolis City of Wine). Telephone: 020 7887 8888. www.tate.org.uk. 10am-17.50pm. You can use your travel pass for a discount on this service. There are family day tickets.

Tube. If you arrive at Heathrow or Gatwick you will find that the fare to London is quite expensive. A push button machine at Heathrow will tell you how to reach your destination and the quickest route. After 9.30, a one-day travel pass is the best value, or a weekly or monthly travelcard and now carnet of tickets and weekend travelcard. Late night travel is difficult after 12 midnight but there are night buses. On New Year's Eve all travel is usually free, due to sponsorship.

Taxis. London cabbie/taxi drivers (black cabs) are world famous for their friendliness and charm. They are very knowledgeable about the city and have to take a test called "The Knowledge", to show that they know London well enough. Other radio car drivers do not take this test, so be careful and choose black cabs where possible. Radio cars at night time locally are cheaper however, but not advisable for single females!

Addison Lee are also excellent. Telephone: 020 7387 8888. Rates are very reasonable. They are reliable drivers.

Cars. Hiring a car is expensive, but worth it for trips outside London. If you have a car you may need a resident's parking

permit or otherwise there are meters. There is also the congestion charge now in central London.

Bicycles. Definitely the quickest way to get around London and keeps you fit. There are cycleways in some parks, but since a whizz-kid roller-blader killed a cyclist in Hyde Park, no bicycles are allowed there except on the cycleway at the far end. Crazy logic as far as I am concerned! You can hire bikes or buy them secondhand for longer stays. See Yellow Pages phonebook for addresses and phone numbers.

Pickpockets! Beware, as London has groups of pickpockets from South America and Eastern Europe, that pray on Oxford Street in particular. A well-known trick is for two youths to stand, one in front and one behind at a bus stop and one pickpockets while the other one draws attention away to something else. Always look streetwise!

Charles Rennie Mackintosh tearoom, Sauchiehall Street, Glasgow.

Travel outside London

Buses.
National Express. www.nationalexpress.com. London to 20 UK cities.

Megabus. www.megabus.com. Operates between London and 11 other cities. Fares start at £1 plus booking fee!

Green Line Buses. Eccleston Bridge, off Buckingham Palace Road, Victoria. Telephone: 020 7834 6563. Open 8.30am-9.30pm. Take the bus to Hampton Court, Windsor, Surrey Hills, the zoo and various stately homes for the day.

National Travel. Victoria Coach station, Buckingham Palace Road, Victoria, SW1W 9TP. Telephone: 020 7730 3499. Website: www.gobycoach.com. Buses to most British towns, villages and cities. Young Person's Coachcard for under 25s, which for £9 gives a 30% discount.

Trains.
All UK rail services. 0845748 49 50. www.tfl.gov.uk.
Virgin Trains. 08457222 333. www.youngpersons.railcard.co.uk. Students in full time education receive a third discount.
Charing Cross (southern region)
Victoria (southern region)
Waterloo (south west England)
Liverpool Street
St Pancras
Euston
Kings Cross (Scotland,York and northern England)
Paddington (Cornwall, Devon, South west England)
Check with the station for up-to-date fares and special inter-city reductions, bookable in advance.
Eurostar. 0870 518 6186. www.eurostar.co.uk
Trains to Paris, Lille, Brussels from Waterloo.

Planes.
Shuttle services to Scotland from Heathrow and Gatwick are better than before, due to fierce competition now with British Airways, British Midland, Air Uk, Ryanair, and Easyjet all covering British routes. Fare names and prices change so always ask for the cheapest one and insist on knowing that that definitely is the cheapest, unless of course you want to travel first-class.

British Airways, 0870850 9850. www.britishairways.com
British European, 08705 676 676. www.flybe.com
British Midland, 0870 607 0555. www.flybmi.com
Easyjet, 0871 7500 100. www.easyjet.com
Ryanair, 0871 246 0000. www.ryanair.com

Travel Overseas

British Airways, 0871 700 0123. www.britishairways.com
Virgin, 0870 574 7747. www.virgin.com
Air France, 0845 084 5111.
KLM, 0870 507 4074.
Iberia, 0845 601 2854.
Lufthansa, 0845 773 7747.
Easyjet, 0871 750 0100. www.easyjet.com
Wizz Air, www.wizzair.com - Eastern Europe

Time Out advertises cheap flights to most European cities and to the USA, Canada,Australia, New Zealand and worlwide. Also **The Evening Standard** does most days. They also often have last-minute cheap holidays to choose from. www.lastminute.com is also worth looking at for last minute flights and holidays.

Air Travel advisory bureau Telephone 020 7636 5000.Advice on the cheapest and best flights worldwide.

Europe
Eurostar, 0870 518 6186 www.eurostar.co.uk
Since Eurostar started this has definitely become the most pleasant way to travel to Paris or Brussels or even to the rest of Europe, by changing onto the TGV or other trains. Flying to other European cities is still the best way. Again Time Out and The Evening Standard have all the latest prices and offers. **Time Off** holidays are excellent value to most European cities.

Inter Rail Pass, www.interrailnet.com. A month-long pass for under-26s is £295 for all zones.

Eurolines, www.eurolines.com. Operates from London Victoria coach station and has buses to 35 cities.

Overseas
Trailfinders, 42-48 Earls Court Road, London W.8. and 194 Kensington High Street, W.8. www.trailfinders.com Telephone:

020 7937 1234 for USA and Europe and Telephone: 020 7938 3939 for long haul. This is one of the most professional and helpful travel agents in London, especially for long haul travel to Australasia or Latin America. They can advise on round-the-world tickets or alternative routes with stopovers.

Dome, Galeries Lafayette, Paris.

Useful Embassy Addresses

USA Embassy, Grosvenor Square, London W.1. Telephone 020 7499 9000. Press 3 for Cultural Affairs. Visa information 0891 200 290. For UK artists about to visit the USA also contact the Information Resource Centre 020 7894 0925. Contact www.fulbright.com about scholarships to the USA. Visas not needed now for UK visitors to the USA. The American newspaper, 88 Kingsway WC2B 6AA Telephone 020 7242 4033 gives useful information for Americans in London. You now need a visa for entry to the USA and fingerprinting is done at point of entry.

Canadian High Commission, Grosvenor Square, London W1X Obb. Telephone 020 7930 9741. UK citizens do not need a visa for Canada. Canada House, Trafalgar Square. Telephone 020 7258 6600. Visual arts Michael Regan 020 7258 6537.

Australia House, The Strand, London WC2. Telephone 020 7379 4334. Visas needed for Australia. Australian artists wishing to exhibit in London should contact the Public Affairs department. There are exhibitions at Australia House on a regular basis. Since September 11th these have ceased.

New Zealand House, Haymarket, London SW1. Telephone 020 7930 8422. Visas required by UK visitors to New Zealand. Gallery space at New Zealand House on the mezzanine floor for exhibitions of work by New Zealand professional artists. The Cultural Affairs department organises art exhbitions and other cultural events. New Zealand News UK is run from a nearby aracde and available free.

French Embassy, 58 Knightsbridge, London SW1. Telephone: 020 7201 1000. Cultural Affairs department is at 23 Cromwell Road, London SW7 2EL. Telephone: 020 7073 1314. Website: www.ambafrance.co.uk. Ciné Lumiere at the Institut Français has excellent French films. The French Cultural section is very active in promoting French culture in Britain.

German Embassy, 23 Belgrave Square, London SW1. Telephone 020 72824 1300. See Cultural Centres section for the Goethe Institut which shows exhibitions of work by German artists.

Greek Embassy, 1A Holland Park, London W.11. Telephone 020 7229 3850. **The Hellenic Insitute,** in Paddington shows work by Greek artists as does Gallery K in Hampstead.

Italian Embassy, 39 Belgrave Square, London SW1. Telephone: 0900 160 0340. The Italian Institute runs exhibitions, talks, concerts and has a library.

Other Useful information

Bank Opening Hours. Monday-Friday 9.30-4.30. City of London 9.30-3. Hours vary at certain branches and some banks open on Saturday, but not many. Harrods bank is open on Saturday but you have to pay a £3 charge to cash a cheque. Bureaux de change or Thomas Cook are better value. **M&S Marble Arch branch does not charge commission on foreign currency, but the rate is slightly less.**

Shopping Hours. Generally 9.30/10-6, but often late on Thursdays until 7/8 in Oxford Street and Wednesday in Knightsbridge. Locally a half-day on Thursdays at Portobello Road market. Sundays usually 11/12-5/6.

Medical. Hospitals operate a 24-hour casualty service for emergencies at Middlesex Hospital, Mortimer Street, London W.1.; St Mary's Hospital, Praed Street, London W.2.; Westminster Hospital, Horseferry Road, London SW1.

Chemists. Emergencies. Boots at Piccadilly Circus SW1 has a late-night service. John Bell, 52-54 Wigmore Street W.1 is open daily 8.30-10. Bliss at Marble Arch Telephone 020 7624 8000.

Lost Property. Buses/underground: 200 Baker Street Lost Property Office. Taxis: 15 Penton Street, London N.1. Trains: at main line stations. General: local police station near where you lost the item.

Travel enquiries. Telephone 020 7222 1234 is a 24-hour service advising on travel within London, by tube or bus. London transport information offices at Oxford Circus, Piccadilly Circus, Victoria and Euston. www.tfl.gov.uk

Licensing Hours. Now much longer hours, but vary from pub to pub. Sunday openings are far longer now. 24-hour drinking laws start in 2005.

Information by telephone:
London weather: 090 500 951
Directory enquiries: 118 500 (BT one). There are many others such as 118 118. I find BT the most reliable.
Emergencies (Ambulance, fire, police): 999
Post Office Hours: Monday-Friday 9-5.30. Saturday 8.30-12.

Parks

Central London Parks

Central London has a vast selection of parks to visit, each one with its own particular character.

Battersea Park, London SW11. Tennis courts, boating on a pond, running track and the **Buddhist Temple**, which makes impressive viewing from the Chelsea side of the river Thames. Open air circuses, ballet and firework displays have all taken place in this park. More a local park really. 101 Dalmatians was filmed here. Herons are bred in the park.

Hampstead Heath in autumn.

Hampstead Heath, London NW3. This park has 800 acres of fields and woodlands and is perhaps one of London's most famous parks. The views of London are superb and it has the good fortune to be surrounded by a good selection of typical old English pubs. **Spaniards Inn** is on the top part of the heath, where Dick Turpin the highwayman is supposed to have stayed. Hampstead village has numerous pubs, restaurants and tea rooms. **The Flask** and the **Nags Head** for real ale fans and **The Freemasons Arms** at the foot of the heath, nearer Keats House. This has a large garden area for summertime, has been renovated and is now a fashionable gastropub. Highgate on the other side of Hampstead heath is the home of Highgate Cemetery where Karl Marx is buried. Highgate also has numerous pubs and a village atmosphere. At the top of Hampstead heath visit **Kenwood House**, which has open-air concerts in summer on the lawn. The house itself holds the Iveagh Bequest which includes a Vermeer and a Rembrandt and is a beautiful Robert Adam-designed building. The heath has three swimming pools (open-air), tennis courts and space for dog-walking and open-air games, kite-flying etc. Underground Hampstead Heath/Belsize Park or 24 bus .

Holland Park, London W.8. Behind Kensington High Street and runs up the hill to Notting Hill Gate. This park was once the private garden of Holland House and although this building was bombed during the war, it now houses a splendid Youth Hostel in a wonderful park setting. Open air theatre and opera in the summer, tennis courts, squash courts and a cricket pitch. The wildlife in this park is exotic, with peacocks strutting around the elegant Japanese garden; created by ten Japanese gardeners and has a waterfall, pond and rock sculpture, a legacy of the 1991 London Japan Festival. It is beautifully peaceful here, except on summer Sundays. In the wooded areas you will often be surprised by a fox staring at you or an escaped white pet bunny rabbit—never a dull moment for children. Squirrels are also very tame here. The orangerie has exhibitions and concerts occasionally and the murals are worth looking at, re-creating a sunny day in the park over 100 years ago. There are exhibitions in the Ice House also, often of craft, jewellery or photography. The park café is excellent and in summer an ice cream stand is recommended for hungry children. Every summer July-August there is Opera sponsored by the Evening Standard in the remains of Holland House. Underground Holland Park

Hyde Park, London W.1. A royal park since 1536 and once highwaymen rode through it. More recently it has held rock concerts, charity walks and dancing displays, also agricultural events and even a fairground. You can swim in the man-made **Serpentine River** in summer but only at regulated times. I once just leapt in along near the ducks in sheer frustration to cool off one summer day, to the amazement of passing tourists, as the man in charge was being difficult. I am happy to say that they are friendlier now. You can hire boats on the river and there is a riding school on the Bayswater side of the park. The **Princess Diana Memorial Fountain** is by the Serpentine café but opens and closes according to accidents and faults in the design. **Speakers Corner** is at the Marble Arch end of Hyde Park and here you can listen to obsessive fanatics, eccentrics, mavericks, nutters and join in if you like. There is also a cycle path round by the river. 340 acres of wonderful parkland. Underground Queensway, Marble Arch, Knightsbridge.

Kensington Gardens, London W.2. Kensington Palace is worth visiting, since extensive renovations, and to see the sunken garden. The Orangery restaurant and café is excellent and in an attractive setting. The Palace is now a focal point for Diana-worshippers and the gates to the Palace often have flowers beside them. The new childrens playground is a great success, with wigwams and a large recreation of a ship, at the north side of the gardens, to commemorate Diana, Princess of Wales, who

Fountains at Lancaster Gate, Kensington Gardens.

died in 1997 tragically young. **The Albert Memorial** has been renovated next to the Albert Hall on the Kensington Gore side of the gardens. Albert is now a shocking gold, but otherwise the renovations are long overdue. The brown gates and deer sculpture leading up to it though look, to my taste, quite wrong. **The Round Pond** always has either remote-control boats on it or children feeding birds. **The Peter Pan** sculpture is worth visiting to show children and for adults, **The Serpentine Gallery** has been totally modernised and is now one of London's leading contemporary art spaces. Whatever is on, you can guarantee lively discussion afterwards. Students also love it as installations are thought-provoking and stimulating. Underground Queensway, High Street Kensington or Notting Hill Gate.

Kew Gardens, Richmond, Surrey. Although out of London officially, it is well worth visiting these wonderful gardens to see the plants, **Pagoda, Queen Anne's House** near the Thames and the **Marianne North Gallery**. The Cacti houses also occasionally have orchid or other displays. This is an ideal place for a picnic with children or a large group of students and there are many shady trees for summertime and three cafés, with a reasonable restaurant at one by the shop at the far end. From the Thames side of the gardens you can see the magnificent gates of Sion House on the other side of the river and sometimes boats practising for the many races that take place on the River Thames. Take a bus or underground on the District line or catch a boat from Westminster Pier to Kew Gardens. Underground Kew Gardens

Regent's Park, London NW1. This park is surrounded by some of the most beautiful London terraces in the Regency style, designed by Robert Nash. The park itself contains the famous **Zoo** and the **Open Air Theatre**, which in summer holds plays by Shakespeare and other more 20th century playwrights. **Queen Mary's Rose Garden** is a favourite photo setting for overseas married couples, just after the wedding, so don't be surprised if you suddenly see a Malaysian or African bride amongst the blooming roses! The Japanese bridge and lake is also another attractive area near the Park Café. The **Knapp Gallery** in the Inner Circle holds regular contemporary art shows, next to the Baker Street side of the park. You can also reach the park by taking a barge from Little Venice to the zoo. **Frieze Art Fair** takes place annually in October in the park and **Zoo Art Fair** for more alternative work, at the zoo. There are summer displays of sculpture at the southern end of the park. Underground Baker Street.

318

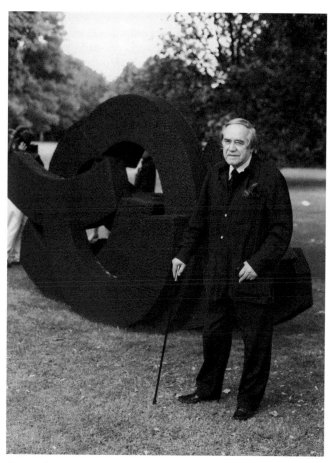

Dzusan Damonja, Croatian sculptor at his Regent's Park open-air exhibition 2004.

Richmond Park, Surrey. Richmond Park could well be somewhere deep in the country or the estate of a stately home. Golf, riding, polo and football are all possible here and deer wander about freely across acres of parkland, 2500 acres to be precise. This is an ideal park for long walks in the fresher air, away from polluted London. **The Isabella Plantation** is full of rhododendrons and azaleas and **King Henry's Mount** has superb views over London and a café. **Poet's Corner** has Ian Dury's memorial on a solar-powered bench that plays his music! Richmond, the town, is an attractive shopping centre, with a quaint village charm around the green where there are antique shops and an excellent theatre. Underground Richmond.

St James's Park, London SW1. This park contains a bird sanctuary and magnificent weeping willows next to an attractive lake. It is the setting for fictional spyland, as many civil servants work near here. It lies next to **the Mall** (which leads up to Buckingham Palace) and the **ICA (Institute of Contemporary Arts)** is directly opposite it. You can walk through this park from Admiralty Arch, Trafalgar Square, to Victoria. Underground St James's Park or Green Park.

Wimbledon Common, London SW19. This common is also quite countrified. You can walk from Putney or Wimbledon to **Roehampton** village. The latter has a lovely old pub and small cottages. On Wimbledon Common you can golf, ride or run for miles. The Windmill café is a favourite walkers' meeting place. **Cannizaro Park and House** nearby are also well worth a visit. Underground Wimbledon.

Markets

London markets vary enormously from the world-famous antique market **Portobello Road, Camden Market** for New Age and retro clothes and jewellery, to **Bermondsey** for jewellery and silverware.

Bermondsey and New Caledonian Market, London SE1. This is primarily a dealers' market for antiques and jewellery. Fridays only, starting early. This is the ideal place for buying antique jewellery, and also if you are looking for stolen jewellery from burglaries and have given up hope of ever finding it! Underground London Bridge.

Berwick Street, Soho, London W.1. Monday-Saturday 8-7. Fruit and vegetables and plenty of **Soho** atmosphere. Cheap material also for sale here. If you are tired of shopping in Oxford Street or Regent Street, wander over to have a look. Soho is now a media, film and gay area. Underground Leicester Square or Piccadilly Circus.

Burlington Arcade.

Brick Lane, London E.1.Sundays 7-2. This is the poor relation of Petticoat Lane and therefore more interesting. Worth visiting the extraordinary **Clifton Indian restaurant** with its exotic, bizarre murals of Indian women. It is very cheap to eat here. The market itself is very rock bottom in items for sale, but will show you another side of refugee and immigrant London. **The Truman building** now houses a variety of fashionable bars such as **93 Feet East, the Vibe Bar, The Boilerhouse** and **Café 1001** set up by Ofer Zeloof who bought the 19 buildings that once housed the old Truman brewery and saw the potential for change. Underground Whitechapel.

Borough Market, SE1, 12-6pm every Thursday and Friday. Wonderful selection of organic food and herbs, bread, cheese, fruit juices. www.boroughmarket.org.uk

Brixton Market, Brixton London SW9. Open every day but busiest on Saturdays. The food market is London's best for Afro-Caribbean produce. Also a good place to buy reggae CDs, clothes and household items. Underground Brixton.

Camden Passage, Islington High Street, London N.1. Wednesdays and Saturdays 9-6. Good selection of antiques and attractive shops in this olde worlde pedestrian precinct. Excellent 20s and 30s clothes shop. Good restaurants and the **Camden Head pub** has a pleasant atmosphere. Underground Angel.

Camden Lock, London NW6. This market is at the top end of the Regent's Canal and you can in fact catch a boat to it from Little Venice. Mainly a craft market with retro clothes now as well. It is very fashionable, especially with Europeans, Russians, French and Germans in particular. Saturdays and Sundays 8-6. Good restaurants by the canal and New Age stalls. Underground Chalk Farm or Camden Town.

Columbia Road Market, between Gosset Street and the Royal Oak Pub, E.2. On Sunday mornings it is very lively with flowers and plants. Prices are much cheaper than in the shops. Also a garden furniture shop with gifts. Open 7am-1pm.

North End Road, Fulham, London SW6. The **Fulham** area is worth a visit as it is a close-knit community rather like the East end once was. Houses are in neat terraces off the North End Road. The market is friendly and mainly local, with cheap clothes, pots and pans and fruit and vegetables. Fulham Broadway has more upmarket shops and restaurants. Underground Fulham Broadway.

Portobello Road, London W.11. Open all week except Thursday afternoons for fruit and vegetables. Friday and Saturday 7-6 are the main days for antiques and old clothes and the market stretches for miles from W11 to W10. The top end near Notting Hill Gate specializes in expensive antiques but from the Westway bridge up to Golborne Road you can find amazing bargains in furniture and 20s, 30s, 40s and 70s clothes. As a student I used to buy and sell Hungarian blouses and 30s dresses, but the 80s consumer Thatcherite attitude towards designer clothes changed everything. Luckily the retro approach has come back into fashion and

Market scene at Covent Garden market.

Portobello Road is having a field day. Good pubs in the area and two contemporary art galleries **East West** and the **Special Photographers Company**. Underground Ladbroke Grove or Notting Hill Gate and walk down the hill.

Spitalfields Market, Organic food, retro furniture, bric-a-brac and many cafés in this area. Also Spitz gallery and bar nearby.

Restaurants
Pubs & Bars

The London restaurant scene has changed dramatically in the last five years. London has now become a major international centre for cosmopolitan restaurants with some 12,000 restaurants and 60 different national cuisines. What London excels in is small, ethnic restaurants in village areas: atmosphere, friendliness and good service are all-important in restaurants such as **Mon Plaisir** in Covent Garden, **Costas** at Notting Hill Gate where there is an open-air courtyard in summer, **Patara Thai Restaurant** and **Jason's** at Little Venice.

The restaurants are listed by area first, then under art eating places, cafés, theatre pubs, bars and pubs and at the end of the section I have categorised some Thai, Turkish, Indian, Japanese, Spanish, Greek and French restaurants.

Soho

This area has changed quite substantially recently and now has stylish, smart shops, cafés, bars, restaurants, but the red-light aspect is still there in the background, although it is better known recently as a gay bar area. Publishers, film production studios and restaurants are neighbours with **Chinatown** across the road in Gerrard Street, where there are Chinese pagoda phone boxes. The Chinese New Year is the most lively time, usually in January or February, when there are processions and celebrations. The restaurants are excellent. Patisserie Valerie, the wonderful café is still at 44 Old Compton Street. The French House restaurant is on the site where the French used to meet in London during World War 11. **West Soho**, off Carnaby Street, near Liberty's, has small designer shops and local restaurants, but has become a fashionable area for creative people. In the 1950s artists such as Lucian Freud and Francis Bacon used to meet writer friends at the louche Colony Club run by Muriel Belcher. Now you are more likely to meet Damien Hirst or Sam Taylor-Wood there.

French House Restaurant, 49 Dean Street, London W1. Telephone: 020 7437 2477. Open Monday-Saturday, 12-3, 5.30-10.30. Typical French food in a dimly-lit warm atmosphere.

Little Italy, 21 Frith Street, London W.1. Telephone: 020 7734 4737. More elegant than Bar Italia but just as busy. Excellent Italian food. Marble bar.

Café Fish, 36/40 Rupert Street, London W1. Telephone: 020 7287 8989. www.santeonline.co.uk. This wonderful fish restaurant is part of a chain, but the menu is excellent and the atmosphere friendly. Piano playing some evenings. Near Chinatown.

The Lab, 12 Old Compton Street, London W.1. Telephone: 020 7437 7820. Media watering hole with a fashionable crowd, often from local film, publishing and arts companies.

Opium, 1A Dean Street, London W.1. Telephone: 020 7287 9608. Indochine décor and menu with Vietnamese and exotic dishes. Film stars and fashion names come here late-night, so it has a fashionable flavour.

Mash, 19-21 Great Portland Street, London W.1. Telephone: 020 7637 5555. Also at 268 Albemarle Street W.1. Space Age appearance and run by the fashionable Oliver Peyton. Clientele tends to be very fashion-conscious and aware of all the latest hip news. Asian and western food—crispy duck and wood-fired pizzas for example. Sadie Coles provided the paintings. (Sadie Coles HQ gallery)

Criterion Brasserie, 222 Piccadilly, London W.1. Telephone: 020 7925 0909. Spectacular interior and ceiling. Good atmosphere. Star-studded clientele. Expensive but beautiful décor and next to the Criterion Theatre for theatregoers. Underground Piccadilly Circus.

Kettners, Romilly Street, London W.1.Telephone: 020 7734 6112. Several bar/restaurant outlets. No reservations taken. Publishing, film and arts people mainly. Reasonable prices. This is Soho's oldest restaurant.

Bar Italia, 22 Frith Street, London W.1.Telephone: 020 7437 4520. Very Soho; good espresso and cappuccino for coffee addicts. Bar atmosphere. Little Italy next door is ideal for a more elegant meal.

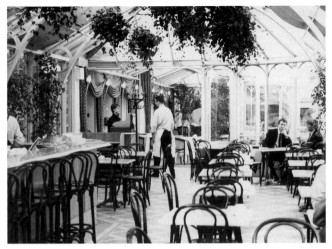

Opera Roof Terrace, Chez Gerard, Covent Garden.

Imperial China, White Bear Yard, 25A Lisle Street, London WC2. Telephone: 020 7734 3388. Dim sum is served 12-5. Otherwise this 3-floor restaurant has a wide variety of dishes.

Hong Kong, 6-7 Lisle Street, London WC2. Telephone: 020 7287 0324. Menu is in Chinese but the staff will help with descriptions. Dim sum is also available 12-5 only.

La Trouvaille, 12 A Newburgh Street, London W1. Telephone: 020 7287 8488. Open Monday-Saturday 12-3 and 6-11. This is a charming French restaurant in what I would call West Soho, tucked away behind Carnaby Street, off Regent's Street. Excellent French food in a pleasant small restaurant.

Bloomsbury/Fitzrovia

Traditionally this area is connected with the **Bloomsbury Group** (Virginia Woolf, Duncan Grant, Vanessa Bell), but around Charlotte Street there are many restaurants worth visiting. Windmill Street galleries are nearby. In September they have an open evening and the bars nearby are full of atmosphere.

Villandry, 170 Great Portland Street, London W1. Telephone: 020 7631 3131. This is ostensibly a shop with deli food available, but also has a small bar for lighter meals and a smart restaurant at the back. Near Great Portland Street station.

Cigala, 54 Lamb's Conduit Street, London WC1. Telephone: 020 7405 1717. Basement tapas bar in a fashionable restaurant. Very relaxing downstairs.

Chez Gerard, 8 Charlotte Street, London W.1. Telephone: 020 7636 4975. Excellent menu with French steak and frites and other French dishes. Now has a more modern interior. Reasonably expensive.

Museum Street Café, 47 Museum Street, London WC1. Telephone: 020 7405 3211. Near the British Museum. Bring your own wine and no smoking. Closed at weekends and no credit cards. If you still want to visit after that, the food is very southern, with sun-dried tomatoes, fresh fish and delicious puddings.

Wagamama, 4 Strathen Street, London WC1.Telephone: 020 7323 9223. Noodle bar, healthy food, modern décor. apanese beers and saké. Very reasonable prices. Branches elsewhere.

West End

This covers other restaurants not in Soho or Bloomsbury/ Fitzrovia. St Christopher's Place is worth visiting as it has a variety of restaurants in an attractive alleyway off Oxford Street. Heddon Street, off Regent Street and Newburgh Street both have good restaurants.

Sofra, 1 St Christopher's Place, London W1. Telephone: 020 7224 4080. This is a great place for Turkish meze dishes and you can eat outside from spring to autumn as they now have heaters overhead. Excellent, reasonably-priced food, Turkish wine and St Christopher's Place is an attractive pedestrian precinct with restaurants and shops, just off Oxford Street, near Bond Street tube station.

Patara, 3&7 Maddox Street, London W.1. Telephone: 020 7499 6008. A wonderful Thai restaurant with elegant, polite waiters and waitresses and interesting menu and décor.

Rocket, 45 Lancashire Court, Brook Place, London W.1. Telephone: 020 7629 2889. Bar and restaurant in a quiet attractive cul-de-sac, behind the Handel Museum. Good atmosphere.

Hush, 8 Lancashire Court, London W.1. Telephone: 020 7659 1500. There is a brasserie downstairs with reasonable prices and a more expensive dining room upstairs. Run by Roger Moore's son and attracts celebrities and people who live and work locally. Beautiful interior and right next to the Handel Museum.

La Trouvaille, 12A Newburgh Street, London W.1. Telephone: 020 7287 8488. This restaurant is situated near Carnaby Street, off Regent Street and near Oxford Circus. Newburgh Street has pretty jewellery and fashion shops and the fare is provincial French cooking at its best.

Momo, 25 Heddon Street, London W.1. Telephone: 020 7434 4040. Attracts a mixture of ages. Algerian restaurant with tagine of lamb, couscous and delicious desserts. Near Gagosian Gallery and Sadie Coles HQ gallery.

Raks Bar, 4 Heddon Street, London W1. Telephone: 020 7439 2929. A Turkish bar and restaurant in this lively street of Regent's Street.

Market Place, 11 Market Place, off Oxford Circus, London W.1. Telephone: 020 7079 2020. Owned by the people who started Cantaloupe, then Cargo in Shoreditch, then The Social in Islington. Brasserie food all day; bar and music club venue. Latin American and Spanish food.

Hard Rock Café, 150 Old Park Lane, London W.1.Telephone: 020 7629 0382. It's been around for 25 years now, but still serves the best hamburgers and sundaes in London. Very American and attracts tourists. Loud music. Children love it!

Café Fish, 36-40 Rupert Street, London W1.Telephone: 020 7287 8989. Near West end theatres and cinemas. Every variation on fish and reasonable prices. The wine bar downstairs is cheaper and just as good.

Café Royal, 68 Regent Street, London W.1. Telephone: 020 7437 9090. The Brasserie is more accessible price-wise, but don't miss seeing the Grill Room with its exotic interior, paintings and mirrors. Oscar Wilde used to dine here with friends, also Whistler, Anna Pavlova, Garibaldi and others. I was taken here once after the theatre and remember being disconcerted by the fact that your reflection could be seen about 7 times while you ate! Now run by Marco Pierre White the famous restaurateur.

Sketch, 9 Conduit Street, London W1. Telephone: 0870 777 4488. Open 7pm-2am. This is a very fashionable, expensive, stylish restaurant and bar with a gallery open to the public 10-6. Celebrities often come to premiere parties here. Worth visiting once to see the extraordinary interior. I went to a French Embassy launch for French artists when 12 video projectors were working all around us: futuristic décor.

Defune, 34 George Street, London W.1. Telephone: 020 7935 8311. Sushi restaurant with some obscure dishes as well as traditional ones.

Covent Garden

This area has become a stylish fashion area with remnants of the specialist shops that once used to dominate the backstreets. The market area is very touristy, but still operates during the week selling old clothes, jewellery and craft and at weekends more touristy junk. It still has its charm as an area, especially up the quaint backstreets. The restaurants have improved enormously. There is an annual Food Lover's Fair in November, when country food producers set up stalls all round the market. At Christmas time there are also German stalls selling gifts.

Bertorelli's, 44 A Floral Street, London WC2. Telephone: 020 7836 3969. Expensive restaurant upstairs and a terrific one downstairs, which usually has a lively clientele in the evening. I took two Australian friends, geologists, there and they loved it. They thought Covent Garden, and the restaurant, were both full of pzazz and that was in October, not even in summer. Avoid it near Christmas where businessmen can be heard talking about their secretaries as "sex on legs!"

Mon Plaisir, 21 Monmouth Street, London WC2. Telephone: 020 7836 7243. One of London's most charming French restaurants. French atmosphere, French waiters and relaxing village ambiance. Good food as well. Reservations essential for dinner.

Don Hewitson's Cork and Bottle Wine Bar, 44-46 Cranbourn Street, London WC2. Telephone: 020 7734 7807. www.don-hewitsonlondonwinebars.com. This is a great wine bar with good food, in a basement off Leicester Square. Atmosphere a bit 1970/80s but always crowded and lively. Film, publishing, arts people come here after work.

Bibendum, Michelin building, South Kensington.

Porters, Henrietta Street, London WC2. Telephone: 020 7379 3556. Home-made English game, chicken and vegetable pies. Syllabub and English puddings. Spacious. Ideal family or group eating place. Recently refurbished and expanded.

The Opera Terrace (Chez Gerard), The Piazza, 35 The Market, London WC2. Telephone: 020 7379 0666. Wonderful setting, high up in the market, with open-air seating, looking down on the cobbled streets. £15 for 3 courses. Open 12-3 and 5.30-11.30, Sundays, 10.30pm. Bar with snacks also during the day. Chez Gerard French menu but the setting is one of the best open-air venues in London.

Belgo Centraal, 50 Earlham Street, London WC2.Telephone: 020 7813 2233. Moules (mussels) frites and Belgian beers. Very cheap. Designed by Ron Arad. 400 seats. Various special offers.

Rules, 35 Maiden Lane, London WC2. Telephone: 020 7836 5314. This restaurant was 200 years old in1998 and has a history of serving actors, lawyers and writers. Traditional English food but served to perfection. Pre-theatre meals are good value, otherwise more expensive. It has a real sense of history.

Tuttons, 11-12 Russell Street, Covent garden, London WC2. Telephone: 020 7836 4141. Tuttons has been here for years, since before all the historical changes in the market area. It is still

a good restaurant, right on the market corner and has a useful bar at the side for meeting friends.

The India Club, 143 The Strand, London WC 2. Telephone: 020 7836 0650. This unpretentious Indian restaurant above a hotel (£29 a double room for interest and very central) serves basic, good Indian food. Drinks can be bought downstairs. Ideal for a cheap night out, but definitely not a glamorous one! A group of us used to eat here after The Australian Film Society at Australia House (£5 a year—best film price in London).

Christopher's American Grill, 18 Wellington Street, London WC2. Telephone: 020 7240 4222. Cartoons of Christopher Gilmour's family (the owner) by Andrea Cunningham. American-style cuisine. More expensive restaurant upstairs.

Notting Hill Gate

This lively area falls into two; up the hill near the tube and Holland Park and down the hill near Portobello Road market, where there are many restaurants on Kensington Park Road, near East West Gallery. This area is a mixture of poorer people, often Portuguese and Spanish, up near Golborne Road and more trendy "trusta-farians" (wealthy trust fund people in their 20s and 30s) nearer the middle of the market. The mixture is heady, with small local Spanish delicatessens and trendy media people, actors and film stars at the Kensington Park Road bars. The film "Notting Hill" ('99) was made here with Julia Roberts and Hugh Grant. Once an art area, there are now only 3 contemporary galleries, whereas in the late 80s there were some 15. Up the hill the restaurants are more demure, but Uxbridge Street and surrounds are still charming. Pharmacy has gone; now M&S store, a sign of the times!

Top of the hill (near Notting Hill Gate station)

Thai Break, 30 Uxbridge Street, London W8. Telephone: 020 7229 4332. This is a charming, slightly old-fashioned Thai restaurant with Thai décor and friendly waitresses. The food is excellent and it is free of the stylish Notting Hill crowd!

Notting Grill, 123A Clarendon Road, London W.11. Telephone: 020 7229 1500. Run by Antony Worrall Thompson, the ever-

Summer Picnic.

present TV chef on the site of his old restaurant Wiz. This restaurant is dedicated to meat, with only the best of course.

Kensington Place, 205 Kensington Church Street, London W.8. Telephone: 020 7727 3184. Mural of a table by a lily pond by Mark Wickham on the far wall. Modern brasserie; popular with successful BBC journalists, actors, actresses, film producers and wealthy locals. Excellent food. Reasonably expensive.

The Ark, 122 Palace Gardens Terrace, London W.8. Telephone: 020 7229 4024. In summer it has a pretty open-air courtyard for several tables. It serves excellent Italian food. The wines are quite expensive though!

Edera, 148 Holland Park Avenue, London W.11. Telephone: 020 7221 6090. This Italian restaurant has become quite popular.

Renaissance, 108 Holland Park Avenue, London W11. Telephone: 020 7221 3598. This is more a local French café than a restaurant and has delicious patisserie for sale. It is very popular with locals and next door to Maison Blanc, the famous patisserie and boulangerie.

The Castle, 100 Holland Park Avenue, London W11. Telephone: 020 7313 9301. Beautiful old pub with aspirations to be a gastropub, but food a bit disappointing.

The Mitre, 40 Holland Park Avenue, London W11. Telephone: 020 7727 6332. This was once a tired local pub but is now a superb gastropub with garden at the back in summer and in the front, beside an attractive florist's stand. Inside the waiters are friendly, the food good and there is a bar, restaurant and comfortable seating area to sit and wait for friends.

Costas, 14 Hillgate Street, London W.8. Telephone: 020 7229 3794. This restaurants is run by a friendly Greek-Cypriot family. The interior is not spectacular, but the welcome is, and the prices are very reasonable. Try the Cyprus wine for a change from Greek wine. The open-air courtyard at the back is usually heavily-booked in summer on good days, so reservations essential for open-air eating. Usual meze, moussaka, souvlakia and Greek dishes. They don't take credit cards.

Geales, 2 Farmer Street, London W.8. Telephone: 020 7727 7979. Old-fashioned, unpretentious fish restaurant. An ideal family eating place and very reasonable prices.

Down the hill (near Portobello Road market)

Kensington Park Road has **Luna Rosso, Mediterraineo** and **Hudson Grill.**

202, 202 Westbourne Grove, London W11. Telephone: 020 7727 2722. A star-spotting restaurant on stylish Westbourne Grove with open-air seating in summer and interesting clientele all year round. Friendly and good food. Only open at lunchtime.

The Oak, 137 Westbourne Park Road, London W.2. Telephone: 020 7221 3599. A Notting Hill gastropub with a wood-burning oven near the bar. Menu changes daily but usually excellent food.

Dakota, 127 Ledbury Road, London W.11. Telephone: 020 7792 9191. Southwestern American food in a fashionable setting. Ledbury Road has many small stylish shops for fashion and accessories. Madonna has eaten here and other visiting celebrities.

The Market Bar, 240 Portobello Road, London W.11. Telephone: 020 7229 6472. Bohemian, local bar with lively atmosphere. The upstairs restaurant has Thai food in an amazing setting with Indian arches and screens. The pub/bar

downstairs has a mixture of local media types and some strange locals as well as passing tourists on Saturdays.

Westbourne Grove/Bayswater

Westbourne Grove is full of Indian, Malaysian and Chinese restaurants. Take your pick but I'd recommend **The Standard** and **Kalamaras**. The Portobello Market end has some very stylish cafés and restaurants and the new **Tea Palace** with 100 teas to choose from.

Khan's, 13/15 Westbourne Grove, London W.2. Telephone: 020 7727 5420. Popular but very poor service, as it's so busy.

Kalamaras, 66 Inverness Mews, London W.2. Telephone: 020 7727 9122. Still as warm and friendly as ever. Cheap Greek restaurant, in a back mews off Queensway.

The Cow, 89 Westbourne Park Road, London W.2. Telephone: 020 7221 0021. Back to "trustafarian" territory. Run by Tom Conran, Terence's younger son. Trendy but lively nevertheless. Many young actors and actresses come here with their friends.

Chelsea

Chelsea was traditionally an art area in London in the 19th century. Nowadays it is a fashionable area for clothes shops and the Kings Road. The backstreets have some beautiful squares, with elegant houses and pretty gardens. In summer the window boxes are lush with richly-coloured flowers outside white Georgian houses. The Duke of York Square has brought some great new restaurants to the area and a skating rink over Christmas, next to the Italian café. The **Chelsea Arts Club** is in Old Church Street, but only open to members. The restaurants vary enormously, but Kings Road, especially at the World's End, has some excellent French and Italian bistros. Duke of York's Square has added some good, attractive restaurants and shops to the area. **Chelsea Harbour** is really outside the traditional Chelsea but is still worth a visit, for attractive open-air settings by the River Thames. They also sometimes have open-air sculpture shows at Chelsea Harbour in the summer.

Manicomio, 85 Duke of York Square, London SW3. Telephone: 020 7730 3366. Italian deli, bar and restaurant. I've been here with children after skating, where the food in the smaller café/bar is ideal for lunch and the waiters are friendly and also to the restaurant, to meet friends back from America. The restaurant is superb but more expensive and they were very impressed, returning to Chelsea after years abroad.

West Wing Café, Duke of York Square, Chelsea, London SW3. Telephone: 020 7730 7094. Patisserie Valerie has now mush-roomed all over London from the original Soho café. This is smartly decorated and perfect for a coffee and patisserie.

Dan's, 119 Sydney Street, London SW3. Telephone: 020 7352 2718. Attractive restaurant with al fresco eating in summer. Modern European cuisine. Along from the old town hall on the King's Road.

Gossip, Chelsea Court Yard, 250 King's Road, London SW3. Telephone: 020 7351 5351. Modern organic cuisine in an attractive setting in a courtyard opposite the old town hall and Heal's store.

Le Colombier, 145 Dovehouse Street, Chelsea, London SW3. Telephone: 020 7351 1155. Simple French restaurant that was once a pub, but renovated by Didier Garnier to provide bistro fare such as grillades and crepes suzettes.

Charco's, 1 Bray Place, London SW3. Telephone: 020 7584 0765. A very Chelsea place, full of wealthy Chelsea hooray Henrys and Henriettas, or their current equivalent. Bar/restaurant.

Blushes, 52 Kings Road, London SW3. Telephone: 020 7584 2138. Good food and atmosphere. Open lunchtime and in the evenings. Open-air seating in summer.

Bluebird, 350 King's Road, London SW3. Telephone: 020 7559 1000. Popular Conran eaterie with smaller café downstairs and open-air eating in summer and the huge restaurant upstairs with stylish waiters and excellent food.

Bucci, 386 Kings Road, London SW3. Telephone: 020 7351 9997. The food is delicious. Italian modern cuisine. Friendly staff. Friendly to children too.

Thierry's, 342 Kings Road, London SW3. Telephone: 020 7352 9832. French cuisine, French owner and good local atmosphere.

The Brasserie, 272 Brompton Road, London SW3. Telephone: 020 7584 1668/ 7581 3089. Typical French brasserie in this French area.

Bibendum, 81 Fulham Road, London SW3. Telephone: 020 7581 5817. Magnificent Michelin building interior. The restaurant is owned by Terence Conran. Stylish, popular with publishing editors (Hamlyn/Octopus offices upstairs) actors, media people. Worth visiting even just once to see the stained-glass windows. Reservations essential. Expensive.

Ziani, 45 Radnor Walk, London SW3. Telephone: 020 7352 2698. A small, smart Italian restaurant in a pretty Chelsea side-street. Reasonable prices for the area.

Hampstead

Hampstead village lies adjacent to Hampstead Heath, where actors and actresses such as Emma Thompson, Jeremy Irons and Tom Conti live. DH Lawrence, the writer, once lived here too and Dickens visited Jack Straw's Castle pub, often on horse-back. Jack Straw's Castle is now modern flats, a sign of the times! Surrealist artists used to meet at Roland Penrose and Lee Miller's house in the 1930s/40s and Barbara Hepworth and Ben Nicholson also lived here until their marriage broke up. The Hampstead and Highgate Festival takes place in May. www.hamandhighfest.co.uk. Other notable pubs are **The Flask, Freemason's Arms** (now a gastropub), **The Spaniard's Inn**. **Louis' Tearoom** is also worth a visit.

Dôme, 38-39 Hampstead High Street, London NW3.Telephone: 020 7431 3052. French café/brasserie atmosphere. Designed by Lubin and Myers. Young literati and local 20s and 30s meeting place. Newspapers to read while waiting for friends.

La Cage Imaginaire, Flask Walk, London NW3. In a quiet cul-de-sac opposite Duncan Miller Fine Art gallery. French restaurant.

The Freemason's Arms, 32 Devonshire Hill, London NW3. Telephone: 020 7433 6811. Once a lovely old English pub but now completely renovated and has becomne a stylish gastropub for South End Green residents. Friendly waiters.

Kenwood House café.

Flame, 7-9 Pond Street, London NW3 2PN. Telephone 020 77433 3200. This wonderful wacky restaurant/café has delicious food at resaonable prices and a lovely garden at the back. Salsa classes can also be taken here! Friendly Russian waitress and Italian owner.

The Brewhouse, Kenwood House, Hampstead Lane, London NW3. Telephone: 020 8341 5384. This wonderful café/restaurant is open 9-6 for breakfast, lunch and afternoon tea and a has a huge open-air seating area with attractive wooden tables and parasols. Used by Heath walkers and people who just want to enjoy the setting of Kenwood House, almost as though in the country. Not much choice and pastries/scones are often stale but the setting is wonderful. A new cappuccino machine would help! The Steward's Room also offers coffee and pastries.

Hoxton

Hoxton has become a fashionable, lively area in recent years. If you do not already know it, it covers the area between Old Street, Curtain Road and Kingsland Road in north London, but bordering on east London. Hoxton Square is right at the heart of this hip area. The Market area has a café/small gallery and **The Real Greek**. **White Cube Gallery** is in the square and more galleries have moved into the area. Most of the restaurants are nearer Old Street or Liverpool Street stations.

The Hoxton Apprentice, 16 Hoxton Square, London N1. Telephone: 020 7749 2828. Trainee chefs are on trial here and you can taste the results! It has an open-air terrace.

Jamie Oliver's Fifteen, 15 Westland Place, London N1. Telephone: 0871 330 1575. Jamie Oliver, start of TV shows and cookery books runs this lively restaurant which has also appeared on television as part of a training course for chefs. Popular with celebrities.

The Real Greek, 14-15 Hoxton Market, London N1. Telephone: 020 7739 8212. As the name suggests this is real Greek cooking. Set up by Theodore Kyriakou who has sold the business but is still involved. This restaurant has been in the area for a long time.

Liquid Bar. Hoxton.

Theatre Pubs

The Gate Theatre, Pembridge Road, London W.11. Telephone: 020 7229 0706. Above the Prince Albert pub, which has hysterically funny notices in the window about all the people that it won't allow in! Membership and reasonable entrance fees to the Gate theatre and some excellent new plays.

Bush Theatre, Shepherds Bush Green, London W.12. Telephone: 020 7743 5030. Well-worth a visit. Good selection of new plays by travelling companies.

338

Kings Head, 115 Upper Street, London N.1. Telephone 020 7226 1916. Nice pub atmosphere. The Theatre offers a variety of interesting plays. You can have a meal in the theatre itself before the play starts. Also lunchtime plays.

The Orange Tree, 45 Kew Road, Richmond. Telephone 020 8940 3633. Beautiful pub with ornate mirrors. Tiny stage but good plays. Underground to Richmond.

Time Out gives up-to-date details of more theatre pubs and current plays. **Leicester Square booth** sells tickets for most West end performances that day. Queue at 12-2 for matineé performances that day or 2.30-6.30 for evening performances. Do not confuse the one near the tube with the real one which is in the square!

Some other interesting London Pubs

There is an alarming trend for closing down old pubs and restyling them into trendy bars and gastropubs. Both have their place but a part of London history is dying with all the changes. These are some of the old pubs. The newer bars are in the next section.

Olde Cheshire Cheese, 145 Fleet Street, Wine Office Court, London EC4. Telephone: 020 7353 6170. Wonderful unpretentious pub in a historical area.

The Nag's Head, 53 Kinnerton Street, SW1. Telephone: 020 7235 1135. Good Adnams bitter for ale enthusiasts and olde English pub atmosphere.

The Dove, 19 Upper Mall, Hammersmith. 16th-century pub overlooking the Thames.

Bulls Head, Strand on the Green, Chiswick. Waterfront pub in a picturesque area near Kew Gardens.

Prospect of Whitby, 57 Wapping Wall, London E.1. Telephone: 020 7481 1095. 660 year-old pub in an area that many artists and designers now live in. Overlooks the Thames. Upstairs the dining room has French traditional food and Sunday lunch.

The Jerusalem Tavern, 55 Britton Street, London EC1. Telephone: 020 7 490 4281. A very small pub with ancient floorboards and snug atmosphere. In fact it is a good replica not original.

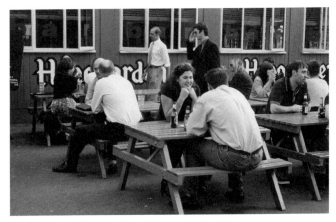

Gabriel's Wharf, South Bank SE1.

The Jamaica Wine House, St Michael's Alley, London EC3. Telephone: 020 7626 9496. Known as the Jam Pot and a listed pub. It was badly burnt in the Great Fire of London. Up a mediaeval alleyway. 17th century doorstep. Best avoided at rush hour after work when city workers crowd in.

Nell Gwynne Tavern, 2 Bull Inn Court, London WC2. Telephone: 020 7240 5579. Up a tiny alleyway near the Adelphi Theatre on the Strand. Dates from 1623. Voted one of London's top 10 pubs.

Hollands, Exmouth Street, London E.1.

Princess Louise, 208 High Holborn, London WC1. Telephone: 020 7405 8816. Central London pub. Many publishing people go there.

Anglesea Arms, 16 Selwood Terrace, London SW7. Open-air setting in summer, next to attractive leafy streets with wisteria.

The Admiral Codrington, 17 Mossop Street, London SW3. Telephone: 020 7581 0005. Run by Joel Cadbury now and rid of its past Sloane image. Good restaurant also.

The Warwick Castle, Warwick Place, London W.9. Little Venice pub, next to the canal, in a side street. Peaceful setting.

Bars

Some of the more stylish modern bars.

The Social, 5 Little Portland Street, London W1. Telephone: 020 7636 4992. Central London hip bar that was the original before the Social Islington was created.

Oxo Tower, Riverside Oxo Tower, Wharf, Barge House Street, London SE1. Telephone: 020 7803 3888. Cocktails in a stylish setting by the river Thames.

Cantaloupe, 35-42 Charlotte Road London EC2. Telephone: 020 7613 4411. Mixture of customers but wooden-effect interior.

Electric Brasserie, 191 Portobello Road, London W11. Telephone: 020 7908 9696. Stylish bar with restaurant and cinema attached on the famous portobello Road market street.

Lonsdale House, 48 Lonsdale Road, London W11. Telephone: 020 7727 4080. Near Westbourne Grove the stylish shopping street in Notting Hill, nearer Portobello Road in fact.

Eagle Bar & Diner, 3-5 Rathbone Place, London W1. Telephone: 020 76437 1418. Near Tottenham Court Road tube station, off Oxford Street.

The Social Islington, 33 Linton Street, London N1. Telephone: 020 7354 5809. Gastropub, one of the originals.

The Market Place, 11 Market Place, London W1. Telephone: 020 7079 2020. Near Oxford Street but away from the crowds.

Grand Café and Bar, The Courtyard, Royal Exchange, London EC3. Telephone: 020 7618 2480. Conran opened this cocktail bar and café in a shopping mall but it is very popular. Excellent food.

Cellar Gascon, 59 West Smithfield Street, London EC1. Telephone: 020 7796 0600. Friendly French wine bar rather than stylish hip bar!

Art Eating Places

Menier Chocolate Factory, 51-53 Southwark Street, Lodnon SE1. Telephone: 020 7403 5893. 1870 industrial space that has been turned into a theatre, gallery and restaurant. Good exhibitions and lively customers, including the occasional celebrity and many actors/actresses.

The Tea Building, 56 Shoreditch High Street, London E1. Telephone: 020 7729 2973. On the corner of Bethnal Green Road and Shoreditch High Street this building has become home to many galleries including Andrew Mummery and Hales Gallery. Not stylish but near galleries and artists.

Spitz Bistro, 109 Commercial Street, London E1. Telephone: 020 7247 9747 ext 234. Open for lunch and dinner. Good atmosphere. Spitz gallery shows photography and they have live music most evenings. Near Liverpool Street tube station.

Delfina Studio Café, 50 Bermondsey Street, London SE1. Telephone: 020 7357 0244. Open Monday-Friday, 10-3pm. Lunch only. Artist-run studios next door, but also open to the visitors to the gallery. Excellent lunch fare such as blinis or char-grilled dishes.

Café Bagatelle, The Wallace Collection, Manchester Square, London W1. Telephone: 020 7563 9500. This beautiful restaurant is situated in the courtyard at the rear of the museum, with light filtering from the dome overhead. Lunch and coffee with pastries.

The Portrait Restaurant, National Portrait Gallery, St Martin's Place, London WC2. Telephone: 020 7312 2490. At the top of the building with magnificent views across London. Run by Searcy's with lunch and afternoon tea menu.

Bradley's Spanish Bar, 42-44 Hanway Street, London W.1. Telephone: 020 7636 0359. Hilariously unfashionable bar, with attempts at a Spanish atmosphere, exotic food and European

beer. Art historians, curators and art critics have visited this tiny bar, near Tottenham Court Road.

RIBA Café, RIBA, 66 Portland Place, London W.1. Telephone: 020 7631 0467. Restyled by Conran and Partners, this café in the Royal Institute of British Architects is catered for by Milburns. Good variety of lunch, brunch and café style fare. Near Oxfiord Circus. Open weekadys until 6 and Saturdays until 5.

Searcys, at Waterstones Piccadilly, London W.1. The enormous Waterstones at Piccadilly's has become a hot venue centrally. On the lower ground floor, the Red Room has excellent lunches. and the News Café has a lighter menu in a self help area. The Creative Juice Bar on the 2nd floor is more healthy. The Studio Lounge on the 5th floor where all the arts books are has a good daytime menu and wine menu.

Wapping Food, Wapping Power station restaurant.

Wapping Food, Wapping Wall, London E.1. Telephone: 020 7680 2080. Spectacular venue near the Prospect of Whitby in a renovated old power station. This is also an arts and design venue with interesting installations and events. Brasserie food and an excellent selection of Australian wines.

RSJ, 13 Coin Street, London SE1. Telephone: 020 7928 4554. Near the Tate Modern and other Southwark arts venue. Named after the rolled steel joist that holds the restaurant up! Good selection of wines from the Loire valley and good food.

Poetry Café, 22 Betterton Street, London WC2. Telephone: 020 7240 5081. An alternative arts café and restaurant with char-grilled fish, crunchy vegetables and tasty cakes, below the Poetry Society in Covent Garden. Art for sale on the walls and an interesting mix of people.

Archduke Wine bar, Concert Hall Approach, London SE1. Telephone: 020 7928 9370. Successful wine bar with restaurant. Open-air seating at the courtyard in the back. Near the Hayward Gallery and South Bank Centre.

Museum Street Café, 47 Museum Street, London WC1. Telephone: 020 7405 3211. Near the British Museum. Home-made food. You have to bring your own wine.

Sotheby's: The Café, 34 New Bond Street, London W.1. Telephone: 020 7408 5077. Expensive, but fascinating to see the customers who are mainly Sotheby's clients and local Bond Street art world.

The Globe Theatre Restaurant, Shakespeare's Globe, New Globe Walk, Bankside, London SE1. Telephone: 020 7928 9444. Next to Tate Modern. Recommended. Sunday jazz brunches at the café. Popular with theatregoers and popular with Tate Modern visitors .

Barbican Waterside Café, Barbican Arts Centre, Silk Street, London EC1. Surprisingly good food here as well as cappuccino and cake fare. Open-air eating by the lake in summer.

St John, 26 St John St, London EC1. Telephone: 020 7251 0848. An elegant restaurant in a converted smokehouse. British food and its own bakery. Near the Barbican Arts Centre.

National Gallery, Crivelli's Garden, Trafalgar Square, London SW1. In the Sainsbury wing, the murals are by artist Paula Rego. Stylish restaurant with brasserie food and good cappuccinos. In the main part of the museum the café/restaurant has been taken over as part of the recent renovations.

Royal Academy Restaurant, Burlington House, Piccadilly, London W.1.Telephone: 020 7439 7438. Excellent daily menu, both hot and cold, in this basement self-service restaurant. It has been redesigned recently but seems very cold with steel greys and black.

October Gallery Café, open for lunch only.

Most artists tend to meet at pubs in areas such as Hoxton, Spitalfields or at other people's houses in the East end, but the Art Project Spaces are also good meeting places. www.capri-art.org.uk Private views in London tend to be from 6-8 most evenings. It really depends on the gallery, as to whether you are likely to meet new faces and go on to pubs/bars or restaurants. The Windmill Street and Cork Street parties are annual events in September and summer respectively. Art Fairs (see art addresses) are useful meeting points.

Other interesting restaurants

Afghan
Caravanserai, 50 Paddington Street, London W.1. Telephone: 020 7935 1208/224 0954. Afghan restaurant with tandoori dishes. Recommended.

Afghan Kitchen, 35 Islington Green, London N1. Telephone: 020 7359 8019. Not a stylish restaurant but authentic Afghani food.

French
The French House, 49 Dean Street, London W1. Telephone: 020 7437 2477. Traditional French haunt from the 1920s to today. Pub and restaurant.

The Admiralty, Somerset House, The Strand, London WC2. Telephone 020 7845 4646. Elegant dining room and excellent food in a formal restaurant setting. Expensive. Wonderful setting at Somerset House where the Courtauld Institute, The Hermitage Rooms, the Gilbert Collection are al situated.

Les Associés, 172 Park Road, London N.8. Telephone 020 8348 8944. This is a Crouch end local with excellent French food and no fear of being rushed out to be replaced by other customers.

Le Colombier, 145 Dovehouse Street, Chelsea, London SW3. Telephone 020 7351 1155. This used to be a pub but has been converted by Didier Garnier into a simple French restaurant with bistro fare.

Gastro, 67 Venn Street, London SW4. Telephone 020 7627 0222. Small backstreet lively French restaurant in Clapham. Very reasonable for excellent fruits de mer and bistro cooking.

Chez Gerard at the Opera Terrace, 35 the Market, the Piazza, Covent Garden, WC2. Telephone 020 7379 0666. Part of a chain but the setting here, in Covent garden market, high up above the crowds is wonderful. French traditional food and open-air seating in summer.

La Trouvaille, 12A Newburgh Street, London W.1. Telephone 020 7287 8488. Next to Carnaby Street in this pretty area with jewellery and fashion shops. Two former Poule au Pot staff work here and it is provincial French cooking at its best. Not far from Regent Street and Oxford Circus.

L'Escargot, 48 Greek Street, London W.1. Telephone 020 7437 2679. Once a famous London restaurant, but now under new ownership a traditional French restaurant. More expensive on the first floor.

Lobster Pot, 3 Kennington Lane, London SE11. Telephone 020 7582 5556. Fish and shellfish restaurant with waiters and waitresses in nautical outfits!

Mon Plaisir, 21 Monmouth Street, London WC2. Telephone 020 7836 7243. For me the best French restaurant, with a relaxed atmosphere and no trendy customers in sight.

Thierrys, 342 Kings Road, London SW3. Telephone 020 7352 9832. This is a traditional French restaurant in Chelsea. Pleasant atmosphere.

Greek

Lemonia, 89 Regent's Park Road, London NW1. Telephone: 020 7586 7454. Run by the same family, the Evangelous for many years. Greek-Cypriot food.

The Real Greek, 14-15 Hoxton Market, London N1. Telephone: 020 7739 8212. Greek food, not Greek-Cypriot and well known in London before Hoxton became famous.

Costa's, 14 Hillgate Street, London W8. Telephone: 0207229 3794. The real attraction of this Greek-Cypriot restaurant is the friendly family who have run it for many years and the courtyard in the summer at the back.

Indian

Westbourne Grove, in Bayswater has several Indian restaurants such as The Standard.

River Spice, 83 Wapping Lane, London E1. Telephone: 020 7488 4051. Modern Indian menu and restaurant.

Star of India, 154 Old Brompton Road, London SW5. Telephone: 020 7373 2901. An old favourite with locals but reasonable prices.

The Cinnamon Club, The Old Westminster Library, Great Smith Street, London SW1. Telephone: 0845 1664250. Unusual Indian restaurant near the Houses of Parliament, so attracts politicians.

Sardinian
Pane Vino, 323 Kentish Town Road, London NW5. Telephone: 020 7267 3879. Friendly, family-run Sardinian trattoria.

Spanish
Cigala, 54 Lamb's Conduit Street, London WC1. Telephone: 020 7405 1717. Tapas and three-course lunch menus.

Gaudi, 63 Clerkenwell Road, London EC1. Telephone: 020 7608 3220. Established Spanish restaurant but a new home next door.

Café Espana, 63 Old Compton Street, London W1. Telephone: 020 7494 1271. Well-known tapas bar.

La Mancha, 32 Putney High Street, London SW15. Telephone: 020 8780 1022. Popular local tapas bar and live music downstairs.

Thai
Patara, 3 & 7 Maddox Street, London W.1. Telephone 020 7499 6008. Off Regent Street. Beautiful interior and polite, friendly waiters. Exquisite Thai food.

Papaya Tree, 209 Kensington High Street, London W.8. Telephone 020 7937 2260. This friendly restaurant is a bit run-down, but has excellent very cheap Thai food. It is also a take away restaurant. There are paintings on the walls too.

Tawana, 3 Westbourne Grove, London W.2. Telephone 020 7229 3785.

Churchill Arms, 119 Kensington Church Street, London W.8. Telephone 020 7727 4242. At the back of the Churchill Arms pub there is an excellent Thai food restaurant. It is very unpretentious and very good. It is also popular with the locals, so go early.

Thai Break, 30 Uxbridge Street, London W8. Telephone: 020 7229 4332. Very friendly small restaurant and excellent Thai food. Good atmosphere.

Thai Gardens, 249 Globe Road, London E.2. Telephone 020 8981 5748.

Bangkok Restaurant, 9 Bute Street, London SW7. Telephone 020 7584 8529.

The Wharf, 75 Wapping High Street, London E.1. Telephone 020 7702 9559. Recent Thai restaurant, popular with Wapping locals.

Iranian
Alounak 2, 44 Westbourne Grove London W.2. Telephone 020 7229 4158. Similar menu to the other Alounak. Fountain in the middle of the room and more gracious surroundings than the other one though.

Javad's Restaurant, 45 Cricklewood Broadway, London NW2. Telephone 020 8452 9226. Vegetarian menu.

Open-air

Osho Basho Café (Highgate)
Oxo Tower Restaurant and Brasserie (South Bank)
Bluebird Café (Chelsea-King's Road)
Canyon (Richmond by the river)
Freemason's Arms (Hampstead- south end green)
Flame (Hampstead)
Hoxton Square Bar and Kitchen (See Hoxton)
Costas (See Notting Hill Gate)
Opera Roof Terrace (Chez Gerard)(See Covent Garden)
The Ark (See Notting Hill Gate)
Café Pasta (Wimbledon Village, London SW19)
Café Rouge and Café Med (Portobello Road area-Kensington Park Road)
Putney Bridge (by the river, Putney)
Soho Soho (See Soho)

Cafés

A selection of some of London's cafés. The following range from typical English to delicious French patisserie or Eastern European. **Prêt a Manger, Starbucks** and **Caffé Nero** have all revolutionised the café scene in London and brought far more variations than there ever used to be. **Patisserie Valerie**, the original in Soho, now has branches in Marylebone, Kensington, Belgravia, Knightsbridge, Chelsea, Covent Garden.

W.1

Patisserie Valerie, 44 Old Compton Street, London W.1. Telephone: 020 7437 3466. Deliciously freshly-made patisserie, croissants, strawberry tarts, with tea or coffee. This is one of London's best-known continental patisseries. The décor is very plain, but the atmosphere and people very Soho. Open Monday-Saturday, 8.30-7. Underground Leicester Square. Also branches now at Knightsbridge (020 7823 9971) on Old Brompton Road, Marylebone High Street (020 7935 6240), Kensington (020 7937 9574), Covent Garden (020 7240 0064), Chelsea at Duke of York Square (020 7730 7094), Belgravia on Motcomb Street (020 7245 6161).

Maison Sagne, 105 Marylebone High Street, London W.1. Telephone: 020 7935 6240. Swiss patisserie and bakery serving a wide range of freshly-baked cakes. Tea and coffee. Monday-Friday 2.30-4.45. Underground Bond Street/Baker Street.

Maison Bertaux, 28 Greek Street, London W.1. Telephone: 020 7437 6007. Open Tuesday-Saturday, 9-6. French patisserie with an amazing variety of cakes. Michele Wade took over Maison Bertaux in 1988 and was taught by Madame Vignaud of the original family the Vignauds, who bought it in 1909. Décor old-fashioned but the patisserie is superb. Underground Leicester Square.

Fortnum and Mason, Piccadilly London W.1. This store has the most amazing displays of English fresh and preserved food in the most beautiful tins and wrapping. Variety of restaurants and English tea and cakes downstairs.Expensive but wonderful setting. Don't miss the chiming clock outside the front door, as it is spectacular.

The Ritz, Piccadilly London W.1. Telephone 020 7493 8181. Scene of the famous Palm Court Orchestra. Afternoon tea 3.30-5.30. Booking essential as it is apparently so popular now! Expensive, but what a setting!

Café Bagatelle, Wallace Collection, Manchester Square, London W1. Telephone: 020 7563 9505. Wonderful setting in a courtyard at the Wallace Collection with light filtering through overhead. Excellent cappuccinos and pastries. Elegant setting.

Maison Blanc patisserie, Holland Park.

Café Royal, 68 Regent Street, London W1. Telephone: 020 7439 1865. This magnificent Edwardian room was once used by Oscar Wilde and you can see yourself reflected in the mirrors seven times, quite extraordinary experience. Famous setting in the late 19th and early 20th century.

W.2

Maison Bouquillon, 45 Moscow Road, London W.2. Croissants, brioches, petits pains chocolats and other delights. Open seven days a week 9-11.30pm. Underground Bayswater.

Pierre Péchon, 127 Queensway, London W.2. Telephone: 020 7229 0746. Also a bakery branch at Pembridge Villas nearby. Family-run cake shop with original recipes for their cakes. Open seven days a week 9-5. Underground Bayswater.

W.8

Muffin Man, 12 Wrights Lane, London W.8. Telephone 020 7937 6652. Devon cream teas, delicious freshly-baked cakes and an English country town atmosphere (well, a bit more Eastern European due to new ownership) to match, right in the heart of Kensington, just off the high street. Open 8.45-5.45, Monday-Saturday. Underground High Street Kensington. Also Maison Blanc on Kensington Church Street.

W.11

Renaissance, 108 Holland Park Avenue, London W.11. Telephone: 020 7221 3598. A relaxed and friendly Holland Park French patisserie, open daily including Sundays. Reasonable prices for lunch, coffee or afternoon tea. Near Holland Park and the beautiful Japanese Gardens, both worth a visit.

Maison Blanc, 102 Holland Park Avenue, London W11. Telephone: 020 7221 2494. No seating area here, but the window displays are true to French style. They also operate a catering service for weddings, parties and picnics.

NW3

Louis' Tearoom, 32 Heath Street, London NW3. Telephone: 020 7435 9908. Visit this patisserie and tearoom after a walk on Hampstead Heath. Hungarian patisserie with freshly-baked cakes and fresh tea, no tea bags! Open seven days a week, 9.30-6. Underground Hampstead.

Richmond and Kew

Newens Maids of Honour, Kew. Telephone 020 8940 2752. Next to Kew Gardens, but sadly not open on Sunday. Perhaps the most English tea place in London. Dates back to Henry VIII, with original recipes. Waitresses are dressed in old-fashioned country-girl dresses. Good atmosphere and many English families come here after a walk in Kew Gardens.

Wimbledon

Cannizaro House, Wimbledon Common West side. Telephone 020 8879 1464. This wonderful old Georgian house has beautiful grounds with a lake and gardens, also an aviary. Wimbledon

art school sometimes shows sculpture here. Afternoon tea is expensive but what a setting in spring or summer! They also have live jazz and theatre in the gardens in summer.

Music Places

Classical

English National Opera, London Coliseum, St Martin's Lane, London WC2. Telephone 020 7836 3161/240 5258.

South Bank Arts Centre-Royal Festival Hall, Queen Elizabeth Hall, Purcell Room. The South Bank houses the National Theatre, the National Film Theatre and the Hayward Gallery. The three main concert halls mentioned above, offer a variety of classical music, ranging from quartets to full-scale orchestral concerts.

Royal Albert Hall, London SW7. Home of the annual Proms (promenade concerts) from July-September. Also other events and rock concerts.

Wigmore Hall, 36 Wigmore Street, London W.1. Telephone 020 7935 2141. Where Jacqueline du Pré famously played her last concert.

Royal Opera House, Covent Garden. Telephone 020 7304 4000. Box office in Floral Street. Opera and ballet. Tickets are expensive but cheaper if bought on the day of the performance. You can now have tours of the backstage areas.

Barbican Hall, Barbican Arts Centre, Silk Street, London EC2. Telephone 020 7628 8795 for reservations. Variety of concerts in this beautifully-designed hall.

Jazz

Jazz Café, 5 Parkway Camden Town, London NW1. 020-7344 0044. Stylish venue in trendy Camden Town. Also has occasional art shows by contemporary artists.

Pizza on the Park, 11 Knightsbridge, London SW3. 020-7235 5273. This is a stylish, but more conventional and mainstream venue.

Ronnie Scotts, Frith Street, London W.1. 020-7439 0747. Right in the heart of Soho. London's main jazz club. Expensive but worth a visit.

Rock

London is still a centre for rock music internationally. There are now so many venues that it would be best to buy **Time Out magazine** weekly to check the places. Here are a few.

The Ministry of Sound, 103 Gaunt Street, London SE1. 020-7378 6528. £15 entrance fee, but the club for most people.

The Rock Garden, 6-7 The Piazza, Covent Garden, London WC2. Telephone 020-7836 4052. Bar and live rock music. Groups change each night. All ages, but mainly older group.

The Hanover Grand, 6 Hanover Street, London W.1. Telephone 020 7499 7977. Has been around for years and still popular, but slightly older crowd-30s not late teens.

Notting Hill Arts Club, 21 Notting Hill Gate, London W.11. Telephone: 020 7460 4459. Lively local venue, but also popular with other Londoners. Music varies according to the night. Age group 20s-late 30s. In 2005 they swapped staff with a Norwegian bar as part of Norway's independence anniversary celebrations.

Subterania, 12 Acklam Road Ladbroke Grove, London W.10. Telephone 020-8960 4590. Run by Vince Power who seems to own half of London's clubs. Like the Ministry of Sound, a must. 20s/30s/early 40s.

Sport

A variety of sports facilities feature below; tennis, swimming, football, cycling, horse-riding, fishing and boating. See under Parks for specific facilities in each London park. Boating in Battersea and Hyde Park for example.

Cricket

Visit Lords Cricket Grounds and the Oval in South London to see first class cricket.

Tennis

You can only play for an hour at a time at most London parks. Parks are listed in the telephone directory. The Lawn tennis Association, Barons Court, London W.14., will give a list of tennis clubs in London if you send an sae. Wimbledon is the big event in tennis at the end of June and beginning of July annually.

Football

The season runs from August until April. Some London teams are Chelsea, QPR, West Ham United and Tottenham. Football Association, Lancaster Gate, London W.2. for further details.

Rugby

Rugby Football Union, Twickenham for all information about rugby. There is also a Rugby museum at Twickenham now.

Swimming

Indoor public pools are usully approximately £4 entry fee. Central London pools at Marshall Street, West Soho, Porchester Baths W.2., Oasis, Endell St Covent Garden, Seymour Place W.1. Open-air pools at Hampstead (020 7485 4491), Parliament Hill Lido (020 7485 4491, Richmond (020 8940 0561), Serpentine (020 7706 3422), Victoria Park, Brockwell Lido (020 7274 3088), Finchley Lido (020 8343 9830), Oasis Covent Garden WC2 (020 7831 1804), Gospel Oak NW5 (020 7485 3873),Tooting Bec

Lido (020 8871 7198). www.thegreatswim.com. In August on one Sunday this event enables Londoners to swim at all London pools in one day!

Skating

Queens,17 Queensway London W.2. Open daytime and evenings.Prices vary according to the time you visit. **Broadgate Centre,** has an open-air skating rink, next to Liverpool Street station, in winter. Somerset House now has an open-air rink in November-January which is very popular, also Marble Arch, King's Road (a very small one and plastic ice) and out of London at Hampton Court and Greenwich.

Sports Centres

YMCA, Great Russell Street, London WC1. Telephone 020 7637 8131. Squash, swimming, dancing, mountaineering, badminton, keep-fit. Excellent sports shop here.

Crystal Palace, National Recreation Centre, Norwood, London SE19. Telephone 020 8778 0131. One of the best sports centres in London. British Rail from Victoria.

Swiss Cottage Centre, Adelaide Road, London NW3. Telephone 020 7278 4444. Squash, swimming, badminton.

Sobell Centre, Hornsey Road, London N.7. Telephone 0181 020 8607 1632. Squash, badminton, mountaineering.

Health Clubs

Ring each club to find out about classes and facilities. Some local swimming pools do provide gym, solarium and other facilities for as little as £3. Health clubs are rather elitist and local sports centres often provide the same facilities. Health clubs are, however, usually free of children whereas sports centres thrive on them—take your pick! These are just a selection.

Courtney's at W10. 020 8960 9629; at Seymour Centre W1 020 7723 8019; at Queensway Porchester Centre 020 7792 2919.

The Sanctuary, 11-14 Floral Street, London WC2. Telephone 020 7240 2744. Magnificent swimming pool and very relaxing club. You can visit just for the day, but it's not cheap!

Skating at Duke of York Square, King's Road, in early January.

Dance Works, 16 Balderton Street, London W.1. Telephone 020 7629 6183. Ideal for dance fanatics.

Cannons, Cousin lane EC4. Website: www.cannons.co.uk 13 clubs all over London.

Esporta, Website: www.esporta.co.uk. There are now 8 Esporta clubs in London.

Fitness First, Website: www.fitnessfirst.com. There are 25 of these clubs in London.

The Harbour Club, Watermeadow Lane, Fulham SW5. Telephone 020 7371 7700. Exclusive health club. Website: www.harbourclub.co.uk

Holmes Place, 188 Fulham Road, London SW10. Telephone 020 7352 9452. Swimming pool, gym, classes and steam room.

Holmes Place at the Barbican, Barbican, London EC2. Telephone 020 7374 0091. Largest health club in Europe. Pool, 3 gyms, circuit training, jacuzzi, steam and sauna, classes and crêche for children. Holmes Place now has branches at 31 venues throughout London and the South East. Website: www.holmesplace.co.uk for details and numbers.

Heather Waddell

Heather Waddell was born and brought up in Scotland. She has written for the following papers and magazines; *The Independent, Independent on Sunday, The Times, The Glasgow Herald, Vie des Arts* (London correspondent 1979-89), *The European* (Arts Events editor 1990-91), *Chic* magazine (Visual arts editor 1994-98), *Artline, The Artist, Artists Newsletter, Artnews USA* and many others. Her books include this guide, and *The Artist's Directory, Henri Goetz: 50 years of Painting* and *London Art World 1979-1999.* She has also contributed to *L'Ecosse: lumiere, granit et vent* (1988), *Londres* (1997 & 2000), *Editions Autrement, Paris,* MacMillan's *Encyclopedia of London*, the *Blue Guide to Spain, Australian Arts Guide* and the *Glasgow Arts Guide.* In 1981 she set up Art Guide Publications, publishing art guides to Paris, New York, Amsterdam, Berlin, Madrid, Glasgow, Australia, Great Britain and London, which was the first guide.

She has five art world photo-portraits in the National Portrait Gallery 20th-century Collection. She has exhibited in 5+1 at New South Wales House Art gallery, at Battersea Arts Centre and at ACME Open studios in the 1980s.

359

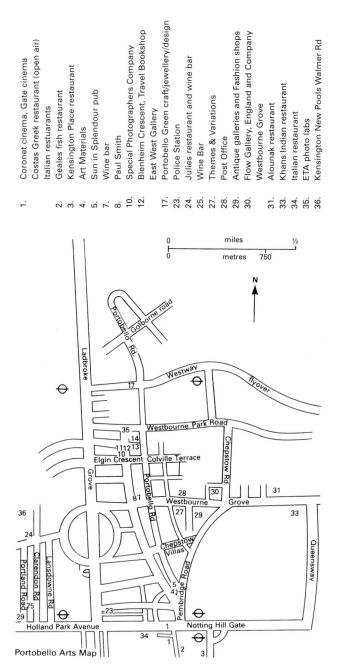

Portobello Arts Map

City and East London Art Map

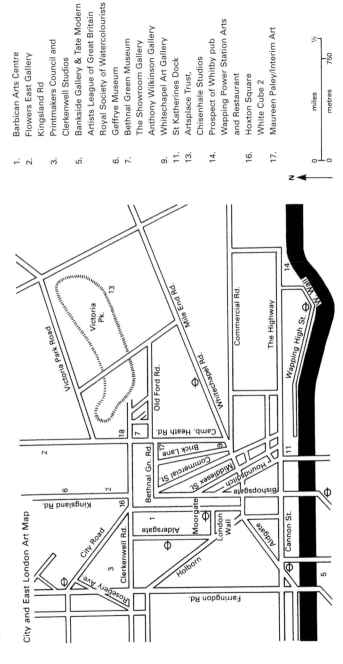

1. Barbican Arts Centre
2. Flowers East Gallery
 Kingsland Rd
3. Printmakers Council and
 Clerkenwell Studios
5. Bankside Gallery & Tate Modern
 Artists League of Great Britain
 Royal Society of Watercolourists
6. Geffrye Museum
7. Bethnal Green Museum
 The Showroom Gallery
9. Anthony Wilkinson Gallery
 Whitechapel Art Gallery
11. St Katherines Dock
13. Artsplace Trust,
 Chisenhale Studios
14. Prospect of Whitby pub
 Wapping Power Station Arts
 and Restaurant
16. Hoxton Square
 White Cube 2
17. Maureen Paley/Interim Art

N ◀

0	½
	miles
0	750
	metres

361

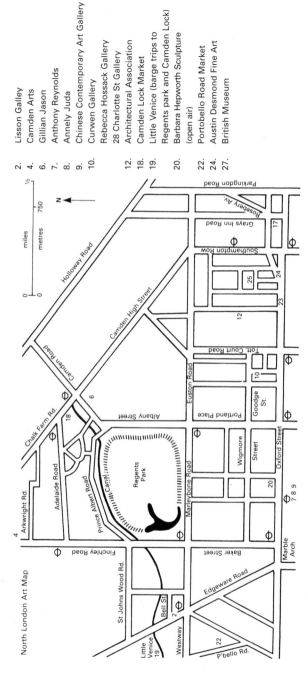

North London Art Map

2. Lisson Galley
4. Camden Arts
6. Gillian Jason
7. Anthony Reynolds
8. Annely Juda
9. Chinese Contemporary Art Gallery
10. Curwen Gallery
 Rebecca Hossack Gallery
12. 28 Charlotte St Gallery
 Architectural Association
18. Camden Lock Market
19. Little Venice (barge trips to
 Regents park and Camden Lock)
20. Barbara Hepworth Sculpture
 (open air)
22. Portobello Road Market
24. Austin Desmond Fine Art
27. British Museum

N

0 ½ miles
0 750 metres

362